THE BLUE SERIES

THE STORY BEHIND THE COLOR

VOLUME ONE

W0009540

EDITED BY BEN BLACKWELL

For more Blue Series material visit:
thirdmanbooks.com/theblueseriesbook
password: thestorybehindthecolor

Printed in the U.S.A.

Library of Congress Control Number: 2017902700

FIRST EDITION
Art Direction: Ryon Nishimori & Jack White III
Design & Layout: Ryon Nishimori & Jessi Yohn
Photography: Jo McCaughey, unless otherwise noted
ISBN 978-0-9964016-4-7

THIRD MAN BOOKS

NASHVILLE, TENNESSEE

CONTENTS

"DO MORE OF THAT THING, THE LICK YOU WERE PLAYING AT THE END."

That was Jack White — singer, songwriter, musician, producer and serial entrepreneur — speaking over the talk-back mic to Reine Fiske, guitarist for the Swedish psychedelic modernists Dungen, one evening in September, 2010. White was at the console in his Nashville, Tennessee home studio, hunched over the knobs and meters, pushing faders into the rattling-speaker zone with a mad-scientist grin. On the other side of the control-room glass, Dungen — Fiske, bassist Matthias Gustavsson, drummer Johan Holmegard and composer-founder Gustav Ejstes were making "an iridescent thunder," as I later wrote in *Rolling Stone*, caught on eight-track tape and destined for pressing at 45 RPM by White's Third Man Records, in the label's year-old Blue Series of seven-inch singles.

This was an unusual session for Dungen, who were passing through Nashville on tour. Ejstes typically played most of the instruments on the group's studio albums. Here, cutting live with his road unit, Ejstes "hammered a hypnotic winding-staircase figure on piano," lined with Fiske's "snake-like coils of scouring-fuzz guitar," while I drank it all in and wrote it down at my sweet spot — behind White, leaning against a vintage tape machine. After one take, White — hearing a new possibility in his head — asked Ejstes to try that piano motif alone, as an intro before the rest of Dungen stormed in. "Man, that was sick," White exclaimed after the next pass, the entire band revving into an extended "metallic early-Procol Harum high" — a phrase I actually scribbled in my notebook. White, visibly jazzed, quickly announced over the intercom, "Let's have another one."

I eventually learned the title of that piece — "Öga, Näsa, Mun," Swedish for "Eye, Nose, Mouth" — when I got TMR 065, the finished Blue single, backed with a shape-shifting space-out, "Highway Wolf," in one of the series' signature-portrait sleeves: Dungen shot by photographer Jo McCaughey as if between takes on a smoking break, complete with ashtray, against a regulation regal-blue backdrop. I also noticed this when I examined the actual disc, an absolute rite of entry into my collection: On the A-side, in the run-out groove, someone had etched the words "Fricke's Picks" — the name of my Rolling Stone review column at the time. It was official: I wasn't just present at the creation. I was on the record.

That is the kind of attention to detail — smart, playful, attuned to the moment, executed to the highest standards of record-making craft and independent ideals — that hits you everywhere in the Third Man discography, as any exhausted collector of the imprint's colored-vinyl delirium and cunning one-off variations will tell you. "I ran my business like a cartoon," White told me in 2005, recalling his days in upholstery restoration, running his own outfit in Detroit before he started future-blues duo The White Stripes. "I was making out bills in crayon and writing poetry inside people's furniture." It was the joy of art in expertise, making individual works in a line of quality.

So it is in the Blue Series, now at the 40-singles mark. I was there at the start: Mildred and the Mice's howling No Wave revival "I Like My Mice (Dead)," TMR 003. Two dozen entries later — TMR 106, Welsh baritone-gladiator Tom Jones' thumping vengeance on Willie Dixon's "Evil" (with a chaser of the Doors' "Wild Child") — I felt like I needed a user's manual to navigate that deceptive uniformity: the diversity of celebrity, collaborative surprise and left-turn repertoire that came with each single.

Finally, I have one.

This is hardly a news flash to anyone who knows me, as a byline or otherwise: I love records — the buying, receiving, spinning, investigating, treasuring. Which means I love great books about records too: ripping yarns about everything that happened on the way to my stereo, with no minutiae too small to matter. *The Blue Series: The Story Behind the Color* is the tale, in depth, behind every Blue single, curated by Ben Blackwell: Dirtbombs drummer, deep-indie-punk and Michigan garage-rock authority and Third Man's "Psychedelic Stooge," a business-card summation of his pivotal stewardship of vinyl manufacturing, distribution and format fun at the company. He also has his own label of love, Cass Records. Blackwell loves records too, knows the ones you need to hear and brings back the archaeology. You couldn't ask for a better friend riding shotgun.

The Blue Series was one of White's first initiatives when he opened Third Man's Nashville office-venue-store in 2009. But it is part of a long tradition — at once evolving and consistent — that runs through the single sleeves in my record room. A few examples: the grunge-era subscription hi-jinx (new bands, covers sabotage, limited editions) of the Sub Pop Singles Club; the guerilla mischief, in design and pressing, of the early Stiff 45s; the specific identity and reliable class I associated, especially in the Sixties, at 45 and 33 1/3, with the iconic E on the Elektra label.

In a roundabout way, the Blue Series reminds me of the first happy daze at the Beatles' Apple Records: the eccentric solo and protégé-act singles, frequently in dashing picture sleeves but tied together by that Magritte-like apple on the label, green on one side and sliced in half on the other. Initially, the Beatles tried to run their company as an art-house project. Likewise, the Blue Series was launched with museum-ready values. Line up these sleeves in any order and you have an instant portrait gallery of vintage and contemporary pop faces in striking variations from their more familiar, public images. There's Gibby Haynes of the Butthole Surfers crouched in a fetal position, something I never saw at riotous Surfer gigs; Beck in a fedora and black-lens glasses, looking like a young, blond Blind Willie McTell; rockabilly femme fatale Wanda Jackson miles away from Fifties chiffon, bent over a guitar in zebra print, picking with laser-like focus.

I recognize another precedent with a twist. Blue Series singles are typically made thusly: Friends, peers and admirers pulling through Nashville stop by Third Man and swiftly cut a 45, produced by White and often featuring musicians from his wide circle of bandmates and players. Photos are shot in the Third Man "Blue Room." It's like field recording in reverse, except the voices in the field come to Third Man. And that harvesting of songs, Lomax and Folkways style, is here too, in the resurrection and variation of tunes passed down like blues and hollers. The English folk singer Laura Marling reaches back on TMR 044 to "Blues Run the Game," a London-club anthem in the Sixties by the star-crossed American expatriate Jackson C. Frank. In "Shivers," on TMR 321, Australian rocker Courtney Barnett pays homage to her renegade-punk ancestors Boys Next Door aka the Birthday Party with raw, plaintive immediacy.

I could go on. But that's what this book is for. Just a couple more things: The Blue Series only spins at 45 — you can't get this music on albums. And it's not just for collectors. Singles may go out of stock; they never go out of print. So it's never too late to dive in. And when you get to the end here, of the story so far — Dwight Yoakam pulling the Bakersfield country out of the Monkees — you'll feel like Jack White at that Dungen session:

Let's have another one.

— DAVID FRICKE

I AM JUST A FAN.

Through the assembly of this book, re-listening to singles, tracking down long-lost performers, speaking to artists who hold my deepest respect and admiration, all I could help but think is that I am merely a fan who worked hard to get lucky.

So as I dig through chains of seemingly ancient emails from 2009, the first internal Third Man reference to the Blue Series was April 8th and I'm surprised to remember the Blue Series wasn't some big, thought-out plan. I can't help but be amused by the fact that we'd already recorded two of these records but had yet to even consider them a "series."

Even prior to that, Jack, Ben Swank and myself made an in-person pitch for what we had envisioned for the first single in the yet-to-be-named approach. On March 18th, a mere eleven days after we'd opened the doors and told the world Third Man Records existed, we clambered onto a tour bus parked walking distance from our Third Man offices. Jack handled the pitch primarily, well-spoken, enthusiastic and, from my vantage, completely convincing.

But the artist just wasn't feeling it. No shade or hard feelings, everything was cool, but it just didn't seem like her cup of tea. While her performance that evening surely captivated the couple hundred people in attendance at the Cannery Ballroom, I was distracted by a nagging thought ...

"Maybe recording singles this way isn't a good idea."

Thankfully, I was wrong. I'm not exactly sure how to gauge the fact that we were turned down by Adele, an artist who, at the time, we had no clue was on the precipice of all-encompassing worldwide domination. But I often think had she recorded the first Blue Series single the whole thing would be considered a downhill slide by the lazy armchair record label pundits ... "there's only one direction you can go if you start with the biggest singer in the world!"

In the same spirit in which the Blue Series was birthed, this book came to be. Quickly, without too much planning, with a guiding ethos of "we'll figure this out" in a manner to further art and the discussion surrounding it. With the emphasis on the artists, their words and thoughts became paramount, so oral documentation by phone conversation, email interview or even essay became the vehicle. I reached out to every artist. Most responded, some did not. There wasn't even time to be concerned, I just had to keep on working.

A few weeks ago I finally upgraded my work "briefcase" from a worn messenger bag silk-screened with the phrase "DETROIT SOUL" to a more respectable, adult-like bag from Filson. As I fished out the scraps and remnants of the past eight years of transport between my domicile and the Third Man office, I found the backstage pass for that Adele show. Knocking around all that time, constantly with me, I couldn't help but think that pass was an unknowing totem of inspiration sprouted from my skepticism that night. Don't overthink, don't second-guess. Press forward, create and share your enthusiasm with the world.

That is the Blue Series. That is this book. I am still just a fan.

— BEN BLACKWELL

JACK WHITE

INTERVIEWED BY **BEN BLACKWELL**

PHOTO: ANGELINA CASTILLO

"Third Man has sort of a family of artists, and those artists join that family when they become part of the Blue Series.

BEN BLACKWELL: Is there a specific impetus behind the idea of the Blue Series? What precipitated what?

JACK WHITE: That we had a store and a label right here in Nashville, that there should be records that come right out of this system, and that we're not just selling other peoples' records, that we're not just another record store. Also this — very often I'm asked by people if we can do something together, people that I love and respect, but I didn't really know how to make a collaboration work with them. The Blue Series gave me another outlet for that. So, these records became a way to solve several things at once. Third Man could have our own series of singles, allow me a new, different way to work with people, and more, give Third Man a chance to do for touring bands something I personally always wanted to do while on tour — a quick spontaneous recording session. I remember the White Stripes tried to do that in Australia once — record direct-to-acetate, release it down there, and let the record be this thing that only existed in this tiny little world. I wanted to make that scenario possible here with Third Man. Let me produce one or two tracks while you are in town, we'll do it in one day, and that's it. It will become a time capsule of that moment. We'll always keep it in print, and we'll always treat it like it came out this week. I don't know if I've ever seen anything just like it at any other label — have the same producer work on every single in the series, every record recorded in the same studio, and the cover always photographed in the same room.

BLACKWELL: Was the Blue Room painted before you had the idea? What came first?

WHITE: It was painted blue. The color was about being able to take photos and film videos — we needed a background we could use for a green screen. Either cobalt blue or lime green would work, but I wanted to use green in the Third Man buildings for storage. So, it just sort of turned out that the logical place to take photos for the covers of these records was the Blue Room. After we did the first one, I guess we started calling it the Blue Series, I'm guessing [laughs].

BLACKWELL: I gotta go back through my e-mails from 2009, but I think we started calling them Blue Singles and then Blue Series. I remember those first singles we released as soon as they showed up in the building, we just put a notice on the website and put 'em in the bins out in the shop, the day that they came in. That was our goal, let's just get these out as fast as possible. About the artists, you've said to me before that you are far more interested in working with some unknown punk band than getting some marquee producer job for some multi-platinum fill-in-the-blank name. Why is that? What's the appeal of working in that realm?

WHITE: I think, in most cases, if I worked with a pop singer who's expected to sell millions, it would become a committee deciding what's the right way to approach it, and then you have to sell them certain buzzwords, and how we're gonna use this kinda style, and how we're gonna go about this record, like we have to sell it to somebody in a room, in a conference room. I'm more interested in what's the best way to bring the best out of this punk band that nobody's ever heard of, and how can we get the rawest recording. But that has its difficulties, too. I don't want to boss them around. I don't want them to feel like I'm telling them what to do. So a lot of times I bite my tongue with a lot of the ideas, and I end up not really doing what I really want to do. In the sort of hip, underground, garage rock-y worlds it's very dangerous if I say anything. Because the more you care about it, the more they'll walk away and sit on a barstool and say, "Eh, he wasn't that cool to work with blah blah blah," and, "He told us to tune our guitars up," or something like that. Sometimes you're expected to kinda come in and say, "Alright I'll just press record and watch this magical thing happen," with absolutely no ideas behind it, and no thought put into what you're actually trying to accomplish. Then, something accidentally, magically is expected to happen in 30 seconds. That's pretty fucking rare man. I mean, I've been in and recorded things a million times very quickly. But I know the way I work. I've already thought of all the ideas at home in my bedroom for what I'm trying to accomplish. I know that when I set up and press *record*, we're already halfway there. But when you work with people you don't know very well, and they have some sort of ultra punk rock sensibilities, it can sometimes be dangerous to say out loud exactly what you're trying to get out of them. You could be really kind of crucified.

BLACKWELL: Punk doesn't really lend itself to the idea of production. Inherently it's kind of supposed to be quick and it's supposed to be ephemeral —

WHITE: Exactly.

BLACKWELL: When you're saying "caring" too much for some, you mean it can reek of too much of effort.

WHITE: It's a double-edged sword. It's almost not punk to work with somebody like me because I'm well known. It's more punk to work with somebody nobody's heard of and record for $5. So it's sometimes tough for me to figure out the best thing for everybody involved. Whether to use fake names, not promote it, or just kinda let people word-of-mouth about it. It's also very disappointing at the end of the day, that it's not about the actual music, and the sound of it, it's about all the crap surrounding it and whether or not it's cool or not.

BLACKWELL: The baggage of it.

WHITE: I've been punished with that enough to realize that it's not important, and it doesn't matter. It's a shame to still see that happening. It makes you jealous of country music, and those kind of genres where they don't even talk about stuff like that. They're just trying to record the best song they can in their world. You have to kind of pretend you're not doing that in the punk world. You have to pretend you're not trying too hard.

BLACKWELL: How did you hear about Transit? A band that is very definitely neither punk nor country.

WHITE: I was on an airplane flying back to Nashville and sitting in the row in front of me were these people talking about some sort of party. Some kind of battle of the bands. One said the best band, he thought, was a band made up of all these people from the Metro Transit Authority, the Nashville public bus company. The guy next to him was like, "Really?" And he said, "Yeah! They have their own band they put together. It was amazing!" I didn't ask the guy about them, but I decided as soon as I got home that I had to figure out who these people were talking about, because it sounds incredible. So, we found them and invited them to come do a record.

BLACKWELL: Now when you say you found Transit and invited them to come do a record, the main point that needs to be stated here is ... that happened without ever hearing any of their music.

WHITE: Right! Just the idea that people working at the bus company had a band, and it's supposedly pretty good ... well, I had not heard anything by them, and it didn't matter. It's just the idea that that's possible. If you told me there's a band of ten people at Ford Motor Company who play funk or something, I'm already interested. What's that gonna be like?

BLACKWELL: We Are Hex kinda stands out to me as a unique entry in the Blue Series, too. What do you remember about that session? What drew you to them?

WHITE: That was a random thing I found on the Internet. I really liked the first 30 seconds of what I heard. They just had a really cool attitude, looked like a young band that nobody had really heard about and was about to go out and start touring, getting really busy. It's hard to find those moments, opportunities where you can really work with a band before they've gotten out there. So I thought I would just take a chance with them and see if we could come up with something cool. It's also very much a gamble to work with people that nobody knows, and hope for them to go out and really work on the road. I don't really know much about what happened to that band after we worked on that record. Are they still a band?

BLACKWELL: They are not.

WHITE: But I really loved working with them. I thought their guitar player was writing really cool parts.

BLACKWELL: Going back to what you said earlier about working with some big pop singer, it kind of brings me back to who was the first person you asked to do a Blue Series with?

WHITE: We asked Adele earlier on to do a Blue Series after we first opened Third Man. She was in Nashville, performing at a local club, these were obviously early days. Anyhow, she decided she didn't want to do the session. I don't remember the reason why she didn't. Whenever you ask someone if they want to be involved, do something like record, or play a live show, it's hard to know what they're thinking, what they've already got going on in their world. They may have things that they can't tell you about, that the timing might be really bad, and all they can say is they can't do it. There have been times when I've wondered why somebody doesn't want to do what we're offering them, it seems almost ridiculous that they're not, but you know everyone has their reasons. I've learned over the years to not let that bother me as much.

BLACKWELL: Arguably the most punk thing on the Blue Series is Gibby Haynes from The Butthole Surfers. Did you approach him or did he approach you?

WHITE: I would argue that our first Blue Series record, Mildred and the Mice, is the most punk-sounding record we did, BUT did Gibby Haynes approach me? I don't remember, I'm sorry. I don't remember which one of us contacted each other, but somehow, sometime the idea did come up between us. What I do remember is him not understanding until we were done recording that the Blue Series was just named after the background color. I think he thought the series was supposed to be all blues songs, which was fine, cause doing that came out great. Also, he wanted me to record guitar, which I usually say no, but I thought, well, I would love to do this, probably the only chance that me and Gibby Haynes are gonna have to work together. So yeah, I really loved it. He had great ideas.

BLACKWELL: One thing I see as kind of a reoccurring theme as I look through all the Blue Series releases, that these are kind of a timeline, or reference chart, for your career. For example, you do a Blue Series single with Chris Thile. Over time he becomes the new host of *A Prairie Home Companion,* and you perform with him there.

WHITE: Right.

BLACKWELL: Or you do a Blue Series with Stephen Colbert and then you're performing one of the first weeks of his late night show on CBS. A lot of Blue Series artists have opened for you on tour, too, whether it's First Aid Kit or Duane the Teenage Weirdo. Seven years on and forty plus-ish releases, does it feel any different than it felt on day one? Does it mean something different to you now? Or has it become its own thing, that you just put it into motion?

WHITE: It's become harder and harder as the years pass, finding for me the free time to do them. I wish I could do them more. But I think they feel exactly the same. Especially when they're unknown acts, I kinda feel like this is a lot of work for something that will not yield a lot of sales, but it's something that I really love doing, and the artists really want to do. That makes it worth every amount of, every ounce of energy we put into it. And I think it also becomes a family of people, that Third Man has sort of a family of artists, and those artists join that family when they become part of the Blue Series. And it's great we become more like cousins or aunts and uncles, who you don't see very often, but feel like we're all part of that same team.

BLACKWELL: Specific to that, I think of the Blue Series with Lillie Mae, which a couple years down the line leads to Third Man putting out a full-length with her. Working with Lillie Mae on the Blue Series, that experience for you, did it make you feel like you wanted to do more with her?

WHITE: Yeah. It took a long time to talk her into doing an album. It took a couple years, she's just wasn't ready yet.

BLACKWELL: She had never done anything solo before that Blue Series single?

WHITE: She did one record with somebody else, I think called *Rain on the Piano?* She was recording that album while we did that Blue Series. So she was worried about doing two things at the same time, and when we were talking about doing a whole album she was worried about all of that. She comes from a different world of traveling musicians, or playing on Broadway in Nashville five nights a week, and performing on people's records as a session musician. She doesn't really have any kind of ego at all, so it's very hard for her to do things that have her name on it, and it's all about her. She feels a little bit embarrassed, I think, so it took some talking her into getting a full album done. But that Blue Series was amazing, that did lead to us wanting to do an album together. Same with Wanda Jackson. Her Blue Series led into us doing her full album. Which in turn because I used so many musicians in like a ten-week span on a record, broke me in as a large band producer, and eventually led into me using an all-male and all-female band on my *Blunderbuss* album. So I learned a lot from the Wanda album that led directly into my production for my own record. But about *Blunderbuss* itself, that came out of RZA booking a Blue Series session. He was scheduled to come in, but canceled the day of, so that kind of led into me making my first solo record, which is pretty funny, because we just didn't know what else to do with the musicians.

BLACKWELL: Did you send RZA a thank you note?

WHITE: I saw him and I didn't know how to explain that [laughs] but we had a good conversation. Thank you, RZA.

BLACKWELL: Glad we got that on tape. Back to Wanda Jackson, her single seems like a lynchpin in the Series because it's one of our most well-known, but also there were lots of tracks where you recorded backing music for Wanda that she couldn't or wouldn't sing that ended up being used for others — Secret Sisters, Tom Jones and Kate Pierson —

WHITE: Tom Jones "Evil," Kate Pierson "Venus" — those were all possible tracks for Wanda that either she or I decided wasn't going to work.

BLACKWELL: "Wabash Cannonball" too?

WHITE: Yes, "Wabash Cannonball" too.

BLACKWELL: So there's a lot of people who appear on a lot of Blue Series singles from one day in the studio.

WHITE: Yeah, exactly.

BLACKWELL: Tom Jones for instance, he comes along and just sings his vocals along to "Evil." There's no band performing on any of that, but you also had a band in the studio ready to record the B-side with him.

WHITE: Right, exactly.

BLACKWELL: And his approach, what's the scenario there?

WHITE: He was incredible. I mean his voice right off the bat, how can you sing so clearly this early in the day? When you see people who are real professionals or real showbiz professionals who have been doing it for decades, you can tell right when they start that they know how to do what they're doing. And it comes with ease to them, and that's always a great palette cleanser for all the times you've worked with people early in their career who aren't so sure of themselves, they don't really know what to do. People like him that are veterans know exactly how to go about something.

> ## "I think Zane Lowe even challenged me whether I produced it ... It's not about looking for credit. It's how to bring the best out of the artist."

That's great to see, it gives you a lot of inspiration how to do things when you get to be at a certain point in your own career.

BLACKWELL: I think of all the Blue Series singles you've done, probably the one I would imagine that's talked the most about is Insane Clown Posse.

WHITE: Yes.

BLACKWELL: What can you tell us about what it was like being in the studio with them? Didn't they write everything just on the spot, that they didn't come with any lyrics or anything like that?

WHITE: They did. That record came from me reading about somebody in the music industry being called "very brave." And to me, I thought, "what's the bravest thing I could possibly think to do?" And what

popped in my head very quickly was produce tracks for Insane Clown Posse. I called them and asked them if they would come and do this, you know, two tracks and they said, "Yeah, we'll do it but," — I think it was Violent J asked me — "let me just ask you: Why us?" And I said, "You know, I look at what you guys do all the time, I think once every six months I check in and see what Insane Clown Posse is doing." And that I've never understood the vitriol for the band. It's like getting mad at a professional wrestler for wrestling being fake. I mean, it's just so obvious that wrestlers know what they're doing, they know it's fake, you idiots. If you think the Insane Clown Posse doesn't know what they're doing, you probably don't understand that "Fuckin' Magnets, How Do They Work" was purposefully written. But other perceptions clouded their idea, *oh see these guys aren't smart enough to know, look how ridiculous they are.* Really, they're the smart ones. And that's what I was trying to explain to Violent J. When the session came, I had no idea what to do with them. I really didn't. I had some musicians lined up to possibly come in, but the night before I just happened to click on some article that talked about Mozart writing a song called "Lick My Ass." I thought, "Ok, I know what this session is gonna to be about." It's gonna be about perception, and that's what ended up happening. They recorded a song by Mozart with a woman singing opera in German, one of the coolest underground bands of the time, Jeff the Brotherhood, playing the music on it, and Insane Clown Posse rapping their lyrics made up on the spot.

BLACKWELL: And produced by you.

WHITE: And produced by me. Everybody else gets a free Get Out of Jail Free card except for them, and possibly me. Mozart wrote "Lick My Ass." He's fine. He's good. Jeff the Brotherhood, yeah that's fine, I understand why they were part of that. Insane Clown Posse? Fuck those guys! Jack White working with them? Fuck him for doing that! It's all about perception. Mozart gets a Get Out of Jail Free card because he's Mozart. He's the one who fucking wrote a song called "Lick My Ass!" It's just about perception — you think I didn't know what people were gonna think when I stood there taking a picture with Insane Clown Posse? If you don't look at the little video we made to promote that, and not laugh, and not think that's amazing and hilarious and beautiful ... Nobody's using anybody, nobody's getting used in this process. Everybody is benefiting everybody else. Even Mozart's benefited from all this. And the lyrics they wrote are fucking incredible and hilarious. I can't believe that they did it so fast. "Mozart / Dope for the most part" — when's the last time you heard somebody say something that clever about Mozart? Now that's incredible.

BLACKWELL: Tell me about recording with Beck, that was pretty much one day and was in the middle of him doing another recording session at Blackbird in Nashville, right?

WHITE: Right, yeah he recorded a whole bunch of songs for his album at the time, I think it was *The Information* —

BLACKWELL: No, *Morning Phase?* Probably *Morning Phase.*

WHITE: Ok, yeah, it was *Morning Phase* yeah. I did songs with him over at Blackbird, also. Two or three songs, I can't even remember which. Beck and I have a whole bunch of songs. We could release a whole album of songs that no one's ever heard — which we probably should do one day. But back to our record with him, first of all, Blackwell, I'm probably — anything I tell you I could be wrong, but I seem to remember him coming to take a tour of Third Man and showing him the Blue Series that we were working on, and he said that he would like to come by and try something out, too. So we did. I still think that those songs are very underrated. Those are some of my favorite Beck songs. Because they're not part of an album of his, it's hard to get people to take a real good listen to them. They're these solo, slow beautiful songs. I think some of his — my favorite lyrics — he's ever written.

BLACKWELL: The ending of "I Just Started Hating Some People Today" — did that come about organically with the hardcore screaming and the kind of jazzy bee-bop scatting?

WHITE: [laughs] I can't remember what that was. I know Karen Elson's voice is on there somewhere.

BLACKWELL: Yeah, she's at the end jazz ba-ba-ba-zee-bop-bah ...

WHITE: God, I don't remember why that happened, I really am sorry.

BLACKWELL: It's great though.

BLACKWELL: Tell me about Dex Romweber. Did you have any reservations or apprehensions about working with him?

WHITE: I wanted to work with Dex as soon as possible, as soon as Third Man in Nashville opened. I wanted to do something with him. He came with his sister, and they threw around the idea of me singing with him. Which normally I always try to not do because I don't wanna look like I'm trying to be on everyone's record that comes to Third Man, but with Dex there's no way I would ever say no. If Dex wanted me to sing with him, I'm gonna sing with him. So, I just tried to downplay it on the cover. It's more about him than me. I really do love how we chose that blues song "Last Kind Words Blues" together. I remember when I played it for him asking if he would want to cover it, he said, "I was just thinking about this song a couple weeks ago, I can't believe you mentioned it." That was kind of nice. A couple years later the song itself ended up becoming a story in the press. People had started talking about Geeshie Wiley, and a big *New York Times* piece came out with Greil Marcus writing about other peoples' versions of the song, including ours.

BLACKWELL: Dexter hasn't really ever, in my knowledge, done downright blues kind of stuff. He's usually more early rock 'n' roll.

WHITE: And for some reason this is the only session, the only song I've ever recorded where my mom was sitting in the control room at the time [laughs] and offering suggestions. So that was funny. I'm trying to figure out what the words were, "Across the Richland field," and my mom said, "I think it's rich *man's* field." And I said, "Yeah it might be, but I don't know, it just doesn't roll off the tongue as well." I did not use her suggestion. So she's probably right about the correct lyric.

BLACKWELL: Recording The Black Belles Blue Series, do you want to talk about how the idea of the Black Belles came about?

WHITE: Some of it's blurry to me, but the idea of putting a band together had crossed my mind a couple of times. When I heard Olivia Jean's demo, I thought this girl is very cool and has a lot of talent at a young age. But she's by herself, she doesn't have a band. So that became, can I create a band around her, can we work together to make up a band around her? Maybe it would best if it's not her name, but has a band's name? So there were a lot of elements involved there, a lot of sort of Monkees elements, and production from my end with someone who's very new to the business. And just a lot of bizarre ideas thrown into the mix about what this band could be. I found all the other members of the band, but the girls knew each other a little bit before these ideas started coming together. Some knew how to play their instruments, some didn't. It really didn't matter. Some of your favorite bands of all time — Sex Pistols, Ramones, etc. etc. — did not know how to play their fucking instruments. That doesn't scare me at all. It's all about attitude. And coming together in a room and making something happen from nothing and challenging all of us. Challenging me as a producer, us as a record label, them as musicians, Olivia as a songwriter and possible front person for a band. Let's create something new. And it just became an idea. And then I found this hat when I was at the Optimo Hat Shop in Chicago, when I was getting a custom hat made for myself, but he had a black furry hat and I said, "What's that?" and he said "Oh that's just blank, we're gonna shape it and sand off all that fur and make it into a fedora." I said, "No, no, no can I please have one of these just as a blank?" And those are the hats that the Black Belles wear.

BLACKWELL: Awesome. That is awesome.

WHITE: Also, Alison tried to steal that hat from me on tour, on The Dead Weather tour bus and I said, "No, no I have a great idea for this hat."

BLACKWELL: [laughs] You're saying, "I *promise* something is going to happen with this hat."

WHITE: I love that band. I love the sounds and the way all the Black

Belles performed, how quickly they learned to play together and what happens when you kind of just throw strangers in a room together and try to make something new out of it. People don't realize this happens to everything they see. All the famous songs that sell a million copies, these are all strangers in a room whether they're professional musicians or not. These are all people put in a room together that don't know each other. It's sometimes even more beautiful with people who are younger and more inexperienced, because a lot of the veteran studio musicians who've played a thousand times on a backing track — that's different from when I was describing Tom Jones as a front man and veteran — can just kind of go on autopilot.

BLACKWELL: How does that affect your approach when you have an artist, a vocalist, and you are putting together a band to back them for these recording sessions?

WHITE: For Tom Jones, I called up people in Nashville that I thought were interesting players, who if I were to tell two weeks prior, we're doing a Tom Jones session, by the time they got in the studio they would have made up all this stuff in their head about what they were expecting, all these preconceptions. But to call someone and have them come over within the hour, and tell them they're gonna be on a Tom Jones record or a Beck record, you're gonna get an amazing amount of energy from them. So me putting together a band of people to back up Tom Jones, that's no different than the Black Belles being put together in a room to back up Olivia Jean, you just give them the name of a band. Same thing with The Raconteurs. I wanted to work with Brendan Benson, I could have produced Brendan's album, I could have co-wrote with him and hung out in the background, or we could give it a name and call it The Raconteurs. Same with Alison. I wanted to work with Alison, we could have just put out a 7" and called it Alison Mosshart. Instead it turned into how about this is a band, how about this band has a name The Dead Weather. People gotta remember that not everything is done to make money, not everything is done to pull the wool over people's eyes, sometimes it's just the way you want to present things to people. Even if it might not be a smart business move to do when you're in The White Stripes to come up with other bands. People don't necessarily reward you for the risk you're taking, they kind of almost tell you, "well maybe that's a bad idea," like they don't realize you don't know what you're doing and you're making a big mistake. Again, it's like the ICP scenario, people know what they're doing.

BLACKWELL: Yeah, the good idea to save money is to stay a White Stripe.

WHITE: Yeah.

BLACKWELL: Quickest Blue Series recording: Courtney Barnett or Laura Marling?

WHITE: Gotta be Laura Marling because the recording that is on the record is the test, us testing the microphone. You can hear me close the door during the song at one point, but it was so good we just allowed that to be a mistake to be in there. It was just so beautiful. There was no point in even trying to do it again.

BLACKWELL: I think that's also the most simple Blue Series recording too? It's her and a guitar. No overdubs.

WHITE: I think Zane Lowe even challenged me whether I produced it. He said, "Oh c'mon you didn't produce anything, it's her playing guitar and singing on one track." I was like, "Yeah, you're right but then who put the microphone up, and who picked the board it was recorded to? Even the idea of it even being the final recording." All those kinds of things. It's not about looking for credit. It's how to bring the best out of the artist. Not tell them what to do, but set up a scenario where they can get the best out of themselves. And I agree, half the time the producer's name shouldn't even be on a record. But it is the job of the producer to bring out the best they can in an artist, however they can. Sometimes it's not a good match up. Sometimes that producer doesn't know how to bring out the best in that artist; they're not a good mix together. But when it works, it works out great. And people think, *oh well that producer didn't do anything.* Well they might not have, but they also might not have said it out loud what they were doing. They might not have talked about what style of microphone was best on that acoustic guitar to bring out the best in your playing. But they talked about it in the control room when you weren't standing there.

BLACKWELL: There's a lot of decisions and ideas that are already, before an artist plays note one, already happening that are production.

WHITE: Even a guy standing in a room calling himself the producer and saying absolutely nothing during the whole session — even that alleviates some sort of tension for the artist themselves to know that they are in some kind of capable hands that are gonna accomplish something.

BLACKWELL: An engineer as well. It gives an engineer a peace of mind.

WHITE: Right. It gives direction. If the producer says an idea, the producer does not need to know how the idea is physically and scientifically done, it's the engineer's job to know how to turn that knob, and what mic, and how far away to put that mic to achieve that idea.

BLACKWELL: Who told you that?

WHITE: Albert Einstein.

BLACKWELL: Story checks out.

WHITE: Albert Einstein in his famous theorem: "How to Produce Records and Other Atomix Junk" [laughs].

BLACKWELL: That's the parenthetical title of this book. Are there any other releases that stick out as memorable to you, or stories you remember from recording anyone from, I don't know, from Rachelle Garniez to Dwight Yoakam or anything?

WHITE: The Rachelle record is the only record that I engineered on the Blue Series. I just did it to prove a point to the engineers that I could do it if I wanted to.

BLACKWELL: [laughs] I didn't know that. Are you credited as an engineer on that?

WHITE: Yes.

BLACKWELL: In regards to your choice in engineers and crew, does that play into your production and your ideas? Is it the same approach you take with the musicians, that you're only going to call an engineer the day before.

WHITE: I wish I knew more mixers and engineers in a certain way, so I could pull them for certain types of things. There just aren't many that I've met and/or had a chance to work with and/or trust because there is a lot of trust involved. Once you become comfortable with a couple people, it's a lot easier to continue working with them. But also, the nature of an engineer's job is to be able to do very different things like a heavy metal band one day and a folk singer the next day. That shouldn't be a problem. You shouldn't necessarily expect engineers to have the greatest taste in music in the world, but you can definitely expect them to have the best knowledge of how to get certain tones and certain effects across, and that's what they should be completely obsessed with. I've had a lot of engineers over the years think that I'm not a real producer because I don't know the name of a certain microphone or the number, the 1073, mic pre- going into an 1176, you know all those numbers that those guys memorize and spout off left and right, that shit's just whatever. Who cares about that. That's not important. I don't have any problems pointing at something and saying, "I want to use that blue compressor over there." I know that one sounds good on drums. You end up learning all that stuff, but I never wanted to be someone who obsesses about the numbering and if the serial numbers are consecutive for stereo compressors or whatever. That's not too much what I'm interested in, I'm just more about let's get this sound this way. It needs to be a ribbon mic, I don't care which ribbon mic, you know?

BLACKWELL: Talking more about the production aspect of it, you built the studio and you selected the board, and all those decisions had been made, but is there anything else in regards to your methodology — you do primarily try to keep the band playing live. You're trying to minimize overdubs, and separations ...

WHITE: The studio is small. We're trying to record things on 8-track. Small so that people can't walk away and go off on their phones or their laptops. We don't really allow people to sit and hang out in the control room if we can help it without being rude. The studio is small so people are right in front of each other and have to work together. And I love when it's overflowed with musicians, and the actual singer and the main artist is in the room with lots of people, lots of strangers, and the energy is incredible. That's different from having the singer come in, the band's already done and they're sitting all by themselves, and there's four managers sitting behind you on laptops, BlackBerrys, or whatever. That kind of crap. This is a different scenario for how to record, this is real and visceral. And that's the scenario I like to try to get to.

BLACKWELL: You'd be surprised, or maybe you wouldn't, how many artists when asking them for recollections and stories about their recording sessions, how many folks end up saying, "You know what's really crazy, we were only there for one day, and you're working so hard, and we were so excited to be recording with Jack White, that it kind of all happened so fast, I don't have that many memories of it." It's not like recording an album where you go back to the studio three, four weeks in a row and you get kind of familiar.

WHITE: We almost don't have enough time to become friends, really, because it's just going so fast, but there's a bond there, a musical bond created of trust, that you know you can rely on that person, even if you never speak to them again for another twenty years. We know that we worked together, it's like two actors that have done a scene together in a film twenty years ago. It has that feeling. You might not remember what color clothes they were wearing, or food they ate, but you will say *oh I remember that one note they pulled out in the solo. That really tied the room together* [laughs].

MILDRED
AND THE MICE

TMR-003

As the legend goes, Mildred appeared before Jack White at a hardware store in Kentucky. She sang "I Like My Mice (Dead)" at the top of her lungs before shyly walking out of the store. White immediately signed her. While claiming to hail from the Mammoth Cave area (her Myspace page specifically lists Ollie, Kentucky), apparently Mildred was dropped off at her recording session by her mother who patiently waited in a Winnebago for the recording to finish. Utilizing a Gretsch Princess guitar that Mildred called a "gitch," both songs were recorded live to eight-track in one take. At the time of the release White said, "This is exactly the kind of record we want to put out." Raw and punk in an unrehearsed, unpolished manner, these two songs are the only music Mildred has ever released.

A SIDE: I LIKE MY MICE (DEAD)
B SIDE: SPIDER BITE

RELEASED: MAY 25, 2009

MILDRED
AND THE MICE

—

A SIDE
I LIKE MY MICE (DEAD)
(MILDRED)
Mildred's Mousic, BMI

—

B SIDE
SPIDER BITE
(MILDRED)
Mildred's Mousic, BMI

—

MILDRED
Vocals and Guitar

THE MICE ARE
TRAP: Drums
TAIL: Bass
SQUEAK: Guitar

—

Produced and Engineered by
Jack White III

Recorded at Third Man Studio,
Nashville, TN 2009

Mixed by Jack White
and Vance Powell

Mastered by Eric Cohn at
Independent Mastering, Nashville, TN

Photos by Jo McCaughey

Layout by Miles Johnson

All Songs Written by Mildred
(Mildred's Mousic, BMI)

Performed by Mildred and The Mice

THIRDMANRECORDS.COM

TMR-003

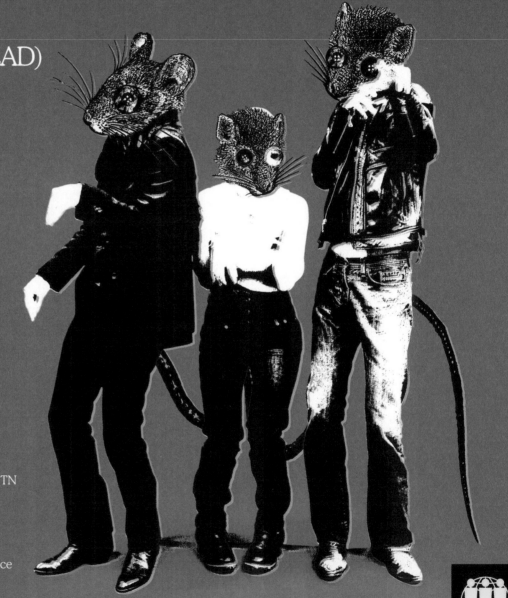

> *"Jack's created such a playground for artists, to come into his Third Man home and create a single simply for the music, for the preservation of vinyl, and for the love of it."*

BEN BLACKWELL: You were the first Blues Series single ever! Did you have any idea what you were getting yourself into?

MILDRED: I had no idea what I was getting myself into. I'm an introvert by nature, and living in Mammoth Cave, I'm a little isolated and I don't get out much, so to be in the studio and make this single when I'd never made a lick of music before was out of my comfort zone, so I basically went ballistic and freaked out, hence the Music.

BLACKWELL: What was the inspiration behind the songs you wrote/recorded? Dare I say it is probably the only "themed" Blue Series single of the 40+ different ones we've released.

MILDRED: Themed? I'm no THEME thank you very much. I'm Mildred!!! My inspirations are doom and gloom.

BLACKWELL: Did Jack impart any insightful knowledge or advice in the session? What was your impression of him as a producer? How did he smell?

MILDRED: Jack told me to plug in a guitar and sing into the mic. I did that, and a holy scream appeared that I'd never uttered before in my life, a guttural, primal roar, then soon after I became disillusioned with the music business and gave it up. Jack smells like Ralph Lauren Chaps ... ask him about it.

BLACKWELL: What did you think about the studio space, the equipment used, the vibe in the room? Inviting? Cold? None of the above?

MILDRED: Jack was very inviting, he understood my nature, he's skilled at telepathy, so I didn't have to speak much.

Obviously his "gear" is very fancy and all analog, he's not into modern ways, and I'm thankful for that, because music now sounds like it's been recorded through a cell phone.

BLACKWELL: What was your main takeaway from the session and subsequent release?

MILDRED: I got a taste of notoriety, money and fame. My life was amazing and I was on top of my game. Then one of the mice left the band because she said I'd changed and had become an awful person to be around, so I gave it all up and retreated back to Mammoth Cave, and subsequently found Jesus in the process.

BLACKWELL: ANYTHING you'd like to say, anecdotes from the session, thoughts about it all seven years later, would be greatly appreciated. I'm shooting to have a well-rounded, thoughtful, insightful story to tell about each of these singles and that's impossible without you.

MILDRED: All joking aside ... Jack's created such a playground for artists, to come into his Third Man home and create a single simply for the music, for the preservation of vinyl, and for the love of it. I was there at the very beginning when all these ideas were brewing and Jack was formulating his idea for his Third Man headquarters in Nashville. I'm very proud of Jack and the Third Man team for all the hard work, innovation and lack of fear they have when it comes to being a label. The Blue Series has now become a vast body of work, from so many talented artists. I'm honored to be a part of it.

RACHELLE GARNIEZ

MY HOUSE OF PEACE

TMR-004

A multi-instrumentalist based out of New York City, Rachelle Garniez came to Third Man's attention while working on sessions that would ultimately produce Karen Elson's album *The Ghost Who Walks*. During downtime for those sessions, Rachelle was tapped to lay down her own song, which was rumored to be written about former United States president George W. Bush. A B-side felt unnecessary in the evanescence of the moment, so the flipside of the vinyl pressing is actually adorned with an etching of the classic Third Man Records logo, making it the only Blue Series single to feature just one song.

A SIDE: MY HOUSE OF PEACE

RELEASED: MAY 25, 2009

RACHELLE GARNIEZ

MY HOUSE OF PEACE

PRODUCED AND ENGINEERED BY JACK WHITE III
RECORDED AT THIRD MAN STUDIO, NASHVILLE TN, MARCH 2009
ADDITIONAL ENGINEERING BY VANCE POWELL
MIXED BY JACK WHITE AND VANCE POWELL
PHOTO BY JO MCCAUGHEY
LAYOUT BY MILES JOHNSON

MUSIC AND LYRICS BY RACHELLE GARNIEZ
SWIMMING POOL BLUE MUSIC, BMI

RACHELLE GARNIEZ: VOCALS, PIANO, WURLITZER
JACK LAWRENCE: BASS
JACK WHITE: DRUMS

TMR-004

THIRDMANRECORDS.COM

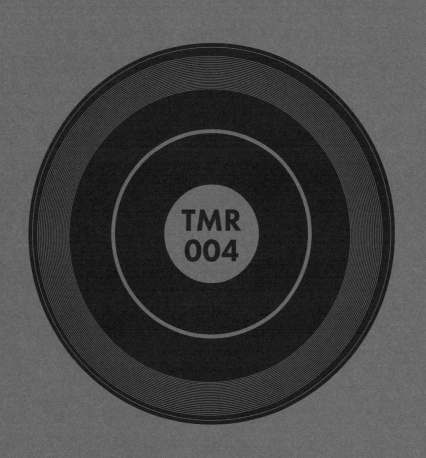

DEX ROMWEBER DUO

Featuring JACK WHITE

TMR-009

While a longtime admirer of Romweber's seminal band Flat Duo Jets, Jack White initially turned down the offer to appear on what would end up being the Duo's 2009 album *Ruins of Berlin*, featuring the likes of Cat Power and Exene Cervenka as guest performers. Touring in support of *Ruins* brought Dex and his sister Sara to Nashville and White took the opportunity to finally work together. Upon hearing Dex's original song, "The Wind Did Move" White commented, "I've wanted to hear that guitar sound in my studio for so long." White adds backing vocals to "Wind" and contributed a guitar solo played on his four-knot Gretsch Round-Up guitar. The flipside "Last Kind Words Blues" comes from one of the most mysterious, sought-after and pricey 78 rpm records in the world. Written by Geeshie Wiley and performed by Wiley and Elvie Thomas, the haunting track was floating around the TMR offices at the time on a compilation released by Mississippi Records titled *Last Kind Words*. Tackled at White's suggestion, it is arguably Dex's first foray into "blues" in his thirty-plus year career.

A SIDE: THE WIND DID MOVE
B SIDE: LAST KIND WORDS BLUES

RELEASED: JUNE 9, 2009

DEX ROMWEBER DUO
Featuring JACK WHITE

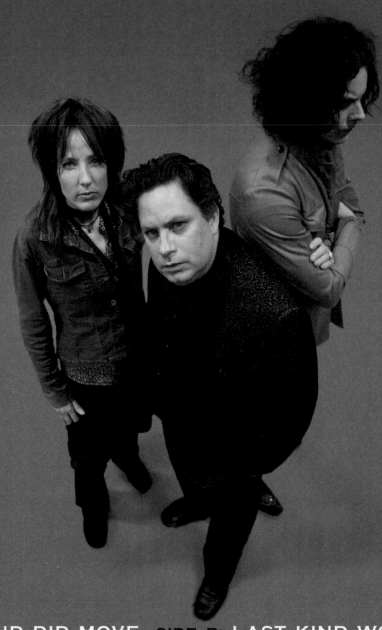

SIDE A: THE WIND DID MOVE SIDE B: LAST KIND WORD BLUES TMR-009

"The Wind Did Move" written by Dexter Romweber (Dexter Romweber Music (BMI)) "Last Kind Word Blues" written by Geechie Wiley • Produced by Jack White III • Recorded At Third Man Studio, Nashville TN, April 2009 • Engineered by Vance Powell Assisted by Joshua V. Smith • Mixed by Jack White and Vance Powell • **Dexter Romweber:** Vocals, Guitar, Piano, Organ • **Sara Romweber:** Drums, Percussion • **Jack White:** Vocals, Guitar, Bass, Sawing Wood • Photos by Jo McCaughey • Design by Miles Johnson • DRD Management: Brett Steele/Steele Management • bloodshotrecords.com

MYSPACE.COM/DEXTERROMWEBERDUO Dexter and Sara Romweber appear courtesy of Bloodshot Records **THIRDMANRECORDS.COM**

"The photo shoot was funny ... as i'd put on a lil weight and my manager told me to 'suck in' my gut ... i kinda yelled back at him to let me be ... strange. "

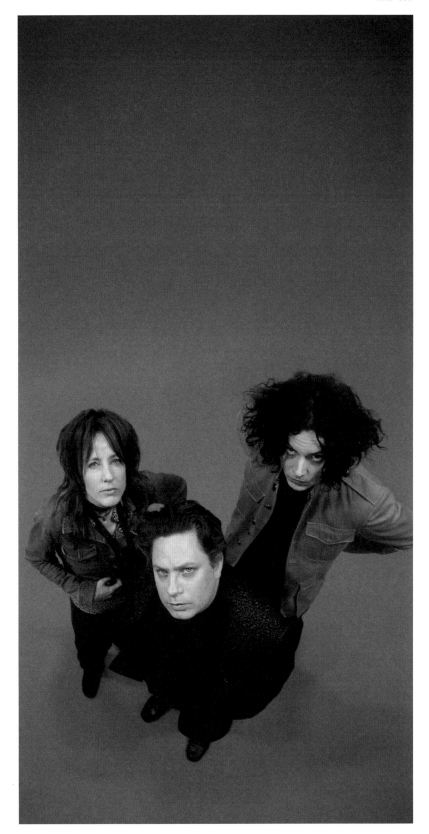

BEN BLACKWELL: How were you asked to record a Blue Series single? Were you surprised? I know you'd asked Jack to appear on the *Ruins of Berlin* album and had even opened for The White Stripes back in the day ...

DEX ROMWEBER: i was on tour with my sister...we were passing through nashville.....we got a call from our management.....that jack wanted to record with us. yes we were blown away!.....but jack had mentioned to me yrs back that we would record. i didnt know when. surprised? excited.....of course......just had to figure timing of it all.

BLACKWELL: Were you previously aware of any Blue Series records before being asked to record? Any stick out to you as being favorites? Any you hate? Any thoughts about Third Man in general? Or even Jack?

ROMWEBER: i havent heard any of the other "blue" records. 3rd man......jack....were all very nice, very forthcoming. It was really no problem.

BLACKWELL: What was the feeling while recording in the studio? How do you decide which songs to record? I seem to remember that Jack brought "Last Kind Word Blues" to the table ... but maybe you remember otherwise?

ROMWEBER: the recording was very relaxed. i'd actually heard "last kind words blues" before....was rather obsessed with the song... before jack brought it forth. i felt that strange.....complete fate. a couple yrs before i wrote a song inspired by "last kind words".......its called "prison called life"......on my *blues that defy my soul* LP

BLACKWELL: Did Jack impart any insightful knowledge or
 advice in the session? What was your impression of him as
 a producer? How about as a performer/co-vocalist?

ROMWEBER:jack was fine as producer, performer,
 co-singer........he kinda reminded me of marc bolan.....i
 liked that he didnt copy the song in singing.

BLACKWELL: What did you think about the studio space, the equipment
 used, the vibe in the room? Inviting? Cold? None of the above?

ROMWEBER:the studio space was cool. the old 8
 track we recorded on blew my mind. i'd never recorded
 on anything like it. plenty of studio space.

BLACKWELL: I think your back cover photo is the only Blue Series pic that
 has Jack in it. What do you remember about the photo shoot? Weren't
 you playing a show in Nashville at the same time as this session?

ROMWEBER: the photo shoot was funny.......as i'd put on a lil weight and
 my manager told me to 'suck in' my gut ... i kinda yelled back at him
 to let me be...strange. we played in nashville and had a fine show.

BLACKWELL: Did you notice any newfound attention after releasing
 a record on Third Man? Did it help the band? Maybe it hurt?

ROMWEBER: no any attention we got was positive. it didnt hurt
 us at all. believe me we needed all the help we could get!

BLACKWELL: What was your main takeaway from
 the session and subsequent release?

ROMWEBER: the takeaway.......was more press. inspired creativity.
 interesting to see all 3rd man in grand operation. i think jack has done
 alot for people like me, wanda jackson, loretta lynn, and my god the
 reissues....of blues from 1920s, 30s, 40s.........is such an AWESOME
 thing and jack was always very kind to me. also the show in NYC
 with the romweber duo and wanda jackson........was a fucking great
 night!......and we also toured with wanda...........amazing really.

DAN SARTAIN

TMR-011

Alabama born and raised, Dan Sartain was introduced to many in the Third Man world via his opening slot on what ultimately ended up being the final shows by The White Stripes in 2007. Sartain is unique in that both Third Man co-founders Ben Blackwell and Ben Swank have separately served time as drummers in his band. "Bohemian Grove" gives a musical stylistic nod to "(I'm Not Your) Steppin' Stone" with lyrics about the illuminati-esque campground in Northern California that Richard Nixon once described as "the most faggy goddamn thing you could ever imagine," while referencing the classic 60s garage song "Primitive" by The Groupies. The B-side addresses Sartain's point-of-view regarding so-called atheist friends who, as they age, do things like get married in church. Both songs exist in two different arrangements ... the "slow" versions appear on the 7" and the "fast" outtakes, of which similar takes appear, on the *Dan Sartain Lives* album.

A SIDE: BOHEMIAN GROVE
B SIDE: ATHEIST FUNERAL

RELEASED: AUGUST 11, 2009

DAN SARTAIN

"Bohemian Grove" and "Atheist Funeral" written by Dan Sartain • Produced by Jack White III • Recorded At Third Man Studio, Nashville TN, July 2009
Engineered by Vance Powell Assisted by Joshua V. Smith • Mixed by Jack White and Vance Powell • Dan Sartain: Vocals, Guitar • Matt Patton: Bass
Adam Renshaw: Drums • Jack White: Piano • Design by Miles Johnson • Photos by Jo McCaughey • Manufactured at United Record Pressing, Nashville, TN • thirdmanrecords.com

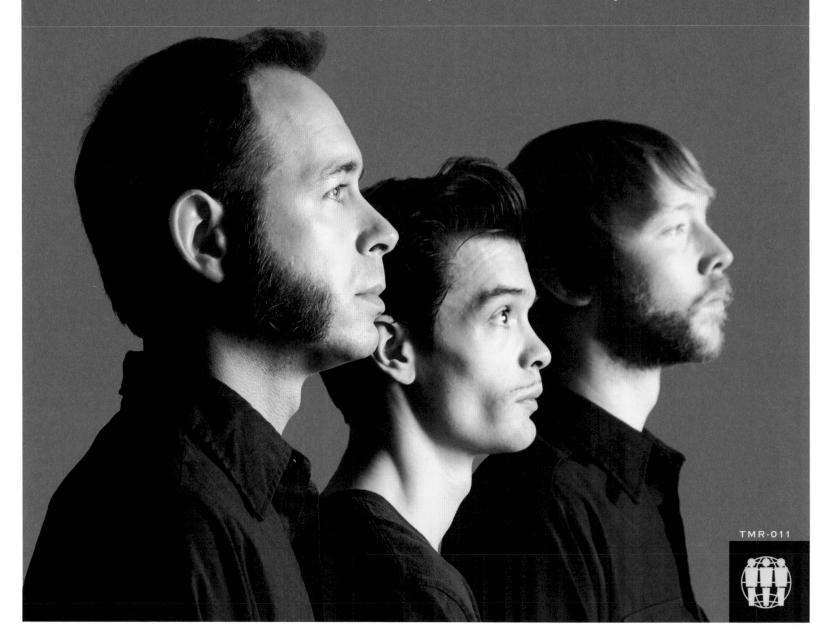

TMR-011

TRANSIT

TMR-012

Inarguably one of the least expected releases in the Third Man catalog, Transit is a group comprised of members who all work for Nashville's Metro Transit Authority in one capacity or another: mechanics, bus drivers, office workers, etc. Jack White overheard a stranger mention that a band made up of bus drivers had just won a contest (the Music City Corporate Band Challenge in March 2009) and immediately tasked label manager Ben Swank with tracking down the group and getting them to record a single with Third Man ... all without ever hearing a single note of their music. The mellow "C'mon and Ride" was written for the Challenge and originally had more of a gospel approach, as the writer/keyboardist of the band James Dunn Jr. is also a pastor. Dunn also had hopes of the song being utilized as a jingle for the MTA. The song helped the band win the competition and also brought them to the attention of Nashville's then-mayor, Karl Dean, who personally requested they perform at numerous civic celebrations. The B-side "After Party" references what the group does once they're off the clock. Not long after this single's release, local Nashville bus benches were spotted featuring an advertising campaign that touted "C'mon and Ride" while the musical notation of the song was a featured graphic on bus stop shelters on Gallatin Avenue in East Nashville.

A SIDE: C'MON AND RIDE
B SIDE: AFTER PARTY

RELEASED: AUGUST 11, 2009

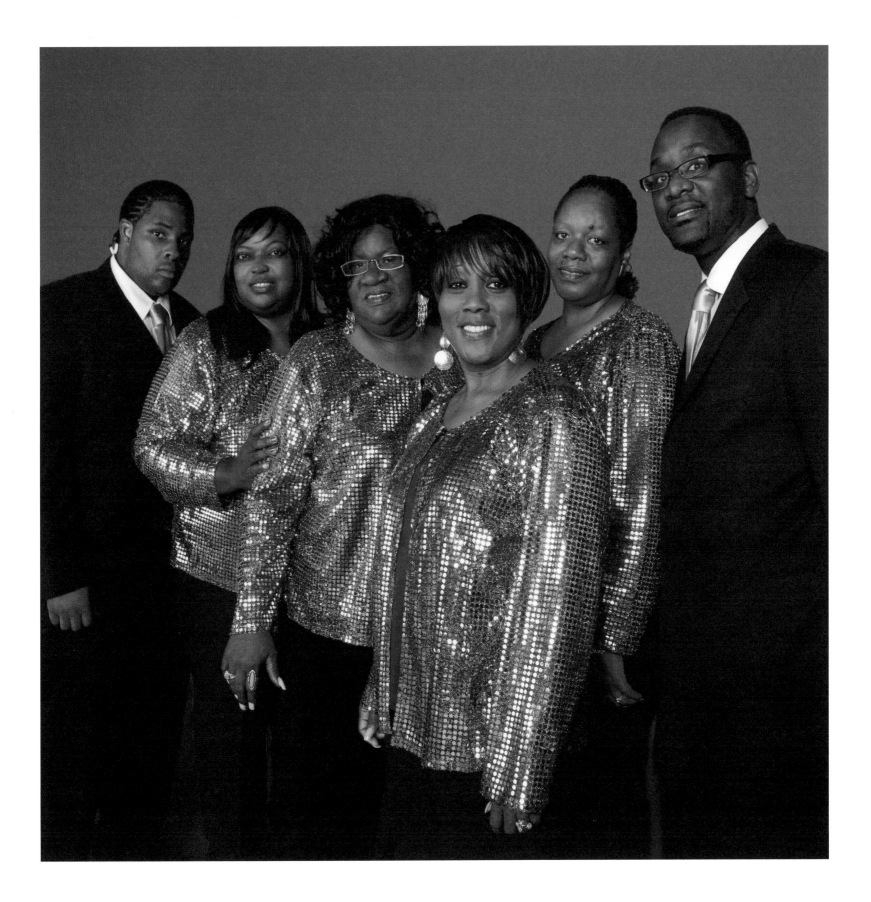

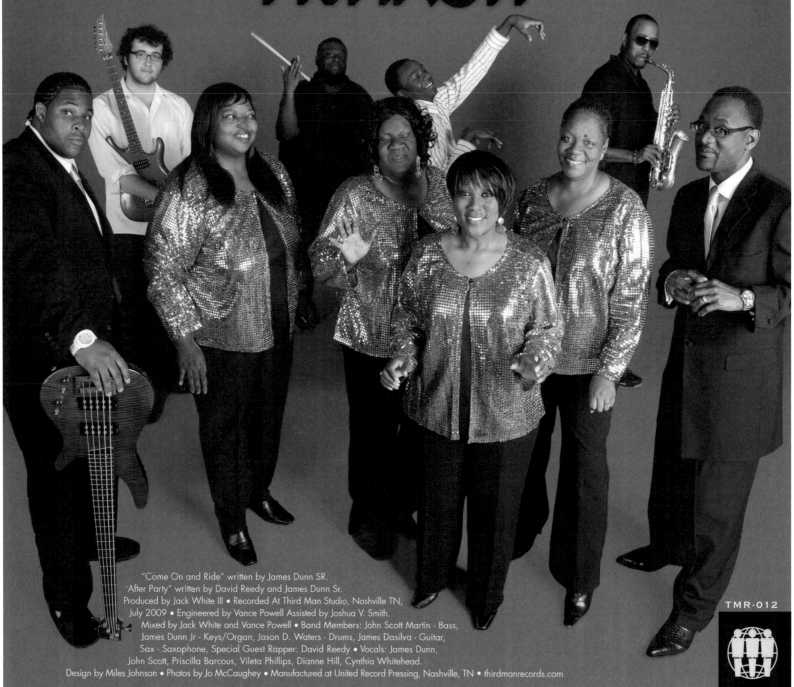

SIDE A
C'MON AND RIDE

TRANSIT

SIDE B
AFTER PARTY

"Come On and Ride" written by James Dunn SR.
"After Party" written by David Reedy and James Dunn Sr.
Produced by Jack White III • Recorded At Third Man Studio, Nashville TN,
July 2009 • Engineered by Vance Powell Assisted by Joshua V. Smith.
Mixed by Jack White and Vance Powell • Band Members: John Scott Martin - Bass,
James Dunn Jr - Keys/Organ, Jason D. Waters - Drums, James Dasilva - Guitar,
Sax - Saxophone, Special Guest Rapper: David Reedy • Vocals: James Dunn,
John Scott, Priscilla Barcous, Vileta Phillips, Dianne Hill, Cynthia Whitehead.
Design by Miles Johnson • Photos by Jo McCaughey • Manufactured at United Record Pressing, Nashville, TN • thirdmanrecords.com

TMR-012

SMOKE FAIRIES

TMR-021

The soft-spoken UK duo Smoke Fairies (consisting of Kaf Blamire and Jessica Davies) received a hot tip that The Raconteurs would be hanging out at the Old Blue Last bar in the Shoreditch neighborhood of London in 2008. They slyly convinced the DJ — TMR's own Ben Swank — to play their self-released "Living With Ghosts" single which, while clearing the dance floor, was ultimately taken home by Jack White that evening. Fast-forward one year and the Smoke Fairies are opening for White's new band The Dead Weather and then invited to come to Nashville to record a single for the Blue Series. Their single is unique in that it is one of the very few Third Man 7" releases to include an insert ... particularly this one featuring the lyrics to both of these original songs. The relationship continued when Jack White invited Davies and Blamire to join him on a cover of Bob Dylan's "One More Cup of Coffee" at the MusiCares 2015 Person of the Year celebration in honor of Dylan.

A SIDE: GASTOWN
B SIDE: RIVER SONG

RELEASED: DECEMBER 8, 2009

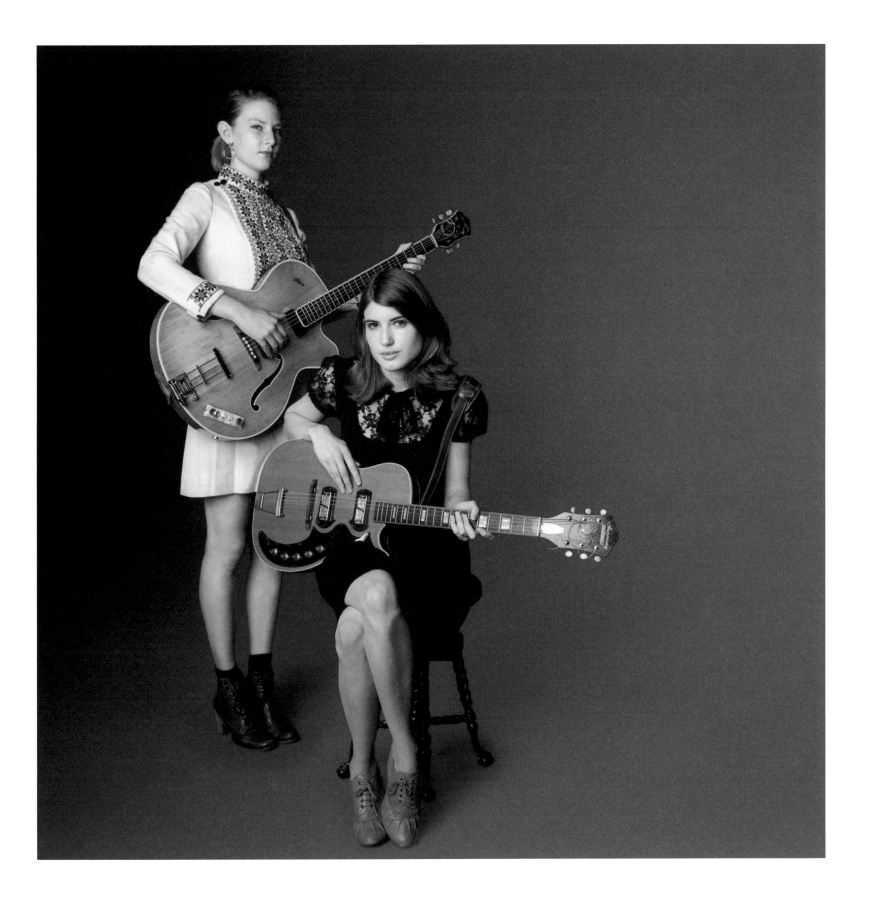

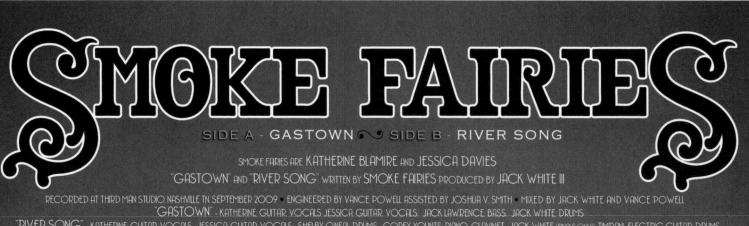

SMOKE FAIRIES

SIDE A · GASTOWN ∾ SIDE B · RIVER SONG

SMOKE FAIRES ARE KATHERINE BLAMIRE AND JESSICA DAVIES
"GASTOWN" AND "RIVER SONG" WRITTEN BY SMOKE FAIRIES PRODUCED BY JACK WHITE III
RECORDED AT THIRD MAN STUDIO, NASHVILLE TN, SEPTEMBER 2009 • ENGINEERED BY VANCE POWELL ASSISTED BY JOSHUA V. SMITH • MIXED BY JACK WHITE AND VANCE POWELL
"GASTOWN" - KATHERINE: GUITAR, VOCALS. JESSICA: GUITAR, VOCALS. JACK LAWRENCE: BASS. JACK WHITE: DRUMS.
"RIVER SONG" - KATHERINE: GUITAR, VOCALS. JESSICA: GUITAR, VOCALS. SHELBY ONEAL: DRUMS. COREY YOUNTS: PIANO, CLAVINET. JACK WHITE (FINALE ONLY): TIMPANI, ELECTRIC GUITAR, DRUMS
DESIGN BY JACK WHITE AND MILES JOHNSON. PHOTOS BY JO McCAUGHEY • ALL SONGS PUBLISHED BY COPYRIGHT CONTROL • MANUFACTURED AT UNITED RECORD PRESSING, NASHVILLE, TN
SMOKEFAIRIES.COM · THIRDMANRECORDS.COM

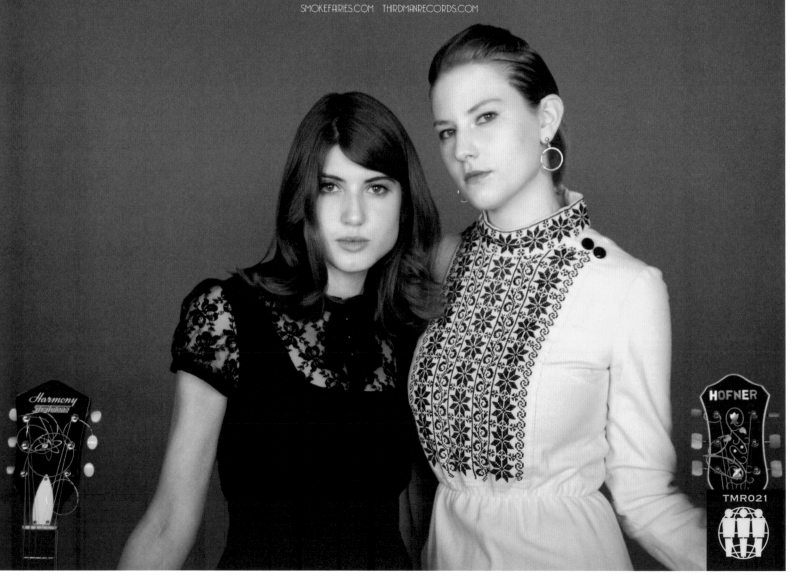

"When I plugged my guitar in, the tone sounded warmer than it ever had before."

A few words from **JESSICA DAVIES**

Walking into the studio, I had no idea what to expect. We hadn't actually done that many studio sessions and had never recorded to tape before and the thought of trying it for the first time in Jack's studio was quite terrifying. What if we mess up and fail to ever complete a take? What if everybody there thinks we are crap amateurs?

As soon as we got in the studio with Jack and the engineers, Vance [Powell] and Josh [Smith], all those demons vanished. Josh made us cups of tea to make us feel more at home. As soon as I had that cup of tea in my hand, I knew it was going to be a good day. Josh became a good friend and has been coming to visit us in London for cups of tea ever since.

We must have arrived in Nashville with a few options to record but god knows what the other songs were. Jack moves fast — and before I knew it — we were beginning to record the first song that we had shown him, "River Song." I don't think we ever discussed any other options. After a few runs through, Jack brought in drummer Shelby O'Neal [Shelby Lynne of the Black Belles] and pianist, clarinet player Cory Younts and the song took shape.

It was dark and pretty late by the time we came around to recording the second track, "Gastown." The crickets were chirping outside, people were dropping in and out to hear what we were up to, and the jet lag was kicking in. It was a Nashville dream. "Gastown" was recorded with Jack on drums, Jack Lawrence on bass and Kaf and I on guitars. Jack said that our guitar rhythms would be confusing to the public. I said they made perfect sense. There was a little debate. He was right of course, the guitar parts are completely illogical but he went with it in the end. Now, when we are in the studio we use the phrase "C to the P" to describe something that has gone a little wayward. The take we chose has a little cough in it and Kaf's amp broke right at the end, producing a weird horn noise that strangely fits. My impression about Jack as a producer is that he strives to capture the atmosphere and feeling of a track. "Gastown" really caught the late night energy that was in studio. At the end of the night Jack Lawrence drove us back to our hotel and we sat in our room thinking, did that just happen?

We'd never had a contract before and thought you could just add strange stipulations in if you wanted. We tried to slip a clause into our contract that Jack would go out with us for a pancake breakfast. I think it got removed. That's ok though. We still see Jack sometimes when he is in London. A few years ago we saw him at Brixton Academy and after the show we went and waited at the bus stop to go home. After a few minutes standing around, a car swung around, Jack opened the door, and told us we were not getting the bus home. A few stunned fans watched us climb in and he gave us a lift back to Peckham.

When we released that record, it had a massive impact on our career for years. Having that association with Third Man and Jack White got us press and interest that is hard to come by. It's the gift that keeps giving. Still to this day, when we put out new music, a lazy journalist will come up with something crazy like; "Produced by Jack White on the Isle of Wight."

The only downside is that every interview we do from now on will contain the question "What is Jack White actually like?" and for a while after the release people seemed to expect Jack White to appear at our sides wherever we went. We did a few gigs where people genuinely thought he was going to appear from behind a curtain. There was one bizarre incident when we did an in-store in Arizona and a rumor got started that he was hiding in one of our amp cases.

Whilst we were in Nashville, Ben Blackwell took us down to the record pressing plant and showed us how our record was going to be made. United Record Pressing has been our friend and supporter ever since. We went on to release a compilation record with them and recorded one of their *Upstairs at United* releases.

For me being on the Blue Series side-by-side with so many talented musicians is huge. It made me feel validated as a musician. I have the Gastown / River Song 7" on my shelf at home and the tri-colour is one of my prized possessions. There is no one else out there doing what Third Man is doing. Through the Blue Series, Jack White is showcasing and cataloging acts that might get overlooked. I think in years to come the Blue Series will be seen as a valuable snapshot of what was happening across all genres during this generation.

An interview with **KATHERINE BLAMIRE**

BEN BLACKWELL: How were you asked to record a Blue Series single? Were you surprised?

KATHERINE BLAMIRE: A friend had word that The Dead Weather [The band was The Raconteurs — Ed] were going to be hanging out in the Old Blue Last in Shoreditch. We had been playing a gig round the corner in Rough Trade East so we weren't far away and decided to go and see if it was true. We were big fans and wanted to try to give Jack a copy of our first single 7" "Living with Ghosts." We headed down there and waited for a while. It started to get late and all our friends got bored and left, but we carried on sitting there and after a while the band wandered in. The bar was quite loud and rowdy by then and everyone was dancing around to songs a DJ was playing.

I was pretty nervous so I downed some whiskey shots first. We went up to Jack, gave him a whiskey and told him we were in a duo and he said "Well, that's never going to work," which took me until the next day to find funny.

Somehow we managed to persuade the DJ to play "Living with Ghosts" on the turntable. As the title suggests, it is not exactly a party tune, and it emptied the dance floor, but Jack was listening intently and he said he liked it. He took the record with him when he left. We went home that night high on the feeling that we'd personally given our record to Jack, not expecting anything more to come of it.

About a year later we sat at our desks at our temping jobs in London. I was a receptionist in Mayfair, extremely bored, Jessica was a receptionist somewhere else. Then out of the blue came an email from our managers saying that we had been offered the support slot for The Dead Weather concert. We'd been wanting to go, but it was sold out. This was not the way we'd envisioned getting in.

Before we even went on stage at the gig, Jack came into our dressing room and asked if we wanted to go to Nashville to record at his studio. It was a great moment, but I really couldn't believe it was true until we actually flew out there.

BLACKWELL: What was the feeling while recording in the studio? How do you decide which songs to record?

BLAMIRE: We had some unreleased songs we liked and had been working on at the time. I've always been terrible at dealing with jet lag, and the night before I couldn't sleep in the hotel, worrying about the songs and how we would choose what to record. In the end there was barely a discussion. I was surprised as I imagined that Jack would want to hear a whole load of songs before deciding, but we just started playing them to show him how they went, and he

immediately just said "Yep, let's do that"... and that was it. Everything seemed quite impulsive and there was something liberating about that.

Going into the studio we were a little anxious, it was a great opportunity and we didn't want to screw it up. Our nerves were quickly dispelled. I remember having a ridiculous conversation with LJ [Jack Lawrence, bass] about what there was to see in the area. He said we could potentially drive out to the state fair and see a pig jump off a platform into a paddling pool. After that I knew it would be fine.

BLACKWELL: Did Jack impart any insightful knowledge or advice in the session? What was your impression of him as a producer?

BLAMIRE: As a producer he created a feeling that time was precious and slipping by quickly. Capturing an intense moment and atmosphere was more important than perfecting and polishing. That suited us because we were not really the polishing kind either. At that point we weren't particularly used to being in a studio environment at all. Just singing to music coming out of the headphones was an unusual experience. I remember being relieved when I opened my mouth and my voice came out. I think there is a tension to the sound of the whole thing. I'm not sure we could replicate that now that we are older and more experienced. I think it says a lot about Jack as a musician, he often sees something others might have overlooked and values musicians for their innate spark, rather than their existing credentials.

BLACKWELL: What did you think about the studio space, the equipment used, the vibe in the room? Inviting? Cold? None of the above?

BLAMIRE: When I plugged my guitar in, the tone sounded warmer than it ever had before. It was like my guitar had found its perfect match. I naively asked about where I could get one. There was a weird silence, and then someone told me something along the lines that it was maybe one of three left in the whole world, and they had spent awhile seeking it out and tracking it down when they were building the studio. I realized that everything in there was chosen for its unique character, being either bespoke or classic vintage equipment. It worked too — when we were recording a valve must have blown in the amp, but it was at the perfect time in the song and that was the final take. You can hear it breaking up with a distorted hum at the end. I had never been in a place where someone had impressed their ideas on every small feature, down to the plug sockets. It felt quite private to me, like Jack had designed a world for himself, to feel at home in, and somehow we'd got the golden ticket and were allowed inside.

BLACKWELL: Any specific thoughts about the session players on the recording? How's Jack White as a drummer?

BLAMIRE: Playing "Gastown" with Jack on the drums and Jack Lawrence on the bass late at night is a very clear memory for

CORY YOUNTS

me. When we started playing it sounded so groovy and dark. It was exactly what the song needed and brought it to life in a new way. I looked over at Jessica and felt a lot of emotion. I was proud that we had stuck at it, through difficult times trying to make music in London, lugging amps and guitars across the city after work. Some combination of luck, our cheeky personalities, our friendship, our music, and Jack's open mindedness had led us to that point in time. It was affirming and gave us a lot of courage and confidence that we were creating something worth hearing. It gave us a legitimacy in our minds and in the minds of others.

BLACKWELL: What was your main takeaway from the session and subsequent release?

BLAMIRE: The takeaway was pizza. When we went back the second time it was sushi.

TMR
021

WANDA JACKSON

TMR-023

Long-known as the "Queen of Rockabilly" for such classics as "Funnel of Love," "Fujiyama Mama" and "Let's Have a Party" from the 1950s and 60s, Jackson's first single for Third Man, recorded when she was 73-years-old, is a staggering pairing of the moody Amy Winehouse favorite "You Know I'm No Good" and a horn-accented rave-up on Johnny Kidd and the Pirates' "Shakin' All Over." This disc led to Wanda's discovery by a whole new generation of fans and also led to a full-length release, also produced by Jack White, titled *The Party Ain't Over* which would feature both of the tracks from this single.

A SIDE: YOU KNOW I'M NO GOOD
B SIDE: SHAKIN' ALL OVER

RELEASED: JANUARY 26, 2010

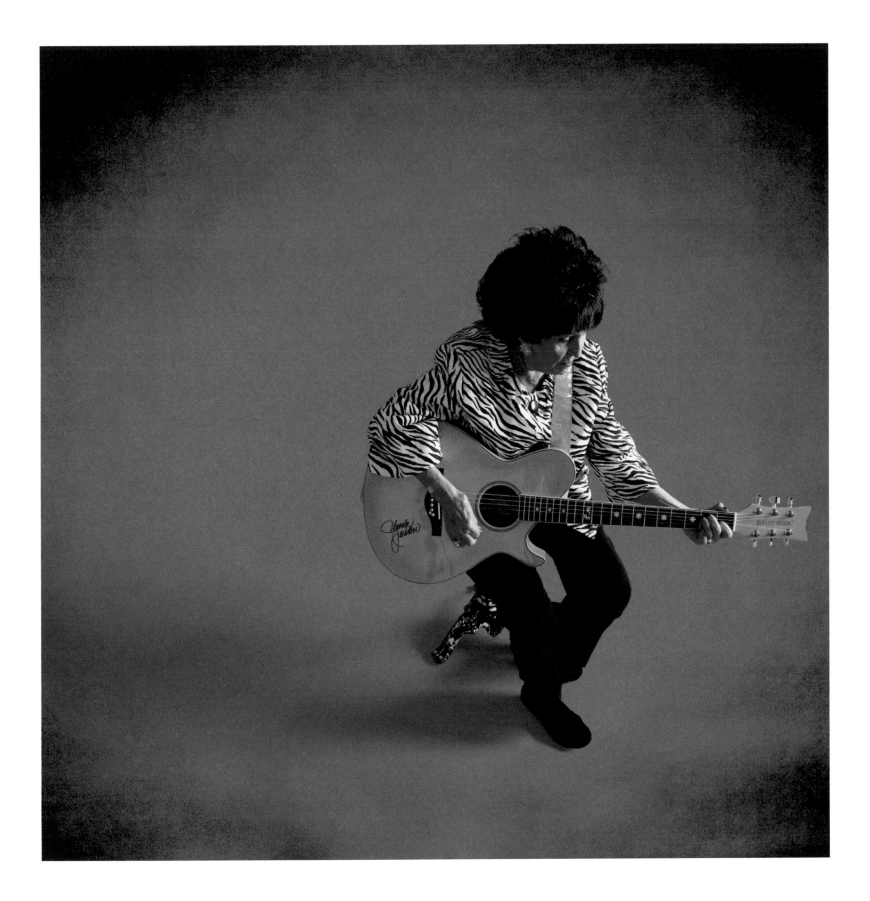

side a
"YOU KNOW
I'M NO GOOD"

—

WANDA
JACKSON

side b
"SHAKIN'
ALL OVER"

"YOU KNOW I'M NO GOOD" WRITTEN BY AMY WINEHOUSE "SHAKIN' ALL OVER" WRITTEN BY JOHNNY KIDD RECORDED AT THIRD MAN STUDIO, NASHVILLE, TN. NOVEMBER 2009
PRODUCED BY JACK WHITE III • ENGINEERED BY VANCE POWELL, ASSISTED BY JOSHUA V. SMITH • MIXED BY JACK WHITE, ASSISTED BY JOSHUA V. SMITH
CARL BROEMEL – STEEL GUITAR. JOE GILLIS – ORGAN. PATRICK KEELER – DRUMS. JUSTIN CARPENTER – TROMBONE. LEIF SHIRES – TRUMPET. CRAIG SWIFT – SAXOPHONE.
OLIVIA JEAN – GUITAR. JACK WHITE – BASS, GUITAR ON "SHAKIN' ALL OVER". JACK LAWRENCE – BASS ON "YOU KNOW I'M NO GOOD"
DESIGN BY JACK WHITE AND MILES JOHNSON • PHOTOS BY JO McCAUGHEY • "YOU KNOW I'M NO GOOD" PUBLISHED BY EMI/BLACKWOOD INC
"SHAKIN' ALL OVER" PUBLISHED BY EMI MILLS MUSIC LIMITED MANUFACTURED AT UNITED RECORD PRESSING, NASHVILLE TN • THIRDMANRECORDS.COM WANDAJACKSON.COM

TMR023

"And there was this big ol' tape machine, he had just got that one in. The name of it just happened to be Wanda. And the way his studio was set up, just everybody around you, I loved that part of recording in the sixties, it was like then."

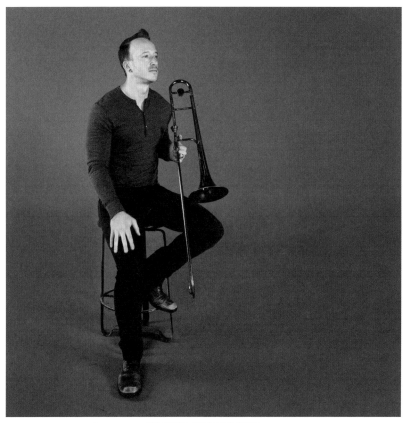

JUSTIN CARPENTER

BEN BLACKWELL: I guess my first question is, were you aware of Jack before being asked to do the single?

WANDA JACKSON: Well, not so much. I had heard his name, of course, and when I was in Europe, I kept hearing about Jack White playing at the stadium shows and I'm thinking, "Who is this guy? He must really be something." So when I talked with him, I thought, well, I don't know what I'm letting myself in for, I'm just a little country girl. But he had done such a great job with Loretta Lynn, and so that gave me more confidence. I still had to be kinda talked into it. But I'm glad that they did, it was a wonderful experience, it truly was.

BLACKWELL: That's great to hear. Do you remember how he actually got to talking to you? How did you get connected?

JACKSON: My publicist at the time was Jon Hensley. Jon and I were having dinner at the hotel one night, talking about how I needed a new album out, and trying to get some direction for it. A friend of his came in, a lady that does hair and make-up. She joined us, heard what we were talking about, and she said, "Well, if you do this, you be sure to contact Jack White because he's a fan of yours." And I said, "Really? Young whipper-snapper is a fan of mine?" And she said, "Oh yeah, he knows roots music and he knows yours. So be sure to contact him, I'm sure he'll wanna do one with you." We

thought well, we're doing an album of *Wanda & Friends,* you know, different artists come in and sing with me ... So Jon eventually got hold of you folks at Third Man and got hold of Jack I guess. I asked him would he be interested in singing a duet with me on my album. And he said, "No, I really wouldn't." [laughs] "But, I would be interested in producing an album for Wanda." That got the wheels turning and Jon asked me about it, and I said, "Oh I don't know Jon ... he's a rocker and he's so different than anything I've ever done." And he said, "No, you can trust me on this one." Then when I mentioned his name to my grandkids, they couldn't believe it, "You gotta be kidding! Jack White wants to produce you?" That told me a lot too. I thought I better check into this. So that's what we did, we continued to talk back and forth on the phone. Of course, we let the other people work out the business things, and then Jack and I started talking about songs and sending songs back and forth because I'd been living in Oklahoma City, not Nashville. I was happy with everything that he had sent me, most all of it, except the Amy Winehouse song. That really got my attention, I said, "Waiiiit a minute ..."

BLACKWELL: What got your attention about it specifically?

JACKSON: I told Jack later, "It's just too sexually explicit for me, see. And the fact it's not even age-appropriate. I don't think my fans

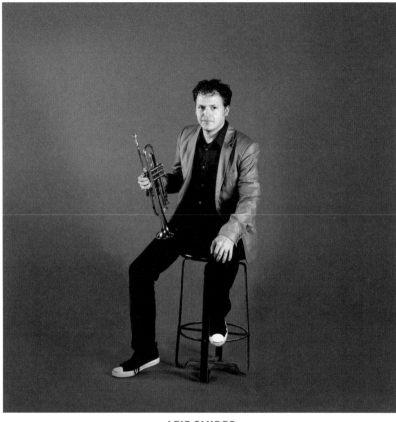

LEIF SHIRES

would even want to hear me do something like that." But he assured me they would — and I'll tell you more about that in a minute. So I looked over this group of songs he sent, and here was one from the 1940s. I was just like six, seven-years old or something from California and it was during the war days. And it was a song I'd always just loved. It was the Andrew Sisters' "Rum and Coca Cola" and I said I'm not believing this, I get to sing this?! That got me a little more excited. So we kept going, and I kept saying I'm not doing the Amy song. He said, "Well try to learn it." And I thought to myself, "No, I'm not even gonna bother learning it." I had my mind made up on that one. And I tell audiences now, "You gotta watch Jack now, because he is so sweet-talkin' and before you know it, he's gonna have you doing whatever it is you said you weren't gonna do."

BLACKWELL: I can tell you working for him is quite the same way, it is not exclusive to the studio.

JACKSON: Oh, I figured that. And so, when I got up to that number. He said, "Just listen to the arrangement." He had that laid down so I listened. I started trying to sing it but I didn't know it, and he was so adamant about me doing this song. He said, "Well, I'll tell you what, just go in the studio and just kinda start playing around with it and I'll help you with the melody." That was the first hurdle. I put on headphones and he sang in my ear to the track so that I could get

the melody. And then after that, I kinda started liking it better. I said, "Well, I'll tell you what, I'm not singing that second verse, it's just too much for me." Then he took my lyric sheet and wrote down some different lyrics, kind of altered it a little bit, and he said, "Now try it." And I liked it. So that was the first hurdle, just learning the dang song. Then when I started actually recording it, he kept saying, "Just push a little harder. Give it a little more push." I said, "Jack, you're trying to get that 18-year-old girl I used to be out here singing this song and I can't do it." And he said, "Yes you can." Here we went with that just push, push, push. And he left it on the record, if you do listen to the very beginning, before I start the song I say, "Why do I always have to push?" So that's where that came from. But once we got it down, I think it's about my favorite song I do on stage, I just love to sing it.

BLACKWELL: That's great. And do you get a good crowd reaction?

JACKSON: Oh yeah, they're amazed. They stand with their mouth open. I'm just doing this.

BLACKWELL: Had you been aware of Amy Winehouse before that?

JACKSON: I'd heard of her. I just heard that she did these kinda sexy-cat songs. When I heard that I said, "Yeah they're right. It definitely is." It's such a good melody, and it's got a lot of attitude in it. I like songs like that.

BLACKWELL: I think it's interesting in that the attitude can come through without being brash, and it's not completely tied to her personality. Like you're saying, she's young and she's coming from this very, very salacious viewpoint, but I think you still get the attitude across in your entirely different point of view, from where you're singing from. I think that is truly the testament of one, a great song, but I think even more so a great performer. That you're able to inhabit that song in that manner.

JACKSON: Yeah, thank you very much.

BLACKWELL: You are very welcome.

WANDA: I think that's what I learned from Jack. I learned some things working with him.

BLACKWELL: Do you remember, while you were in the studio, how you felt in the studio, the design of the studio, the equipment used? Do you have anything that you remember that you took away from that setup?

JACKSON: Well, of course I did. Because it was being done analog. First of all, I went into the — what do you call it ...

BLACKWELL: The control room?

JACKSON: Yeah, control room. And there was this big ol' tape machine,

he had just got that one in. The name of it just happened to be Wanda. And the way his studio was set up, just everybody around you, I loved that part of recording in the sixties, it was like then.

BLACKWELL: When you say everyone around you, you mean kinda all the performers are in one room, like there's a lot of —

JACKSON: It wasn't until I did the actual vocals in the one song — ok what was I saying?

BLACKWELL: You said everyone was in the one room to track but when you sang you were isolated kinda.

JACKSON: Yeah in the old days that's the way it was. I wasn't even too isolated, I was just kinda out there with everybody. But we hit a snag on some song, and he said it just didn't, he didn't care for it, scratch that one. And I had to come up with another song, like we had to come up with two like that. So the song I chose was the Elvis Presley song on there, "Like a Baby." And so the next day when I came in it was the whole band in the studio with me and that made me feel real comfortable, I liked that. But he couldn't isolate me enough so I wound up in the hallway with the Coke machine. I said, "Are you sure you don't want me outside by the tree? Do you even want me on this record?" Oh, we had a lot of laughs and a lot of fun.

BLACKWELL: That's very cool. Do you have any thoughts or anything about the B-side to the single, "Shakin' All Over."

JACKSON: What was the A-side?

BLACKWELL: The A-side was "You Know That I'm No Good" and the B-side was "Shakin' All Over."

JACKSON: Well, that was another one. I didn't realize what a really good song that was. But my husband and I had talked before we got there really. And we both agreed, we're putting my next album in the hands of this young man, who's the most popular guy on the planet, so I better let him have his way, I better try to do what he's asking me to do. I agreed. And I hadn't had any direction as far as singing, I hadn't learned a song, what to do with the line, in so long that I relished that part. I just loved that he was that involved in it. And most of the producers I'd worked with, which were scattered all over the world, I think their attitude was, "Well this is Wanda Jackson she's been recording for sixty years, we can't tell her what to do."

BLACKWELL: Right, you think maybe people were a little bit intimidated by you or —

JACKSON: Probably, yeah. I don't come across that way to them, I know, but they already have their minds made up. It's so nice to have someone come in the studio and talking

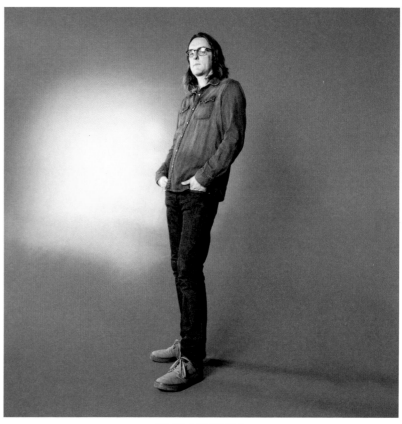

CARL BROEMEL

with me and explaining things and teaching me a song, I just loved him for all the attention he gave me like that.

BLACKWELL: We started off with the single first, and then we did an album afterwards. Once the single came out, did you notice anything different in your world in terms of who might be showing up at your shows or who's buying your records?

JACKSON: Yeah. It began I guess with that single. My whole audience are the young adults. No one in the audience is my age. I said, "Well they can't get around well enough to stand up for an hour." But it's so nice to have those young faces to look at, and they respect me so much, and they listen to every word I say, so it's been a great ride, I'll tell ya.

BLACKWELL: When we released the single, you actually came here and did an autograph session. You signed copies of the record in the shop.

JACKSON: Uh-huh I remember that.

BLACKWELL: Yeah we haven't done that very much. You're one of the few that we've done that with.

JACKSON: And when we got there, there were all these people lined up outside in their lawn chairs and with their igloo things, it looked like they'd been camping out.

BLACKWELL: They certainly were. There's no way around that, they definitely were camped out. I guess, to kind of wrap up, is there anything else you remember or recall or would like to share in regards to working with Jack, or working with Third Man, or your memories of any of that?

JACKSON: Well as far as working with him he was so much fun. Because he was still being helpful to me but he was so playful on stage. I've always kind of been that way too and we had a lot of fun just, he'd go by and say something to me or —

BLACKWELL: Yeah, so you're talking about how you guys had played a handful of shows together once the live album came out, he put together a band, and we put out a live version of that band, an LP of that.

JACKSON: Yeah, we did that in Nashville. But another thing that I noticed and I do tell some audiences if I have time, or tell people like this in an interview, that I began to notice how very much he reminded me of Elvis Presley. You know, tall, dark-headed — physical features — but this charisma that he has is like Elvis, 'cause you know, Elvis, we'd all be talking somewhere, a bunch of us, and he'd just walk out to join us and we all got quiet and we looked to him like, "What do you wanna talk about Elvis?" And I just felt that, or I noticed it with Jack, he just kinda demands that attention because of his charisma and he's always thinking. A little bit jittery, hyper — is that the word?

BLACKWELL: Yeah absolutely. Other than that, I think I'm done. I really, really thank you for your time, it's been very, very —

JACKSON: Give Jack my love when you see him.

BLACKWELL: I absolutely will. I will give him a hug AND a kiss from you.

JACKSON: Well, you can skip the kiss, but —

BLACKWELL: Alright the kiss will be from me and the hug will be from you.

JACKSON: [laughs] Ok. Whatever.

TMR-024

Featuring Olivia Jean, Ruby Rodgers, Shelby Lynne and a revolving cast of fourth members, the idea and approach behind The Black Belles was a combination goth garage girl band, never to be seen not wearing their trademark black hats. Jean originally demoed "What Can I Do?" under her solo surf moniker Idée Fixe, a CD-R of which she got into the hands of Jack White when his band The Dead Weather played the Magic Stick in Detroit on June 12th, 2009. The B-side "Lies" is an interpretive cover of the lone hit by New Jersey's Knickerbockers, originally released by Challenge Records in 1965. The only single in the Blue Series to have videos shot for both songs on the record.

A SIDE: WHAT CAN I DO?
B SIDE: LIES

RELEASED: JANUARY 26, 2010

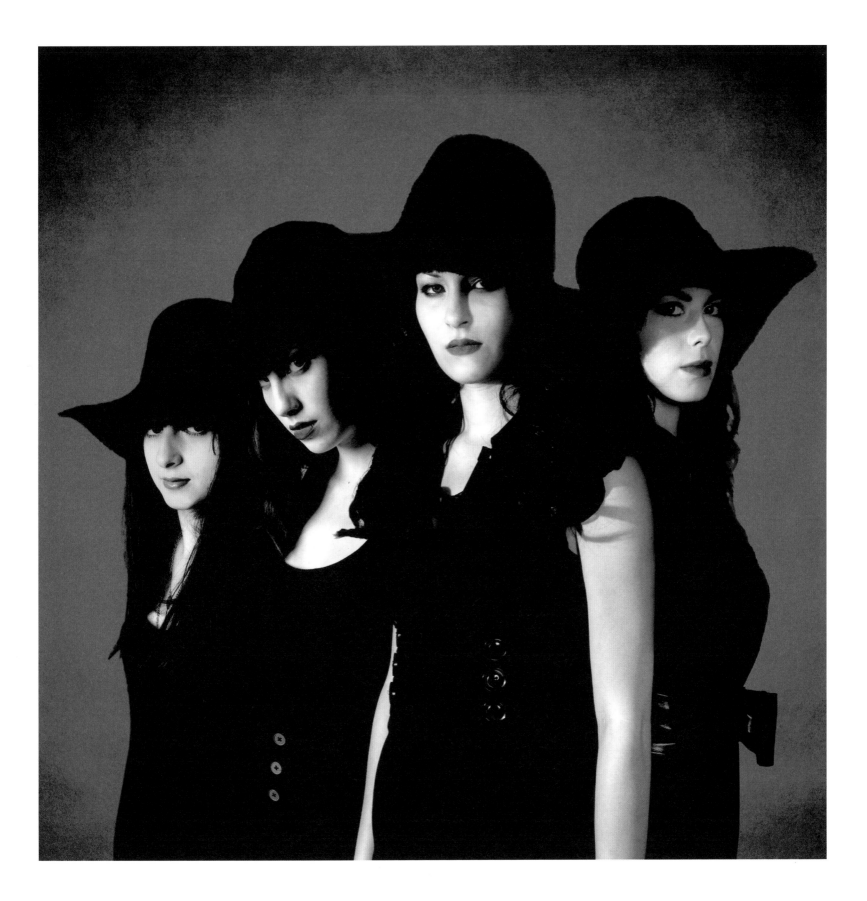

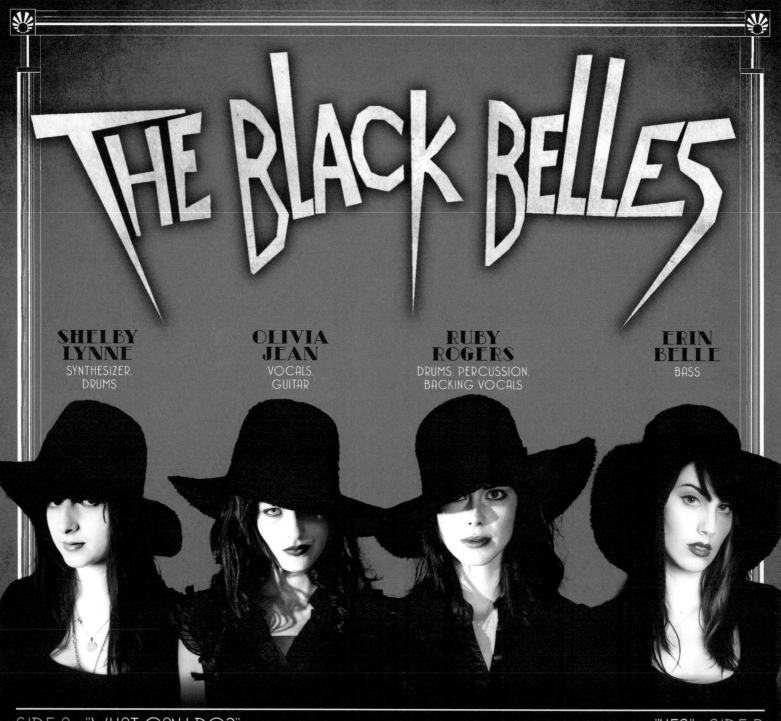

THE BLACK BELLES

SHELBY LYNNE
SYNTHESIZER, DRUMS

OLIVIA JEAN
VOCALS, GUITAR

RUBY ROGERS
DRUMS, PERCUSSION, BACKING VOCALS

ERIN BELLE
BASS

SIDE A "WHAT CAN I DO?" (O. JEAN) (B. CHARLES AND B. RANDELL) "LIES" SIDE B

"WHAT CAN I DO?" AND "LIES" RECORDED AT THIRD MAN STUDIO, NASHVILLE, TN NOVEMBER 2009 • PRODUCED BY JACK WHITE III • ENGINEERED BY VANCE POWELL ASSISTED BY JOSHUA V. SMITH • MIXED BY JACK WHITE AND VANCE POWELL ASSISTED BY JOSHUA V. SMITH • DESIGN BY JACK WHITE AND MILES JOHNSON PHOTOS BY JO McCAUGHEY • 'WHAT CAN I DO?' PUBLISHED BY OLIVIA JEAN MUSIC, 'LIES' PUBLISHED BY SONY/ATV ACUFF ROSE MUSIC MANUFACTURED AT UNITED RECORD PRESSING, NASHVILLE, TENNESSEE • WWW.THIRDMANRECORDS.COM • WWW.THEBLACKBELLES.COM • TMR024

"The look of the studio reminds me of the De Stijl art movement. The dim lighting of the studio is warm and inviting."

BEN BLACKWELL: How were you asked to record a Blue Series single? Were you surprised?

OLIVIA JEAN: There had only been four Blue Series releases prior to The Black Belles. When I learned that we were recording my songs for The Black Belles Blue Series I was taken aback. I hadn't completely known the specialness and uniqueness of the series until I became involved. It was a new thing to me, and, admittedly, nerve-wracking at the time to hand my songs over to a project I didn't quite grasp the fullness, but I'm glad that I did. It's an honor to have songs featured on a Blue Series record so early on.

BLACKWELL: Were you previously aware of any Blue Series records before being asked to record? Any stick out to you as being favorites? Any you hate? Any thoughts about Third Man in general? Or even Jack?

JEAN: In my opinion the most shocking Blue Series release is I.C.P. I think to myself, "What is the most unexpected band that Third Man could work with?" I.C.P. tops that list. Nowadays it's pretty funny to think about. Now, Third Man Records can check that goal off their bucket list. But my favorite Blue Series record has always been Mildred and The Mice. I like the rawness of the instruments and the savageness of the vocals. I also really like the vague story behind the band, which has helped them remain mysterious, incognito.

BLACKWELL: What was the feeling while recording in the studio? How do you decide which songs to record? Did any of these songs go back to Idée Fixe? Any particular differences between those versions and what ended up on TMR?

JEAN: All of the songs I had written and prepared for Third Man were from my Detroit solo band Idée Fixe. We re-recorded several of those songs to choose favorites for this project that, like I mentioned, I didn't quite fully understand yet. When the altered recordings were finished, they were drastically different than my original demos. The foundation of the songs remained intact. However the new versions were much heavier and aggressive. Incidentally, the altered versions of my songs helped to shape The Black Belles' composition and aesthetic.

BLACKWELL: Did Jack impart any insightful knowledge or advice in the session? What was your impression of him as a producer?

JEAN: Jack is a great producer. Every day is a blast working with him. The atmosphere of Jack's studio inspires enthusiasm and creativity. Those two things make a twelve-hour recording session a piece of cake. Plus, Jack is completely honest and forthright in his contributions to the songs. His attention to detail, song structure, and quality was such a huge help. During my first sessions at Jack's studio, I was stuck in my ways regarding my songs. I instinctively wanted to duplicate my demos, but Jack helped me listen to my songs with new ears.

I also used vintage equipment in Jack's studio, which I was completely unfamiliar with. Before recording at Third Man, I didn't even own a tuning pedal! Jack eased my confusion by teaching me about the vintage equipment and their sounds. Since he was so enthusiastic about teaching me new possibilities during the recording, I felt much more comfortable and welcomed. There is no judgement in Jack's studio, only honesty.

BLACKWELL: What did you think about the studio space, the equipment used, the vibe in the room? Inviting? Cold? None of the above?

JEAN: The look of the studio reminds me of the De Stijl art movement. The dim lighting of the studio is warm and inviting. Masses of amps, guitars, and obscure instruments line the walls. Huge reels of tape are displayed on shelves that are labeled with artists that I know and love. Each wall is textured to reflect or bounce sound waves differently. The meticulous detail of his studio can not be replicated; it isn't a typical studio by any means.

BLACKWELL: The Blue Series was the first-ever release by the band. What was the public reaction once this was out there?

JEAN: It was interesting. Third Man released teasers for The Black Belles which created some hype. Ultimately, the reaction to our record was mixed. Some loved the idea while others were confused. I can only guess why, but for some reason, a lot of listeners assumed that the band was born on a silver platter. Critics even wrote that we didn't actually play the instruments on our songs, and people called us a "fake band." We were furious. All of us girls had been playing music our entire lives ... and without any record labels to help. Working with Third Man Records wasn't a magical golden rollercoaster that weaved us through the hardships of being a band; we did that part on our own. What Third Man did do — they helped

promote our project and spent a ton of time helping us build a solid foundation. Still, at the end of the day, we were in control of every aspect of the band. Blood, sweat, and lots of tears were shed while working on our first release. I want listeners to know the real story.

BLACKWELL: What was your main takeaway from the session and subsequent release?

JEAN: I admit sometimes I'm very pushy when it comes to writing music. I am accustomed to writing and playing all components of a song by myself. When I began working in Nashville, I realized that would change: Nashville songwriting is typically written in collaborations. Working with a producer and other studio engineers was also new and overwhelming. I had tried to collaborate earlier on in my music-life, but musicians had taken credit for components I had written way before Third Man Records, and those bad experiences had left an impression on me, and to this day, I admit it can still feel challenging sometimes for me to collaborate with others, but, truth is over the years I definitely have become a tiny bit more comfortable working with others.

The songs I wrote back then for The Black Belles remain very sentimental to me. Someday I would like to release my original demos so listeners can hear where all of the Black Belles songs came from. I think it would be neat to compare.

BLACKWELL: Any other thoughts or anecdotes or experiences from the recording, please feel free to expound on them as much as you want.

JEAN: There are little dents on the floor of the studio. When I recorded vocals for the first Black Belle release I was nervously stomping my foot really hard on the ground. My high heels dug into the nice wood flooring. I hope that Jack keeps those ugly dents because they remind me of good times!

As a result of my nervousness while recording vocals on "Dead Shoe," I did a couple of stupid things. I drank from a mason jar of moonshine hoping it would ease my nerves. I also insisted that the studio lights be turned off because, for some reason, there was a disco ball in the studio. So, while recording vocals on that song, I was drinking moonshine in a dark room with a disco ball spinning above my head. It's quite a picture. Next time you give that song a listen you'll see what I mean.

Last thing: there's a cement pathway that leads to Jack's studio. All of us Black Belles wore high-heels everyday because we wanted to. Anyway, Jack named that cement path "High Heel Highway" in honor of us wobbling our way to the studio.

TMR-044

Without argument the simplest entry in the Blue Series, these two songs performed by the folk singer from Hampshire, England feature only her voice and guitar. Recorded live in very few takes, the overall feeling coming from this single is one of effortlessness. Originally written by overlooked folk singer Jackson C. Frank, "Game" has approached folk standard status, being covered by the likes of Simon and Garfunkel, Nick Drake, Sandy Denny, Bert Jansch and countless others. "The Needle and the Damage Done" is originally written and performed by Neil Young, and while Marling released a version as the B-side to her 2008 single "Ghosts," the version released with Third Man is a different arrangement.

A SIDE: BLUES RUN THE GAME
B SIDE: THE NEEDLE AND THE DAMAGE DONE

RELEASED: NOVEMBER 9, 2010

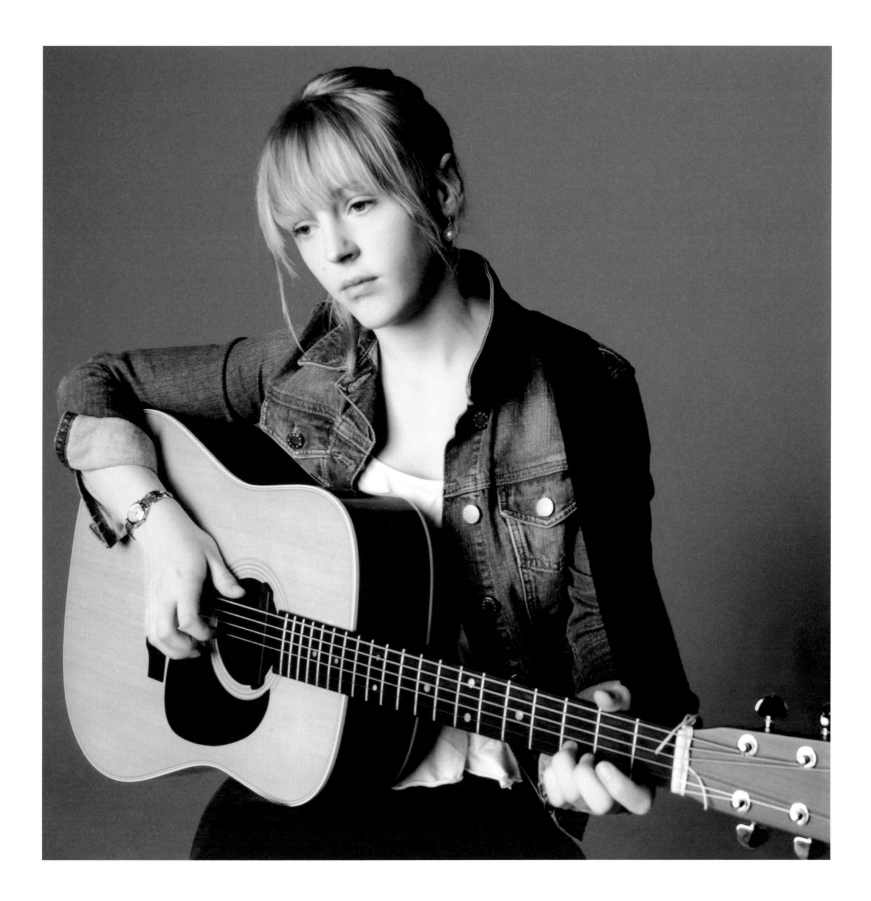

Laura Marling: Guitar and Vocals. **Produced by** Jack White III. **Recorded at** Third Man Studio, May 2010. 'Blues Run the Game' (written by Jackson C. Frank/ AGELONG MUSIC PUBLISHING, INC) 'The Needle and the Damage Done' (written by Neil Young /BROKEN FIDDLE MUSIC C/O WIXEN PUBLISHING) **Engineered by** Vance Powell. **Assisted by** Joshua V. Smith. **Mixed by** Jack White and Vance Powell. **Design by** Miles Johnson. **Photography by** Jo McCaughey **Manufactured at** United Record Pressing in Nashville, Tennessee. Third Man Records, 623 7th Avenue South, Nashville, Tennessee 37203.

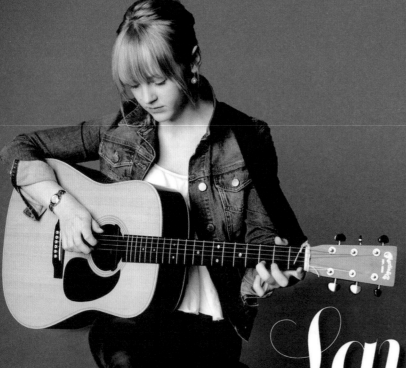

— SIDE A —

BLUES RUN THE GAME
(JACKSON C. FRANK)

Laura Marling

— SIDE B —

THE NEEDLE AND THE DAMAGE DONE
(NEIL YOUNG)

TMR044

"It was a long driveway in Nashville. And that's where I was dropped off at the gate with my guitar ... I walked up to the studio and it was surreal."

BEN BLACKWELL: Do you have any recollection as to how your recording a Blue Series came about?

LAURA MARLING: Yeah actually I got an email from Jack when I was travelling across the States on a touring break. I was touring with a band called the Smoke Fairies, who he'd already done a Blue Series session with — an amazing duo, a pair of English girls — and then he got in touch via them and we happened to be coming through Nashville I think a week later. So it happened quite quickly.

BLACKWELL: Very cool. And were you aware of the Blue Series beyond the Smoke Fairies having done it? Were you aware of any other singles or anything else Jack had done in that realm?

MARLING: I obviously knew a lot about Jack, but I hadn't heard of the Blue Series, I must admit, until the Smoke Fairies had been telling me about their working with Jack because it was a fairly big deal for English, obscure English girls, to be asked to do that kinda thing. So they were still reeling about it and they came to join us on tour, but that's what I knew about it.

BLACKWELL: So you're on tour in Nashville, you come in to record, what is the feeling in the studio, the overall vibe, what's your impression as you're entering into this?

MARLING: Well, I mean I was 19 at the time, or maybe 20, no I was 19, so it was certainly surreal. I was not that long into, I think it was like I booked the tour in America, so it was quite a thing turning up at the gate. It was a long driveway in Nashville. And that's where I was dropped off at the gate with my guitar and I ordered the man to bring the van after me. And I walked up to

the studio and it was surreal. Everything is incredibly aesthetically pleasing everywhere you look. And I was very shy at 19, and everyone was a bit overwhelming to me but they were nice and kind. And it wasn't long I was only there for 45 minutes.

BLACKWELL: From what I can recall, I think everything was basically if not one take, one or two takes?

MARLING: Yeah we did, it was all in the first take, I think for them.

BLACKWELL: And it was just, it's clearly just your voice and guitar — was there ever any question of if there would be any accompaniment or a band, was that at all broached?

MARLING: No I mean that was up to Jack, but I think he wanted it to just be me and a guitar. And I used like six guitars I think. I used a v-neck type Gibson, I'm not sure which one it was, but it was an extraordinary guitar.

BLACKWELL: You did two cover songs, the Jackson C. Frank song "Blues Run The Game" is as close your going to get to a folk standard that isn't 100 years old. What was your connection to that song, or what made you choose that song?

MARLING: What did make me choose that song? Years ago I heard the Jackson C. Frank version when I was a teenager, and I'd been playing it as a cover since I began playing music as a teenager as well. And I'd been obsessed with his fantastic life story and tragic character. So that was it really. I'd been playing it on that tour.

BLACKWELL: Very cool. And then "The Needle and the Damage Done" you had — had you recorded that previously as a B-side for somewhere else? I know there's another version of you doing that. Did you view recording it again as wanting to reinterpret it or what was your approach?

MARLING: Well the B-side that we did was fairly simplistic, and this one, I think because of the guitar that we were using had more sort of dirt to it, but then again, it's just a cover that I, the first song that I learned, my dad taught me it on the guitar.

BLACKWELL: That's really, really sweet.

MARLING: Yeah it's quite a random one he taught me. But yes, that had sentimental value to me and I don't play it very much but I did play it a lot then.

BLACKWELL: So you did a session and a show the same day, the show was phenomenal by the way, and when you came in the day after to do your photoshoot, you did it in five/ten minutes? It was pretty quick.

MARLING: Yeah it was.

BLACKWELL: I mean you kinda just walked in, I don't think you did hair or makeup, you just sat down, took some photos, and had to be off on the road, is that right?

MARLING: Yeah that's right, that's how we do.

BLACKWELL: I think that is probably the purest intention of this series — to catch people at a very specific moment, not think about it too much, not over-think it, not over-produce it or anything like that, and I think yours is the perfect example of that. I'm struggling to think of any other of these singles that is just one artist and their instrument. It's definitely simple in a very beautiful way and I really, really enjoy it for that.

MARLING: Aw, brilliant. Really glad to hear that. That to me, the whole series, definitely captured that idea.

BLACKWELL: It almost seems like there's very little in the way of actual, or what you would call classic "production" of that record, it sounds like Jack just maybe stepped away and maybe said, "it just needs to be your voice and your guitar and we don't really need to fiddle too much with anything else." Was that how you felt?

MARLING: Yeah, well, yeah, it was very, I mean I recorded it so quickly. It seems we wanted to keep it really simple and have that amazing track and I forget who engineered it with the incredible beard.

BLACKWELL: Josh and Vance are the engineers, two bearded guys —

MARLING: Yeah, yeah that was it really.

BLACKWELL: For some reason I recall that single on the legal end taking us a long time to get everything squared away. For the quickest record recorded it was fairly slow to release. Do you recall anything different in regards to people paying attention to you or what, if anything, changed once the record did come out?

MARLING: That record is the one I see the most presented to me by hardcore music nerds (in the best possible way), because obviously it was hard to find for a lot of people, and I felt very proud of it when people came to shows and they showed it to me. I felt very proud. So yeah, it was a very limited release.

BLACKWELL: Yeah, reasonably I guess you could say.

MARLING: So yeah, I think it probably got me a bit of street cred.

BLACKWELL: It seemed to catch you at a very, very beautiful moment, too, at least in the United States, right before you really hit through to a wider consciousness, or a wider publicity.

MARLING: Yeah.

BLACKWELL: Is there anything else you recall from either the recording or your time here, anecdotes or stories or anything that would be of interest, or that you would care to share in regards to your single?

MARLING: It was very quick. There was barely any time to have an anecdote. Other than Karen [Elson] making me a proper British cup of tea which is much appreciated. But no, it was obviously a real massive honor and I wish I'd been less shy and more involved in it. But no, it was phenomenal.

BLACKWELL: Well you're always welcome back anytime if you want to play a live show or just come by and say hi. On behalf of everyone here, I would like to say that we are very, very — I feel very proud to have that as part of the catalog. I think it's very important and introduced me to Jackson C. Frank who I hadn't previously heard of and have since become a massive fan of and bought the box set and truly, truly love everything he's done. So, it hits home and has a place in my heart for several reasons and I really appreciate that.

TMR
044

TMR-050

Hailing from Muscle Shoals, Alabama, Lydia and Laura Rogers were discovered at an open audition in Nashville in October 2009 and in mere months they had recorded their debut LP with T-Bone Burnett and Dave Cobb. Their Blue Series single, notably featuring ¾'s of The Raconteurs and showcasing a heavy take on the Johnny Cash-penned "Big River" and the American folk standard "Wabash Cannonball," was recorded after that LP but released before it, making these two songs the first recorded appearance of the duo. They would go on to tour with the likes of Paul Simon, Bob Dylan and Elvis Costello.

A SIDE: BIG RIVER
B SIDE: WABASH CANNONBALL

RELEASED: AUGUST 10, 2010

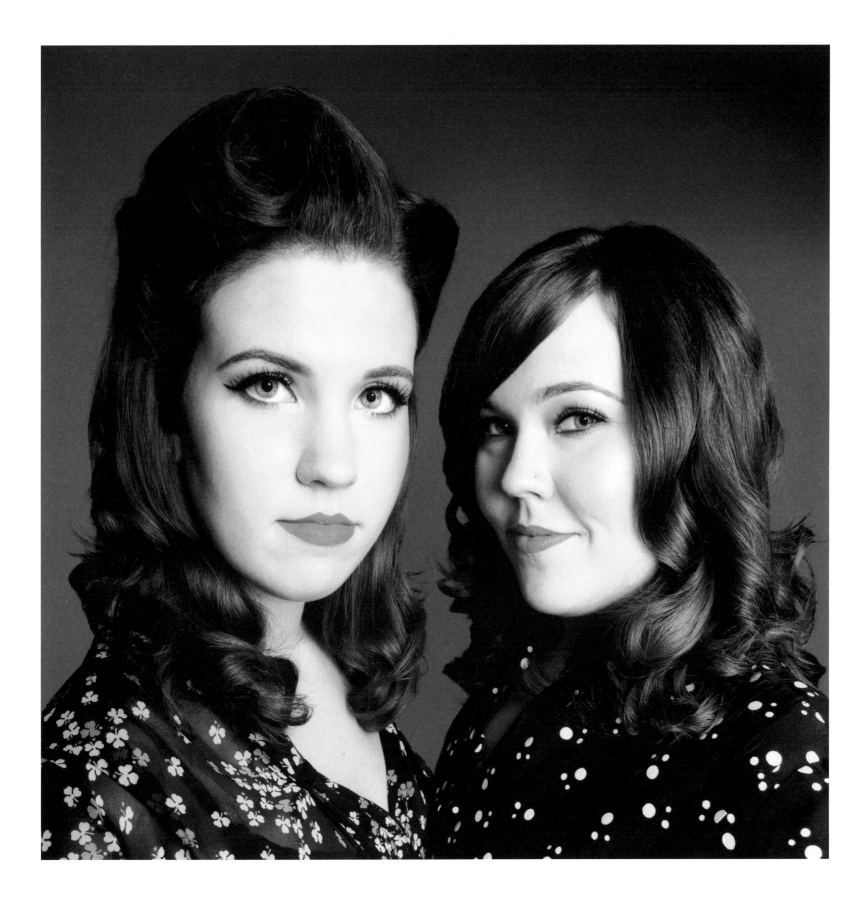

The Secret Sisters

SIDE A
BIG RIVER

WABASH CANNONBALL

SIDE B

The Secret Sisters are **Laura Rogers** and **Lydia Rogers** - Vocals

BIG RIVER, written by Johnny Cash (BUG MUSIC O/B/O HOUSE OF CASH) Carl Broemmel – Pedal Steel. Patrick Keeler – Drums. Jack Lawrence – Upright Bass. Jack White – Lead Guitar. **WABASH CANONBALL** written by William Kindt (SONGS OF UNIVERSAL, INC.) Carl Broemmel – Pedal Steel. Justin Carpenter – Trombone. Dominic Davis – Banjo. Joe Gillis – Autoharp, Cell Phone Train. Olivia Jean – Electric Bass. Patrick Keeler – Drums. Jack Lawrence – Upright Bass. Leif Shires – Trumpet. Jackson Smith – Acoustic Guitar. Craig Swift – Saxophone. Jack White – Mandolin. Recorded at Third Man Studio, Nashville, TN 2010. Produced by Jack White III Engineered by Vance Powell, Assisted by Joshua V. Smith and Mark Petaccia. Mixed by Vance Powell and Jack White, Assisted by Mark Petaccia. Design by Miles Johnson. Photography by Jo McCaughey. Manufactured at United Record Pressing in Nashville, TN. Third Man Records, 623 7th Avenue South, Nashville, TN 37203.

TMR050

"I remember we were getting tongue-tied over the words when we were trying to sing the lyrics, but the energy of it, I mean it literally sounds like a freight train barreling at you."

BEN BLACKWELL: I guess the first question is do you recall how the single came to be? How you were asked or how it came together?

LAURA ROGERS: I think at the time we were kinda in a busy phase of our career, we had just finished our first record and we were preparing to get that out into the world. And I believe it was in the summer when we just heard from our management that Jack White wanted to get us into the studio to do a 7". I remember it was so early for us that we had not been trying to be recording artists, so everything was just a whirlwind and kind of completely unexpected. And so when these big names like T-Bone Burnett and Jack White come into your world kind of suddenly, it's a bit startling. I remember thinking like, all through my teenage years and my early 20s, The White Stripes and Jack White as the pinnacle of coolness and the godfather of great music. I thought, "What in the world does he want with The Secret Sisters?" So there was definitely some intimidation and curiosity. I was awestruck that he even knew who we were, because we didn't even know who we were at that point.

BLACKWELL: I recall in the lead-up to the single that you guys were referred to as the Rogers Sisters and me wondering whether you were aware that there was a band, a punky New York band, called The Rogers Sisters in the early 2000s. They had played shows with various bands that guys who worked at TMR played in, so we all owned their records. Jack would talk about you guys in meetings, "Yeah we're talking about doing something with The Rogers Sisters," and me and Ben Swank are like, "Really? The Rogers Sisters?" We're just scratching our heads, and Jack would make references to your vocal traits and musical style, and we're just sitting there

scratching our heads like, "That does not sound like the band that was doing no-wave punk music in Brooklyn in 2001." So were you guys originally going as The Rogers Sisters until you found that out, or when did Secret Sisters become what you tagged it as?

LYDIA ROGERS: I think we were going as The Rogers Sisters at the time. But then we found out about that band, and they had the name already trademarked. We had to come up with something else. We liked the alliteration of The Secret Sisters. But before we ever came up with "secret," we knew wanted something with "sisters"; and quite frankly, everything was taken. When we finally came up with our name, we liked how it sounded and that it sounded mysterious.

LAURA: I think the name decision happened around the time that we were getting ready to come and do the work with you guys, because as I mentioned earlier, we literally didn't even really know who we were at the time. So, I think at first we were by default The Rogers Sisters, and were like yeah cool, but then we realized the value of establishing your own brand and your name. In hindsight, it's all really funny because I think we are quite a bit different from the original Rogers Sisters.

BLACKWELL: So once you get in the studio, how would you describe the studio itself, the feeling, the vibe, your emotions, how would you describe all of that at the time?

LAURA: We went to Jack's house to record in his back building studio, I don't know what I expected, I think it was just really mysterious, I don't know, it was strange because when we got there, your first impression is like, "I want to see what Jack White is like in person." And I've always thought he was so cool and mysterious, and he still is that way in person, but he was also just incredibly nice and down-to-earth. He showed us pictures of his kids and was just really relatable and easy to talk to.

But about preparing for the session ... we're very nerdy and like to be prepared, we don't like to be caught off guard and spontaneity is sometimes difficult for us. So I remember in the weeks leading up to the recording session that we kept asking, "What song are we gonna do?" and wondering if we need to practice anything, does he have something in mind? And we kept hearing back: don't come in with any ideas just come in and we're gonna be completely spontaneous, we're just gonna get you in and capture the moment. And so that was very terrifying for us because we're natural perfectionists. I remember we got into the studio and we started talking about what we could do, and Jack said, "Well I thought the Wabash Cannonball, I would really love to see what you girls could do with it." So we ended up recording that and it was so wild and crazy — we got to kick off our shoes and have a good time. And then he started talking about the other song. "What are you guys listening to lately?" And I was on a huge Johnny Cash kick at the time and I said, "Johnny Cash, he just

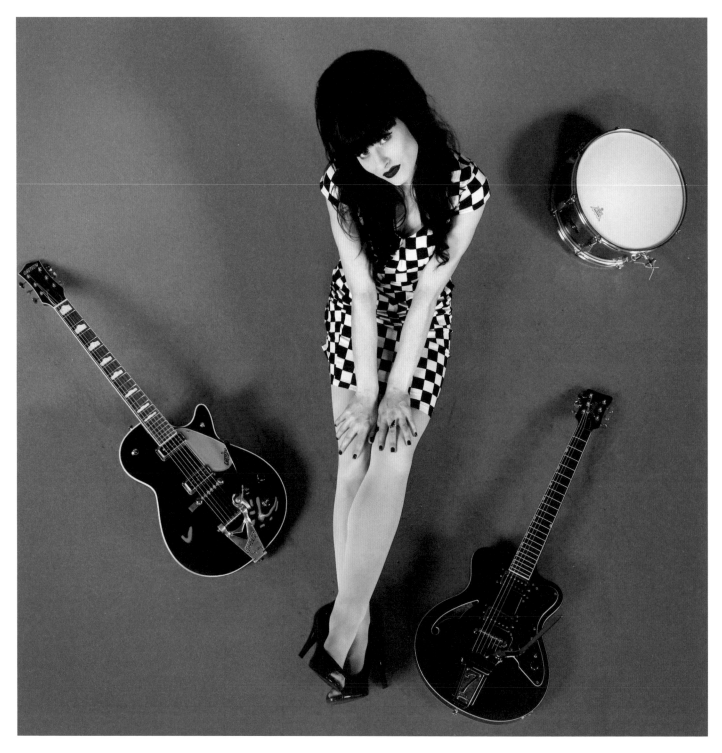

OLIVIA JEAN

really hits home for me these days." And Jack was like, "Oh what song?" I said "Big River," and he was like, "Ok cool let's do that one." There was not a lot of debate about what we were gonna do, it was just like, "Cool, let's do it." And I think that was really good for us because it kind of showed us that you don't have to be so planned out and perfect and you can kind of let your humanity show and just kinda go with it because what you come out with naturally is exactly what people want to hear. And so we started recording this song and I remember thinking, it will probably be like a cute little mid-tempo cover kind of similar to Johnny Cash's version, and then Jack came out with his guitar and started playing this like wild riff that was a really incredible interpretation. So yeah, that was kind of the mindset, it just happened so quickly but it's just the way you want it to happen.

BLACKWELL: Tell me if I'm correct, was the instrumentation for "Wabash Cannonball" already recorded, did you guys just sing along to that or was there already have a track?

LYDIA: They did already have a track of that. They already had it down because I think, if I recall correctly, he was gonna have Wanda Jackson sing "Wabash Cannonball" but it was too fast for her, and so he asked if we would give it a shot and somehow we got it out.

BLACKWELL: I think there's one or two other similar instances; I think the Tom Jones single where he sings "Evil," the Howlin' Wolf song, I'm pretty sure that was the same situation where they wanted Wanda to do it and she wouldn't do it, and so Jack just had this backing track trying to find someone to do it.

LAURA: It was really fun to do "Wabash" because, I mean, we know the traditional version of that song, but it was just like, it was very fast and so I'm not surprised that Wanda Jackson was like, "Nope, too fast for me." Because I remember we were getting tongue-tied over the words when we were trying to sing the lyrics, but the energy of it, I mean it literally sounds like a freight train barreling at you. So it's amazing how Jack is able to capture just that feeling, you know?

BLACKWELL: Do you look back and think it happened so quick that you don't even have the ability or the recall to really have comprehended it at the time until sometime afterward?

LAURA: Yes, that's very true. And I think it's that way no matter what you're doing in the music industry, no matter who you're collaborating with. You just keep yourself busy doing different things that inspire you, and it just happens in no time, and you don't know what it's gonna be, you don't know if it's gonna be a song on a movie or if somebody else is gonna cover it and it goes huge on the radio. You just have no idea what the work you do today is gonna do for your future. And I think that that's the thing we've been most grateful for with our Third Man experience, is that it's gotten us fans that are just really dedicated and diligent, and they love

what we did and they love what we're doing and that's really special. You can't, there's no amount of money that can buy that. It's funny how even to this very day we have those experiences.

BLACKWELL: That's as much a testament to you two as it is to the people that Third Man speaks to.

LAURA: I know this isn't a question you're asking, but Lydia has this story that I'm gonna make her tell because it's so funny. I'm gonna set it up, but I want her to tell it. When we were recording with Jack at his house, he has this really cool old Coke machine, and he was like, "Hey do you want a Coke?" Now Lydia's gonna tell the rest of this story. Remember about the Coke bottle?

LYDIA: No I don't remember!

LAURA: Ok I'll tell the story. So, we were recording and Jack, everything that Jack has is so cool, like the aesthetic, the décor, everything is so fantastic. And he has this great old Coke machine. And he asked if we wanted a Coke and Lydia is like, "Yeah sure I'll take one!" so he pulls a dime out of his pocket and puts it into this Coke machine, and this glass Coke bottle comes out and he hands it to Lydia, and Lydia was like, "that's so neat!" And she drank the Coke out of the bottle, and she saved the Coke bottle because it was such a special thing, it was like a souvenir, it was just so neat. She got to drink out of a glass Coke bottle in Jack White's studio and he bought it for her. Like this is to show what nerds we are [laughs]. I mean it's not that great of a story, but I thought it was so funny and wonderful.

LAURA: I've got one more if you want to hear it.

BLACKWELL: Absolutely.

LAURA: I have a bunch from that day I'm telling you. One of the most hilarious moments, you know, when you go into the studio, even if you're starstruck, you kinda want to seem like you have your act together, like you're cool and professional. It's really difficult for us. But I remember when we were in the studio, Jack put us into an isolation booth for recording vocals because we were all playing at the same time on "Big River," and the band was playing, and he was singing, and it was all live. And I remember in our little isolation booth there was a glass window so we could see out into the room where everyone else was playing. And I remember Jack was just like two or three feet away from us on the other side of this isolation wall, and the way that "Big River" goes is that there's a section where we sing, and then there's a section where the band just kind of rocks out. And we were concentrating really hard on getting the words right and good vocal takes. So we sang our part on one section of the song, and then it came time for the band to play and Jack was doing this incredible guitar playing and we were watching him through the window of the isolation booth, and he was just right there with his guitar playing and

just being incredible two feet from us and then it came time for us to sing again and we were still watching Jack and so entranced by it that we forgot to come in and sing on our section. And it happened like multiple times, we would get so distracted by just watching Jack and the band that we would forget to even come in on our parts. And I remember thinking we are so unprofessional at what we're doing we keep getting starstruck. But it was just a moment and I look back at life and how young an innocent we were, we were just so fascinated to be in that moment and we couldn't believe it was happening in front of our eyes. And we were not incredibly professional that day and I hope that they've all forgotten how unprofessional we were.

BLACKWELL: Well if they've forgotten it will be transcribed and it will be imprinted in a book for them to remember for the rest of time [laughs]. Do you have any specific memories about the photoshoot here at Third Man in the Blue Room?

LAURA: I just remember being so fascinated at the floor in the room where we took the pictures because it didn't have corners it was just this sloped wall-to-ceiling-to-floor-to-wall strange thing that I've never seen before. And when we got in there we were all kind of dressed up trying to look good and Jack came in wearing this really cool western shirt and they rolled in this kind of vintage cigarette machine for us to prop up against. I remember feeling really proud that we had made it that far, proud that we were doing something that we were so inspired by, that if no one else gave us any credibility for it, it gave us credibility that we needed. And the pictures were beautiful and when they came out, especially the ones that were chosen for the album artwork, it was just so beautiful. And actually the guy that I was dating at the time had it all framed up for me with a copy of the 7". So yeah, everything about it was such good quality. The photos were great, it was tastefully done, it was everything that we ever could have wanted it to be and then some. Jo was the best.

PUJOL

TMR-051

Fronted by Nashville punk mainstay Daniel Pujol, both songs on this single were released in earlier forms on the 2009 cassette release *Ringo, Where Art Thou?* on Infinity Cat Records. Live versions of both songs would also be included on the band's *Live at Third Man* 12" EP recorded in the Blue Room on May 21st 2010. Listed in his bio as "a prominent social critic, shreditorialist, unlicensed metaphysician and polymathmagician," Pujol's elder-statesman status in the local Nashville scene is hard-earned and well-deserved as his prolificacy features many impressive releases including many for Omaha-based indie label Saddle Creek Records.

A SIDE: BLACK RABBIT
B SIDE: TOO SAFE

RELEASED: OCTOBER 2, 2010

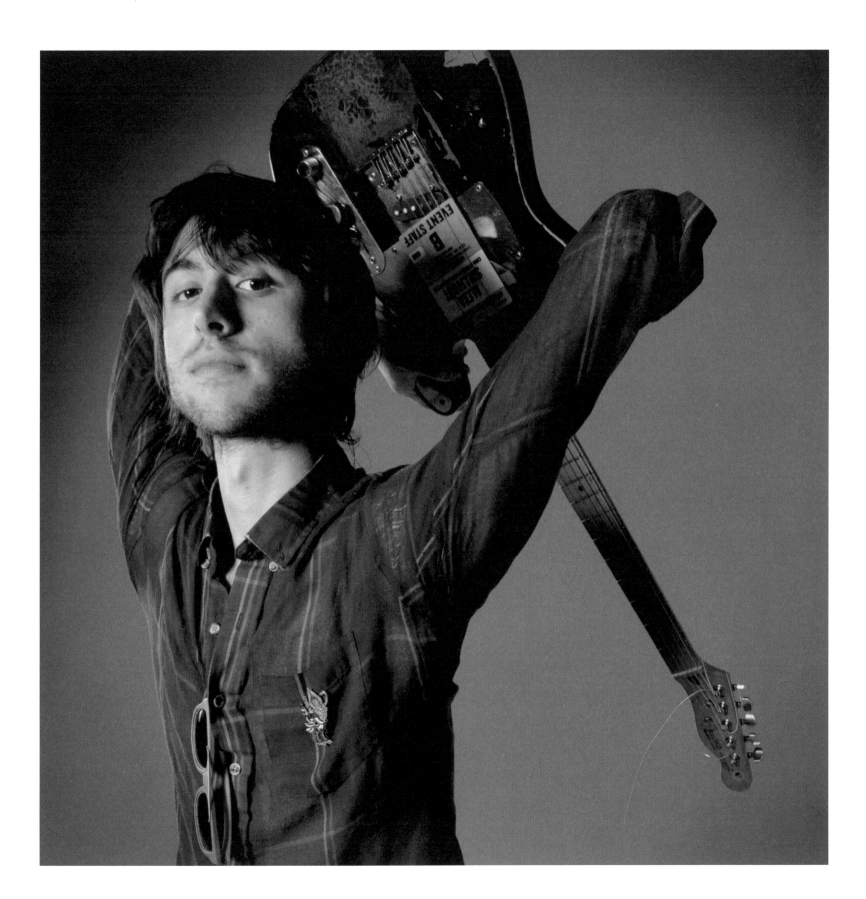

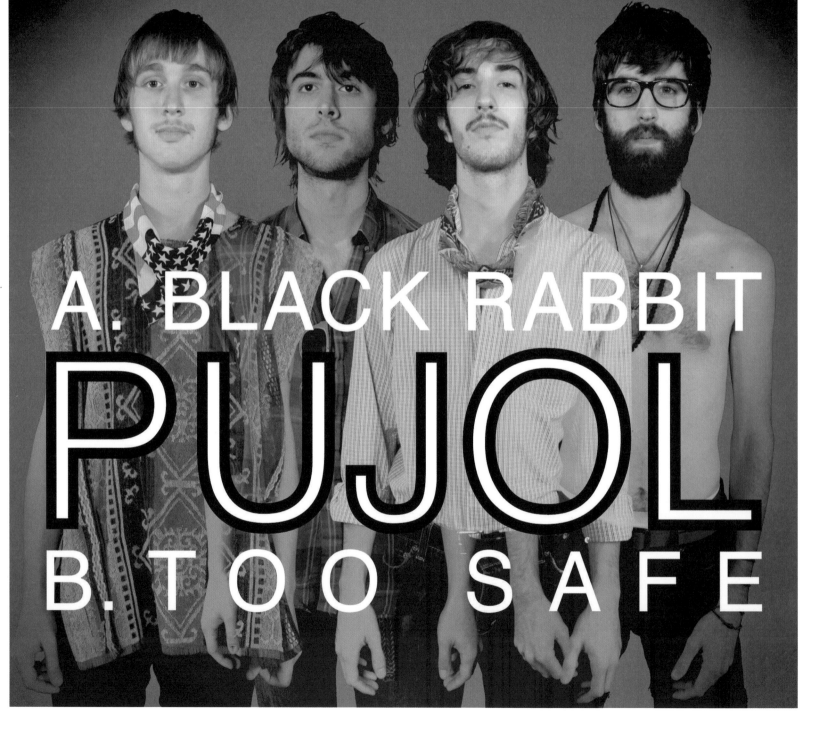

ALL SONGS WRITTEN BY DANIEL PUJOL. [HARD DAYS PETE/BMI] • PRODUCED BY JACK WHITE III
RECORDED BY JOSHUA V. SMITH AT THIRD MAN STUDIO, NASHVILLE TN • MIXED BY JACK WHITE AND JOSHUA V. SMITH
DANIEL PUJOL - GUITAR, VOCALS • MIGHTY JOE SCALA - BASS • SEAN TO THE WALL THOMPSON - LEAD GUITAR • GREGHEAD MEREDITH - DRUMS
℗ & © 2010 THIRD MAN RECORDS, LLC 623 7TH AVENUE SOUTH, NASHVILLE, TN 37203 UNAUTHORIZED DUPLICATION OF THIS RECORDING IS PROHIBITED • THIRDMANRECORDS.COM

TMR 051

A. BLACK RABBIT

PUJOL

B. TOO SAFE

"He kept things moving, but with an emphasis on quality control. There was a part in one of the songs that I thought was harmonically incorrect. He heard it before I could bring it up. That was great."

BEN BLACKWELL: What were your initial thoughts upon being asked to record a Blue Series single? Surprised?

PUJOL: As usual, I thought a lot of things — but they're embedded in backstory; so here we go: Basically, in 2009 I was messaging people and entities around Nashville putting out an ad for a touring drummer. One of the places I messaged was Third Man Records. I got a reply — I believe from Swank — that complimented the material. After I found a drummer, Swank started coming to local shows and we began to get to know each other. If I remember correctly, I think we waited until the live-band cohered before we talked about making a record together. Which was smart — and I still agreed with. When y'all finally popped the question I thought two things: One, that I was fortunate to have a group of people guide me toward an opportunity, and two — that this was because of songs. My initial message had led Swank to hear some songs, and that was the starting point. Now, in 2009 it was all about a hyperbolic live-show — because no one "sold records" anymore and the live-show was how you — and other people — got paid. So records and songs were just merchandise and fodder for your Bacchanal of a live-show. Songs were not art — they were product differentiation. To me, this said more about advanced-capitalism than it did the value of song — because Gawd forbid something have qualitative value, am I right? — but here I was with a good opportunity all because of a song. Not because I fired T-Shirt cannons like a Court Jester for the Duke Of Yum! Brands

Phone-App Launches. So, as mawkish as it sounds, you could say I thought, "This 7" is a testament to the living power of song."

BLACKWELL: Were you previously aware of any Blue Series records before being asked to record? Any stick out to you as being favorites? Any you hate?

PUJOL: Yes — I enjoyed the Wanda Jackson one.

BLACKWELL: Did the session move smoothly? What informed the decision of what songs you would record ... how did you choose them?

PUJOL: The sessions did move smoothly — because the producer kept things moving. I chose the songs by their lyrics. Whatever lyrics I thought would best serve their exposure. You get an opportunity to put something out there; choose the thing you think can help the most, I suppose.

BLACKWELL: Did Jack impart any insightful knowledge or advice in the session? What was your impression of him as a producer? How did he smell?

PUJOL: He kept things moving, but with an emphasis on quality control. There was a part in one of the songs that I thought was harmonically incorrect. He heard it before I could bring it up. That was great. I didn't have to stop everything to dissect — and it would've taken me valuable time as well since I'm not the most readily articulate in music theory — but he heard it, and addressed it. He did his job as a producer so I could do my job as a performer. He smelled like your favorite scented candle.

BLACKWELL: What did you think about the studio space, the equipment used, the vibe in the room? Inviting? Cold? None of the above?

PUJOL: At the time it was all over my head. I'm functional, but still not great with gear, it was all great stuff — I just had no idea what it was. However, everyone there helped me out and we got good sounds. There is a small Coca Cola machine in the studio that takes nickels or dimes. I was an ace with that.

BLACKWELL: You have some unique insight to this entire process as you come in to Third Man as a temp worker during big mailings. I heard you say the other day, "I've recorded three albums with the money I've made working here." That's really fucking cool. Talk about that if you can.

PUJOL: It is true. I've used the money I've made working for y'all to finish or start-and-finish at least three records. I've used that money to hire specific mastering engineers, lathe cutters, etc., when I felt so strongly

about their necessity, that I was willing to use my own money as opposed to a label's. I've used it for remixes as well. I made my 2015 *Record Store Day 5"* with the money, and I made my 2015 *Kisses* EP with it. It helped pay for the radio servicing, manufacturing, mixing, mastering, etc. The temp work let's me do things like *Kisses* and make a relevant piece of artwork that I feel needs to be out sooner-than-later because we are at an important turning point in our culture.

BLACKWELL: You're the first born and bred Nashville artist to do a Blue Series single. Were you aware of that at the time? You also recorded a live show around that same time. How did either/both of these recordings help you (or possibly hurt you?) moving forward?

PUJOL: Technically I'm not "from Nashville." (I was born in a dark place called Tullahoma and moved here in 2006.) But I was told that! Very nice of y'all. Thank you. Yes, I did make a live record — but here's the best part — I did not know we were being recorded. So, it is the best kind of live record. I think it was mixed quite well too. You can hear the guitars. It's not sub-flub kick and vocals.

Obviously the two TMR records helped me — I think they solidified me as an artist if that makes sense. People started referring to me as an artist. That sure made things easier! Hurt me? You could say afterwards I garnered the attention of others who might've thought I was a "sure thing," and they might've taken me for a ride a bit by not doing the work they promised to do — those types always disappear at crucial times — but I saw a lot of that coming anyways, so I just kept myself prepared to do their jobs for them, and now I know how to do their jobs. So, in the long run, I don't even know if that really hurt "me" — but it was stressful having to pick up that slack while finishing graduate school and touring. Didn't affect my grades, though.

BLACKWELL: Thoughts about the filming of your music video?

PUJOL: Stewart works the same way I do. He gets together a plan and a proposal, he presents it to whoever he's working with, and then once approved — he just starts working. I just let go and let Stewart go. He has as much intent in his filmmaking as I do in my songwriting or recording. I respect that; so I allowed myself to be directed. I did, however, accidentally run over my guitar with my van during the filming — somehow the guitar was fine, but of course its case wasn't so lucky.

BLACKWELL: You say "Black Rabbit" is a song written about (for?) your little sister. Can you explain that?

PUJOL: I have a lot of little and big sisters. Can you explain that?

BLACKWELL: I'm pretty sure both "Black Rabbit" and "Too

Safe" were recorded prior to (and after) your TMR single. What are your thoughts about how the different versions of both of these songs compare to the others?

PUJOL: I always try to do multiple versions of songs I like. First, because it keeps the songs alive. I like there not being definitive versions of my material. The songs change like I do. They grow. Second, sometimes you get access to better resources and the song deserves those resources. Sometimes songs deserve things. If a song does good by me, I try to do it some good too. Give it another go. People do the same thing with photographs — constantly. The different versions are just different photographs. Different bands. Different arrangements. Different inflections. But still the same lyrics — still the same song.

BLACKWELL: What was your main takeaway from the session and subsequent release?

PUJOL: That y'all know what you're doing and I was surprised by how smooth it was.

DRAKKAR SAUNA

TMR-052

Hailing from Lawrence, Kansas, Drakkar Sauna feature songwriter Wallace Cochran and multi-instrumentalist Jeff Stolz. The duo was asked to record a Blue Series single after blindly sending unsolicited copies of their previous vinyl releases to Jack White's attention at the Third Man Records address in Nashville. Joined on this record by Jason Groth (Magnolia Electric Co.) this single would be the only record by Drakkar Sauna that was not released by Portland-based Marriage Records.

A SIDE: LEAVE THAT HOLE ALONE
B SIDE: BRUNDLEFLY, MY CHARIOT

RELEASED: OCTOBER 19, 2010

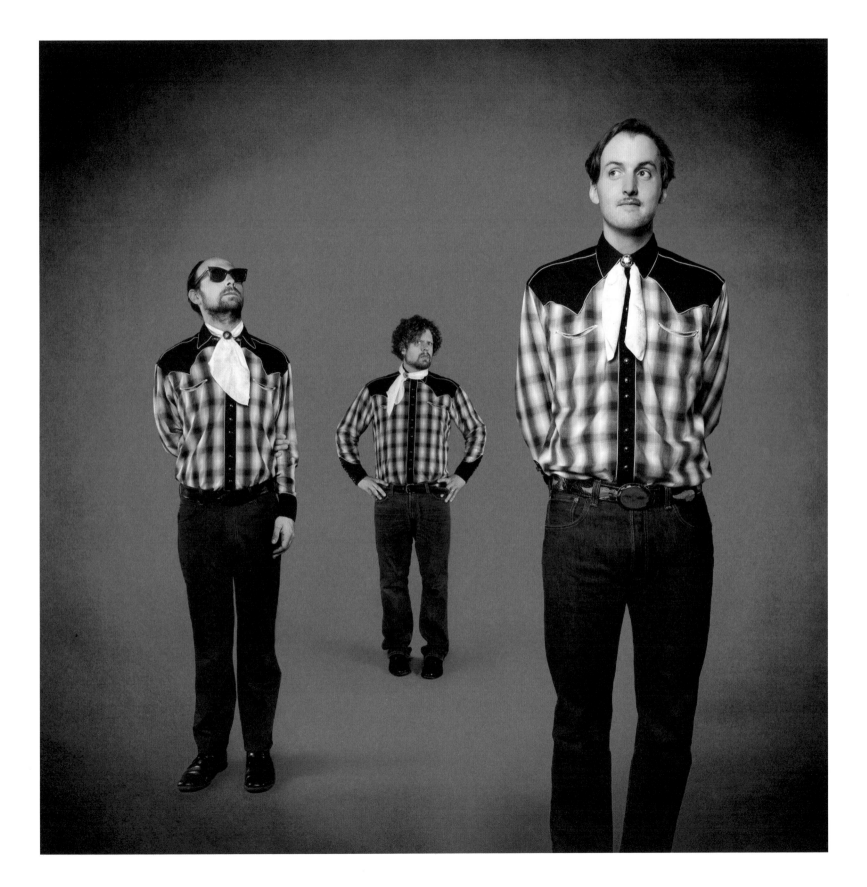

DRAKKAR SAUNA

• SIDE A •
LEAVE THAT HOLE ALONE

• SIDE B •
BRUNDLEFLY , MY CHARIOT

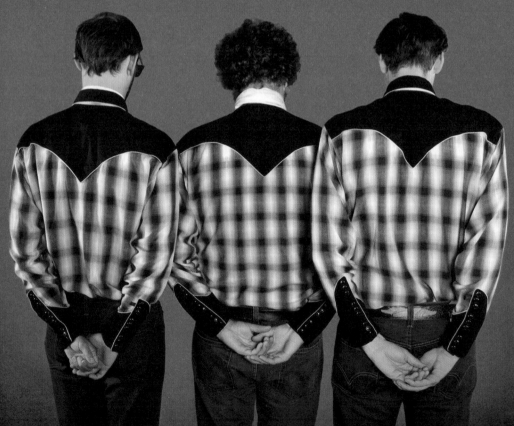

All songs written by Wallace Cochran, Clarvoe Entertainment (BMI) • Produced by Jack White III • Recorded by Vance Powell at Third Man Studio, Nashville TN Assistant Engineer: Mark Petaccia • Mixed by Jack White III and Vance Powell at Third Man Studio, Nashville, TN • Mix Assistant: Joshua V. Smith • "Leave That Hole Alone" WALLACE COCHRAN - vocals, guitar, harmonica, JASON GROTH - bass, electric guitar, saxophone, vocals, JEFF STOLZ - drums, harmophone, moog, vocals "Brundlefly, My Chariot" WALLACE COCHRAN - vocals, JASON GROTH - lap steel guitar, bass, vocals, JEFF STOLZ - drums, piano, vocals • ©2010 Third Man Records, LLC. 623 7th Avenue South, Nashville, TN 37203 • Unauthorized duplication of this recording is prohibited. All Rights Reserved • www.thirdmanrecords.com

TMRO52

"Jack suggesting we record 'Hole' backwards, and then cheering us along, is potentially my favorite recording moment of all time."

A few words from **JEFF STOLZ**

Of course, being in the studio with Jack was intimidating. Two things set me at ease. One, we invited Jason Groth to join us for the session. He's just a sweet man, a joy to be around, and a bad-ass guitar player. Second, Jack White's professionalism. I remember specifically that Jack had suggested the piano arpeggio in "Brundlefly." I hadn't really practiced my arpeggios in a bit and told Jack so. He was genuinely encouraging and more than gracious while sitting through my practice and then more than a few takes. I think he may have frankensteined that thing together despite it being a fairly simple arpeggio, but I was sweating.

Also, Jack created the entire dynamic to "Leave That Hole Alone." Wallace and I usually play as a two-piece. Wallace sings and plays guitar. I sing and play a kick drum and tambourine shoe with my feet while switching between guitar and harmophone. So our dynamic usually consists of me waiting to come in with my harmony vocal until the second verse or adding the tambourine to the drum beat a few measures in or only during the choruses. Very complicated. Granted, the instrumentation to "Leave That Hole Alone" is more rockin' than our usual affair, but the dynamic that Jack suggested in the mixing probably never would have occurred to us, was exceptionally tasteful, and added a lot to the final sound.

An interview with **WALLACE COCHRAN** and **JASON GROTH**

BLACKWELL: How were you asked to record a Blue Series single? Were you surprised?

COCHRAN: I had sent Third Man Records letters about Drakkar Sauna for some time. Jack White called my house and left a message about the possibility of recording and later that week we spoke on the phone. I was very surprised. I don't think I was particularly charming on the phone. I was nervous with surprise.

GROTH: As a member of the band who didn't ever live in the same town as the two permanent members, I heard about everything regarding my involvement a week to a year late. So I'll relate the story I was told — Wallace communicated with Jack via letters, because he admired Jack and Jack's work. And, after a series of letters (in my mind it plays out like a movie montage with voiceovers and a lot of staring off into the distance by both of them — by windows, of course) Jack asked Wallace if we'd be interested. I don't know if Wallace was surprised, but I was utterly thrilled when I got the call that they wanted me to be part of the band for this recording. Drakkar Sauna is one of my favorite bands of all time. Just being able to be in the band was amazing. And then being asked to be part of a session with Jack — a person who I have looked up to as a producer, singer, songwriter, guitarist, visionary, etc. — just made it all that much more unbelievable. So, yeah, I was surprised. I was also thrilled that a great band was going to do something with someone incredible like Jack.

BLACKWELL: Were you previously aware of any Blue Series records before being asked to record? Any stick out to you as being favorites? Any you hate? Any thoughts about Third Man in general? Or even Jack?

COCHRAN: I was not aware of the Blue Series. I enjoyed Haxan's jam, Laura Marling, John C. Reilly all very much. I don't hate anything. The whole process was a delight, except for one thing. Our friends the Tuley's got married the day we recorded and we missed their wedding. It felt like something we had to do, the opportunity to come to Nashville and record felt like it couldn't be delayed, but we hurt their feelings by not being there to play, and I didn't like that.

GROTH: I had been following the series pretty intently, as I was good friends with the owners of Landlocked Music in Bloomington, Indiana, who loved it. I had the Nobunny LP and (maybe?) the PUJOL single before we recorded. I really love both of those. But the We Are Hex single may be my favorite. Honestly, I haven't heard one I didn't like. I admire Third Man — I admire the chances it takes on not only content but also carrier. I pay attention to what's coming out whenever it comes out, which is more than I can say for almost any other record label. And, as I said above, Jack's dedication to the universe of music is inspiring. I'd say that — Third Man is inspiring, on all fronts.

BLACKWELL: What was the feeling while recording in the studio? How do you decide which songs to record?

COCHRAN: Nervous energy. We brought the two songs in pretty well rehearsed, and they were both a little bigger than our other songs. Just before we started, Jack asked if we had any songs like "the one in the video with the girls" which was "Paul's Letter to St. Job (There's Glass in My Hat)," a slow song from our third record. We said no. We probably should have seemed more flexible.

GROTH: I often reflect on how recording with Jack that day was one of the highlights of my musical career. The feeling that any idea we had was potentially a good one is not something I have always felt in recording sessions. I felt inspired all day to play my best, to try out things we hadn't even considered, and to be open to changing anything at the drop of a hat. We recorded "Leave That Hole Alone" backwards, essentially — we started by all playing acoustic guitar, then did vocals, THEN added the bass and drums. I would have never thought to do it that way. We were all excited. I will never forget loading up on healthy snacks and taking a bunch of multivitamins, drinking tons of water, and feeling totally jacked on health and musical inspiration. The songs were chosen ahead of time, and we had only ever played them together the day before. And our arrangements were all re-imagined in the studio. It was great.

BLACKWELL: Did Jack impart any insightful knowledge or advice in the session? What was your impression of him as a producer?

COCHRAN: He worked really fast. They all three did, it was great. And he had good ideas that made the songs stand apart in our catalogue, which I like very much. He suggested I learn to play piano.

GROTH: Jack suggesting we record "Hole" backwards, and then cheering us along, is potentially my favorite recording moment of all time. He seemed as excited as we were to try out effects on my guitar solo (he was actually working the pedals as I played that solo), to take us out to sing in the barn so we could use the reverb tank, to try out the crazy synthesizers, to use his new 1920s Gibson acoustic — it was so generous, truly collaborative, and totally fun. I've never enjoyed recording as much. I can safely say that I'd never worked with someone who seemed so comfortable producing, which made everyone else feel comfortable, too. He was constantly thinking, he accepted all ideas, and his ideas were spot-on. It was great.

BLACKWELL: What did you think about the studio space, the equipment used, the vibe in the room? Inviting? Cold? None of the above?

COCHRAN: I played through a Silvertone amp which was tremendous. We also used some pre-war Gibson acoustics. Jeff kept walking into a red buffer and suggested that, in order to see it better, it should be painted pink. Jack White called this a blasphemy.

GROTH: I've never felt more at home in a studio. It reminded me of a midwestern rec room that I think I have a memory of as a child in the early '80s, but probably just made up because it was so comfortable and functional. Good vibes that invoked both nostalgia and forward thinking, incredible equipment, a sense that all music from all eras co-existed there in total harmony.

BLACKWELL: Having listened to these songs MANY times ... what in the HELL are they about? The lyrics about Michael J. Fox? "Leave that hole alone?" Any insight would be quite appreciated.

COCHRAN: Leave that hole alone. Transiency. The sore tooth, the bad memory, the circular thinking. Michael J. Fox represents us all. Michael J. Fox does not exist, though our perception contradicts that. His suffering does not exist, is what I'm saying. If he does in fact suffer, he suffers needlessly. Angels and solipsists, lines and triangles. "Brundlefly My Chariot" is about the romantic elements of David Cronenberg's *The Fly*.

GROTH: Good question. I don't know the answers but I will say that my take on the "Michael J. Fox does not exist and so he suffers needlessly" was a take on that fact that Michael J. Fox isn't actually his name. I'm not sure how to interpret it beyond that, but it sure is catchy.

BLACKWELL: Did you notice any newfound attention after releasing a record on Third Man? Did it help you out at all in your career? impression of the TMR single from fans of yours?

COCHRAN: It didn't have any impact on us other than the joy of doing it. We're open to it. We have a new album. If you'd like to listen to it and help us put it out that might affect the old career. Would you like to hear this new record?

GROTH: I was told by many people that my guitar solo on that track was their favorite that I had ever recorded and that they loved it. I don't know the answers to the other questions, but I do know I've met several people since it came out that learned about Drakkar Sauna because of it.

BLACKWELL: What was your main takeaway from the session and subsequent release?

COCHRAN: The harder I try the more embarrassed I feel. Also, we recorded in July. That November Jack emailed me a picture of him with Elvira at a Halloween party. He captioned it: "I'm the one in the space suit."

GROTH: An incredibly creative, intense, and utterly fun session that produced two, these-could-have-only-happened-this-way songs. I can't believe I got to be a part of it.

TMR-058

Formed in metro Detroit in 2009 by cousins Tamara Finley and Jim Wiegand III, the Thornbills were beyond surprised when contacted directly by Jack White and asked to record for the Blue Series. Finley recalls asking White the impetus behind the offer and says his reply was simply, "I don't feel comfortable disclosing my sources." The single, the first-ever release by the duo, would lead to a slot opening for Wanda Jackson in the Third Man Blue Room as well as a spot on the 2011 MI Fest at Michigan International Speedway in Brooklyn, Michigan. This single features a hidden track, "My Star" pressed underneath the label of the "Uncle Andrei" side.

A SIDE: UNCLE ANDREI
B SIDE: SQUARE PEG

RELEASED: NOVEMBER 23, 2010

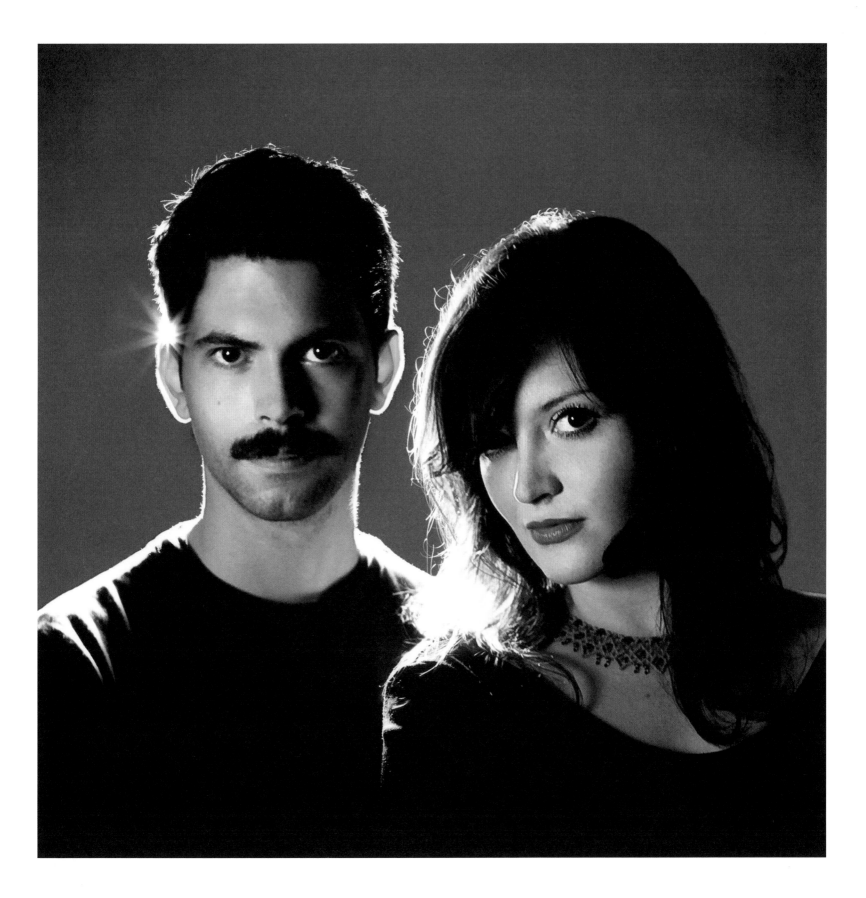

the Thornbills

SIDE A: Uncle Andrei

SIDE B: Square Peg

TMRO58

The Thornbills are Jim Wiegand III and Tamara Finlay • All songs written by The Thornbills, Rusalka Music (ASCAP) • Produced by Jack White III • Recorded by Vance Powell at Third Man Studio, Nashville TN • Assistant Engineer: Josh Smith • Mixed by Vance Powell and Jack White III at Third Man Studio, Nashville, TN • Mix Assistant: Joshua V. Smith • "Uncle Andrei" Jim Wiegand III - guitar, vocals, Tamara Finlay - autoharp, vocals, Cory Younts - piano, Mark Watrous - fiddle, Jack Lawrence - bass, Jack White - drums • "Square Peg" Jim Wiegand III - guitar, vocals, Tamara Finlay - autoharp, vocals, Cory Younts - piano, Mark Watrous - fiddle, Jack White - Kick Drum ©2010

"He played a very dark driving circus oompa-pa type beat on 'Uncle Andrei,' that while minimal, was super effective."

A few words from **JIM WIEGAND III**

Before we were contacted by TMR, I wasn't familiar with Third Man at all, nor was I aware of the Blue Series, but I had been a fan of The White Stripes for many years and I considered Jack White to be a pretty big fucking deal. When we received an email from Ben Blackwell saying that Jack wanted to talk to us, the whole thing was completely out of the blue and both Tamara and myself were extremely surprised and so excited.

When we first met Jack in the studio my first impression was that he was very outgoing, kind, and full of energy. Going into it I was pretty nervous, but Jack's relaxed attitude put me at ease very quickly. As we worked on the songs, it became clear to me what a great producer Jack really was and is. Before we even got there, he already knew the direction he wanted to take the songs and his ideas definitely took our music to a whole new level.

At the time Tamara and I were asked to come to Nashville and record at TMR, we had been together writing music for only six months so the whole experience was a complete whirlwind. The songs we decided to record were basically the two songs that Jack liked best. The feeling in the studio was incredible and unlike any other time in my life that I can remember; Tamara and I were like children in the studio. Incredible fun.

... And the session players were fantastic! Cory Younts played piano, Mark Watrous played fiddle, and Jack Lawrence played bass. All three of these guys are such great musicians and are really fun to hang out with. I was so impressed with what they were doing since they had never heard the songs before. Besides the session players, Tamara and I really enjoyed working with (and partying with) engineers Vance Powell and Josh Smith as well. And yes, Jack is a phenomenal drummer! He may even be a better drummer than he is a guitarist ... which is saying something.

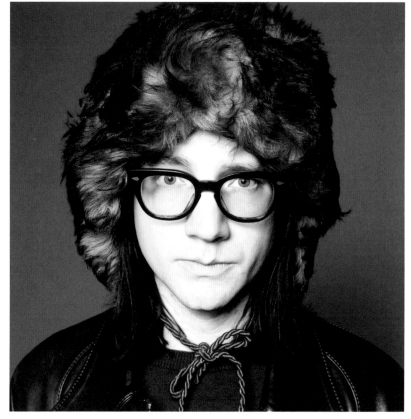

JACK LAWRENCE

After our Blue Series came out on the streets, we definitely received more attention after the record was released and we got a lot of positive feedback, not only from the fans, but there were many bands that suddenly wanted to play shows with us. It's funny because that's exactly what Jack told us was going to happen. Suddenly people gave a shit! Both Tamara and I are very proud of what we did at Third Man, and it's pretty cool that we have the whole experience pressed on vinyl forever.

A few words from **TAMARA FINLAY**

When we received an email from Ben Blackwell saying Jack White was interested in talking about the band. We were such a new band at the time, we honestly thought we were being put on! After a few weeks of correspondence and sharing some demos with Jack, he invited us to record in Nashville and we were absolutely over the moon about it.

I had been vaguely familiar with the Blue Series beforehand, I knew Conan O'Brien had done a recording, and really dug the Carl Sagan one. Once we'd been to Nashville, I had a chance to hear the Laura Marling single, which was fantastic. Dungen was my very favorite. There've been many Blue Series singles since, and I've got to say I've liked most of them a lot.

For us, recording our Blue Series was a really great experience, especially since our band was so new. As soon as we stepped out of the car we were greeted warmly by Josh [engineer], then Jack and we felt very much at ease and welcome. The studio was impressive, but not intimidating. Recording to tape was awesome, and had a nostalgic warmth. We already had a pretty solid idea of the tracks we were going to record, "Uncle Andrei" was an absolute given, as it really encompassed what we were about, and Jack's dark circus-y take on it gave it the dark edge it needed. Jack came up with ideas at light speed and communicated them to us, and the session musicians efficiently. It was really amazing to listen to the songs bloom so organically. He'd throw us an idea, get our take on it and we built it from there. Being that we were a duo at the time, there was a lot of room for experimentation. It was great. We also added a third hidden track of me singing a Russian song, it came out haunting and ethereal.

Everyone was a pro, but really warm and down to earth. They made their contributions seem effortless, Jack could hum a part to Mark Watrous or Cory Younts and they'd be off! Jack Lawrence nailed the bass lines in a millisecond. It was awe inspiring really. Being that Jim's guitar style is pretty percussive, Jack didn't need to add much in the way of drums. He played a very dark driving circus oompa-pa type beat on "Uncle Andrei," that while minimal, was super effective. We heard him jam on the drums just for kicks though (see what I did there?) He is of course, amazing. Engineer Vance Powell was the coolest guy in the world to work with, too, cool and calm and always got the perfect take. It was a dream team, and a tough act to follow.

Our band definitely received a lot of attention following the single's release. It opened a lot of doors for us and we had a lot of great experiences as a result. I received a lot of messages from people in Ukraine, who were moved by "Uncle Andrei," especially since it incorporated a verse in Ukrainian. I got a lot of props for honoring a language that up until fairly recently, had been suppressed. One woman even told me it had her mother in tears.

It was an incredible experience making this record, not only for me and Jim as a band, but as family. Kind of like winning a golden ticket. Being able to play that record and fondly recall the time we had making it is really special.

DUNGEN

TMR-065

Based out of Stockholm, Sweden and lead by lyricist/songwriter Gustav Ejstes, Dungen is a highly-regarded psychedelic rock band who recorded their single in September 2010 on a day-off during their North American tour. The A-side title translates to "Eye, Nose, Mouth" and was performed by the band live on the Swedish national morning television show Nyhetsmorgon in January 2011. The B-side was originally titled "Chris Newmyer - Highway Wolf" in honor of the band's faithful tour manager, Chris Newmyer.

A SIDE: ÖGA, NÄSA, MUN
B SIDE: HIGHWAY WOLF

RELEASED: JANUARY 11, 2011

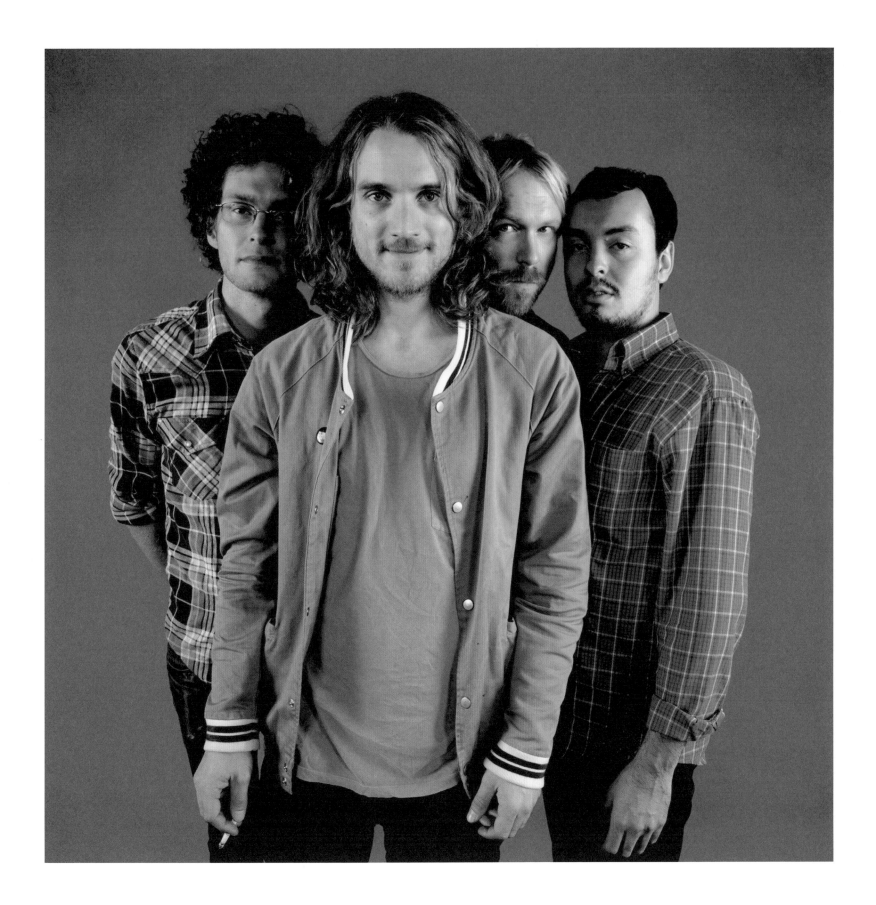

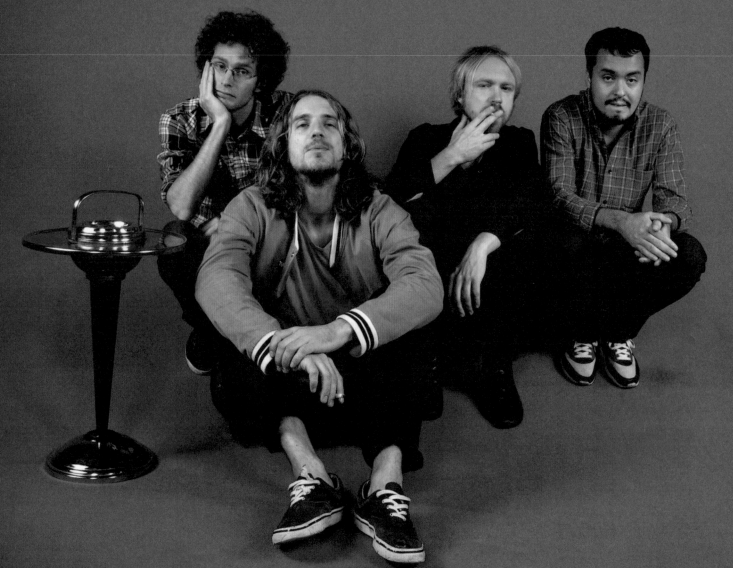

SIDE A ÖGA, NÄSA, MUN

DUNGEN

SIDE B HIGHWAY WOLF

PRODUCED BY JACK WHITE III
ÖGA, NÄSA, MUN WRITTEN BY G. EJSTES. HIGHWAY WOLF WRITTEN BY R. FISKE, J. HOMEGARD, M. GUSTAVSSON, G. EJSTES
RECORDED BY VANCE POWELL, ASSISTED BY MARK PETACCIA AT THIRD MAN STUDIO • MIXED BY VANCE POWELL
ASSISTED BY JOSHUA V. SMITH. DUNGEN ARE: LEAD VOCALS, KEYBOARDS, FLUTE: GUSTAV EJSTES
LEAD GUITAR, VOCALS: REINE FISKE • BASS, VOCALS: MATTIAS GUSTAVSSON • DRUMS, PERCUSSION: JOHAN HOLMEGARD
DESIGN BY MILES JOHNSON • PHOTOGRAPHY BY JO McCAUGHEY. ℗ & © 2010 THIRD MAN RECORDS, LLC
623 7TH AVENUE SOUTH, NASHVILLE, TN. UNAUTHORIZED DUPLICATION OF THIS RECORDING IS PROHIBITED
THIRDMANRECORDS.COM • DUNGEN-MUSIC.COM

TMRO65

"Later he took us in his white Cadillac to get burgers at this drive-in along the road. Unreal. I actually found a Costa-Rican one hundred dollar bill on the car-floor in the back that I took as a souvenir. Sorry, Jack."

BEN BLACKWELL: How were you asked to record a Blue Series single? Were you surprised?

REINE FISKE: I don't remember, but it must have been through either *Mexican Summer* or *Subliminal Sounds* of course. I was thrilled. This meant that Jack White himself must be sort-of-a fan of Dungen, and that is a lot of fun.

MATTIAS GUSTAVSSON: The first I remember hearing about it, was from our tour manager Chris Newmyer (aka Highway Wolf himself) when we were already on tour, but I have no idea who originally contacted who. We had a day off that fit perfectly in the area of Jack's home studio, so we set it up for that day. So many unexpected things happen when you are on tour, so I honestly can't say I was surprised. (And that leads me to your next question.)

BLACKWELL: Were you previously aware of Third Man? Any thoughts about Third Man in general? Or even Jack?

FISKE: I knew about his label and his passion for the vintage ways of producing records. Apart from that, I had only heard the occasional White Stripes song, really. When Jack took us to the offices it was amazing to see the concept behind the whole label. We had some whiskey and had our picture taken for the cover. Later he took us in his white Cadillac to get burgers at this drive-in along the road. Unreal. I actually found a Costa-Rican one hundred dollar bill on the car-floor in the back that I took as a souvenir. Sorry, Jack — couldn't help it.

GUSTAVSSON: I wasn't aware of Third Man, or Blue Series, and had never even really listened much to Jack's music. And I don't think anybody else in Dungen had either. That baffled our tour manager of course, and he had to explain how awesome this whole thing was. Haha!

BLACKWELL: What was the feeling while recording in the studio? How would you explain "Highway Wolf"? What does "Öga näsa mun" translate to?

FISKE: Getting to the studio was sort of exotic, just us in the van as usual but this was totally different of course. It took a while before we could enter the studio so there was a bit of tension built up before we actually entered the premises and Jack's house. When he showed up he was, in our eyes, like taken out of a White Stripes video; what was so great was that he was such a sweet guy, he really made us feel secure and like fellow-musicians. The studio wasn't big, but it was perfect and all the gear was sort of special. Everything down to the smallest patch-cable was red, white or black. I played through an old Selmer-amp that sounded incredible — so powerful. Since we got a bit confused by what to actually record, I came up with the idea of recording "Öga, Näsa, Mun" ("Eyes, Nose, Mouth"). I don't know why. I remember we had a hard time in starting something. Maybe there was a furious jam going on, but I think Jack wanted to find something that was typical "Dungen-music." We had tried to play the song live at times, and I still think it's one of Gustav's most amazing songs. I just dropped the idea into thin (or thick actually) air, and suddenly we were struggling with this old song. It was originally intended for the *Ta det lugnt* album but was left out. I actually feel a bit bad about "forcing" Gustav into doing the song; I think Gustav thought I "took over" his role a bit, but something just had to happen.. "Highway Wolf" that ended up on the B-side was done the day after because we stayed up until 5 in the morning. Our tour manager Chris Newmeyer (aka "Highway Wolf") was sleeping in a stool outside the studio. So when the vocals were done, I actually think the song lost its original power a bit, because it sounded so heavy in the control-room. I've never experienced such volume in a control-room before. I think Jack had PA-monitors in the roof or something. I think everyone was getting a bit dozed up and tired by that time.

GUSTAVSSON: I remember Gustav wanted us to just improvise something for the flip side, and as we had set up our instruments and amps in the studio we just started playing, trying out our sounds, getting comfortable with the monitoring and what not, like we usually do, and that jam grew into one of those that just takes off and you lose track of time and space. And as we silenced Jack's voice came in the earphones: "That's great! We're ready for recording whenever you are." The actual recording (Highway Wolf, that is) was nowhere near as good.

"Öga, Näsa, Mun" literally translates to "Eye Nose Mouth," but it's really a department in the Swedish health care system, although in the song, I think Gustav used it for its phonetic poetic qualities more than any sensible meaning. But what do I know? In the end, that part of the song isn't even in there anymore, right?

BLACKWELL: Did Jack impart any insightful knowledge or advice in the session? What was your impression of him as a producer?

FISKE: He had an awesome amount of good energy, and his engineer was really working hard to keep up with the pace. I had some ideas on sounds and Jack seemed to be on the same level there.

GUSTAVSSON: Jack was a rather humble quiet guy. He mostly let us do what we do, as I remember it. I really like the end result, so I guess that makes him a good producer.

BLACKWELL: What did you think about the studio space, the equipment used, the vibe in the room? Inviting? Cold? None of the above?

GUSTAVSSON: The studio was amazing! I have never been a gear guy, but all the equipment sounded great, everything was in excellent condition and the sound was top notch. But I was really blown away by the red/white/black color theme. I mean, there wasn't a cable or pick or anything that was off color wise. Major OCD heaven!

BLACKWELL: Did you notice any newfound attention after releasing a record on Third Man? Did it help you out at all in your career?

FISKE: I haven't got a clue. I got a copy of it, that's all. There was something written about the whole thing of course — some journalists asked us about the session and so on. David Fricke mentioned it of course, which was great.

GUSTAVSSON: It's hard to measure the effect of whatever different moves you do in your career, but it's of course a very impressive feather in your hat to have been recorded by Jack White. We did get to perform the song on national TV back in Sweden when it was released, and that is pretty big. But the fact that it was only released on 7" made it a somewhat instant rare gem among the already in-the-know crowd.

BLACKWELL: David Fricke was in the room for part of the session. How cool was that? He seems like a big fan. Had you met before? Impressions of him?

FISKE: We, or I, had met him before actually. Suddenly he was just there — I wonder what he thought about us, really. He seems to be a very nice and cool person.

GUSTAVSSON: That was of course a slightly unbelievable honor! I don't remember meeting him before, but I have the memory of a goldfish when it comes to brief encounters so I can't be trusted.

BLACKWELL: What was your main takeaway from the session and subsequent release?

FISKE: Well, I felt personally privileged to be there. It was a very pleasant but also difficult session in a way. It's something to look back on. The nice thing is that Jack came to Detroit later on the same U.S tour (our longest tour there ever — 7 weeks) because his mother just turned 80 years old. I heard he has a lot of siblings. It would be nice to meet him again.

GUSTAVSSON: My main take away from this session may sound strange. When the basic tracks had been laid down and it was time for Gustav to record vocals, Jack took me to the pool house, which was full of more classic pinball machines than any pinball player could ever wish for. For free! I used to spend hours every day playing pinball when I was younger. I have probably spent more hours playing pinball than I have playing music! So had we not been on tour, I would probably have overstayed my welcome and, to this day, still be found playing *Scared Stiff* in that pool house.

FIRST AID KIT

TMR-074

Sisters Klara and Johanna Söderberg came to notice in 2008 when they posted a video of themselves on YouTube covering the Fleet Foxes' "Tiger Mountain Peasant Song." Hailing from Enskede, Sweden, the sisters cover the 1964 Buffy Sainte-Marie anti-war song "Universal Soldier," popularized by folk singer Donovan's cover in 1965, which hit #53 on the Billboard Charts. The B-side "It Hurts Me Too" is based on the Elmore James version of the blues standard originally penned by Tampa Red. Both songs feature an appearance by their father, Benkt Söderberg. The band would open select tour dates for Jack White in Europe in 2012 and covered his song "Love Interruption" for Australian radio station Triple J's "Like a Version" series in 2014.

A SIDE: UNIVERSAL SOLDIER
B SIDE: IT HURTS ME TOO

RELEASED: JANUARY 18, 2011

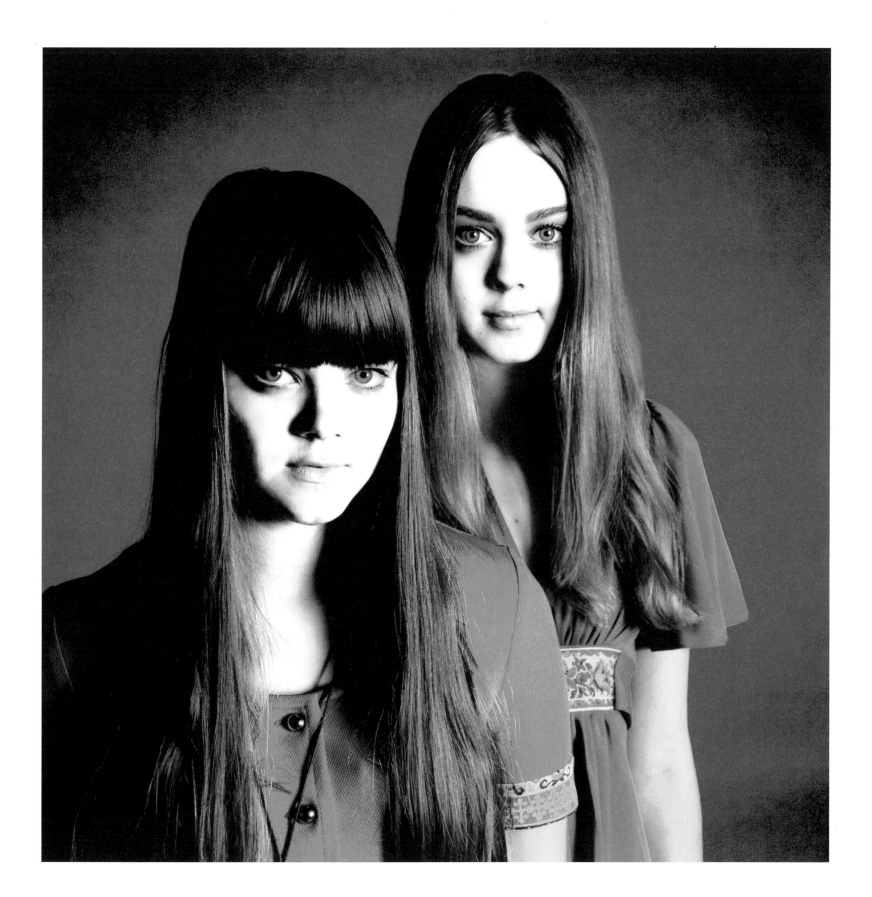

FIRST AID KIT

SIDE A UNIVERSAL SOLDIER IT HURTS ME TOO SIDE B

PRODUCED BY JACK WHITE III

FIRST AID KIT ARE...
JOHANNA SÖDERBERG & KLARA SÖDERBERG

"UNIVERSAL SOLDIER"
WRITTEN BY BUFFY SAINTE-MARIE
(ALMO MUSIC CORP (ASCAP))

JOHANNA SÖDERBERG - VOCALS
KLARA SÖDERBERG - VOCALS
JOSHUA HEDLEY - FIDDLE
BENKT SÖDERBERG - GUITAR

"IT HURTS ME TOO"
WRITTEN BY MELVIN LONDON
(CONRAD MUSIC/LONMEL PUBLISHING INC (BMI))

JOHANNA SÖDERBERG - VOCALS, AUTOHARP
KLARA SÖDERBERG - VOCALS, GUITAR
JACK LAWRENCE - BASS
JOSHUA HEDLEY - FIDDLE
FATS KAPLAN - STEEL GUITAR
MATTIAS BERGQVIST - DRUMS
BENKT SÖDERBERG - MARACAS

RECORDED BY VANCE POWELL ASSISTED BY JOSHUA V. SMITH
AT THIRD MAN STUDIO, NASHVILLE TN
MIXED BY VANCE POWELL ASSISTED BY JOSHUA V. SMITH
FIRST AID KIT APPEAR COURTESY OF
WICHITA RECORDINGS

PHOTOGRAPHY BY JO McCAUGHEY
DESIGN BY MILES JOHNSON

℗&© 2010 THIRD MAN RECORDS, LLC
623 7TH AVENUE SOUTH, NASHVILLE, TN 37203
UNAUTHORIZED DUPLICATION OF THIS
RECORDING IS PROHIBITED
THIRDMANRECORDS.COM THISISFIRSTAIDKIT.COM

TMR074

"We're passionate about the roots of country music, we can get really nerdy about the Carter Family and The Louvin Brothers. There's a magic there that's almost impossible to re-create, but we like to try."

A few words from **KLARA SÖDERBERG** & **JOHANNA SÖDERBERG**

It was in October 2010 — at the time we had just released our first record and started touring the US. We had a tiny club show scheduled in Nashville at a venue called The End, and we were recording a session during the day for some website. In the middle of our shoot Klara got a surprise call from Jack White. She couldn't believe he was calling, we had no idea he'd ever heard of us. He asked us if we could record a Blue Series single the next day. Of course we wanted to! We were screaming for joy afterwards and psyched to go into the studio.

We'd been big fans of Jack and his work for a long time. We'd heard of the Blue Series before, but not listened to any of the singles. Earlier on the tour we met our Swedish friends in the band Dungen. They told us they had just recorded at Third Man and raved about how amazing it was. We were a little jealous and never thought we'd end up doing it as well!

It turned out to be the first recording we ever did in a "proper" studio. All our early stuff was recorded at home, with basically a computer and a mic, in my bedroom. So maybe you can imagine how grand and exciting it was to us to step into the Third Man studio. It was surreal and it almost seems like a dream to us now. We remember all the strong colors, the crazy taxidermy animals, all the old equipment and strange little trinkets here and there. It was as much a visual experience as a musical one, overwhelming in every sense. When we told Jack it was our first studio experience, he said "Well, it's all downhill from here!" and maybe he was right, haha.

The entire recording was a very quick and intense affair. We picked the two songs in the moment. Nothing was prepared, as we found out about it all a day before. Everything was done so fast. Jack was just like "let's try this! and this! and what about this?" and then it all worked out instantly. I don't think we've ever had so much fun while recording. The atmosphere was very inviting and casual.

We'd been performing the Buffy Saint-Marie song for a while live and had longed to do a real recording of it. The song is so darn powerful. Even though it was written in the sixties the message still rings true, which is unfortunate. That's why we changed the lyrics to fit more into the current political situation. We want to pass on the message to a younger generation. We try not to shy away from taking a political stance. We're definitely pacifist and anti-war. Today when there's this scary wide-spread racism everywhere, amongst big popular political parties, it's important to point out that the soldiers everywhere are the same. They're all spreading some kind of hate, all doing the same terrible deed for an oppressive regime.

More about the recording, we think we share an immense love for old music with Jack. We're passionate about the roots of country music, we can get really nerdy about the Carter Family and The Louvin Brothers. There's a magic there that's almost impossible to re-create, but we like to try.

The session players were incredible, too, and it was an honor to play with them. We loved playing with Fats Kaplin on "It Hurts Me Too," his pedal steel work is amazing. We got goosebumps continuously throughout that day listening to him play. We also remember how excited Joshua Hedley, who played fiddle, got when we plugged his fiddle into an amp on "It Hurts Me Too." It gave his instrument the craziest, coolest new sound.

We were very inspired by the session and in hindsight we learnt a lot from it. Of course just to get Jack's approval was big. But more importantly we also got to try a new, edgier and more raw sound. That influenced us to get out of our comfort zone a little bit more in our later records. We still listen to the single a lot, we think it's one of the best things we've done, so far. That record was a huge deal for us. It was early in our career, and we were just trying to get our music out there. A lot of people who'd probably never listened to us if it wasn't for Third Man found out about the single.

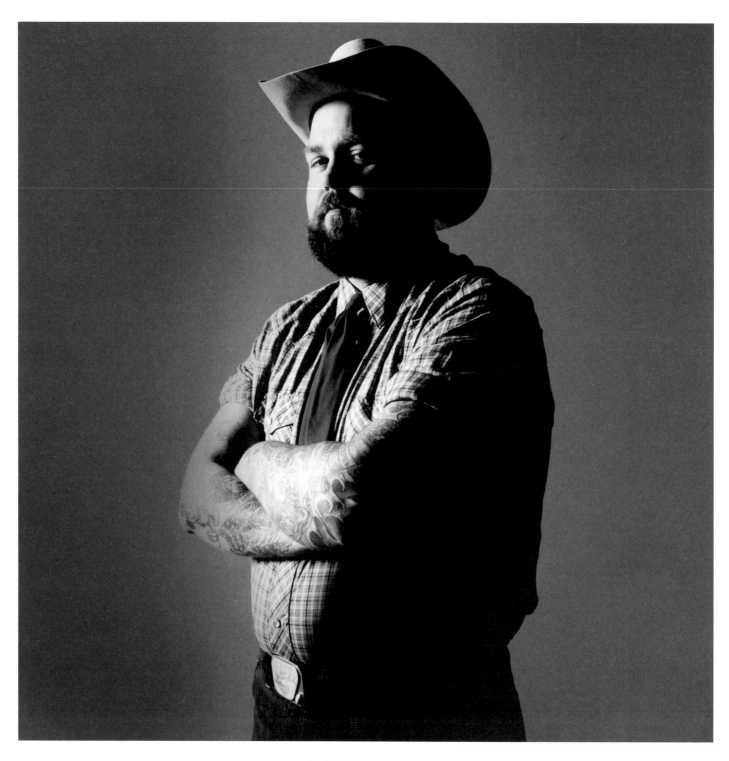

JOSHUA HEDLEY

TMR
074

the 5.6.7.8's

TMR-075

The 5.6.7.8's are best-known as the Japanese girl garage band featured in Quentin Tarantino's "Kill Bill Vol. 1" where they perform a cover of the song "Woo-Hoo." Jack White has long been a fan of the band, performing their song "I Walk Like Jayne Mansfield" live in The White Stripes, who's first-ever small club gig in Japan in 2000 was opening for the 5.6.7.8's. The recording of this single coincided with the band's live performance in the Third Man Blue Room on October 22nd, 2010, which coincided with Third Man's reissue of their self-titled LP from 1994. "Sho-Jo-Ji" is derived from the Japanese folk song "Shojoji No Tanuki Bayashi" which translates to "Racoon Dogs Dancing at the Shojo Temple." The use of the Bo Diddley beat is a welcome addition. The flipside "Charumera Sobaya" is about the popular Japanese dish soba noodles and a version is also included on their live LP on Third Man.

A SIDE: SHO-JO-JI (THE HUNGRY RACCOON)
B SIDE: CHARUMERA SOBAYA (THE SOBA SONG)

RELEASED: MARCH 1, 2011

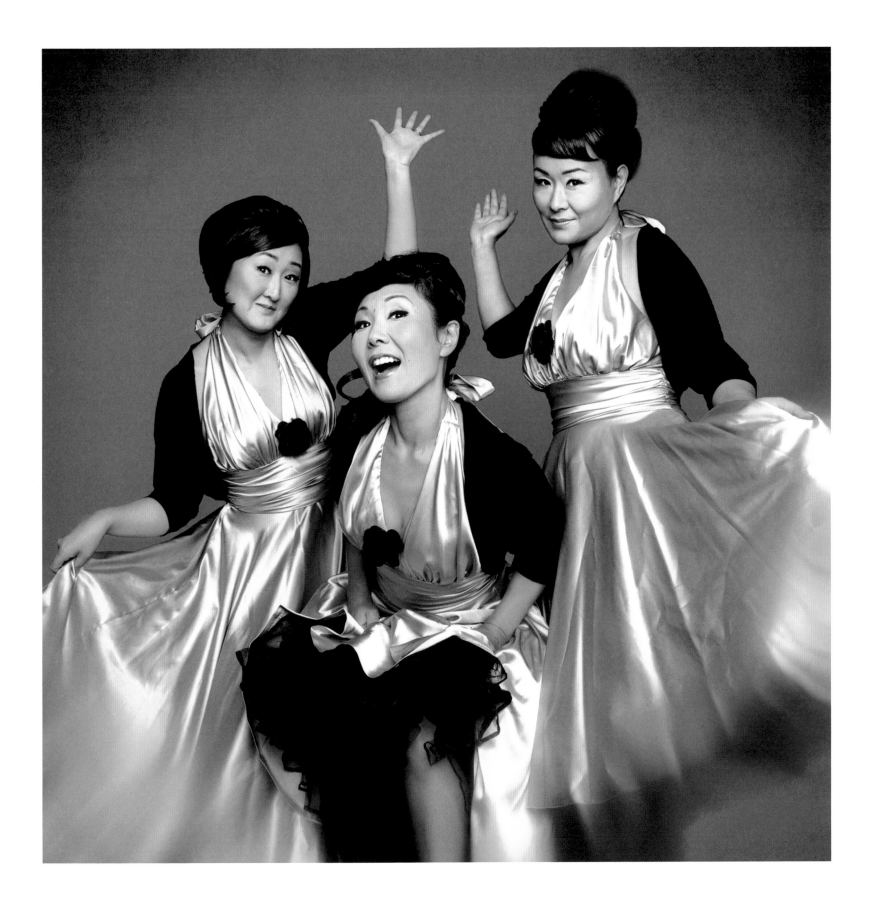

the 5.6.7.8's

SIDE A

証城寺の狸囃子
SHO-JO-JI
(THE HUNGRY RACOON)

SIDE B

チャルメラそば屋
CHARUMERA SOBAYA
(THE SOBA SONG)

• Produced by Jack White III • Recorded by Joshua V. Smith at Third Man Studio, Nashville TN • Assistant Engineer: Kazuri Arai • Mixed by Vance Powell and Jack White III at Third Man Studio, Nashville, TN • "Sho-Jo-Ji" by Ujoh Noguchi and Shinpei Nakayama • Yoshiko Ronnie Fujiyama - guitar, vocals. Omo The Screaming Chellio Panther - bass, backing vocals, percussion. Sachiko The Geisha Girl - drums, percussion, backing vocals. Mabo The 88 and Baby Racoon - backing vocals • "Charumera Sobaya (a.k.a. The Soba Song)" (Robert Norton) Peer International Corp. (BMI) • Yoshiko Ronnie Fujiyama - guitar, vocals. Omo The Screaming Chellio Panther - bass. Sachiko The Geisha Girl - drums. Mabo The 88 - steel guitar.

TMRO75

"We wanted to record Japanese folk songs, and Japanese post-war music in Nashville."

(TRANSLATED FROM JAPANESE)

BEN BLACKWELL: How were you asked to record a Blue Series single? Were you surprised?

RONNIE YOSHIKO FUJIYAMA: We had a reunion with Jack at a concert venue in Tokyo. Dale Hawkins had just passed, and we introduced Japanese rock legends SHEENA and Makoto Ayukawa to Jack. We had quite some fun, 20 minutes of "Susie-Q," and a session. Jack mentioned to us that he had established a studio in Nashville, and he invited us to visit ... we didn't actually think we would be recording at the studio at the time, but lo-and-behold, we ended up in Nashville recording this Blue Series record.

BLACKWELL: Were you previously aware of any Blue Series records before being asked to record? Any stick out to you as being favorites? Any you hate? Any thoughts about Third Man in general? Or even Jack?

SACHIKO FUJII: I have a collection, all unopened, including Brittnay Howard & Ruby Amanfu, First Aid Kit, Wanda Jackson. Dex Romweber Duo ... etc. We love Third Man ... it's like a secret hideout/fort consisting of Jack and his wonderful friends ... and we love that friendly, open environment.

BLACKWELL: What was the feeling while recording in the studio? How do you decide which songs to record? Are both of these songs considered folk or traditional music in Japan?

YOSHIKO: We wanted to record Japanese folk songs, and Japanese post-war music in Nashville. It was pretty nerve wracking, but Jack was super supportive, and there were children, and it was a lot of fun.

BLACKWELL: Did Jack impart any insightful knowledge or advice in the session? What was your impression of him as a producer?

AKIKO OMO: Jack made sure we were comfortable and relaxed during the session (although we were all super anxious and nervous). He took note of our style and incorporated it into the production, and we had a lot of fun during the session.

BLACKWELL: What did you think about the studio space, the equipment used, the vibe in the room? Inviting? Cold? None of the above?

OMO: There were so many pieces of vintage equipment, and the interior design was fantastic. There was enough space to comfortably spread out and perform. The studio is surrounded by nature, and we were able to enjoy the outdoors during breaks as well.

BLACKWELL: I can't remember ... is Baby Raccoon your daughter? Did she seem to enjoy her time during the recording?

YOSHIKO: My daughter listened to our record ... and she was surprised hearing her voice. She doesn't remember the recording session too well, but it was definitely a magical time for her, being away from Tokyo and in another country. We felt like we were invited to the residence of a wizard.

BLACKWELL: Did you notice any newfound attention after releasing a record on Third Man? Did it help you out at all in your career? Impressions of the TMR single from fans of yours?

SACHIKO: Not so much in Japan, but we've been grateful that our music can be distributed/shared with more fans.

BLACKWELL: What was your main takeaway from the session and subsequent release?

OMO: It was a very condensed schedule, but we were able to relax, enjoy the city, enjoy the outdoors and studio session, and we also enjoyed Jack's presence. We were able to feel relaxed, and it was a great experience.

BLACKWELL: Your Blue Series single is unique because you also recorded a live album AND a fan club single at the same time, in addition to Third Man reissuing your self-titled album. The 5.6.7.8's are one of the most-released artists on Third Man. How does that feel?

YOSHIKO: We're grateful to be associated with such a wonderful label. We may not have performed our best, but all-in-all was a very good experience.

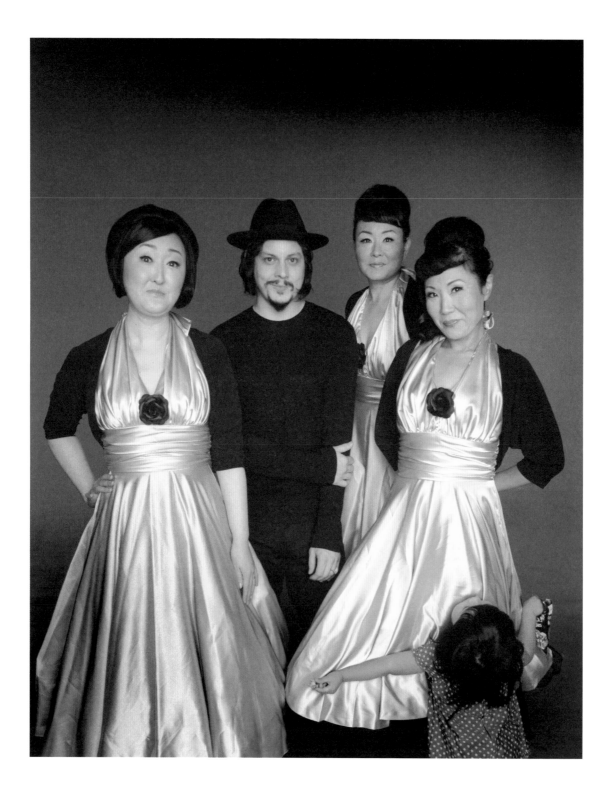

TMR
075

POKEY LAFARGE

TMR-082

Born Andrew Heissler and living his early years in Bloomington/Normal, Illinois, the name Pokey LaFarge would emerge with residency in St. Louis, Missouri and help mold the performer as featured on this single. Said to be derived somewhat from "St. James Infirmary Blues," the song "Chittlin'..." is originally written by Arthur Smith and was performed by LaFarge on April 20th, 2011 on Music City Roots, Nashville's acclaimed roots and Americana variety show broadcast on both radio and television. The back cover photo of this single was shot in what was then Third Man Records' design office, utilizing an applique photo of a band labeled "The Syncopators" in between the bodies of LaFarge and his bandmates. As of 2015, what used to be the design office is now a third room in the Third Man Records storefront, featuring the Monkey Band, a listening booth and other delights for discerning aesthetes. LaFarge and band would go on to support Jack White opening for his 2012 North American tour dates, being featured on White's song "I Guess I Should Go to Sleep" from his "Blunderbuss" album and performing the White-penned "Red Theater of the Absurd" in the 2013 film *The Lone Ranger* in which the band also makes an appearance.

A SIDE: CHITTLIN' COOKIN' TIME IN CHEATHAM COUNTY
B SIDE: PACK IT UP

RELEASED: MARCH 24, 2011

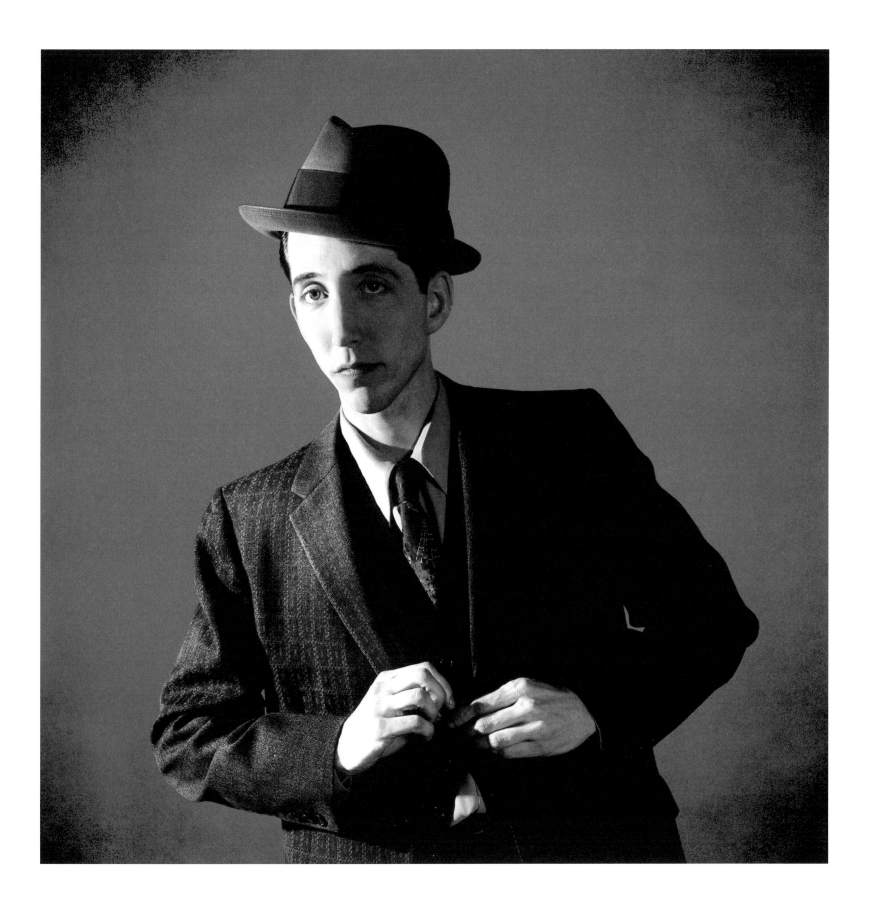

POKEY LAFARGE

AND THE SOUTH CITY THREE

SIDE A: CHITTLIN' COOKIN' TIME IN CHEATHAM COUNTY SIDE B: PACK IT UP

PRODUCED BY JACK WHITE III • RECORDED BY VANCE POWELL AT THIRD MAN STUDIO, NASHVILLE TN • ASSISTANT ENGINEER: JOSHUA V. SMITH • MIXED BY VANCE POWELL AND JACK WHITE III AT THIRD MAN STUDIO, NASHVILLE, TN

"CHITTLIN' COOKIN' TIME IN CHEATHAM COUNTY" BY ARTHUR SMITH, BERWICK MUSIC CORP (BMI) ARRANGEMENT BY POKEY LAFARGE AND JACK WHITE. POKEY LAFARGE - VOCALS, GUITAR. ADAM HOSKINS - GUITAR, BACKING VOCALS.

RYAN KOENIG - HARMONICA, BACKING VOCALS. JOEY GLYNN - UPRIGHT BASS. JUSTIN CARPENTER - PIANO. KEITH SMITH - FLUGELHORN. CHRIS GREGG - CLARINET. PATRICK KEELER - DRUMS.

"PACK IT UP" BY POKEY LAFARGE . POKEY LAFARGE - VOCALS, GUITAR. ADAM HOSKINS - GUITAR, BACKING VOCALS. RYAN KOENIG - PERCUSSION, BACKING VOCALS. JOEY GLYNN - UPRIGHT BASS. • PHOTOGRAPHY BY JO MCCAUGHEY

MANUFACTURED AT UNITED RECORD PRESSING IN NASHVILLE, TN • ©2011 THIRD MAN RECORDS, LLC. 623 7TH AVENUE SOUTH, NASHVILLE, TN 37203

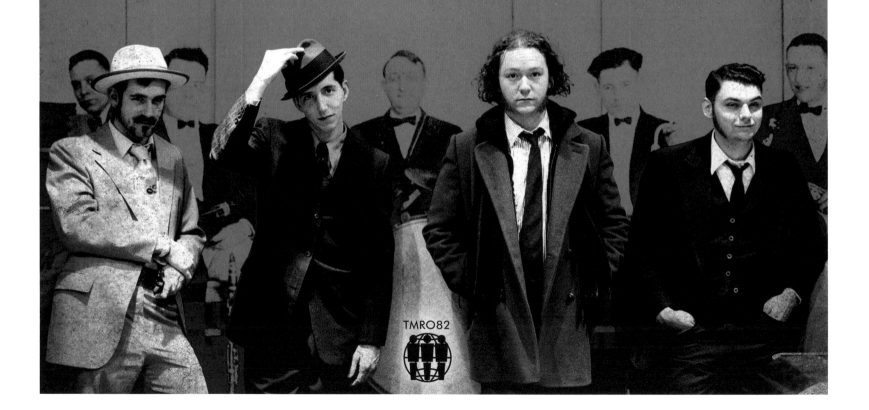

TMR082

"I think it may have even been the first drum machine ever. It was just a fucking box that you programmed by playing and recording the drums yourself."

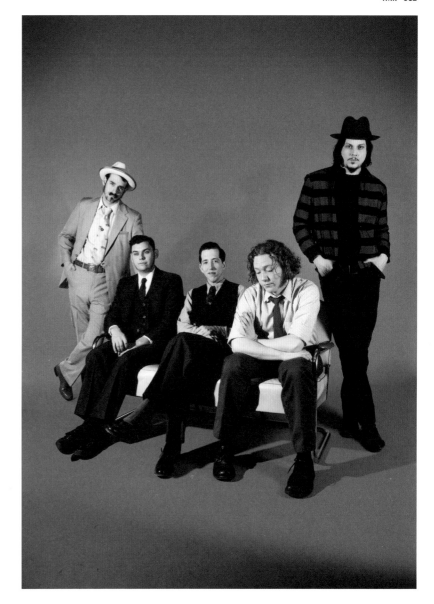

BEN BLACKWELL: How were you asked to record a Blue Series single? Were you surprised?

POKEY LAFARGE: Well, it was funny, because Jack just straight up called me on my cell phone. It was really shocking. Hell, he doesn't even own a cell phone. Of course, I didn't know that then. Anyway, he called me up and asked would me and the South City Three (my backing band at the time) come down to Nashville to record two songs for a 45rpm release on Third Man Record's Blue Series. Jack said that he had heard a song of ours "Sweet Potato Blues" on WSM during a Thanksgiving-themed broadcast. He said he liked my voice. I believe our song had just followed a Bob Wills tune called "Tater Pie." Of course, he hates my guts now, but hey, at least, I have the memories of the good ole days.

BLACKWELL: Were you previously aware of any Blue Series records before being asked to record? Any stick out to you as being favorites? Any you hate? Any thoughts about Third Man in general? Or even Jack?

LAFARGE: Yeah, what's that weird band [Drakkar Sauna — Ed] from Lawrence, KS, you know the one with the accordion in it? I remember that we were fairly early on in the Blue Series world. Subsequent releases that I have enjoyed are Margo Price, Lillie Mae Rische, Tom Jones, and Beck, to name a few. But I want to say that Third Man and Jack White mean the world to me. I owe them a lot for where I am today — no bullshit. It opened a lot of people's eyes up to me, like it has done for so many artists. It made my family proud. Jack has become a friend, a confidant. I think I'll ask him to deliver my first born child. He seems to be good at that kinda thing.

BLACKWELL: What was the feeling while recording in the studio? How do you decide which songs to record?

LAFARGE: That was so early on. I feel like I didn't really know shit. Plus, Jack is a towering figure. I'm miniature, kinda like a Shetland Pony. Anyway, all the red and white everywhere, and all the gadgets and doo-dads. It was intimidating. We got some good work done though. It was virtually painless. Hell, it was even inspiring. Actually, a funny thing too, it was the first time I ever played with a drummer.

BLACKWELL: Did Jack impart any insightful knowledge or advice in the session? What was your impression of him as a producer?

LAFARGE: Well, I remember that Jill brought us coffee and then I think Jack poured us all shots of high-end tequila. Then it was on. We played him the songs that we had and he picked two out. I thought the arrangement he did for "Chittlin' Cookin Time in Cheatham County" was cool in a fucked up kinda way. It made the song. He sorta came up with it on the spot and flipped the tune on its head. I thought that was impressive. It was also the first time I had worked with a producer so I'd like to think that the incredibly positive experience I had that day, with Jack producing, has carried into every session I've done since.

BLACKWELL: What did you think about the studio space, the equipment used, the vibe in the room? Inviting? Cold? None of the above?

LAFARGE: If I had to describe the room, I'd say that it was a red and white colored sound laboratory filled with antique sound equipment. Cables were seemingly coming out of nowhere. I mean there were all kinds of gear I had never heard of at the time. It was the first time I had ever seen an analog drum machine. I think it may have even been the first drum machine ever. It was just a fucking box that you programmed by playing and recording the drums yourself. It had a tape machine inside. But we really loved the vibe. Vance, the engineer, and Josh, the engineer's assistant, are two of the sweetest people. I think Jack only hires people with beards.

BLACKWELL: Did you notice any newfound attention after releasing a record on Third Man? Did it help you? Maybe it hurt?

LAFARGE: Definitely. Soon after we opened 16 shows for Jack on the Blunderbuss tour. Then we played the Jools Holland Hootenanny. Then we released a full length record on Third Man. So much has happened since, but I know for a fact that because of WSM 650am, then Jack calling me up, and the recording of the Blue Series single with Third Man was the catalyst.

BLACKWELL: What was your main takeaway from the session and subsequent release?

LAFARGE: Well, I can't speak for my band, but I have to say, there was quite a lot of validation that we belonged in the "scene" or whatever at the time. It gave me the confidence to say,"Shoot man, if Jack and his team believe in us then we can do anything." Kind of a "fuck the haters" kinda thing. Kinda felt like we made it. But also we were grateful for the fact that we had made it and yet there was so many other great musicians that deserved to have the spotlight too.

CHRIS THILE & MICHAEL DAVES

TMR-083

Guitarist Daves and mandolin virtuoso Thile first met in New York City at a bluegrass jam at the Baggott Inn. The two paired together well and continued to play long after everyone else had left. Two years later Thile moved to NYC and started regularly attending the jam where he and Daves first met. The two were inspired to record and reached out to Jack White to produce. In addition to the two songs released in the Blue Series, the duo recorded covers of an additional sixteen traditional and classic bluegrass songs at Third Man Studio and released them on Nonesuch Records as the album *Sleep With One Eye Open.*

A SIDE: MAN IN THE MIDDLE
B SIDE: BLUE NIGHT

RELEASED: MAY 24, 2011

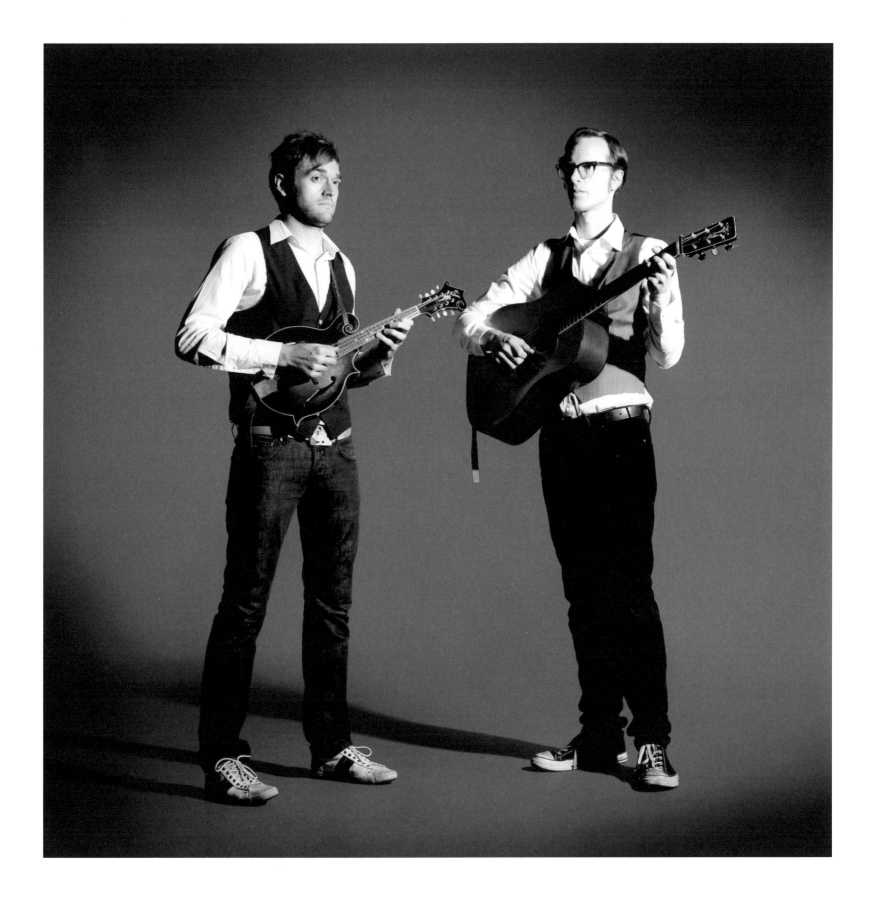

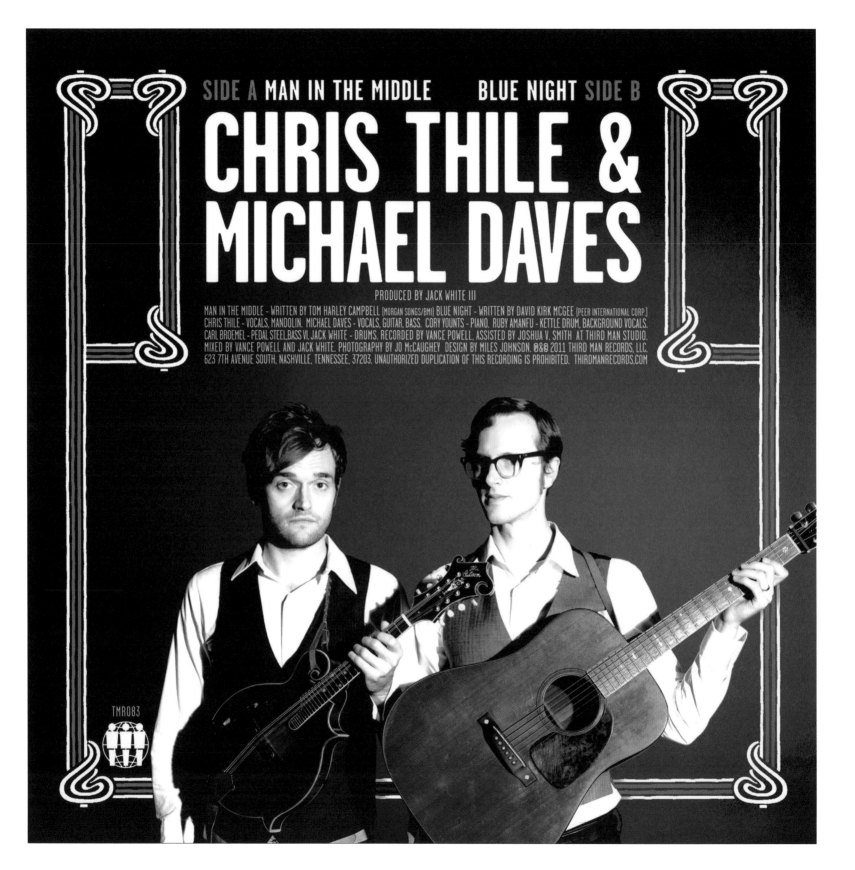

SIDE A MAN IN THE MIDDLE BLUE NIGHT SIDE B

CHRIS THILE &
MICHAEL DAVES

PRODUCED BY JACK WHITE III

MAN IN THE MIDDLE - WRITTEN BY TOM HARLEY CAMPBELL (MORGAN SONGS/BMI) BLUE NIGHT - WRITTEN BY DAVID KIRK MCGEE (PEER INTERNATIONAL CORP.)
CHRIS THILE - VOCALS, MANDOLIN. MICHAEL DAVES - VOCALS, GUITAR, BASS. CORY YOUNTS - PIANO. RUBY AMANFU - KETTLE DRUM, BACKGROUND VOCALS.
CARL BROEMEL - PEDAL STEEL.BASS VI. JACK WHITE - DRUMS. RECORDED BY VANCE POWELL, ASSISTED BY JOSHUA V. SMITH AT THIRD MAN STUDIO.
MIXED BY VANCE POWELL AND JACK WHITE. PHOTOGRAPHY BY JO McCAUGHEY DESIGN BY MILES JOHNSON. ℗&© 2011 THIRD MAN RECORDS, LLC.
623 7TH AVENUE SOUTH, NASHVILLE, TENNESSEE, 37203. UNAUTHORIZED DUPLICATION OF THIS RECORDING IS PROHIBITED. THIRDMANRECORDS.COM

TMR083

"It felt volcanic. It felt like this beautiful — and I mean volcanic-like instability to the creative process that is intoxicating."

BEN BLACKWELL: How did you get asked to do the Blue Series single?

CHRIS THILE: I was working on a project with a buddy of mine, Michael Daves, and by working on it, we basically had gotten together for years in New York and played bluegrass kinda as fast and loud and high as we could. Which was great, I was working on getting Punch Brothers off the ground. And Punch Brothers started as a fairly cerebral project, and certainly intricate, a lot of moving parts. And Michael and I would get together after days spent working on all this crazy Punch Brothers music, get together in Greenwich Village and have a few stouts and just play some bluegrass music but with this kinda lower Manhattan grit and urgency, and my record company president Bob Hurwitz had come to a few of these things, and every now and then I'd sit in with Michael at his open mic at the Rockwood on the Lower East Side and we'd have so much fun. Hurwitz said, "You really oughta record this, you could just do it, you could do it so quick, you guys just kinda step up there and seemingly just kinda turn it on." And so I got to thinking about that and talked to Michael and we made a demo of some of the things, it just didn't sound like anything yet. I got to thinking about the rawness of some of Jack's [White] work, like man I wish we could kinda, appropriate some of that feeling of sound, with how it felt to play it, and I just wasn't hearing it come out of the speakers yet. And so I forget ... Bob Hurwitz gave me Jack's email, because he had spoken to Jack at one point about me and what I was up to. A long time ago — Punch Brothers did a cover of Jack's song "Dead Leaves and the Dirty Ground" [The White Stripes]. So I think Jack was aware of that and liked the cover and gave Hurwitz permission to give me his [Jack's] email. And he wrote back and said, "You know man, I got so much going on but this is interesting to me, what if I produced a single for you, you know the Blue Series single. You guys can just kinda stay set up in my studio with my engineer and I'll pop in and out, I don't really have time to produce, but kinda let

me send you guys off in style, like kinda set you up in style." And that was the best of all possible solutions to me because really the idea of having a producer on a project like that with music that both of us have grown up with didn't seem like it made perfect sense, so doing the Blue Series single almost, that was like Jack winding us up and letting us go. And that's how it seemed to happen.

BLACKWELL: That's great. Were you aware of the Blue Series prior to any of that, or was that kind of an introduction for you when Jack brought it up?

THILE: The Series was new to me, but that Jack was doing amazing vinyl work was not new to me. And you know he's so focused on all this analog gear and putting out vinyl and even the textual aesthetic that he would work in — its evergreen in his hands — it's all like it was the first time, like this is the latest, greatest technology and it may not be the latest but arguably it is still the greatest. He makes a very strong case for that. And so I feel a kinship with that activity seeing that here I am kinda on the acoustic side of things, not because I necessarily prefer acoustic, it's what I know and what I feel comfortable wielding. It can seem backwards looking, but to me, it's by no means a "throwback." Working with acoustic instruments is not necessarily the work of a curator, it can be the work of a creator, and so I found Jack immensely inspiring on that front, he takes a thing that is ostensibly old and is making new things with it. And that's what I'm trying to do in the acoustic world. So to get to be around him for that week or so in Nashville at his studio was a gift. So instructive, informative, getting to see him at work — I've taken what I've learned from that week with me everywhere I go.

BLACKWELL: Nice, that is very well put. So you have that unique experience where you recorded your Blue Series there, but then at the same time, you essentially recorded an album too. So I don't know if this idea is exclusive to the single that you did, or if it spans across to the album as well, how did you feel in the studio? What was that feeling? How would you describe that?

THILE: It felt volcanic. It felt like this beautiful — and I mean volcanic-like instability to the creative process that is intoxicating. And Jack courts that, I would say, he courts that kinda volcanic creative instability where there are chipping sands, the ground is rumbling, and you don't know what's about to burst up through the soil. Then all of a sudden there are all these fountains of sound erupting from nowhere. And that's what it feels like to be in the studio with him. We took two of the songs that we were planning on recording for the record, we were just showing him a bunch of stuff and he was like, "Oh man I really dig that." There's this "Three Men on a Mountain" song, I guess I've always called it "Three Men on a Mountain" but I guess the official name of the song is "The Man in the Middle." But I think Jack instantly took to the lyrics, what with Third Man, and the chorus is "three men on the mountain." So it was that one and "Blue Night" and I think he

RUBY AMANFU

really dug both of them, and next thing you know we start playing it and he goes, "Hey, let me come in there and try something." He gets behind the drum kit and starts laying down the sickest groove, which just eggs Michael and I on, and we just kinda started playing harder, getting nasty with it man. It's this gospel song, you know basically it's an old American gospel song, Jesus is up on the cross and talking to the two other guys up there and kinda conceded their fate. There's this guy who is remorseful and there's this guy who isn't, so there's a lot of energy in the song regardless of what any of that kind of thing means to you. I have no idea what it means to me, it doesn't mean nothing though, it means something. You know, I was raised with all that, and then as I went out and started seeing the world I realized you know what, there are a lot of different ways one can go about being spiritual, including choosing not to be spiritual. And just meeting all these wonderful people who believed different things than I did it clearly changed the way I view things. And so when I sing a song like that, a gospel song, there's this double-edged quality to it where I am really fascinated by the existence of all this gospel music and how it was created and for what purpose it was created. Sometimes it's very noble, a noble directing of one's own fear, you know it takes a lot of strength to admit weakness and so I think in the studio with Jack, none of that was said, but he drew more conviction and more sincerity out of us with each move he made. So he gets behind the drums and he all of sudden will be like, "Hey Michael, why don't you lay down a bass track," and we had kind of a basic Third Master record — the two of us with Jack playing drums — and then he had Michael grab a bass and plugged it in and started messing with the sound. Every move, like an improv artist for instance, that rule of whatever someone improvs you will respond to yes. You would never say, "oh no, that's not what happened." In improv that's breaking the Golden Rule. You always say yes, and that's what we did that night in the studio. Then he called some friends of his into the studio, I know Ruby Amanfu came and sang with us, people from My Morning Jacket, who's name temporarily escapes me ...

BLACKWELL: Carl Broemel.

THILE: Yes, Carl! Carl, exactly. And god, it was just so fun. I think, did Carl play steel?

BLACKWELL: I think he's pedal steel.

BLACKWELL: I remember at one point I think it was my wife and I, we're transplants to Nashville, we're from Detroit, and walking by the Ryman and there's the plaque on the building that says, "This location blah blah blah, Bill Monroe credited with creating bluegrass music" and I remember my wife reading that and saying, "You can't just say someone created bluegrass music!" And I understood the point that she had but it's also like, there's the other point of you CAN trace it, pretty much most of it back to this guy though, you know?

THILE: Yeah you can absolutely trace it to that guy, and the band that he put together that included Lester Flatt and Earl Scruggs. It was created basically by a very small group of people led by Bill Monroe. And that's very exciting to me. A more useful thought about genre to me is like, a tradition that develops. And bluegrass is not traditional music, I always hear people talking about traditional music — in fact I think I even said traditional bluegrass at the start of this interview. But bluegrass is not a traditional music strictly speaking, or at least in terms of how we think about how it's not hundreds of years old, it's like 60 years old, 65 years old at this point, 70 at the most. That's not an old music.

BLACKWELL: Traditional bluegrass is not that far away from saying traditional punk rock.

THILE: Exactly, that's what I'm saying.

BLACKWELL: This is still being figured out, this is not — it gets lumped into the folk music/traditional world but no, it's still a form that's developing and finding different avenues.

THILE: Yeah, and it's a cool — [sounds] — sorry my little boy has had a rough day. But yeah I couldn't agree more. And I think when The White Stripes came bursting onto the scene, one of the things that was so exciting about it was there's this thing about it that's familiar, and then there's just as much about it that's totally alien. And that's generally the very best music, the very most exciting music is balancing that planet. There's things about it that are familiar and comforting and there's things that completely fuck you up that absolutely end up blowing your mind. Bill Monroe is that kind of guy, I think Jack is that kind of guy. And I would like, that's the kind of guy I want to be. I don't know if I'll get within a country mile of those fellas but that's the sort of musicians that I'm interested in. The person that takes these things, they obsess over these materials they find and they absorb them so completely that those materials are changed within them. And then they come out new. And that's exciting. That's a period of music right there.

BLACKWELL: Yeah, I have a friend who says any movement — think of movement broadly whether it's political or whether it's art or anything along those lines — he says any movement it starts as a revolution it turns into a business and ends as a fraud.

THILE: Wow.

BLACKWELL: And so, I said that to Jack once, and he really seemed to think about it and he said — I think specifically towards music — he said, "Yeah, you know the difficult thing is that you want to be on the cusp of something when it changes from revolution to business. Because usually the person to revolutionize something is not the person who sees the fruits of it. It's someone else who's

maybe along for the ride or picks up on it at the right moment and is able to expose it to the masses. And you don't want to be there when it turns into a fraud. But I think about that a lot in music and I think that's appropriate in kind of the conversation that we're having. Did you play your 75316 [the serial number of his Llloyd Loar mandolin —Ed] on this session do you remember?

THILE: I did, I did.

BLACKWELL: Did you notice at all after you put that single out any kind of increased attention, or being noticed from fans or a world you hadn't previously any traction in? Did you see anything like that?

THILE: Absolutely, absolutely. For one, Third Man has fans of its own who are understandably taken completely in by the whole aesthetic that's amazing. That's another thing, Jack is a visual artist as well, you know he has such an eye for these things. Like what's gonna give people visual cues to the music, like basically allows your eyes to help you listen, which is tough, and a lot of musicians are scared of that. Scared of kind of delving into the visual at all. I am one of those. I find thinking about visuals to be very, very scary. And watching Jack, he would just design, the visual design of his studio is just gorgeous, it's like a work of art. And so I think that those people, some people who bought our single just because it was part of Third Man. I've seen those people at shows. They found Michael and me and they found Punch Brothers and it actually all may have just happened because of Third Man vinyl. But I think more importantly for me, I think Jack helped us draw some parallels between aggressive electric music and aggressive acoustic music. So for people to hear past their preconceptions of those two textual aesthetics — like if something is electric it is necessarily more aggressive than if something is acoustic. Like that is false. Whatever your intention, if you play something aggressively then it is aggressive. Providing if you have the skill to get that across. But sometimes I feel like the actual textual aesthetic, like people hear an acoustic instrument and they've heard so much electric music at this point that they automatically assume that if it's acoustic it's like a mellow mentality kind of number. They just automatically go, "Oh it's acoustic time, it's soft and sweet." And that's where we're at. And I think that Jack, the Blue Series experience and then making our record in the wake of the Blue Series experience helped us communicate to our audience, to people who ran across it like, "Whoa, there's some fire here." And then that can be its own fun juxtaposition, then that becomes this hot/cold weather system of like this is acoustic, but it's very aggressive. And that can become this interesting ying/yang thing. I do think that that was a very happy byproduct of that relationship.

BLACKWELL: I think you are one of two artists [Ken Vandermark is the other — Ed.] on Third Man that ever won a MacArthur Genius Grant. The MacArthur news and all that is validation of how good and how important you are to all of this. And so I think of that as a very, very

important entry into not only the Blue Series, but everything we do here at Third Man … And honestly, when you were recognized for the Grant, and we were putting out your single, at that time, I have to say, I knew nothing about you prior to that and it was basically painted to me by Jack as kind of like, a little cautiously saying, "It's very likely that Chris is the greatest mandolin player ever born."

THILE: !@#(*A#)$(*#

WE ARE HEX

TMR-084

Hipped to Jack White by good friend Steve Schmoll (formerly of the bands the Tigerlillies and Lazy), We Are Hex was formed in Indianapolis in 2007 by Brandon Beaver and Jilly Weiss, who cloistered themselves in a storage unit for the better part of a year to write and record a full length that was never released because it just wasn't up-to-snuff. With Trevor Wathen and Matt Hagan joining the following year, the band moved into a house in one of Indy's less-than-desirable neighborhoods and used the Hex Haus moniker to label their record label, their studio space and their living space. As of October 2015 the band is no longer together.

A SIDE: TWIST THE WITCH'S TITTY
B SIDE: THROUGH THE DOLDRUMS TO THE DUM DUMS

RELEASED: MARCH 24, 2011

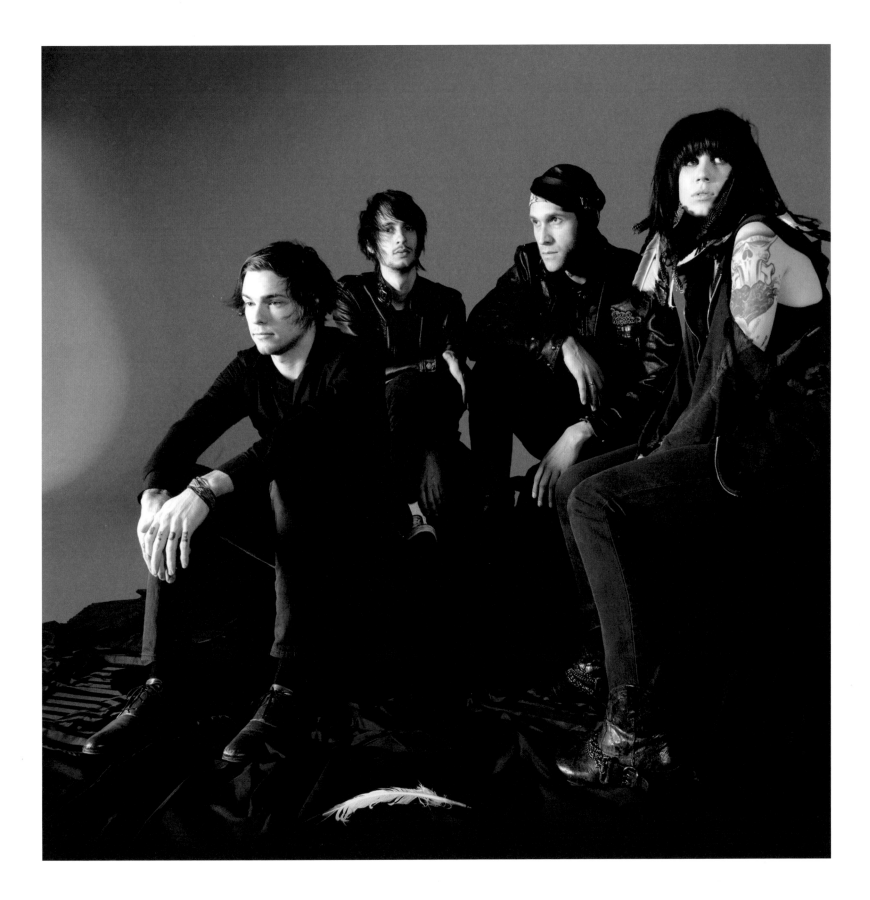

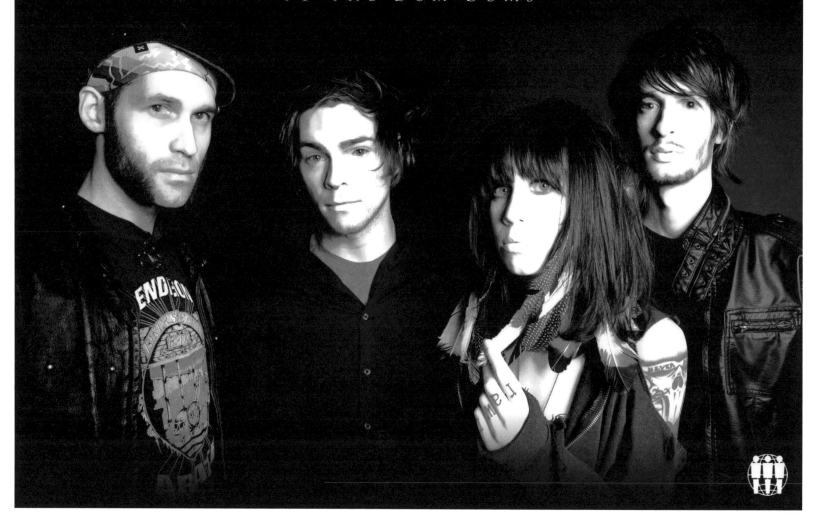

PRODUCED BY JACK WHITE III. ALL SONGS: WE ARE HEX (HEX HAUS/BMI). VOCALS: JILLY WEISS. GUITAR: MATT HAGAN. BASS & BACKING VOCALS: TREVOR WATHEN. DRUMS & PERCUSSION: BRANDON BEAVER
RECORDED BY VANCE POWELL ASSISTED BY JOSHUA V. SMITH, AND MINDY WATTS. MIXED BY JACK WHITE AND VANCE POWELL ASSISTED BY JOSHUA V SMITH. PHOTOGRAPHY BY JO MCCAUGHEY. DESIGN BY THE THIRD MAN. TMR084

A SIDE
TWIST THE WITCH'S TITTY

WE ARE HEX

B SIDE
THROUGH THE DOLDRUMS
TO THE DUM DUMS

"If this experience wasn't already strange enough, the amazing people we were working with were just as passionate and engaged about our music as were we."

Laying on my couch in the old Hex Haus on December 1, 2010, I was having a discussion with Jill Weiss about where our band and lives might be heading. At this point, we weren't entirely sure about the band and were, quite frankly, mildly disillusioned. In the middle of a thought, Jill receives a phone call, "Hold on, it's Brandon."

Only hearing portions of the conversation and watching Jill methodically pace the room, she yelled, "Are you fucking serious?" More than a bit anxious, I thought this was going to be interesting. Did someone have a car crash, did someone die, who needs to be bailed out of jail?

Hang up! "Jack White just called Brandon and wants us to record a 7" with him!" "Huh? How the fuck has he even heard of us?" Four people who care more than anything about their music had converged on the city of Indianapolis, started a band, then controlled and weaved their lives around an idea for the last two years. In this insane train of events we found ourselves in Nashville making a recording with Jack White.

How did we get here? Fortunately, after playing a show in Cincinnati we were able to meet a gentleman by the name of Steve Schmoll and Steve led to Jack White. We had two songs and those two songs would take us down the rabbit hole that would eventually be a distinct interpretation on how we felt and viewed the human condition. "Twist the Witch's Titty" and " ... Doldrums For the Dum Dums." Weeks of dialing in and incessantly prepping, we found ourselves in a strange undisclosed location where the studio resides.

On a brisk winter morning with our van packed full of gear, we arrived at Third Man Studio. Stepping out of the van and meeting Vance Powell and Jack was surreal. Mindy Watts (engineer), asked us if we were nervous. Of course we were but the importance

of what was happening meant that we had to maintain some semblance of keeping our shit together. What I remember next is a whirlwind of gear, sounds, introductions and utter chaos.

Littered with vintage amps, drums, guitars, keyboards, a vintage South African broadcast board with built-in Neve 1073's, two Studer A800 reel to reels, a few cabinets of compressors and a mic pre shoehorned into such a small space capable of so much. If this experience wasn't already strange enough, the amazing people we were working with were just as passionate and engaged about our music as were we. After a five-hour session, which was the shortest recording time of any Blue Series, the music spoke for itself. When the tape stopped rolling, we looked at each other and knew we had made something more than half good.

The next day in the amazingly designed offices of Third Man Records, full of posters and taxidermy, we got back to work. After being informed that it was the darkest photoshoot in the Blue Series canon, we were all quite pleased and proud. The many diverse personalities coming together in this environment drew out the real skeletal dimension of what we had just accomplished.

Working with this group of people really affirmed our belief in our DIY, punk ethos. If the whole process taught me one thing it would be to really truly enjoy these moments and the friends you have made. There are zero guarantees in life or in this industry. Do your own thing or get the fuck outta the way!

This is it.
We Are Hex

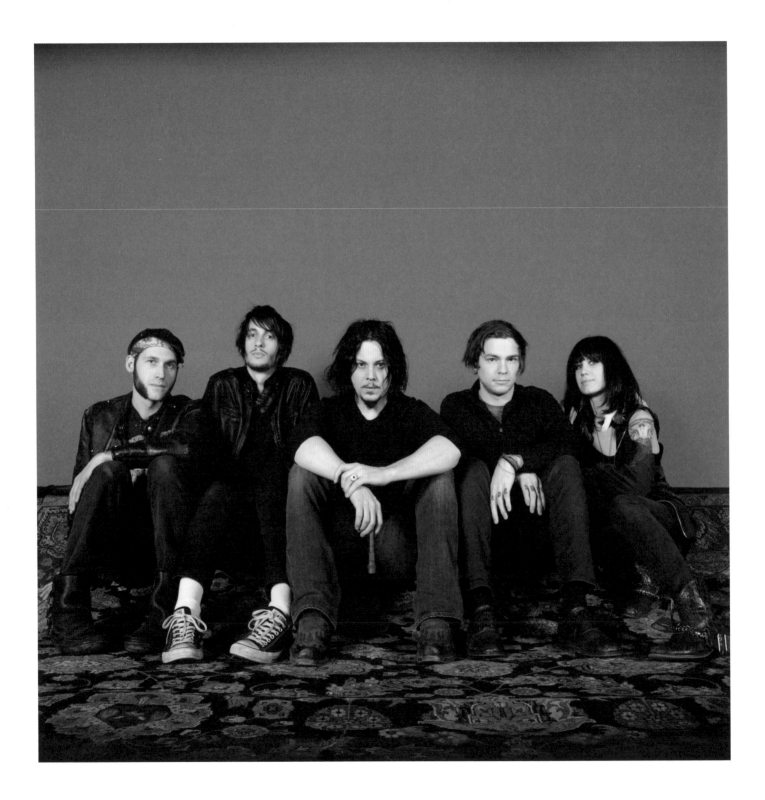

TMR
084

SEASICKSTEVE

TMR-098

With a long and winding musical career spanning many different iterations and names and job titles, Seasick Steve rose to notoriety in 2006 with a performance on the UK television show "Later ... with Jools Holland" and quickly became a highlight on the European festival circuit. Both songs featured here were originally written and performed by the beloved bluesman Mississippi Fred McDowell. Steve would perform the song live at the 2011 iTunes festival with John Paul Jones (Led Zeppelin) on bass, Jack White on drums and Alison Mosshart (The Kills) on vocals. Upon arrival at Third Man's Nashville space, Steve commented that the railroad crossing a block away was a spot where he often hopped trains back in his earlier hobo days. Seasick would also end up recording a live album at Third Man (the only Blue Series artist so far to record direct-to-acetate) in addition to the studio albums *You Can't Teach an Old Dog New Tricks* and *Hubcap Music*.

A SIDE: WRITE ME A FEW LINES
B SIDE: LEVEE CAMP BLUES

RELEASED: MAY 22, 2011

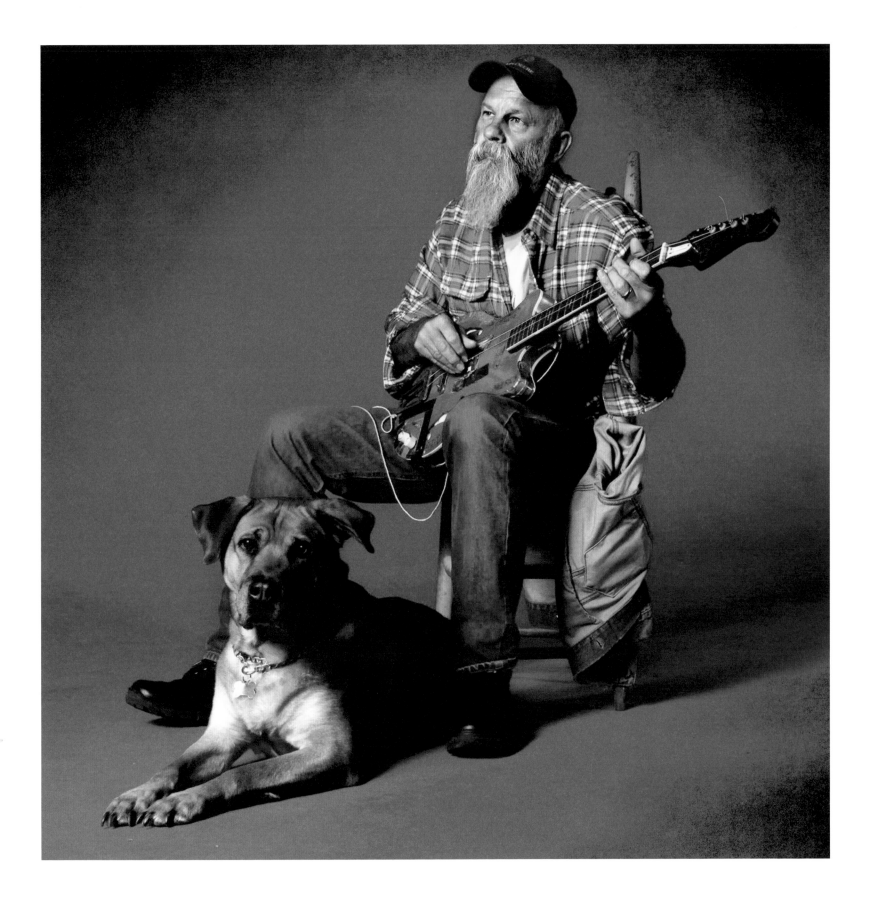

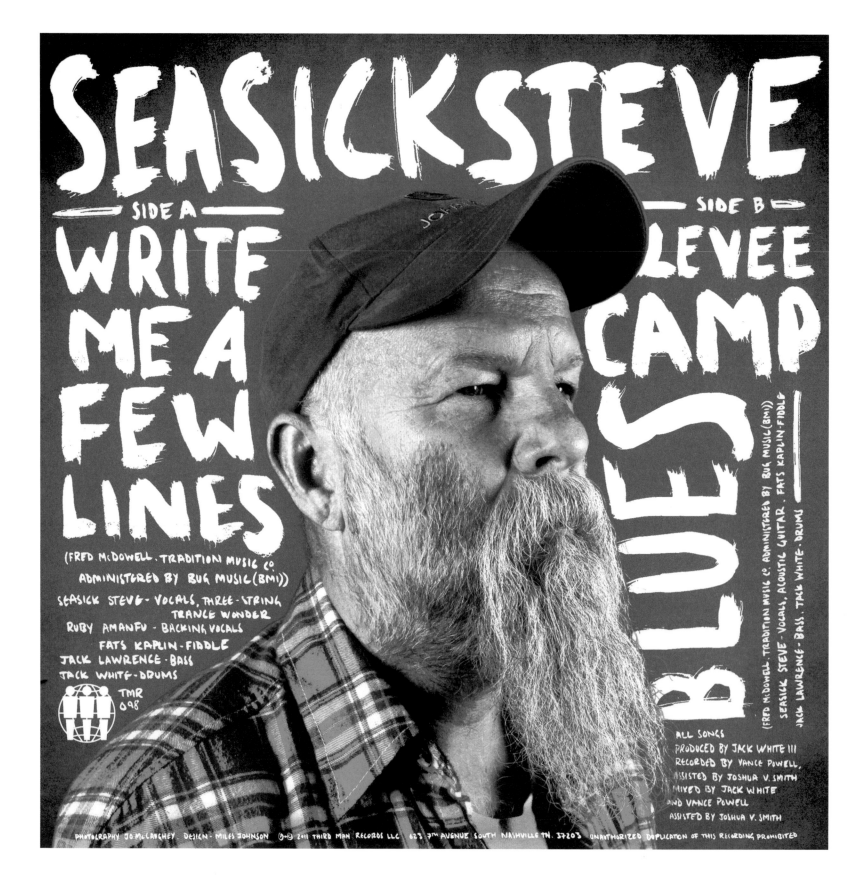

"the thing about jack for me he put his money where his mouth is"

A few words from **SEASICK STEVE**

i think i first really talked to jack at glastonbury i mean we had said hi before
at some other festival but glastonbury where we really met i think
well we was playin right before dead weather i remember they just tore it up
well after in the back stage he called over to me and said alison mosshart wanted to meet me
she was so crazy on stage shit i was a little nervous but she were so sweet
well we became real good friends after that me and her

i think jack then said we should make one of his singles
he was and is one of the only people playin out there that i really respected
so i thought if i could i would
i never saw the white stripes live but i remember hearin them and when jack
put death letter by son house on his record i knew he was deep in it
and plus they just rocked till the house come down

well anyway i said i would like to but i dont think we made no plan
but then i was out in california doin somthin and i think i got an invite to come
to nashville to do the blue series thing i said yep
i remember i was suppose to fly there one day and we was gonna record the next day
well i had to go up to la to get on the plane early like it was like 5 hours flight and somehow
i didnt eat no food just drank a bit
well i get out to nashville and call third man and they tell me jack want me to come
over to his house and just show him what i was thinkin of recording
but wow i was so hungry by then and a little drunk but they said it wouldnt
take too long so i got myself over there met everybody went right into
the studio and me and jack just started foolin around with a couple old
fred mcdowell songs there was other people there vance powell the enginner
who i already new and josh and they was all runnin around doin stuff
 and somehow some whisky just apprear outta no where well we was havin
a great time then jack ask if i mind if this girl come in and sing too that was ruby and oh yeah
there a fiddle player in the house doin somthin can he come in too and oh yeah
theres a bass player too sure thing no problem i says
then this tray come in with some of popcorn suttons moonshine and some more

whisky and jack he organizin everthng gettin people to play and do this
and that and such like a crazy soul conductor im gettin more and more
shall we say tipsy still aint had no food and I vaguely remember some mics gettin set up
and we was a playin and a rockin and then all of the sudden jack say ok we got it i says what?
yep we was done with the record wow it was like some crazy soul whirlwind
experience it just happened before i knew it shit i thought we was just gettin
ready for tomorrow well it was one of the coolest things i ever did
never forget it but wow was i hungry me and vance went right to waffle
house and had 2 breakfasts each i think it was about 1am
then got a call some while later askin if i wanted to come down to austin to south by southwest
ben told me they was rollin out the rollin record store for the first time
i said shit yeah well that was another crazy whirlwind me and jack
playin in a parkin lot plugged right into the side of the truck it was so
crazy the power went off at one point but didnt matter everyone and especially
me had a great time

the thing about jack for me he put his money where his mouth is
he aint foolin around he actually doin somthin that I believe make a real
difference with music and how its made and bringin back the joy
in everything yeah like just buying a record and makin it special again
like when i was young that IS really somthin
i guess the highlight for me was that thirdman put out a few of my lps
i was real proud and then on top of that we got to play at thirdman
and cut live to lacquers my proudest moment i will never forget it
i know we was pretty drunk and such but when i listen to that record i love it and
the whole night there and thirdman and it was all jacks doin with his
whole crew so i got nothin but time and respect for jack
that for sure and for everyone there at third man
i aint just sayin this i aint got no time for that its just what i mean

almst forgot to say how cool the actual studio was
 it was like walkin into analog wonderland right up my alley
and it was so homey and friendly i pretty much forgot i was in a studio
this from a guy who has his own studio ha
it was really amazin to watch jack work the part of my brain that was not pickled
was watchin lot of people can make a lot of noise like do this play that and do this
but when jack was doin it it was like pieces fallen together from a puzzle
up in air or somthinthey would just drop into place and really mean somthing
ya know the kinda stuff i do seems pretty simple and primitive
but to jump into my fryin pan can be more than it appears and ya can get singed yep
and jack just jumped in stirred it up like the master chef and came up
with somethin way real better than i could have imagined surely for me anways

TMR
098

BLACK MILK

TMR-101

Born Curtis Cross, the rapper and producer Black Milk hails from Detroit. To date this single is the only entry in the Blue Series where Jack White shares a co-production credit. Songs were recorded without titles, with Cross only providing names for them weeks after the session was completed. Recording of the single coincided with Black Milk recording a live album in the Blue Room at Third Man. This release marks the debut of Third Man family member Daru Jones ... originally performing on the single (and subsequent live album) as a member of Black Milk's backing band, Jones would be called in to play drums for a proposed Blue Series session with Wu-Tang Clan member RZA. When RZA cancelled at the last minute, White moved forward with the session as scheduled and had the band tackle some original songs he'd been working on. Jones would end up performing on both of White's solo albums in addition to joining White's band for live performances.

A SIDE: BRAIN
B SIDE: ROYAL MEGA

RELEASED: JULY 12, 2011

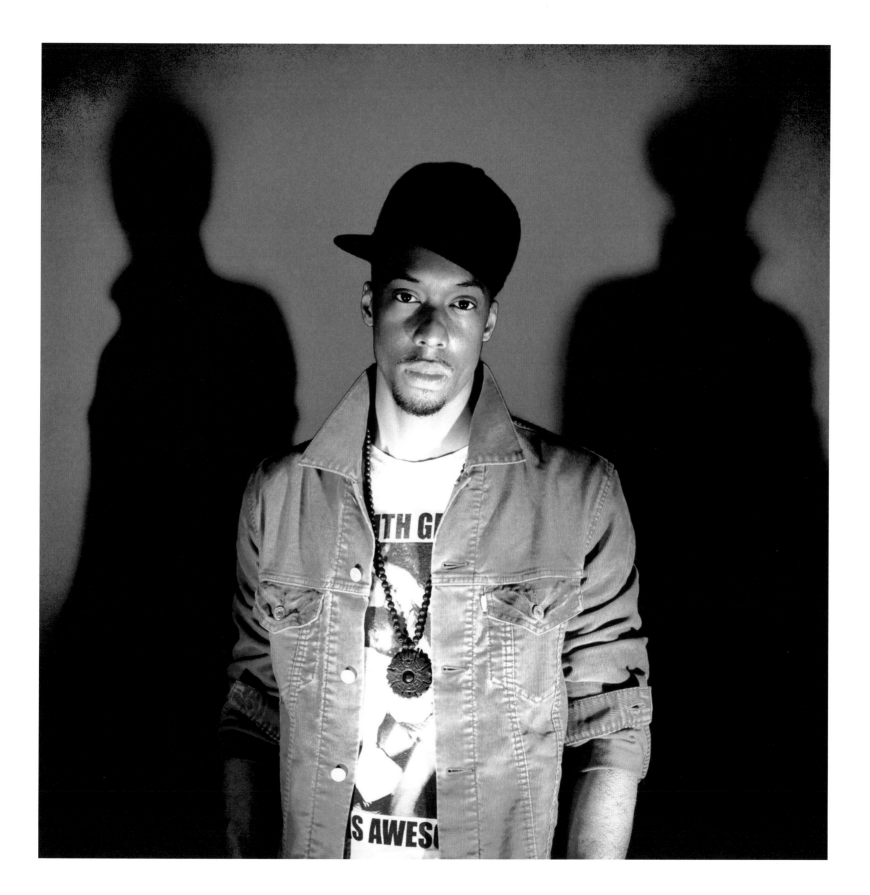

BLACK MILK

SIDE A > **BRAIN**

"BRAIN" BLACK MILK - VOCALS. AARON "AB" ABERNATHY - B3 ORGAN.
MALIK HUNTER - BASS. DARU JONES - DRUMS. FATS KAPILN - FIDDLE.
KEITH SMITH - TRUMPET. JUSTIN CARPENTER - TROMBONE.
CHRIS GREGG - SAXOPHONE. JACK WHITE III - GUITAR

SIDE B > **ROYAL MEGA**

"ROYAL MEGA" BLACK MILK - VOCALS, B3 ORGAN. AARON "AB" ABERNATHY -
KEYS, CLAVINET. MALIK HUNTER - BASS. JACK WHITE III - DRUMS. FATS KAPILN -
FIDDLE. KEITH SMITH - FLUGEL HORN. JUSTIN CARPENTER - TROMBONE.
CHRIS GREGG - CLARINET.

TMR101

"The jam sessions were recorded to tape, all on the first day. On the second day, I chose two of them to write to and spit my verses back to back. "

A few words from **BLACK MILK** via vulture.com

It's a pretty crazy feeling when you're going about your regular, every day routine in the studio and all of sudden you get a phone call that Jack White wants to work with you. The email to my manager came from Jack White himself. My first reaction was one of shock that an artist like him, who most people would categorize as a rock star, would want to work with an independent hip-hop artist. My second reaction was surprise that he even knew I existed, even though we're from the same city. Of course, my response was "Hell yeah! When and where do I need to be to make this happen?" A few back and forth emails led to my band (keyboardist AB; drummer Daru Jones; and bassist Malik Hunter) and I taking a trip to Nashville to record at Jack's home studio.

Upon our arrival, Jack was the first person to greet us. From our brief discussion about music and things of that nature, I learned he discovered my music through the "Deadly Medley" music video. Jack, a team of his musicians, my band and I wasted no time starting a jam session. I immediately felt the pressure of having to create two great songs in two days. Not only were we able to produce two tracks that we felt were great, but we were able to capture our individual sounds. I was prepared to follow Jack's direction with the songs, but not long into the creative process it became clear that he wanted me to take the lead role as the producer. For a guy who is so well-respected and musically accomplished to humbly step into the recording room as one of many musicians and to trust me as the producer to do what I do best was pretty crazy and such an honor.

The jam sessions were recorded to tape, all on the first day. On the second day, I chose two of them to write to and spit my verses back to back. No "edit, undo" like recording digitally in Pro-Tools. On the

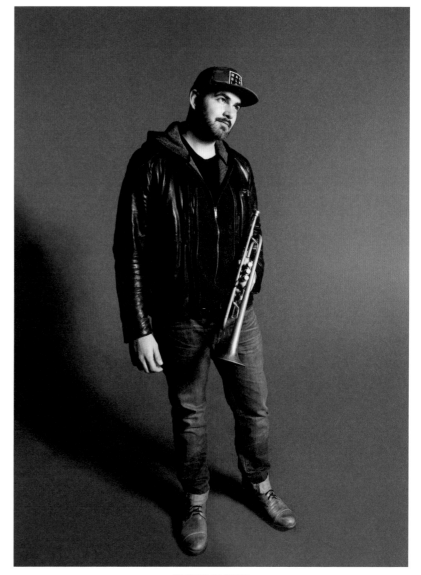

KEITH SMITH

third and final day, we toured Third Man Records (the most amazing place ever), shot photos for the project cover and sound checked for our show later that night. It was a great performance for an amazing crowd, but the craziest part of the night was seeing (and hearing) Jack White in the crowd, cheering us on like a fan and seeming to have more fun than everyone. As a bonus, the live show was recorded to tape (Black Milk Live at Third Man Records), and will be released on vinyl.

The time we spent in Nashville collaborating with Jack White was one of the greatest moments in my music career. It not only inspired me to continue to work hard as a producer, but also confirmed that staying true to my art, without compromise, can manifest into the type of rewards that money can't buy.

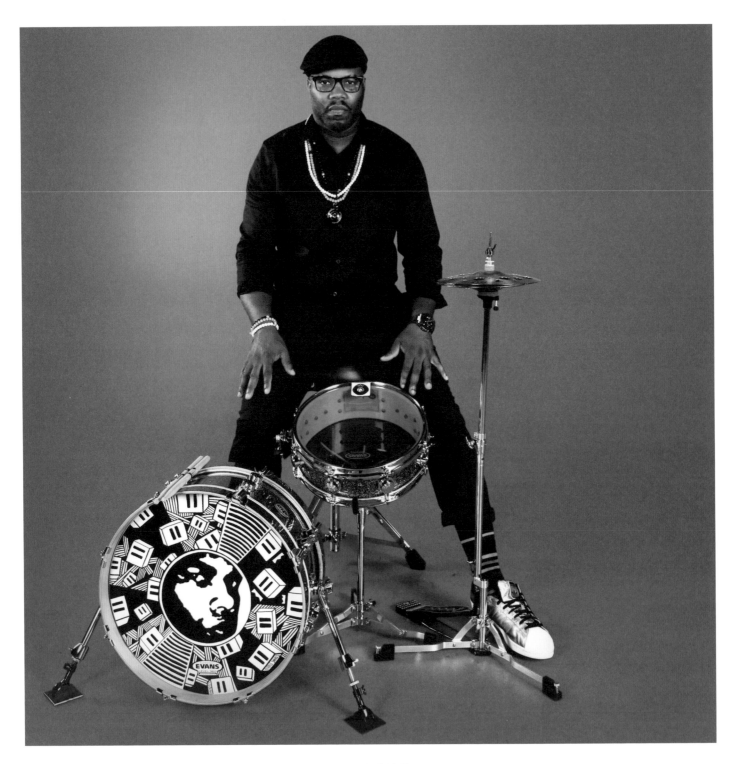

DARU JONES

=STEPHEN=COLBERT=
·❦· WITH ·❦·
THE BLACK BELLES

TMR-105

Satirical late-night television host Stephen Colbert filmed a three-episode arc chronicling his time spent recording this single with lyrics composed by him and his writing staff and music by Olivia Jean of the Belles. When the single was announced and performed on "The Colbert Report" on June 23rd, 2011 the resultant "Colbert bump" caused the Third Man Records website to crash, the only time in memory this has occurred. To date this is the only single in the Blue Series where the tri-color is not in the white-black-yellow vinyl configuration. As a nod to the patriotic manner of Colbert, this tri-color was done in American flag red-white-blue and was sold from the Third Man Rolling Record Store at the Lot at the High Line in New York City, immediately following Colbert and White performing an acapella version of "The Star-Spangled Banner." Colbert would go on to perform a karaoke version of "Charlene II" with Olivia Jean from the Black Belles accompanying on live guitar while the rest of the Belles stood motionless in the background. With this single, The Black Belles are the only band featured on more than one Blue Series release.

A SIDE: CHARLENE II (I'M OVER YOU)
B SIDE: CHARLENE (I'M RIGHT BEHIND YOU)

RELEASED: JUNE 23, 2011

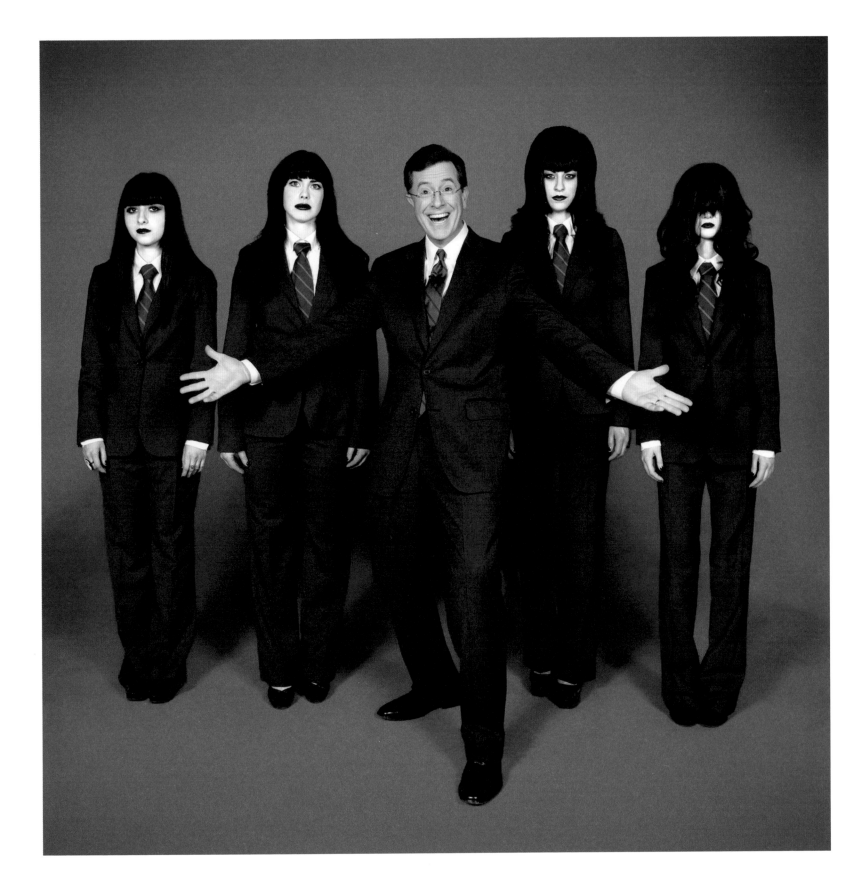

"Oh S-t-e-p-h-e-n. Oh yeah, like the saint. There it is. Yeah. There you go. That's the only way up. Saint Stephen OF Antioch."

BEN BLACKWELL: This is Ben Blackwell from Third Man Records.

STEPHEN COLBERT: Hey! How are ya?

BLACKWELL: I'm good, how are you doing?

COLBERT: Doing just dandy.

BLACKWELL: That's just great. Are you a big fan of Black Oak Arkansas and Jim Dandy the lead singer?

COLBERT: Of course I am. Of course I am.

BLACKWELL: So yeah, I'm calling to talk about the wonderful recording experience you had a couple years back when you came down here to Nashville.

COLBERT: Yeah!

BLACKWELL: So I guess where does your memory bring you in terms of how all this came about? Where did the idea spring from?

COLBERT: Well we were fans of Jack, and one of my producers, a guy named Aaron Cohen, came to me — he was also one of my writer/producers who also was always making music recommendations to me, so he always came in with his music ideas — and he goes, "would you wanna go, would you wanna record something with Jack White at Third Man Records?" And I said "Yeah, sounds great!" And he goes, "We'd have to go to Nashville," and I went, "I don't know about that," because traveling was difficult — we had to do a show every day. And he goes, "No it will be fun, please, let's go. It's supposed to be like a musical playground down there." And I said, "Alright, sure, I'll give it a shot. What are we doing?" "Oh we'll do a sequel to 'Charlene,'" and I said "That will be fun." And I don't think

... I can't remember if we had Jack on the show yet, I can't remember if we had him on yet because I know evidently we had a show where we did something a little different, he didn't want to be interviewed.

BLACKWELL: I don't think you did from my recollection.

COLBERT: Ok. He's pleasantly difficult, is how I would describe Jack. A difficult that leads to creativity because you have to find a new way to talk to him or play with him and it's always fun, because he's particular about the way he likes to do things, which I respect. And so, I said "sure," that was it. Just one of my producers was a fan of Jack's and he knew that I liked Jack and The White Stripes and I said "sure let's give it a shot." But I didn't know what to expect at all.

BLACKWELL: Do you have any recollection — I remember back in, whenever it was, 2005 or so, at some point in the lead up to your show —

COLBERT: — oh shit, yeah! Ok so here's the deal: Jack agreed to do our theme song, the original song, and listen, I didn't have the original conversation with Jack. It was Ben Carlin, one of my old execs, and he goes, "Hey, Jack White said he's up for doing our theme song." And I'm like, "Oh that sounds fantastic! That's great!" And the closer we got, the less it seemed like it was gonna happen so Jack finally said like, "I just don't have time. I know you guys are coming up, I wanna do it, I just don't have time." And I had always thought that — I was very excited that Jack wanted to do it — but I hadn't actually reached out to Jack because I didn't know him. And I was always like, I kinda felt like we were gonna go with Cheap Trick and my exec was like, "Would Jack White be fine too?" And I'm like, "Yeah sure." It was just another thing I didn't want on my plate. And I was thrilled it was gonna be Jack, and then I found out he couldn't do it and I was like, "Man, fuck Jack White!" And then I was like, well let's go with what I wanted. Then we went with Cheap Trick and had a great time. But yeah, Jack was originally gonna do the theme song.

BLACKWELL: And Rick Nielsen has since made millions off of your theme song.

COLBERT: God I hope so.

BLACKWELL: I remember being with Jack at the time and him saying, "Yeah I'm gonna do the theme song for this new Stephen Colbert show." Oh wow, that sounds pretty cool. And not hearing anything from him between when he said that and I was watching the first episode going like, "can't wait to see what Jack did! Ehhh this doesn't really sound like Jack."

COLBERT: [laughs] Does not sound like him, no. And that was my original thought. Because I had totally forgotten about that. So

when they said do you wanna do something with Jack White. I was like "I'd like to plan to do something with Jack White" —

BLACKWELL: So you had to travel down here, you guys — you and a bunch of your writers — kind of started sketching out the idea of the song. Was there a little bit of back and forth? You guys came up with lyrics and —

COLBERT: Yeah, what would the next version of the song be ...

BLACKWELL: Right. You guys didn't do any of the music part at all, right? You guys just only focused on lyrics?

COLBERT: Yeah, I think so we just did the lyrics and Jack came through with the music, I think that's how it worked.

BLACKWELL: Right. And how did you feel about that, did that feel all in concert with the interview and the actual filming or did you view it as two separate, but connected, parts?

COLBERT: Well the funny thing was, the interview that I did with Jack, felt so different from almost any other interview I've ever done because it was all just about music and Catholicism. Those two subjects that we talked about. And he's got an irascible nature, and it was such wonderful friction to go up against. Because you really want somebody to resist you in an interview situation. So you have some place for sparks to happen. And he's all either flint or steel. I'm not sure which one it is. So there are so many sparks, even if — think I was like, "What's your favorite Bob Seger song?" And he's like, "excuse me?" I'm like "C'mon, Seeg?" And it's time for the comeback. "What's your favorite Seger song? Don't tell me you don't have one. Don't tell me you don't have a favorite." And in some ways I'm fucking with him but it was kind of sincere. I ran my interview with him, but the song is totally in character. The song's totally in character. But I was doing the interview with one of the early examples of like, this is what I would be like if I could just interview people not in character. Because yeah, I was fucking with him but just like a comedian, but it was entirely enjoyable just to spend time with someone as opinionated and as, oddly, both opinionated and reticent at the same time. Having to pry answers out of him at times and almost entirely be combative, but seeing that he would enjoy it, it was such a joy to do. So the interview was totally not the song. The process of the song was, let's complete this character game that we created in the first months of the show when the character was very tightly wound. And the interview was the loosest one I've ever done up until that point. Even though I was, I had a game of just messing with him. So, yeah, they were very different.

BLACKWELL: You had said, at some point you said to someone, that Stephen Colbert, the character, and Stephen Colbert, the person, are both huge fans of Bob Seger.

COLBERT: Yeah that's true.

BLACKWELL: And do you recall at the time that Bob Seger was actually in Nashville?

COLBERT: He was?

BLACKWELL: He was in Nashville and it seemed like we almost got him down to appear on-screen to play one of those nights you were filming here.

COLBERT: [laughs] I remember something like that. I actually ran into Seger about a month ago.

BLACKWELL: Oh nice!

COLBERT: I had never met him before, but I was at the Kennedy Center Honors and he was there to sing "Heartache Tonight" for the Eagles, which I guess he co-wrote with Don Henley. I think it was Henley he wrote it with. With Glen Frey, he co-wrote it with Glen Frey. And we were seated next to each other at the actual award ceremony at the White House. He leans forward around his wife and goes, "Heyyyy," and I said, "Oh man! So nice to finally meet you." And he goes, "I saw your thing with Jack. Really liked it, man. We were playing it around the office a lot." And so that was a real joy. I'm still waiting for the re-Segerence. I know he's never going anywhere and he's still been around but somebody needs to do a movie with an entire soundtrack of just Seger. But let's get back to Jack.

BLACKWELL: Well, we've been working on it since, at least since then to try to reissue some of that stuff. But that's another story. So the whole Catholic throwdown thing, you talk about the interview being nothing but talking about music and Catholicism — my side question becomes, you have a — I remember preceeding this Jack said it's really hard to be interviewed by you because first of all, it's not a traditional interview. Second of all, you actually need to come in with an approach as maybe you dealt with a lot of people who were trying to be funny in response to you? And maybe a lot of people weren't coming in thinking no you actually need to dial it back and Stephen's the funny one and you need to be the straight guy. Did that feel at play with that conversation at all?

COLBERT: No, I didn't feel that at all. Not with Jack at all. He was very — I mean, I don't know what he's like to people who have known him for a long time, but he's got a combative nature — at least when I talked to him — and he's also got a little bit of "oh you're not so great. You're not so great. Why are you such a big fucking deal?" And so it's like, "Oh you're not the biggest Catholic, I'm the biggest Catholic." You know? [laughs] He wouldn't give me an inch. And my character is usually very high status. And just like having a TV show is very high status. And he wouldn't give

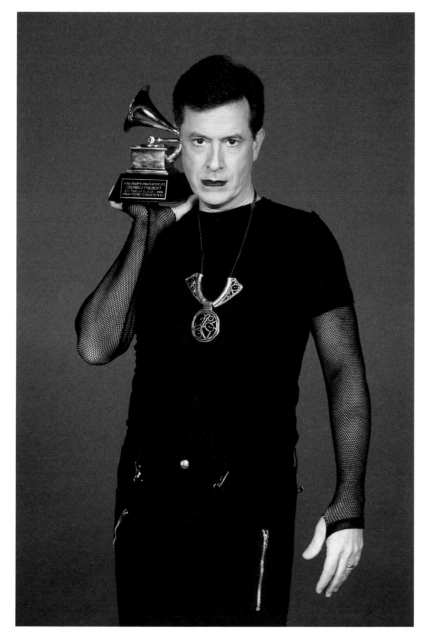

me the status. Which was always fun. It ended up being the status game. The status game evolved very quickly into specifically the Catholic status game. Who could stump the other person. I don't even remember how we got to the first question about it.

BLACKWELL: He asked you how to spell your name.

COLBERT: Oh S-t-e-p-h-e-n. Oh yeah, like the saint. There it is. Yeah. There you go. That's the only way up. Saint Stephen *OF* Antioch. First Martyr. That's how he got into it, yeah. I guess he felt the game right away.

BLACKWELL: I have to say, as someone who's spent a lot of time with him and has often seen him, the humorous and funny and playful side, I think it comes through in all of his different projects and artwork and endeavors, I think that is probably one of the best comedic performances by him in terms of the end result. Because it's hard to come across in the music world, as a record label, or performer or artist, to have a sense of humor without seeming goofy or without seeming campy, there's a way to be funny while still kind of maintaining some kind of respectability out of it and I think with you was the most perfect way.

COLBERT: It's one of my favorite interviews we ever did. I was completely taken aback by how much I liked it. You never know, when you go on the road and make a big choice like this, whether it's gonna be fun. And maybe the most fun day I ever had on the show was being at Third Man that day. And not just the interview but like the atmosphere of the place. It's like a playground. It's a clubhouse.

BLACKWELL: And do you recall the three-part thing on the rapport piece, seemed like people were saying to even do a two-part piece was actually really, really involved.

COLBERT: Super rare. It's super rare to do a two-part piece. We once did a four-part piece, we did very few three-part pieces, maybe one or two.

BLACKWELL: And so on our end too that seemed like, just excitement and kind of really, really anticipatory of how big and fun this was. In terms of the actual recording, of you laying down your vocals what is your recollection? Was it easy, was it in-and-out?

COLBERT: It was hard. It's hard, I'm not a professional rock 'n' roll singer and so it was hard. Jack is firm but fair in the studio, in my opinion. The style that he wrote it was maybe, the style and the music, the way he would want me to sing it might be a little more aggressive than I was, that was my want. But I wanted to please my producer, so, yeah it wasn't right across the play for me. How about that. It was good. It was a challenge.

BLACKWELL: That's a really great analogy. And this also led to you guys performing, you guys had the band The Black Belles with you perform on the show. Which, before or since, have you performed as part of a musical guest ever?

COLBERT: Yeah, I'm sure I did. But I think that was the first time. No, actually that's not true. I sang with Barry Manilow. So no, it wasn't the first, but I was never my own musical guest, if you know what I mean. The Black Belles were there but I was the lead singer. I've assisted other people, that was the first time I ever went out there and was my own musical guest you know, with the Belles.

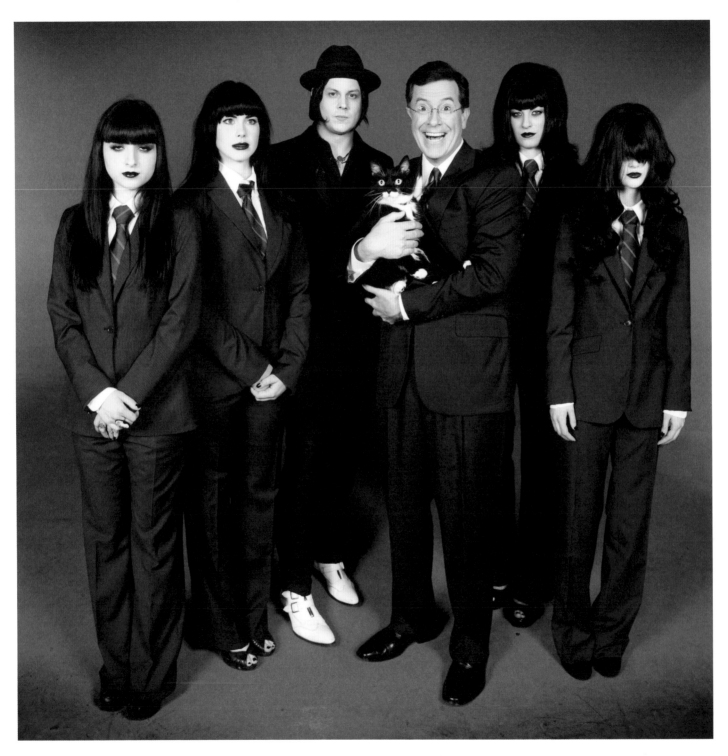

HAVE YOU SEEN THIS CAT?

BLACKWELL: So that night was really interesting too. When you and Jack are doing the interview at your desk, you pull out the record and you talk about it and he says it's available online at Third Man Records dot com and that flashes across the screen. I'm not sure if word ever got to you but that was the week that we first had a tech website IT guy, that was his first week, before that we just had designers who took a two-hour class how to run a website. And so the instant that flashed across the television screen the website crashed. First week for the web guy and so he's freaking out not knowing what to expect anyhow and then that happens. We still have the same web guy, Todd Valentine, as I would say, as a cautionary tale, our website has not crashed since then. And we've had some pretty big news days and events but releasing the single with you left us very — the opposite of gun shy — left us to be very prepared for any future big news events.

COLBERT: Well good I'm glad we could provide that. Our job is to detect aerospace tolerance. The way a skunkworks for peoples' websites.

BLACKWELL: And then you guys did, the next day you guys did the performance outside the High Line in New York. Could you talk about that?

COLBERT: Oh shit! I forgot, yeah we did at the beer garden. Yeah, I forgot about that, we did the signing. That was awesome!

BLACKWELL: Yeah, it was cool. I wasn't there but seeing it and hearing the reports back and having the limited editions of the records. We usually do those records, the tri-colors, black, yellow and white, and we did yours as red, white and blue for America. And I think those were instantly selling for 500 bucks online amongst the collectors, that was definitely amongst the most desirable records that we've put out in the limited edition form.

COLBERT: Yeah I've got one around here someplace.

BLACKWELL: Yeah. Honestly, man, anything else, you have any impressions, thoughts of the process or working with Third Man —

COLBERT: I loved, I love — I think everything helped me find my look.

BLACKWELL: Going from Jack's White Stripes duds to all different kind of goth look and that stuff.

COLBERT: Sure, sure. I'd say it was all in one. I loved playing with the theremin. I liked that they do their own blue screen studio in there, I loved the deep blue theme color everywhere. I loved the little record shop. It was so great going there and playing around. It really did feel like being invited to a clubhouse that I in no way belonged in, but it was one of the most surprising and fun days I've ever had. And then the other night y'all got us into Patterson House. Which was one of my favorite nights of drinking I've ever had.

BLACKWELL: Nice! That's great.

COLBERT: That and some butter-fried donuts.

BLACKWELL: That's the way to go. I have an unrelated question to this. But I'm just curious in your "Comedians in Cars" interview with Jerry Seinfeld, you very beautifully quote Neutral Milk Hotel and I'm curious what your history or what your exposure or you know, being a fan of that stuff, where did you become aware of that stuff or how long has that been on your radar?

COLBERT: I was in, it was the last shoot I did for the Daily ... I was, there was a movie of *Dukes of Hazzard* coming out, and I was down in Tennessee interviewing the guy who played Cooter, in the original series, he was mad about the movie. I don't know why, can't remember why. He was pretty mad. Still had the General Lee. And midday during the day we went to — is there a University in Knoxville?

BLACKWELL: Yeah, UT is in Knoxville.

COLBERT: Ok, so we went to UT that's where it was in Knoxville and we were gonna talk to some frat boys about something, I don't know what, it's been a long time. But I'm in this very hip little coffee shop right off campus and I'm sitting there getting my coffee collecting myself halfway through the day and "King of Carrot Flowers" comes on from *Aeroplane Over the Sea* and I couldn't believe how it just grabbed me by the aorta and kind of like, rattled me listening to it. It really, it sounded different than anything I had heard before and yet oddly familiar. I couldn't, I had to know. So I went up to the baristo and I said, "What is this? What am I listening to?" And he said, "This is Neutral Milk Hotel." And I said, "Seriously, what is this? I'd really like to know." Because it sounds like a band name you would make up. And he goes, "No, it's Neutral Milk Hotel, it's from *In the Aeroplane Over the Sea* which is the greatest single album ever made."

BLACKWELL: [laughs] That's how it was presented to you as?

COLBERT: That's how he presented it to me. And I said, "Really?" And then he goes, "Yeah, Jeff Mangum, the guy who wrote —" then he gave me the whole rundown on like, the Elephant 6 Collective and Athens and The Apples in Stereo, Jeff Mangum, and that now he's off making puppets — he gave me the whole legendarium of the end of the Neutral Milk Hotel and the guy was very into it. Or he's just telling me not concerning other customers in the coffee shop. So as soon as I got back to New York, that was my last piece, I moved over to the new show and I started listening to Neutral Milk Hotel. And I was tapping into it that August because we started in October, so late August through September I was listening to it, that and the song "Aeroplane Over the Sea" and of course "Holland, 1945" and every, almost, I think you could say within aerospace tolerances I could say and be accurate that

every night of the old show during the commercial break when the audience couldn't hear it, we played "Holland, 1945."

BLACKWELL: Wow. That's awesome.

COLBERT: And I wanted to hear that song every night because there was something about the "And it's so sad to see the world agree / That they'd rather see their faces fill with flies / When I'd want to keep white roses in their eyes." There was, that was somehow thematically important to me to remember that all that shit's happening in the world all the time while you're making your jokes. And it's got that sort of brain/skull-thumping sound and then sometimes there would be people in the audience who knew the song and I would sing-a-long with them and I would sing the whole song with them and sing it together. And the audience would love it, and I would feel this real connection, every night I would check with them to see if anybody was singing along with it and find them. And I would say a couple nights a week somebody would be singing along.

BLACKWELL: That's awesome.

COLBERT: Later I met Jeff, he came by the show one night with somebody else, it might have been with The Apples in Stereo I'm not sure because they played the show a couple times.

BLACKWELL: You did the Shred-Off with him.

COLBERT: Right, right. And they did another song too one night. But I forgot who Jeff came with, might have been a different thing, but also saw the concert over at BAM (Brooklyn Academy of Music). I talked with him backstage a little bit then, and on my last show I said, "I know you don't perform live on TV" — he's never done that sort of stuff — "but would you do 'Holland, 1945' on my last show?" I told him why it was important to me, and he goes "No, I just can't." And I said, "Well, can I use it in my closing credits?" And he said, "Sure, absolutely." And so if you listen to my closing credits of my last show, it's just the last verse, the last two verses and the verse that feels more like a chorus, more like a bridge in the last verse, but actually, it ends, our show ended with the last lines of 1945 and that was important to me.

BLACKWELL: That's beautiful. It's just amazing to hear. I could talk forever about it as well, but it's just I guess in a moment where you — being part of an underground or a subculture, when something's important to you and you internalize it — that so often you are protective of it and you don't want even the appearance of it being co-opted. But when something comes through as so genuine and so sincere and everything you just said, you feel like this moment of victory, yes, absolutely, this is the kind of song that should be trumpeted from major broadcasting stations. And so I feel like me, as a fan of you and a fan of Neutral Milk Hotel, that was my like "Fuck yeah!" The world is right.

So often what you care about artistically or musically is just forgotten, it's unheralded, it's unknown. And to see something actually cut through and get it there, you know, even if it might be 15 or 20 years later, there is still that sense of great music and great art cuts through.

COLBERT: Yeah I feel so lucky that I had that moment there in that coffee shop. To just be quiet and hear the music. Because I think hearing that album changed how I think about what's worth talking about.

BLACKWELL: Wow, well that's what we all should be thinking about in our lives. Not just hosts of television.

COLBERT: Yes. So often you work very hard to husband whatever talents you have, and then you have capability and then your decision is where do I point this thing? Like the work that we do. I never have any doubt in our ability to do things, it's always where do you point the big machine you've made? Where do you point the laser that you turn your mind into? And when you hear an artist articulate values or love or longing or a deeply human response to heartbreak you go that's it, that's it, can you do that? And you make a song that is as perfect as a rose.

BLACKWELL: Well I can't think of any other note to end on. Thank you so much, you've been so gracious with your time I appreciate it. Obviously, one of our favorite things we've ever done here at Third Man. Please keep up the good work.

COLBERT: Tell Jack —

BLACKWELL: You have a message for him?

COLBERT: You tell Jack, I'm happy to say "Pussy's Dead" on air and I will have a cup of coffee with him anytime. And I'm not avoiding him.

BLACKWELL: Awesome.

COLBERT: I have three post-it notes in my office that I have kept from the nights Autolux was on, I did say "Pussy's Dead" when I introduced them. And he came in my office and put post-it notes on various things and one of them said, "Why are you afraid to say 'Pussy's Dead' on TV?" The other one was, "Are you avoiding me?" and "Let's get coffee sometime." So if you told him all of those things, I would love it. That would be great.

TMR
105

TOMJONES

TMR-106

Originally tracked at Third Man Studios during sessions for Wanda Jackson's *The Party Ain't Over* LP, "Evil" (written by legendary Chicago bluesman Willie Dixon) was ultimately rejected by Jackson on a matter of her faith. The instrumental remained in the can for almost two years before it found a perfect pairing with Jones, who nailed it in one take and ultimately ended up adding the song to his live set, as featured at the V Festival in England in 2012. "Jezebel" was picked as a B-side at Jones' urging, not to be confused with the similarly-titled but completely different "Jezebel" as featured on his 2012 *Mr. Jones* album. The arrangement necessitated the introduction of Timbre Cierpke who would ultimately tackle the delicate harp parts featured on the song.

A SIDE: EVIL
B SIDE: JEZEBEL

RELEASED: MARCH 12, 2012

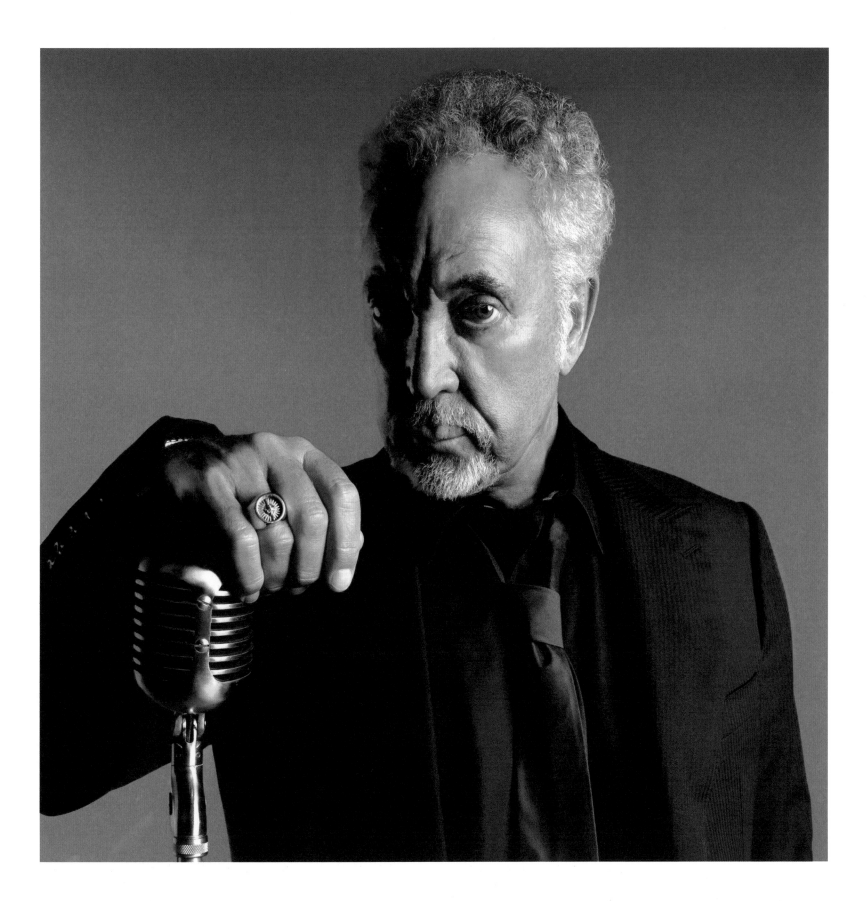

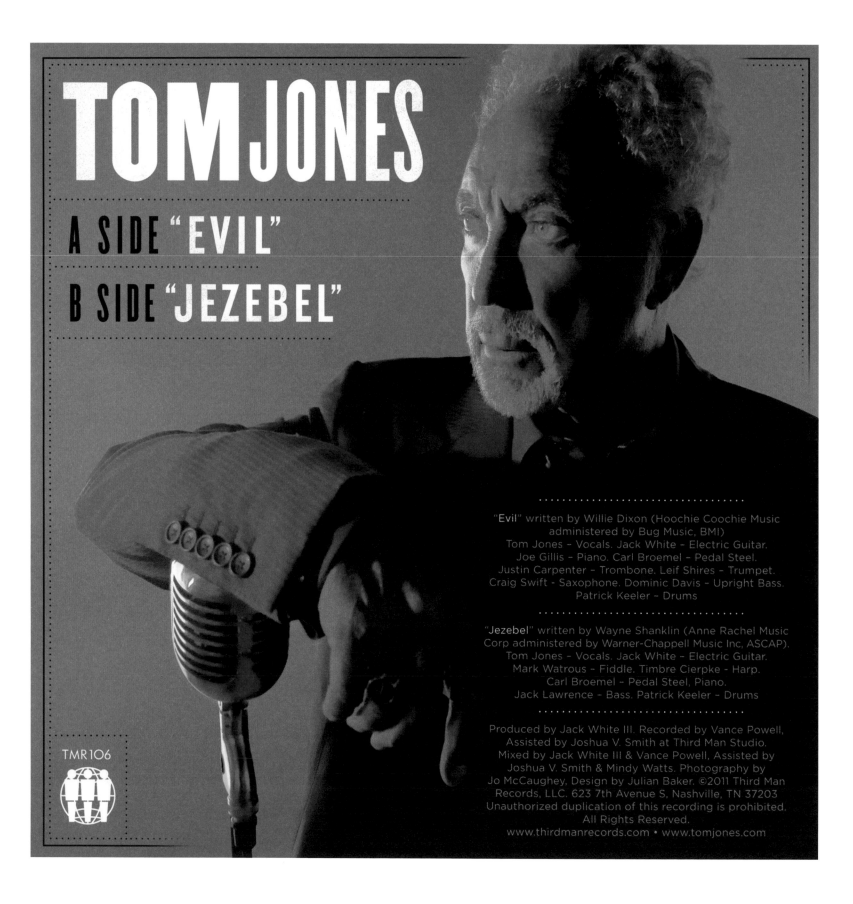

TOM JONES

A SIDE "EVIL"

B SIDE "JEZEBEL"

TMR106

"Evil" written by Willie Dixon (Hoochie Coochie Music administered by Bug Music, BMI)
Tom Jones – Vocals. Jack White – Electric Guitar.
Joe Gillis – Piano. Carl Broemel – Pedal Steel.
Justin Carpenter – Trombone. Leif Shires – Trumpet.
Craig Swift - Saxophone. Dominic Davis – Upright Bass.
Patrick Keeler – Drums

"Jezebel" written by Wayne Shanklin (Anne Rachel Music Corp administered by Warner-Chappell Music Inc, ASCAP).
Tom Jones – Vocals. Jack White – Electric Guitar.
Mark Watrous – Fiddle. Timbre Cierpke - Harp.
Carl Broemel – Pedal Steel, Piano.
Jack Lawrence – Bass. Patrick Keeler – Drums

Produced by Jack White III. Recorded by Vance Powell,
Assisted by Joshua V. Smith at Third Man Studio.
Mixed by Jack White III & Vance Powell, Assisted by
Joshua V. Smith & Mindy Watts. Photography by
Jo McCaughey, Design by Julian Baker. ©2011 Third Man
Records, LLC. 623 7th Avenue S, Nashville, TN 37203
www.thirdmanrecords.com • www.tomjones.com

LANIE LANE

TMR-108

While debut releases for an artist aren't particularly unique in the Blue Series, Lane is the only international artist to have her introduction to the vinyl world be via a single from the series. Born Lanier Stefanie Myra Johnston in the United Kingdom and raised in Sydney, Australia, Lane previously worked as a florist before finding success with her albums *To the Horses* and *Night Shade*. Mere months after the 2014 release of *Night Shade*, Lane retired from the music business, stating "I personally found myself not liking who I was becoming under stress and difficult circumstances. It felt like a lot of the time I was either depressed or anxious, so I've begun to change the circumstances of my life to be back in the flow again."

A SIDE: AIN'T HUNGRY
B SIDE: MY MAN

RELEASED: AUGUST 23, 2011

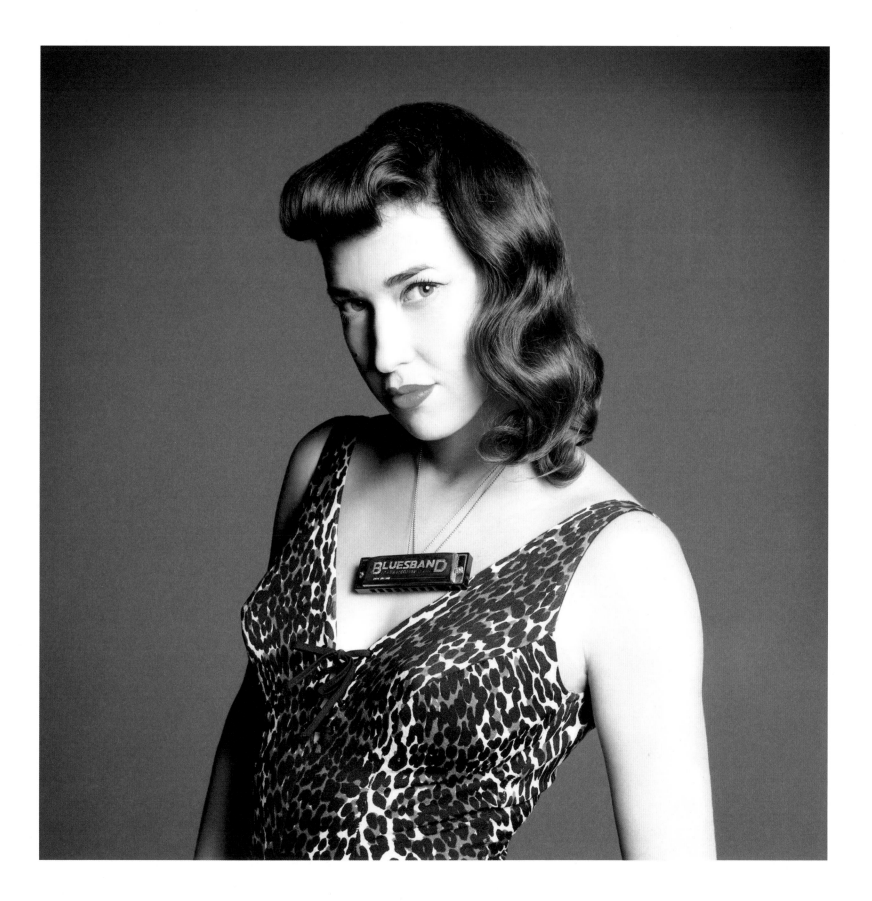

LANIE LANE

— SIDE A —

Ain't Hungry

Written by Lanie Lane (Ivy League Music/Mushroom Music).
Lanie Lane – Vocals, Acoustic Guitar. Carl Broemel – Electric Guitar.
Jack White – Bass. Poni Silver - Drums

— SIDE B —

My Man

Written by Lanie Lane (Ivy League Music/Mushroom Music).
Lanie Lane – Vocals. Joshua Hedley – Fiddle.
Carl Broemel – Pedal Steel. Paul Eckberg – Congas, Bongos.
Mitch Dane – Saw. Ben Jones – Double Bass. Poni Silver - Drums

Recorded by Vance Powell, assisted by Mindy Watts at Third Man Studio. Mixed by Jack White III & Vance Powell, assisted by Joshua V. Smith.
Produced by Jack White III. Photography by Jo McCaughey, Design by Julian Baker. ©2011 Third Man Records, LLC. 623 7th Ave S, Nashville, TN 37203

TMR 108

"I was really happy to just bring a bare, stripped-down song and be happy to let him take the direction on the production stuff because, you know, that's what I wanted to experience."

BEN BLACKWELL: Do you recall how this single even came to be? What the machinations were?

LANIE LANE: Yeah it was awesome — hold on I've got to turn the air on — It's really hot here. Yeah it was like freakin' awesome because I think my manager at the time, Andy Kelly, he'd met Ben Swank (of TMR) years ago when he was managing Jet, I think? [Ed: Swank and Kelly met on a White Stripes tour of Australia in 2002.] I don't know if you know them but they were this huge band. Andy met them in England and it was ten years later, maybe, maybe not that long, but a long time later when Andy signed me. I think I had started doing my first album then, and he was like "I really think Ben would like this." And so he sent it to him, a couple songs, and Swank was on a flight, an international flight, and he was like "oh my god I love this! I'm gonna send it to the boss!" I'll have to go through the original emails because I was literally just starting. So it was really big for me. I mean it's big for anyone, but it was really exciting and so I remember how it worked really clearly. And so he sent it to Jack and within 24 hours, and Ben was travelling — how did he get this all to happen in such a short period of time — and within 24 hours or something I had this email: Would Lane mind if Jack emailed her? And I was like "no" [laughs]. And then he sent me a really beautiful email just asking me, and being really humble: "Would you like to come and record a single?" And I just couldn't believe it. It was amazing. So yeah, I was like yes, and the thing I thought was really cool was he just trusted that I would bring good songs. Like he didn't ask for demos, he didn't ask or need to know what I was bringing before I got there. He just trusted, and I just went there with these two songs and it just happened really effortlessly in one day. Just amazing, I thought that was so cool.

BLACKWELL: Had you ever been to the States before, either for visiting or anything music-related?

LANE: No.

BLACKWELL: So you walk off the plane in Nashville and this is your intro to American Music Business 101.

LANE: Yeah. Well it was wild. And you know, I think we weren't allowed to say anything to Australian media or anything before it was released. But it was just so crazy to go from just tiny little gigs of 50 people to recording at Third Man.

BLACKWELL: The songs that you did bring, was there any rationale behind your choices?

LANE: Jack said he didn't mind what I brought, it could be covers or originals. And to me, because it was right at the beginning of my career, and I'm a songwriter, I was just like well it's a no-brainer it has to be originals. I really want it to be my songs because it's such an amazing opportunity. Yeah I mean, you can do amazing covers but to have an opportunity to have your songwriting heard, you know, so I chose those two. And I had no idea what the production would be like, I was just like so, in the same it way it's nice that he trusted me to bring those good songs. I totally trusted him back, I didn't have to preconceive what I wanted because I didn't want to have an idea already, I wanted it to be really open to any possibility.

BLACKWELL: Did you have any preconceptions in regards to whether you were just going to be playing by yourself or if there were going to be other musicians, or did conversations even go that way?

LANE: I don't think I knew. I was happily surprised that there was a cool band there when I got there, and he just whipped them together that day or something.

BLACKWELL: That's kinda par for the course for these sessions, I've been part of some and knowing other people who have — you just get a phone call and you don't get much time to think about, to prepare or have notions in your head or even look up who you're recording with, you just kinda show up to the studio and figure it all out there.

LANE: That's great. What a luxury! That's not an experience anyone gets to have these days. It's all so pre-thought out and everyone knows exactly what's happening. It is a luxury, really, to get to work so freely and spontaneously. That was the essence I felt of that recording session with the spontaneity and the pure, creative flow and just trusting.

BLACKWELL: When you showed Jack the song, when you ran through or whatever, how did that go? Are you thinking "I hope

he likes this song," or are you thinking "This is the song, I know this is what we're going to do" ... what are you feeling?

LANE: I was probably a bit cocky or something, I was like, I know these are good songs [laughs]. But yeah I was a bit nervous. "My Man," that song I wasn't — I was a bit less sure of that one. I actually might have still been writing it that morning or something. I changed some of the lyrics in the motel that morning. But yeah was a little less sure of that one. I remember feeling a bit more nervous singing that one.

BLACKWELL: Nice. And the people assembled to play on the recordings what were your impressions of them?

LANE: Oh just, you know, top notch players. And just fun, and really talented and incredible. It was nice to play with a female drummer because I've never done that before.

BLACKWELL: Oh yeah, Poni Silver on drums. So when you're working on it, do you get any direction from Jack in regards to — or anyone — in regards to approach to the song or delivery, or parts, or do you show what your idea is to a finished song? What happens in between there, is there much manipulation or is pretty much how you started it?

LANE: I was really happy to just bring a bare, stripped-down song and be happy to let him take the direction on the production stuff because, you know, that's what I wanted to experience. But I wasn't afraid to say what I thought. Like there was one riff in "Ain't Hungry" the descending, doo doo doo doo doo, that he played this one bit on the bass for that song and I heard it a bit different and I went, "How 'bout this?" and sang it the way it ended up and he was like "That's cool." And then that was it. But, I wasn't feeling intimidated that I couldn't say what I wanted because he was always really like your ideas matter kinda thing. But at the same time, everything that was happening was so different to what I would have done, that I wanted to let that happen, so I didn't feel the need to, I just was loving having someone else's input. That was so cool and so outside of what I would have done. Like I would never have made those songs, I would never have conceived just because I didn't have the experience, I didn't hear the song and go, well, you could do these unlimited potential production ideas with it because I was so young and didn't have that much studio experience. You know what I mean? So it was really great to just take that as learning, like wow you can do anything! You can really do anything! And to give that song, to be a part of it, to give it kinda over in a way and just have all this incredible new stuff happen was just, I think that's what was thrilling about it.

BLACKWELL: On "Ain't Hungry" there's a lyric that I can't remember if I was ever told the correct lyric or not, but is it "We forget lunch" or "We fuck at lunch" —

LANE: [laughs] It's "We forget lunch!" But you know —

BLACKWELL: Pardon my French.

LANE: We fuck at lunch!! [laughs] Well that's basically what I was saying!

BLACKWELL: Exactly! Well that was, you know, whether it was disguised via an accent, whether that was actually the line or not that was really subversive in that manner. Even before we talked, I listened to it again and I was like, "Man, I could go either way on that one!" So you played it very well, I have to say, it was one of my more favorite lyrics that I've heard or misheard as it were.

LANE: Well that is so good, I love that.

BLACKWELL: I forget who it is, some 50s rock 'n' roller that has a song where he says, "I bet my peanuts to a candy bar," and it just sounds like he's saying "I bet my penis to a candy bar." Which doesn't make any sense. But that's neither here nor there.

When you did your photoshoot — so it's all part of the same trip — is there anything that stuck out? The focal point to me on your photo is the harmonica necklace, and I remember when that came out, I remember hearing a lot of people thinking how cool that was, and how badass that was, so anything you have to say about that or the ideas behind that would be interesting.

LANE: I don't know how I thought of doing that, but I did wear that necklace like every day, every gig, for at least a year. So it was just part of my outfit that I would have worn. And the top I'm wearing, it's actually a 1950s bathers. And I don't know I always just find different ways to use normal kind of things but in different ways. And like if you looked at my house I've got altars everywhere, and it's all mish-mash of this and that. For example, the other day, because a few years ago I went through this phase of finding all these dead birds. So I've preserved their wings — if they weren't rancid — I'd preserve their wings — and I ended up with doing probably twenty birds in like a year or something and then last year, well I got pregnant this year actually, I just went through and saw like, "I don't want dead shit around me! I don't want dead shit!" I just can't because I was growing life." So I just had furs and bits and pieces that I've collected or preserved whatever, stuff that I've been doing. I've been collecting a lot of stuff from the bush or whatever, anyway — long story — I got rid of a lot of it because I just didn't want it around but I still kept like three sets of bird wings that were hanging around. And the other day I was like, oh I might have an idea for artwork, so it's like this old, like an old box, the paint's coming off or whatever, and I just nailed the bird wings — I could show you later — and made like this artwork with the bird wings. So I don't know, I just always find different things to do with normal — I just love that — it's part of the mutual thing — mutually being creative as well like musically.

PONI SILVER

BLACKWELL: Sounds like the reimagining the use of objects may be commonplace for you. "My Man" is the only song we have on Third Man that has a saw on it. Do you have any specific memories of Mitch playing the saw on that song?

LANE: Um, well it's doubled with the fiddle as well. That's how it sounds so unusual. I don't have that much of a memory about that, oddly enough, but that solo is the freakin' best solo ever. And it's just so scary, it scares me, really good. Yeah it scares me, I love it. I don't have a really strong memory of that actually, for some reason.

BLACKWELL: That's okay. So everything is recorded, photos taken, do you have any other recollections or anything

LANE: Well I've been up since 5:30. One of the other words I'd use to describe the session — I would say raw. 'Cause I just like, I remember when I was doing my vocals and he wanted me to double "Ain't Hungry" and he got me to double vocal. Yeah it was exciting to be able to do, you know just like whole take and that's it and you have what you did, and that was really cool. And then to double it, I was like, "I don't know was that good?!" and he was like, "That was perfect!" And it was just nice to have that, you know, that there's gonna be little tweaky bits but there that's the magic. That rawness really helped me, because I hadn't finished recording, I'm pretty sure I hadn't finished recording my album, no, 'cause I went, yeah so I hadn't finished recording my album, so I got to take that raw, just working with the flow. And I think I'll always have that from that experience, I think I'll always have that from that recording session, and a lot of gifts that just continue — who knows if I'll ever record again or do anything but, and I don't think it will be rock 'n' roll. I'm in a different space now. But yeah, there's just so much that evolves musically and working in the studio and producing that I got from that. That just helped me see that you can trust yourself and you can trust your instincts and go with stuff that you wouldn't necessarily think logically but you just try it.

TMR-109

Easily the most controversial entry in the Blue Series canon, the pairing of ICP with a ribald, lesser-known Mozart song (the title of which literally translates to "Lick My Ass"), produced by Jack White with Jeff the Brotherhood providing the instrumentation resulted in nothing less than some Third Man fans swearing off the label completely. With the lyrics to both songs written by ICP on-the-spot in the studio, the B-side "Mountain Girl" is the only song across all the Blue Series releases that features a writing credit to Jack White. ICP and their ardent fanbase of "juggalos" have been labeled as a criminal gang by the FBI, nevertheless the Detroit-based rap group is entirely self-sufficient and in producing their own yearly music festival, self-releasing their own records and operating their own wrestling league they have literally created their own subculture, a feat that (at least in terms of musical acts) is only matched by the Grateful Dead.

A SIDE: LECK MICH IM ARSCH
B SIDE: MOUNTAIN GIRL

RELEASED: SEPTEMBER 13, 2011

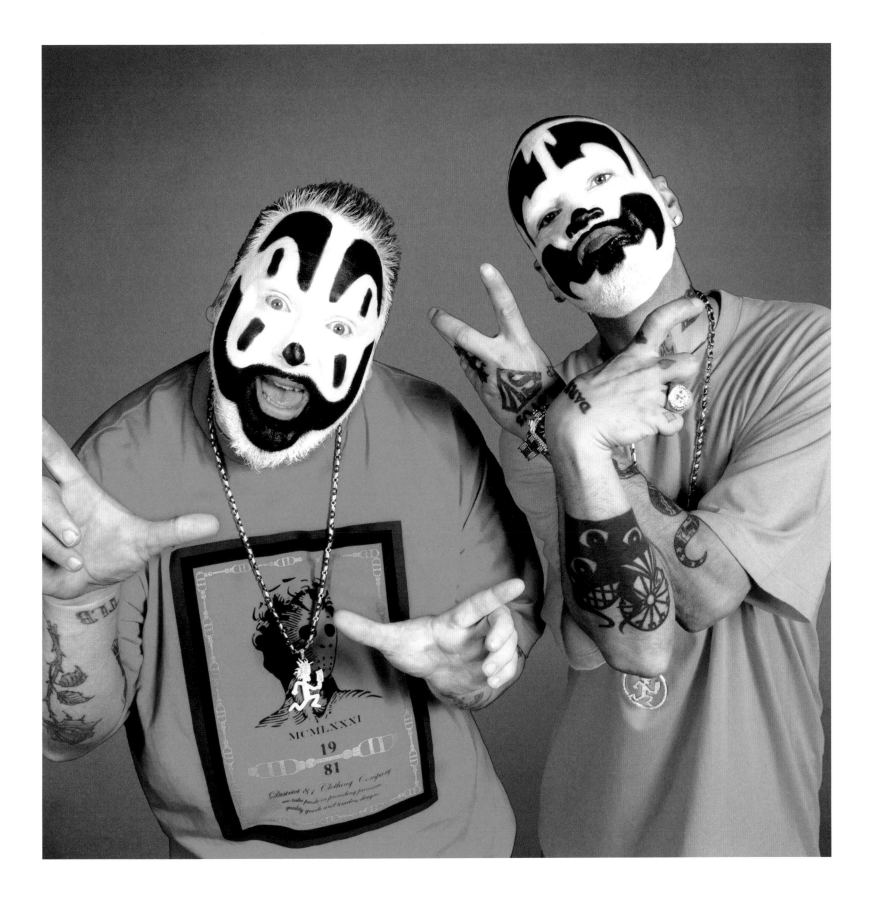

SIDE **A**
"LECK MICH IM ARSCH"

SIDE **B**
"MOUNTAIN GIRL"

THE INSANE CLOWN POSSE: VIOLENT J & SHAGGY 2 DOPE. "Leck Mich Im Arsch" Written by W. Mozart, Violent J & Shaggy 2 Dope (Psychopathic Music Publishing Ltd). Violent J: Vocals. Shaggy 2 Dope: Vocals. Laura Matula: Vocals. Mark Watrous: Harpsichord. Fats Kaplin: Fiddle. Lindsay Smith-Trostle: Cello. Jake Orrall: Electric Guitar. Jamin Orrall: Drums. "Mountain Girl" Music by Jack White III (Third String Tunes, BMI), Lyrics by Violent J & Shaggy 2 Dope (Psychopathic Music Publishing LTD, BMI). Violent J: Vocals. Shaggy 2 Dope: Vocals. Jake Orrall: Electric & Acoustic Guitar. Jamin Orrall: Drums. Rich Murrell: Bass. Mike Clark: Sound Effects. Produced by Jack White III. Recorded by Vance Powell, assisted by Joshua V. Smith at Third Man Studio. Mixed by Jack White III & Vance Powell, assisted by Mindy Watts. Photography by Jo McCaughey. Design by Julian Baker. ©2011 Third Man Records, LLC. 623 7th Avenue South, Nashville, TN 37203. Unauthorized duplication of this recording is prohibited. All Rights Reserved. www.thirdmanrecords.com - www.insaneclownposse.com

TMR109

"You know what I'm saying?"

BEN BLACKWELL: What is your memory of how The Blue Series came to happen? How does it show up in front of you?

SHAGGY 2 DOPE: Our manager had brought it up to us one day. I was floored kinda. You know what I'm saying? I was just like, wait a second. Fucking Jack White wants us to do what? And like the second we heard about it, we're all in. It was a cool opportunity just to work out of our element. We were geeked about it. We were super geeked.

BLACKWELL: When you say "work out of your element," you guys created your own element and don't really have any reason to have to work outside of it. You guys can —

SHAGGY 2 DOPE: Yeah, but you know, for anybody, especially somebody of Jack White's status, asks us to do anything with them, it's an honor for us because not a lot of people wanna go out of their way, especially to work with us, you know what I'm saying, we don't have the best reputation in the world. People that got awesome reputations like Jack White may not want to put carnage on their shit and work with people like us. So, I mean when we heard about it we were, we felt honored.

BLACKWELL: Did you know beforehand that Jack was from southwest Detroit?

SHAGGY 2 DOPE: Yeah. Yeah, yeah. Everybody from Detroit knows that.

BLACKWELL: And you guys lived around there back in the day?

SHAGGY 2 DOPE: Oh yeah, yeah. I was all out of Detroit everywhere. Yeah. I lived in Cass Corridor, I lived in Hamtramck, you know I lived on the eastside, westside, I lived all over the suburbs, I lived everywhere, yeah.

BLACKWELL: I have to ask just personally, because I grew up off of Mack in Detroit, you guys lived on Mack at some point?

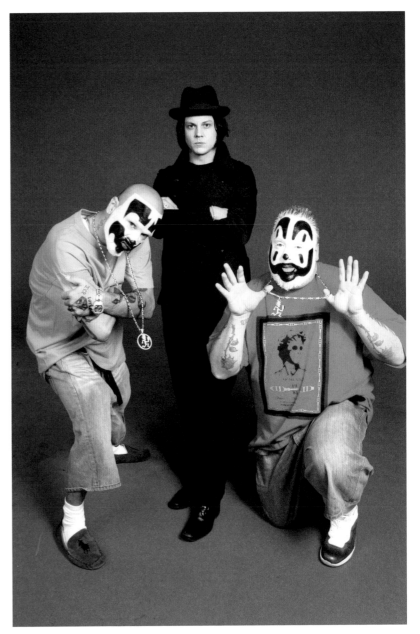

SHAGGY 2 DOPE: I didn't but Violent J did. Yeah he lived above, I think it was a laundromat right on Mack. Yeah, I remember going down there to his house a lot and shit.

BLACKWELL: So when you guys came down to Nashville, and you didn't know anything that was gonna happen, you didn't have any music or anything prior prepped, did you?

SHAGGY 2 DOPE: No, we had no clue what we were jumping into. We knew he wanted to do something with us, and we were open to anything, we were just cool with the whole situation. It's funny

154

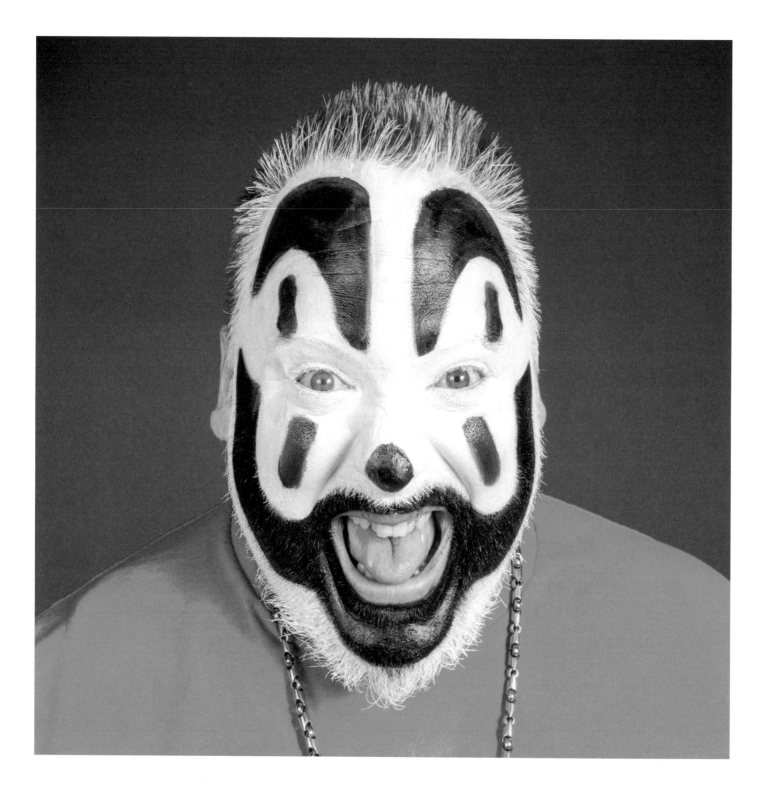

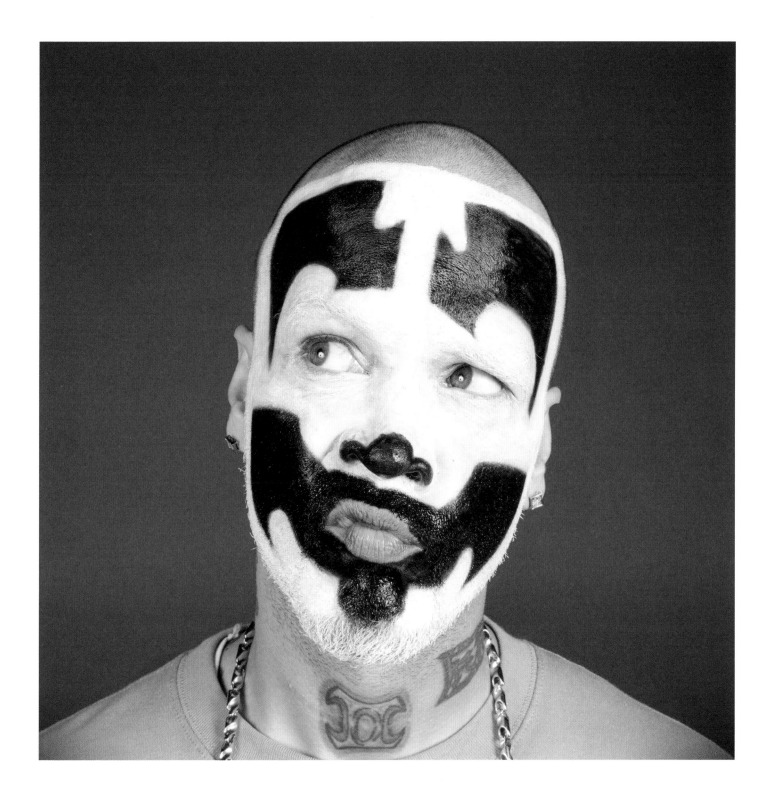

because we certainly work on Pro-Tools to do the newest shit we possibly can, so even when you're listening to your playback and stuff you're still staring at a fucking computer. And it was cool, I just thought what did we do before everybody started working on Pro-Tools, like what would we do besides stare at a computer, you know what I'm saying? Working at Jack's studio was great because there's no computer to stare at or nothing. You just sit there and listen to the music, kicking with each other and stuff. It was great to go back to not using Pro-Tools for a minute.

BLACKWELL: I've heard an engineer mention that once you have a computer, you're taking something that's clearly made for sound, for your ears, but now you start looking at it. Your vision shouldn't actually be playing anything. It should always be about what does it sound like ... How does it sound? Not what does it look like.

SHAGGY 2 DOPE: It's funny you say that, because you know we use Pro-Tools, but a lot of our stuff is still done by sound. Of course it's cool to see the wave and fucking with it and all that, but I mean in the end, you're looking at it, and it's all about the sound. Because when you listen to it in your car or at home, you're not seeing the computer.

BLACKWELL: Absolutely. So you show up and Jack says, "Hey I've got this song by Mozart. It's called 'Lick My Ass.'" Your thoughts when he says that is ...

SHAGGY 2 DOPE: [laughs] We were just like "Lick My Ass" what? First of all, I was like, "Mozart made a song called 'Lick My Ass'"? What the fuck? And then it was, ok that makes sense, we're ICP doing a song called "Lick My Ass" ok we get it, let's do it. I mean we did think, "Ehhh, maybe why don't we try something different," but, you know, it was cool I think it worked. I liked the concept.

BLACKWELL: What is most impressive to me and was relayed to me via Jack, that your entire rap was made up in the studio. You didn't have any preparation, you just said, "Here's Mozart's 'Lick My Ass'" and you guys, in a not too long of a time, completely wrote that song.

SHAGGY 2 DOPE: Yeah, I mean cause it's like we were pressed for time a little bit — well not pressed for time — the whole idea is to get in there, just kinda like almost, not freestyle it, but just sit down, write on the spot and just drop this shit. In all honesty, it's awesome working like that, hearing that shit right there and just doing it. And when we got there he had a little bit of what he worked out ready, he had some backupsingers singing and shit, you know that he had already worked out. So we had a little something to go off of at least, yeah it got done quick that's for sure. Then the other one we did, the other one we did —

BLACKWELL: "Mountain Girl?"

SHAGGY 2 DOPE: Right. All on the spot: music and everything. It was cool too because we brought one of our guys down there with us.

BLACKWELL: You brought Mike, right?

SHAGGY 2 DOPE: We brought Mike [Mike E. Clark, long-time producer and collaborator of ICP — Ed], yeah, and we also brought another one of our guys [Rich Murrell] down there with us, too, that's worked with us for years. He's a musician he plays pretty much everything. And when they had everybody in there making the music, for the bass said "Yo I'll pick it up." He just picked up with the whole rest of the band and banged this track out in just a couple takes. It was cool.

BLACKWELL: Had you guys ever done a track like that where you just went in with nothing and two hours later it was just done?

SHAGGY 2 DOPE: Never two hours. We've started with nothing and gotten some shit done in two days maybe, or a full 12-hour stretch you know, but never that quick, no. 'Cause we don't work with a band like that, we might have a guitarist that comes in plays something. But yeah, it was cool to see too. Just the band going and they were basically just jamming, just feeling each other and going off each other and shit. But I mean they turn that shit out quick, 'cause there were talented-ass musicians up in there, they knew what the fuck they were doing. They got that shit done and it was crazy.

BLACKWELL: When you guys did the photoshoot and the video, you did sort of an advertisement video kind of announcing it all. What's your recollection of how the photoshoot went?

SHAGGY 2 DOPE: They had us in front of a blue screen, and had us pose like we were spray painting something on a wall, then went in with Photoshop later. But that was nothing for me, photoshoots and shit. Just seeing how everything is done in-house, how everything is there, that room is the shit.

BLACKWELL: You guys are the example. I've always said, coming from the rock 'n' roll world in Detroit. I've always had the utmost respect for you guys, because you didn't have to deal with anyone, you did it yourself on your own terms, and it doesn't matter what kind of music or art you make, if you're doing it and operating on your own terms, that is the ultimate goal. And so I think that was an appreciation in how things are done here, knowing that you guys have an operation that's probably three, four times the size of what we're doing here, you know?

SHAGGY 2 DOPE: I don't know about all that, but definitely it was cool to see. How much in-house is done there was cool as fuck to see. And to us, it gave us some ideas. It was funny because we were humbled by what you guys are doing. We were, "man they

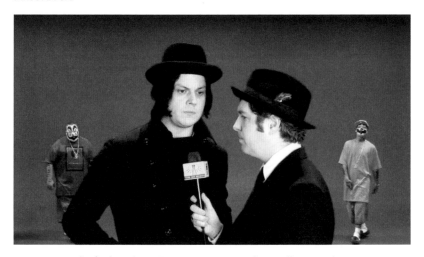

got our shit fucking beat." It's just awesome basically everything is in-house, that's so cool to see people doing it like that.

BLACKWELL: Once the record came out, what do you experience from your fans and your world?

SHAGGY 2 DOPE: From my fans and stuff, everybody thought it was the shit. No doubt, they were "holy shit," man that's dope as fuck. But from outside of our world, it was a whole different story. It was, "What the fuck was Jack White thinking working with these assholes?" You know what I'm saying? But it's cool because that's what we expected, nobody wants to give us credit for anything? When we started hearing it and all, that we got no business working together, ICP what the fuck — we're so used to that. We almost take that as a compliment nowadays.

BLACKWELL: I want to read you a quote from Jack: "That's still one of my favorite things I've ever worked on in my life ... there's definitely things I could say, 'Oh god, I wish I had never taken part of or I regret.' I don't have any regrets, and that is one of those things I'm insanely proud of. Not just to prove a point either, I'm just literally, straight up proud of that."

SHAGGY 2 DOPE: Wow, that's, that's super, man. I don't even know what to say. It's mutual, because working with him was definitely a great experience for us too. We don't get a lot of opportunities like that, so when we do get them, we relish in that shit for a long time.

BLACKWELL: Absolutely. I would assume you'd never done those songs live, those songs they just live on the single?

SHAGGY 2 DOPE: Yeah, yeah, yeah [laughs]. We'd never done them live. But I mean, we would. Shit, if he was doing something and be like yo, come out do this shit, there's no question we would in a heartbeat.

BLACKWELL: There was one more thing that I wanted to ask about which was, the single, the release ... in terms of being in the studio, in terms of production, approach, does anything stick out for you? Jack made a point talking about you guys in his interview, the way you guys interacted with self-editing and trimming down your lines on the fly, he said it was impressive and came off as super professional.

SHAGGY 2 DOPE: That's what a lot of people don't realize about us. We take what we do very, very seriously. A lot of people think we're some goof-asses. But every aspect of everything we do, we try to take it to the highest professionalism we can to the best of our abilities. When we interact with other artists, with other people, we are as professional as we can, we can get to knucklehead status if we have to, you know what I'm saying, but when we're working with other artists, it's all professional. We're not there to waste nobody's time. We're honored to be at Jack's, in the studio, at his fucking house. So we're not gonna go fucking around, we don't get drunk or high in the studio, it's not a party boy thing, it's our fucking career, and that's what we do. Nothing but respect to him for even considering us, so we want to just do it how we do it.

BLACKWELL: I would say the same coming from Third Man as an organization, you guys are professional and it's really, really great. It's hard to make it look that easy, is what I would say.

SHAGGY 2 DOPE: Thank you, man. Everyone associates us as dicks and that we're really hard to work with. Really, it's the opposite. We try to make it easy for people that we work with.

BLACKWELL: Reading J's autobiography, the one point that came through was how you guys non-stop promoted yourselves, and lived only ICP those first years, when people were slamming doors in your faces, how hard you guys worked, you always had flyers, you were always working that shit. I mean growing up in Detroit by 1992 or '93, I thought you guys were the biggest thing in the world and to read the book and see like, "Oh God, these guys were barely scraping by, but they just worked so fucking hard."

SHAGGY 2 DOPE: And you know what, it's all because all of our information of how to do it was built off of lies. People lying to us, saying they were much larger — Esham and Kid Rock — how we perceived how large they were, they were lying to us, making us work a billion times harder trying to get to their level, not knowing that we were already so on their level.

BLACKWELL: Yea! Everyone puffs up their SoundScan numbers that whole bit.

SHAGGY 2 DOPE: Yeah, right.

BLACKWELL: Do you know — this is another eastside urban legend — but I remember when I was a kid all the older kids on the block said that Esham lived on our block. We were on the eastside, do you know if Esham ever lived on the eastside on Bishop?

SHAGGY 2 DOPE: I went to his house a couple times when we recorded in his closet, but I really don't know shit about the eastside. I know it was somewhere on the eastside but I don't remember where.

BLACKWELL: Alright, well the legend lives on then. If you have anything else you want to say about the session or recording, or working on Third Man, have at it. You've been more than generous with your time.

SHAGGY 2 DOPE: It was a super pleasure, we still talk about it to this day, how awesome and what a great opportunity. How great it was to work in that old school style environment, reel-to-reel and all that shit. I wish we were able to still do that, I liked the way we did it.

TMR
109

TMR-110

Long-time mainstays of the Nashville independant rock and roll scene through their band and their Infinity Cat imprint, the brothers Jake and Jamin Orrall have been musically active together since 2001. The back cover photo of their single depicts Jamin skating the curved wall of Third Man's Blue Room ... fitting as the most-asked question upon people first entering the room is: "Has anyone ever skated this wall?" B-side "Everything I Need" is by obscure German hard-rockers Tiger B. Smith.

A SIDE: WHATEVER I WANT
B SIDE: EVERYTHING I NEED

RELEASED: OCTOBER 4, 2011

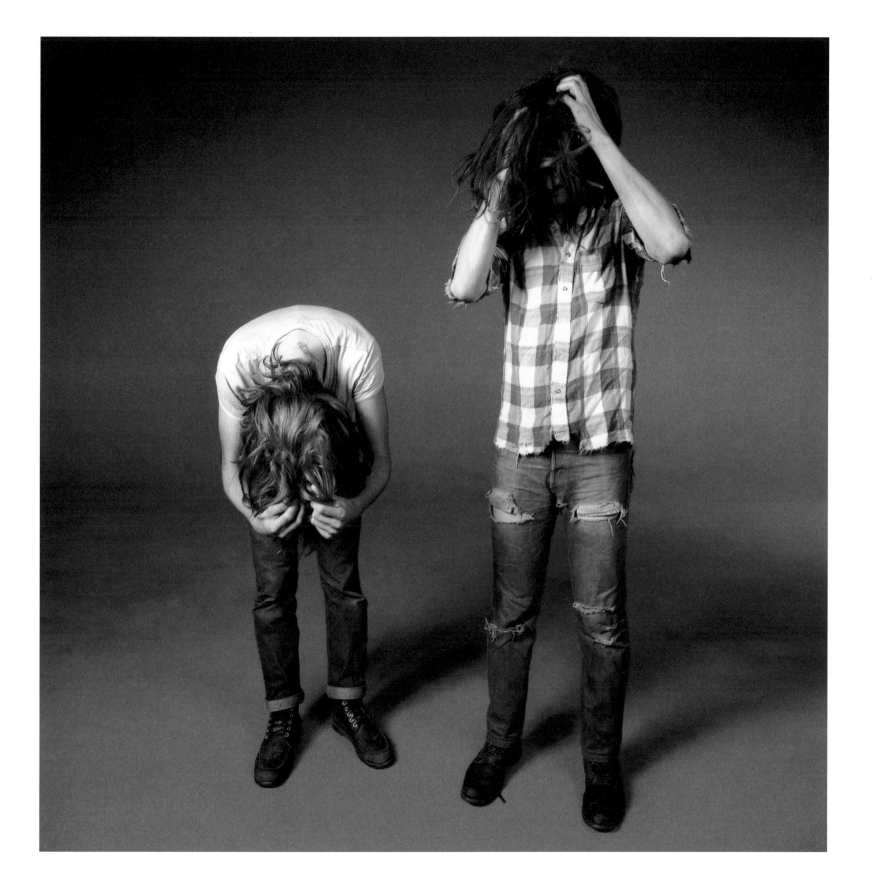

Jeff
the BROTHERHOOD

SIDE A
WHATEVER I WANT
WRITTEN BY JAKE AND JAMIN ORRALL
(INFINITY CAT SONGS/AUTOMATIC BZOOTY/OTISSERY MUSIC, ASCAP)
JAKE ORRALL : VOCALS, ELECTRIC GUITAR
JAMIN ORRALL : DRUMS, MARACAS
JACK WHITE III : HAMMOND ORGAN

SIDE B
EVERYTHING I NEED
WRITTEN BY TIGER B. SMITH (GEMA)
JAKE ORRALL : VOCALS, ACOUSTIC GUITAR, ELECTRIC GUITAR
JAMIN ORRALL : DRUMS

TMR110

JOHN & TOM

TMR-112

The only two Blue Series recordings done essentially in tandem, renowned actor John C. Reilly was given an open invitation by Jack White to record and release whatever he wanted. While multiple ideas were bandied about (and still may see future actualization), Reilly ultimately decided to record one single of Delmore Brothers covers with noted folk and Americana performer Tom Brosseau and another single with Becky Stark (best known for her work in Lavender Diamond and The Living Sisters) also comprised of vintage country songs.

A SIDE: GONNA LAY DOWN MY OLD GUITAR
B SIDE: LONESOME YODEL BLUES #2

RELEASED: NOVEMBER 29, 2011

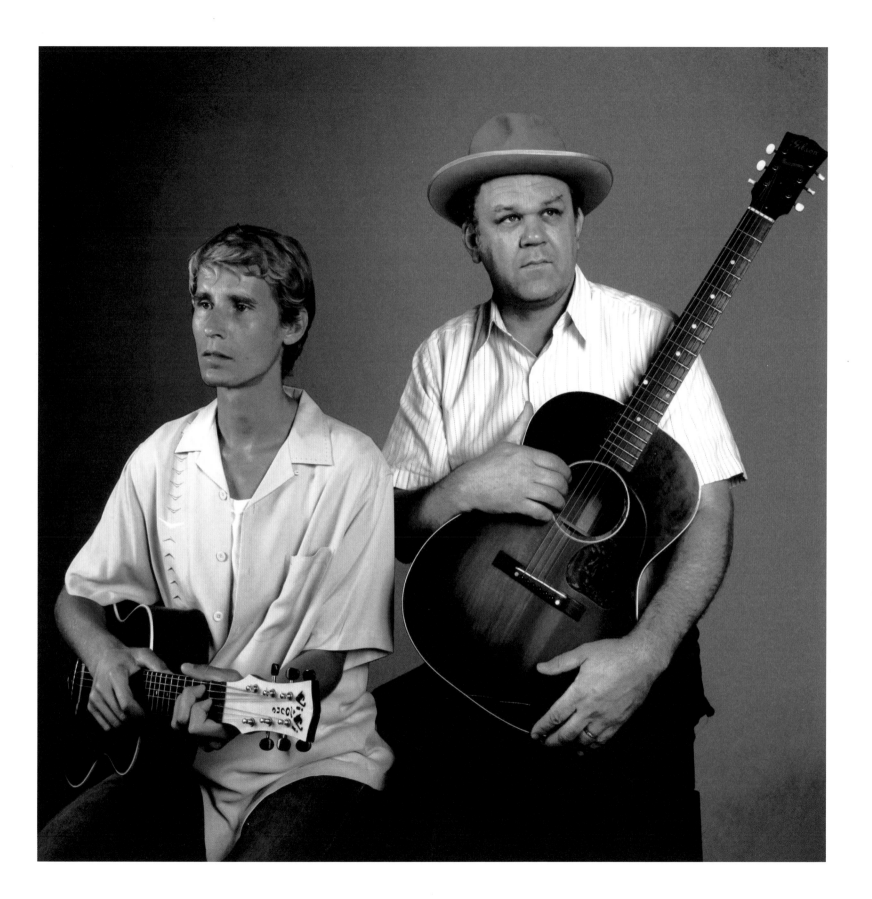

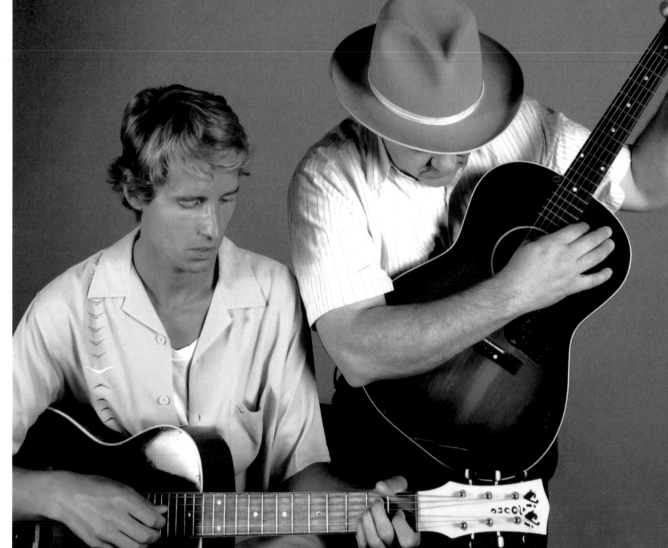

JOHN & TOM &

SIDE A: GONNA LAY DOWN MY OLD GUITAR & SIDE B: LONESOME YODEL BLUES #2

TMR112 "GONNA LAY DOWN MY OLD GUITAR" WRITTEN BY ALTON AND RABON DELMORE (UNICHAPPELL MUSIC/VIDOR PUBLICATIONS BMI). JOHN C. REILLY: VOCALS. TOM BROSSEAU: VOCALS, ACOUSTIC GUITAR. JACK WHITE III: DRUMS, PERCUSSION, BASS, ORGAN. "LONESOME YODEL BLUES #2" WRITTEN BY ALTON AND RABON DELMORE (UNICHAPPELL MUSIC/VIDOR PUBLICATIONS BMI). JOHN C. REILLY: VOCALS, ACOUSTIC GUITAR. TOM BROSSEAU: VOCALS, ACOUSTIC GUITAR. PRODUCED BY JACK WHITE III. RECORDED BY VANCE POWELL, ASSISTED BY MINDY WATTS AT THIRD MAN STUDIO. MIXED BY VANCE POWELL AND JACK WHITE, ASSISTED BY JOSHUA V. SMITH. PHOTOGRAPHY BY JO MCCAUGHEY. DESIGN BY MATTHEW JACOBSON.

"Hurrying might get the job done, but highlight how often you've colored outside the lines. You must find the balance. In the end, you want the best you can do and not be precious about it."

A few words from **TOM BROSSEAU**

John [C. Reilly] and I became friends through the Largo community in Los Angeles. I saw a TV special on Tootsie's once, and this is what Largo is like, like Tootsie's, a place for performers to perform but also kick back a while, have a cup of joe and a little bite to eat, commune with other performers, share in the burdens and joys of life. Flanagan, who runs Largo, has created a lasting home for all those who come through the door. Singers, comedians, players, writers, actors, directors, photographers. He welcomes each one with a smile, story, a joke. A good place to make friends. That's how I got to know John. I remember seeing him in the audience one night. There was no question in my mind who it was. The man's got a magnetism.

John sent me a few of his favorite albums. The Clancy Brothers, The Everly Brothers, The Stanley Brothers, and The Delmore Brothers. Some of the songs I knew and some I didn't. But I could tell he was a serious lover of folk music. The Delmore Brothers seemed the most accessible to me. The harmonies, songs, instrumentation. John and I got together often and in no time built up of a solid repertoire of music. The Delmore Brothers classic, "Careless Love," was the first song we started singing, which later we recorded in Nashville for Third Man Records.

John Reilly had received an open invitation by Jack to come record for Third Man Records, and because John and I, and Becky Stark, had been doing so much singing together, Becky and I came along as special guests. I was excited to be part of the recording, and I know Becky

was, too. Even though John and I had become friends, the prospect of traveling to Nashville and record with John for Third Man Records was nothing I could've ever thought possible. It was a dream. When we got to the studio, Jack came out to greet us. In a way it was startling, like a white bird out of the night. You know, it's quite a thing to meet your idols. But should you ever get a chance to work with them you need to figure out how to get past your own awkwardness and get on the level.

The studio experience was a mix of fun and business. We got to work right away. John and I had Saturday in the studio, and Becky Stark and John had Sunday. You'd think this would be enough time to record four songs, but recording is nothing you want to rush. What you're really doing, what the engineer and the producer and the players are really doing is coming together to make a document, a document of a certain time, which is not to be taken for granted. Hurrying might get the job done, but highlight how often you've colored outside the lines. You must find the balance. In the end, you want the best you can do and not be precious about it. The studio was fun and business. It was a pleasure and an honor to work with Jack White and witness the talented Olivia Jean and Fats Kaplin in action, and see the songs that John and Becky and I brought in take on a transformation, a transformation into the same but somehow a different state, like how ice becomes water.

We had the record release in Los Angeles at Largo at the Coronet on December 15th, 2011. A good crowd and the show went off without a hitch. Third Man Records representatives were there. Their presence that night and in general their support along the way has been special. Jack casts a sacred color on all his projects and that's what creates the environment for good things to happen. Even if they didn't have a record player the audience still bought the 45s of John & Tom and Becky & John. A portion of the night's proceeds went to benefit the Children's Hospital of Los Angeles. We all got something, we all gave back.

Everyone has their other work. Many of us are performers, solo acts, studio musicians that come together for this one thing when the time is right. While there have been times when we don't travel and sing together for what seems a long spell, the magic is still there when we reconvene. I think it will always be there. The core of the group is John and Becky and Sebastian Steinberg and me, but we can get to be a good sized ensemble. Here's a list of the other talented folks who are part of the group: Willie Watson, Dan Bern, Greg Leisz, George Sluppick, Heather McIntosh, Marty Rifkin, Nate Walcott. We've talked a lot about recording a full-length album, and for a long time it's been on the table. Some ideas need more time than others to really take shape. We remain a cool group of revolving motley souls.

BECKY & JOHN

TMR - 113

A SIDE: I'LL BE THERE IF YOU EVER WANT
B SIDE: I'M MAKING PLANS

RELEASED: NOVEMBER 29, 2011

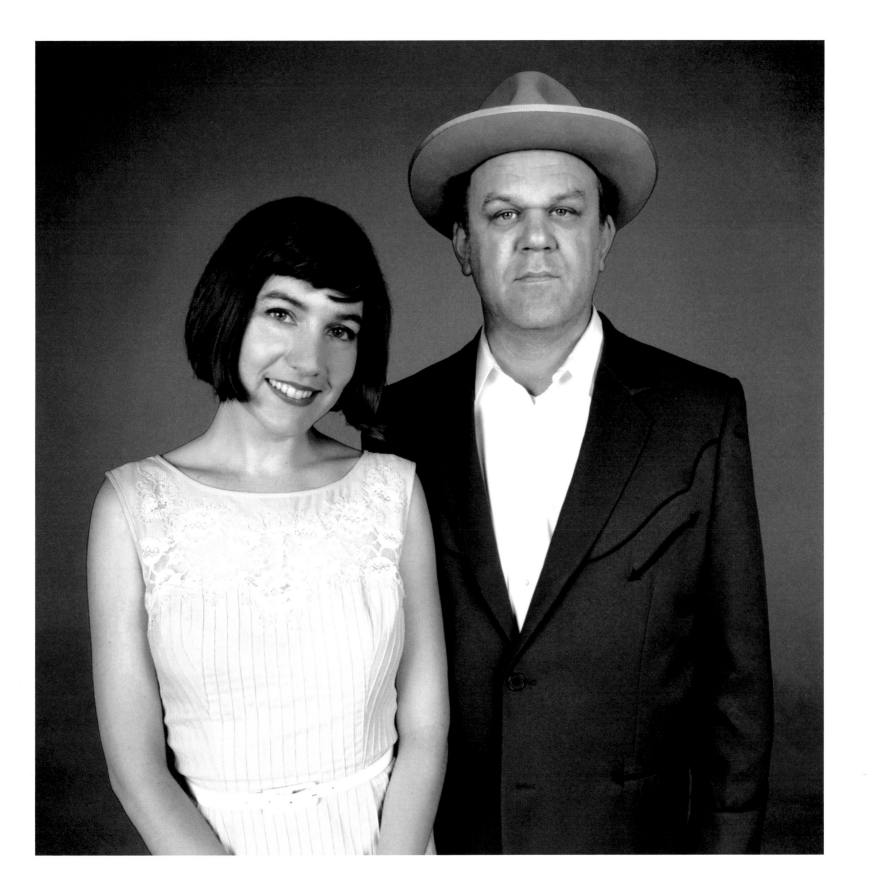

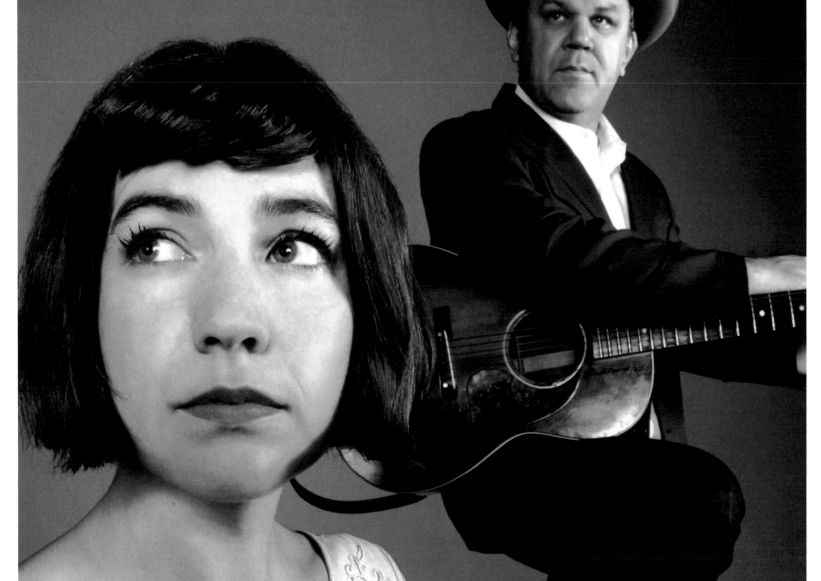

& BECKY & JOHN &

SIDE A: I'LL BE THERE IF YOU EVER WANT & SIDE B: I'M MAKING PLANS

"I'LL BE THERE IF YOU EVER WANT" WRITTEN BY RUSTY GABBARD AND RAY PRICE (ERNEST TUBB MUSIC BMI). JOHN C. REILLY: VOCALS, ACOUSTIC GUITAR. BECKY STARK: VOCALS. JACK WHITE III: DRUMS. OLIVIA JEAN: BASS. DEAN FERTITA: PIANO. FATS KAPLIN: PEDAL STEEL. "I'M MAKING PLANS" WRITTEN BY VONI MORRISON AND JOHN BRIGHT RUSSELL (SURE FIRE MUSIC COMPANY, INC. BMI). JOHN C. REILLY: VOCALS, ACOUSTIC GUITAR. BECKY STARK: VOCALS. FATS KAPLIN: PEDAL STEEL. PRODUCED BY JACK WHITE III. RECORDED BY JOSHUA V. SMITH. ASSISTED BY MINDY WATTS AT THIRD MAN STUDIO. MIXED BY VANCE POWELL AND JACK WHITE, ASSISTED BY JOSHUA V. SMITH. PHOTOGRAPHY BY JO MCCAUGHEY. DESIGN BY MATTHEW JACOBSON. © 2011 THIRD MAN RECORDS, LLC. 623 7TH AVENUE SOUTH. NASHVILLE, TN 37203. UNAUTHORIZED DUPLICATION OF THIS RECORDING IS PROHIBITED. ALL RIGHTS RESERVED. WWW.THIRDMANRECORDS.COM

TMR113

TMR
112-113

TMR-125

The self-described "young queer man of color" Duane Gholston has changed his moniker numerous times over the years from Pop Goes Duane, Duane the Brand New Dog, Duane the Teenage Weirdo and Duane the Jet Black Eel. Upon being notified by the XL Records subsidiary Hot Charity that they had signed Duane, Third Man responded with "Did you sign the Teenage Weirdo or Pop Goes Duane? Because there may be a difference." While an unsuccessful appearance on The X-Factor was seemingly missed by most folks, "Postcard From Hell" would become his de facto introduction to the world. Following the release of the single, Duane would go on to open for Jack White at the Scottish Rite Theater in Detroit on May 24th, 2012 where he performed a mash-up of Rihanna's "Only Girl in the World" and The White Stripes' "Seven Nation Army." Seemingly overlooked by everyone was the fact that the last "L" in "Hell" as depicted on the back cover of the single is made from a postage stamp of Adolf Hitler, as inserted by Third Man's lead designer at the time, Matthew Jacobson.

A SIDE: POSTCARD FROM HELL
B SIDE: BUBBLEGUM ENCORE

RELEASED: JANUARY 24, 2012

SIDE A
POSTCARD FROM HELL

DUANE = VOCALS
JACK WHITE III = THEREMIN + ELECTRIC DRUMS
MARK WATROUS = SYNTH

SIDE B

BUBBLEGUM ENCORE

DUANE = SYNTH + DRUM
JACK WHITE III = DRUMS + C&G SYNTH
MARK WATROUS = SYNTH + BASS

Produced by JACK WHITE III. Recorded and Mixed by VANCE POWELL, Assisted by JOSHUA V. SMITH. Photography by JO McCAUGHEY. Design by MATTHEW JACOBSON.

"I honestly don't remember why I chose 'Postcard from Hell' to record. I didn't have a set plan on what would be on the single. I believe I re-wrote the lyrics to the B-side that day during the studio session."

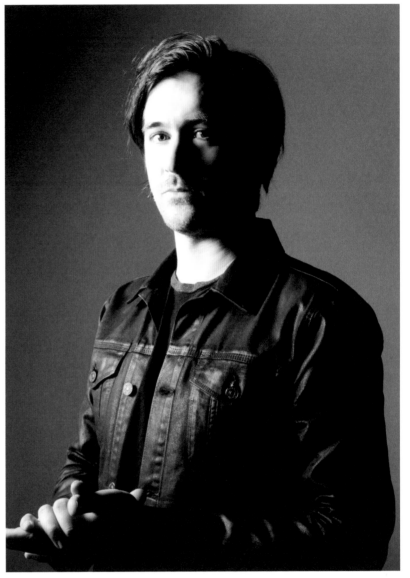

=== **MARK WATROUS** ===

BEN BLACKWELL: What do you remember about being asked to do a Blue Series single? Did you already know about Third Man or Jack White? Were you surprised? Were you aware of any previous Blue Series recordings?

DUANE GHOLSTON: I was aware of Jack's work with The White Stripes. Granted I never listened to them before, but I definitely had heard of them. I had no knowledge of the Blue Series though.

BLACKWELL: When seeing the video of you performing at the I-Rock (I-Rock is a metal club in Detroit, the last place you'd expect to find a character like Duane), Jack originally thought you were literally some act from the mid-eighties. What are your thoughts about that? Did you thank Chris Campbell (lead singer of the Terrible Twos) for sharing that video with me?

GHOLSTON: I was tickled that he thought it was retro footage. That was definitely what I was going for at the time. Early 80s lo-fi look & sound. I believe I did thank Chris in a Facebook message sometime later after the recording session.

BLACKWELL: What informed your decision of which songs to record? What was your impression of the instrumentation/arrangement of your material with a backing band and not a "track"?

GHOLSTON: I honestly don't remember why I chose "Postcard from Hell" to record. I didn't have a set plan on what would be on the single. I believe I re-wrote the lyrics to the B-side that day during the studio session.

BLACKWELL: What were your thoughts of Jack's studio? The atmosphere, the vibe, the equipment used?

GHOLSTON: Jack's studio was like something out of Willy Wonka's chocolate factory. From the personalized equipment and decor to the little bearded Amish-looking men instead of oompa loompas. I'm a very theatrical artist myself, and I like everything to have a cohesive theme and image. So I was very impressed by his overall presentation. The equipment was all analog, something

I had no experience working with. So instead of taking the reins like I normally do on all my recordings, I mostly sat back and watched the magic happen. Very educational experience.

BLACKWELL: I recall that your Blue Series release was teased in your Metro Times cover story. How receptive did you think people in Detroit were to the news?

GHOLSTON: Most people were ecstatic about me putting out a Blue Single. If there were any negative feelings, I never heard/read them. I don't think I've ever experienced any jealousy/ill comments until a few months after when the Black Lips (falsely) posted on their social media that they had signed me. I saw a lot of "haters" on that comment thread [laughs].

BLACKWELL: Maybe this was a rumor, but I heard that you were sick of people trying to put a "band" behind you, to change what you were doing. Did this single have anything to do with that?

GHOLSTON: I'm not sure if you mean band or brand. Cause I did experience some label drama where they were trying to put their own created BRAND behind me. But no one has ever tried to get me to have a band. The funny thing is I'm working on new music with a live band at the moment (DUANE The Jet Black Eel). So I'm very much into performing with live musicians. We've been rehearsing non-stop!

BLACKWELL: What was your main takeaway from the entire recording/release process?

GHOLSTON: Just honored to be a part of the whole shebang to be honest. I like Jack's work (I recently listened to his last two solo records for inspiration on my new writing) and I love what he's doing with Third Man. He's an artist doing what he loves and on his own terms.

TMR
125

TMR-128

With his *Midnite Vultures* album a long-standing staple in The White Stripes tour van, Beck would meet the band in June of 2002 and would make his first of many collaborations with Jack White live on August 11th, 2002 at the Michigan Theater in Ann Arbor. Numerous live and studio collaborations followed for years and it felt predetermined that Beck would someday record for Third Man. Described by White as "sounding like they could come from any era of Beck's career," the schizophrenic sound of "I Just Started Hating Some People Today" goes from traditional country to hardcore to cabaret jazz without warning, while the quiet desperation of "Blue Randy" radiates sadness.

A SIDE: I JUST STARTED HATING SOME PEOPLE TODAY
B SIDE: BLUE RANDY

RELEASED: MAY 28, 2012

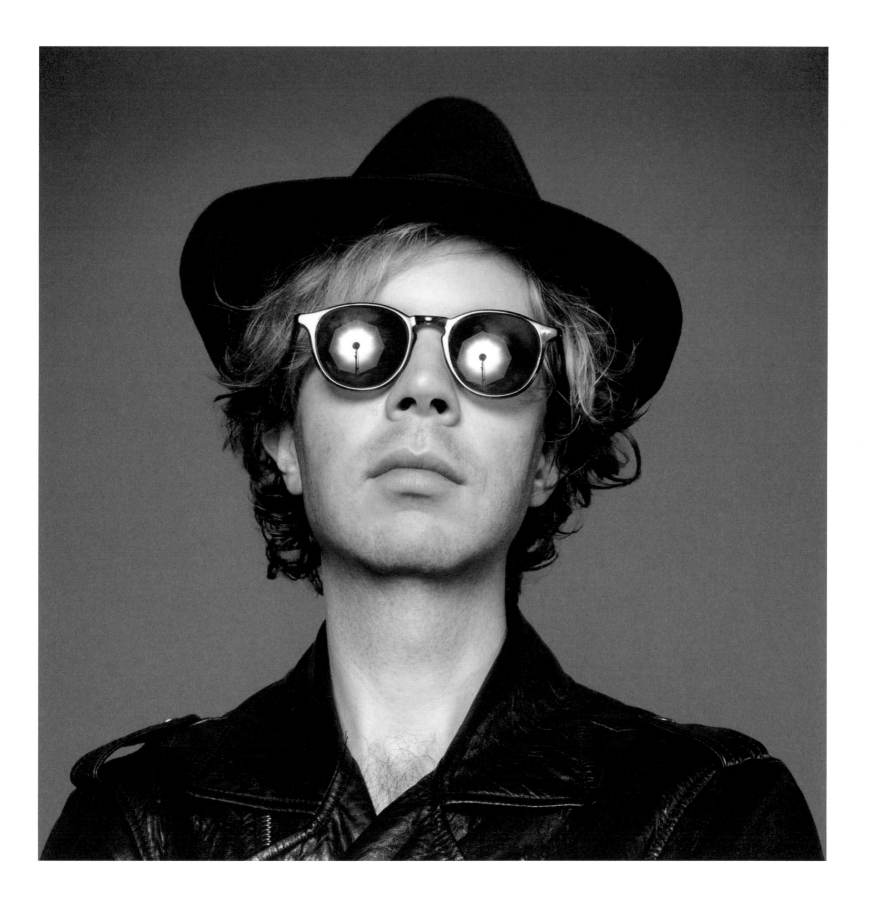

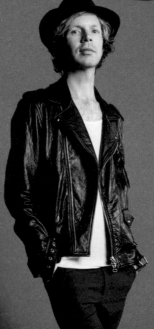

A: I JUST STARTED HATING SOME PEOPLE TODAY **B: BLUE RANDY**

BECK: Vocals, Electric Guitar, Harmonica
JACK WHITE: Drums, Acoustic Guitar, Punk Vocal, Background Vocals
DEAN FERTITA: Keys, Acoustic Guitar, Bass, Background Vocals
FATS KAPLIN: Fiddle, Pedal Steel
KAREN ELSON: Jazz Vocal

BECK: Vocals, Guitar
JACK WHITE: Drums
DEAN FERTITA: Bass
FATS KAPLIN: Pedal Steel
RANDY BLAU: Laser Tag

Produced by **JACK WHITE III**
Recorded by **JOSHUA V. SMITH**
Mixed by **VANCE POWELL**
Record/Mix Assist by **MINDY WATTS**
Written by **BECK HANSEN**
Published by **YOUTHLESS (ASCAP)**
Photography by **JO McCAUGHEY**
Design by **MATTHEW JACOBSON**

TMR128

TMR
128

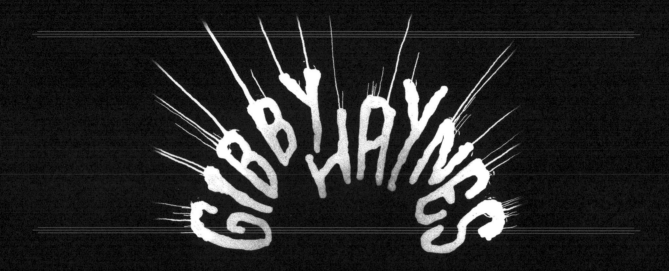

TMR-179

Best known as the antic-prone frontman of the 80s acid rockers Butthole Surfers, Gibby Haynes' Blue Series release is notable for being his only release as a solo performer under his own name. Showcasing a cover of Adrenalin O.D.'s "Paul's Not Home" with TMR Blue Series photographer Jo McCaughey credited as "Mother's Voice" and vibrachime/doorbell, plus TMR's own consigliere Ben Swank on drums, Haynes' comment upon entering the Blue Room for his photo session was "Oh … BLUE series. I thought you said blues series." The limited edition version of this release was pressed on discarded x-ray film in the manner of "roentgenizdat" records in Russia, a method of smuggling and bootlegging Western music into the country during the Cold War. Due to Haynes unavailability, Swank has stepped in to describe the session and is interviewed by Third Man Books editor Chet Weise.

A SIDE: PAUL'S NOT HOME
B SIDE: YOU DON'T HAVE TO BE SMART / HORSE NAMED GEORGE

RELEASED: FEBRUARY 14, 2013

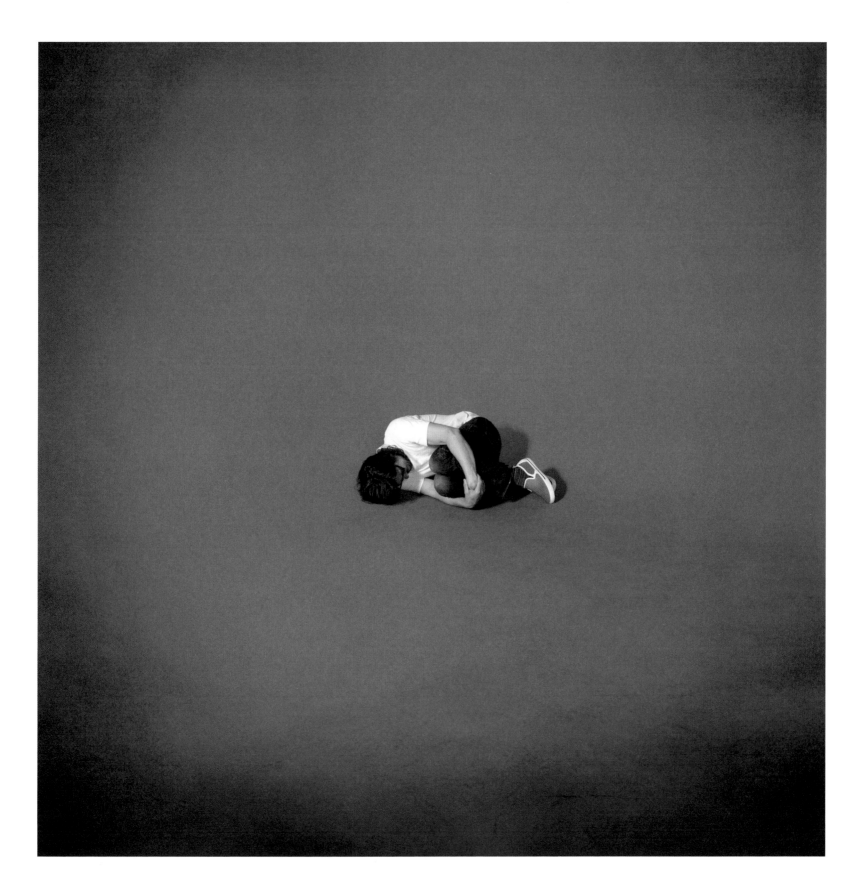

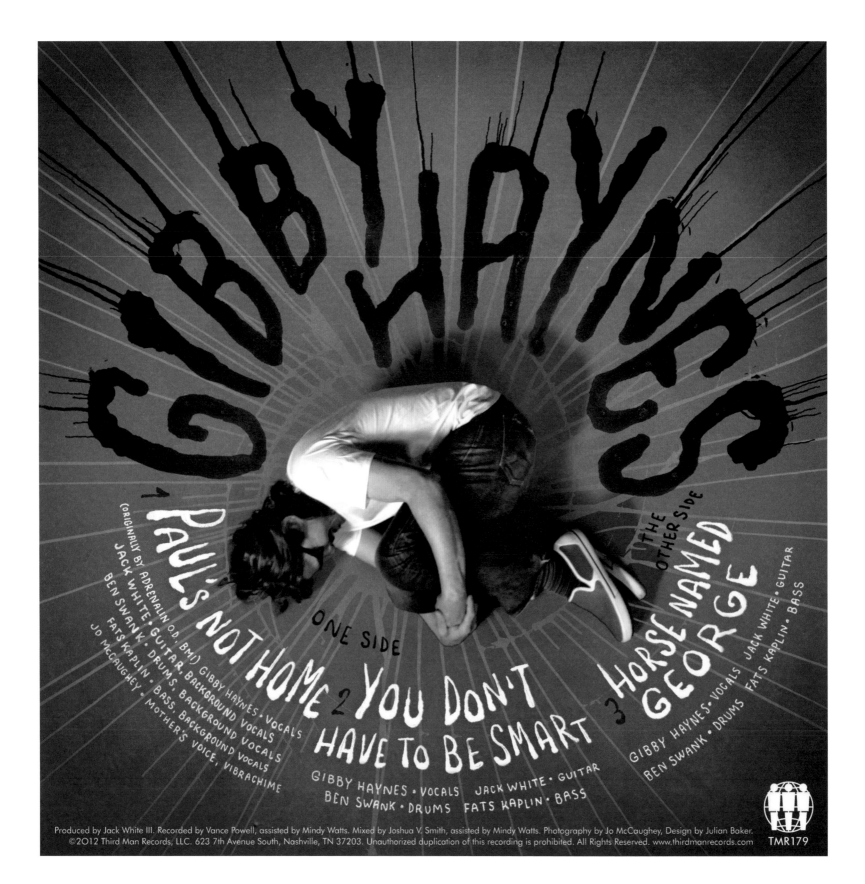

GIBBY HAYNES

ONE SIDE

THE OTHER SIDE

1 PAUL'S NOT HOME

(ORIGINALLY BY ADRENALIN O.D. BMI)
JACK WHITE • GUITAR, BACKGROUND VOCALS
BEN SWANK • GUITAR, BACKGROUND VOCALS
FATS KAPLIN • DRUMS, BACKGROUND VOCALS
JO McCAUGHEY • BASS, BACKGROUND VOCALS
• MOTHER'S VOICE, VIBRACHIME
GIBBY HAYNES • VOCALS

2 YOU DON'T HAVE TO BE SMART

GIBBY HAYNES • VOCALS JACK WHITE • GUITAR
BEN SWANK • DRUMS FATS KAPLIN • BASS

3 HORSE NAMED GEORGE

GIBBY HAYNES • VOCALS JACK WHITE • GUITAR
FATS KAPLIN • GUITAR
BEN SWANK • DRUMS JACK WHITE • BASS

Produced by Jack White III. Recorded by Vance Powell, assisted by Mindy Watts. Mixed by Joshua V. Smith, assisted by Mindy Watts. Photography by Jo McCaughey, Design by Julian Baker.

TMR179

"I played the house drums which are kind of the Jack White / The Dead Weather kit. Which is a lot of drums for a guy of my size and competence."

BEN SWANK

CHET WEISE: How did it come about that you did a session for Gibby Haynes from the Butthole Surfers?

BEN SWANK: I think Jack met Gibby in New York possibly and told him about the Blue Series and asked him if he would be interested in contributing to it. And then kind of helped pull it together directly with him, he doesn't really have a team or anything anymore. How I became involved, I literally seemed to remember (although my memory is tricky), Jack called me the morning of the session asking if I wanted to come join in on drums.

WEISE: You had no previous indication that you were going to be the drummer?

SWANK: No. Not until the day of or the day before the session.

WEISE: When you went to the session were there drums already set up, did you bring your drum set?

SWANK: I played the house drums which are kind of the Jack White / The Dead Weather kit. Which is a lot of drums for a guy of my size and competence. But I should point out that, I don't know if he does all sessions that seat-of-the-pants. I do know that he doesn't like to overthink what his approach is going into the studio. He likes to act instinctually building out the tracks.

WEISE: It seems like from a lot of the recollections that a call the day of/ the day before is not unusual. In fact, when talking about the Tom Jones recording session, Jack mentioned that if players had known a week in advance, that they would have come in to record with a bunch of preconceptions. Would that have happened with you with the Butthole Surfers? Would you have come into that thinking —

SWANK: I would have said I couldn't do it cause [laughs] I'm not like a competent drummer in that — I'm not a session drummer,

you know, so I would have been too nervous. But in the moment it was, "Yeah I'm into it, let's go." I can do punk rock drums so I was just kind of assuming that would be it. If I would have known too far in advance, I might have sweated it a little.

WEISE: Were you happy with the recording?

SWANK: Recordings, absolutely. My performance, I could have done better [laughs].

WEISE: I remember you sending me the songs and you were pretty excited about it.

SWANK: I mean yeah, I was excited about it. I was excited to play with Gibby. But I always think I can do better in the studio.

WEISE: Did you guys run through the song once or twice? Did you hear the song first? How did it happen?

SWANK: So what happened is actually really funny. He came in and keeps going into this really bluesy song, "The Horse Named George," and we just thought wow, that's really unusual for him, that he brought this kind of Chicago 12-bar kind of call-and-response style song to the table, and he's saying, "It's blues, it's blues." And then we realized, oh hold up, he thinks this is the *blues* series. That it didn't jive for him that it was named Blue Series based on the color scheme and the binding factor of Jack producing all the singles. He thought it had to be a blues song, so he wrote a blues song for the thing [laughs]. Saying that, it's a very Gibby Haynes "Horse Named George" sort of song, it's very dark.

WEISE: Did he say anything about the song once he heard it? Did you have any communication with him afterward?

SWANK: I think he really liked it. And then the other song we did was an Adrenaline O.D. cover, "Paul's Not Home."

WEISE: Who's Adrenaline O.D.?

SWANK: It's a New Jersey hardcore band.

WEISE: So nothing like blues.

SWANK: No, no cause once that was kind of out of the way, we were "oh no, it doesn't have to be a blues song." He said, "oh cool, well I've got this other idea." He wanted to do the "Paul's Not Home" Adrenaline O.D. cover, that was a lot of fun. Cause it's just pretty sloppy and crazy, and he kinda didn't want anything from the recordings except to make sure that AOD got some money out of it from the publishing. Which was, I thought, a really cool gesture. So it was me, him and Fats who recorded. I think Fats played bass. I have a very murky memory.

WEISE: Did you listen to the AOD song first?

SWANK: We never listened to it we just played it [laughs].

WEISE: You just got on the instruments for both songs —

SWANK: Just rocked it out. "The Horse Named George" is pretty standard-like bluesy type structure. The AOD began as a knock-knock joke, the doorbell rings, we have Jo McCaughey come in and do the voice of Paul's mom: "Is Paul home?" "No Johnny, Paul's not home." And it's just like, "1, 2, 3, 4! Paul's not home, Paul's not home, Pauls' not — "it just goes like that. I

should add that Gibby as a man in his 50's played the role of a smart ass kid pestering his friends mom ringing her doorbell and asking annoying questions over and over really well.

WEISE: Note: Ben Swank mimes drumming during interview.

SWANK: [laughs] Um, but yeah I think that the thing I mentioned to you that I thought was really interesting was I never played on a Blues Series before or since, and I think that's just Jack understanding that I would be the right person for the recording, because clearly I'm a huge Butthole Surfers fan, but also he knew it might be a fast and loose session and that's kinda my style.

WEISE: When you guys recorded the song did Jack give any direction as far as playing?

SWANK: A bit. But yeah, honestly, it's hard for me to remember specifics but you know, "Try this, don't do that so much."

WEISE: Tempo kind of stuff?

SWANK: Tempo type things, yeah. Nothing major, not overhauling the whole thing, just kind of pulling it back a little bit so it wasn't so full on.

WEISE: Were you there for the mix?

SWANK: I think we rough-mixed it that day. Cause we were doing stuff with Jo and the doorbell.

WEISE: Did Gibby and Jack work together on the mix, or did Gibby lay back, or Jack lay back, or do you remember?

SWANK: I think Gibby kinda let Jack just take the drive. He was just happy for Jack to be in charge.

WEISE: Did you have any contact with Gibby post-recording session?

SWANK: He called and texted me for about a week, he would Facetime me, too.

WEISE: About the record?

SWANK: I couldn't tell — no. I couldn't tell, it was always just like nothing. I couldn't tell if it was like he was either butt-dialing me or you know —

WEISE: There wasn't any message?

SWANK: No, it would be him on like Facetime and he would make a face and hang up. Or, he would text me weird pictures or memes [laughs]. And I would reply and then he wouldn't reply back. It was almost like, "Let me see if this guy can hang with Gibson."

TMR
179

BRITTANY HOWARD AND RUBY AMANFU

TMR-201

Germinating from a backstage conversation between Howard, Amanfu and Jack White during his 2012 solo tour where Howard's band Alabama Shakes opened, the impetus of this single was Brittany mentioning that she'd been teaching herself how to play Memphis Minnie songs. Amanfu sang backup for White at the time and the pairing of the two powerful vocalists seemed to make itself, with Minnie's "When My Man Comes Home" ably backing Rodriguez's "I Wonder," released hot on the heels of the *Searching For Sugarman* documentary (chronicling Rodriguez's unexpected rediscovery) winning the Academy Award for Best Documentary.

A SIDE: I WONDER
B SIDE: WHEN MY MAN COMES HOME

RELEASED: MARCH 12, 2013

BRITTANY HOWARD AND RUBY AMANFU

A-SIDE

I WONDER
(RODRIGUEZ)

RUBY AMANFU
Vocals

BRITTANY HOWARD
Vocals

DOMINIC DAVIS
E. Bass

DARU JONES
Drums

CORY YOUNTS
Piano

IKEY OWENS
Keys, B3 Organ

FATS KAPLIN
Steel, E. Guitar

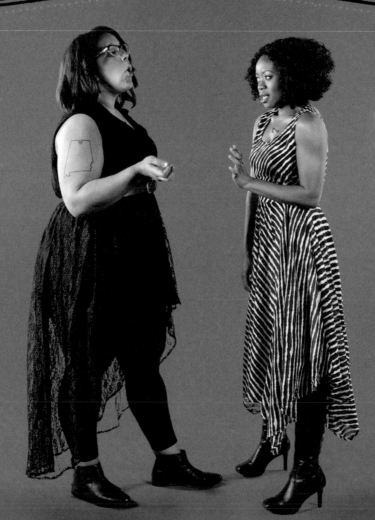

B-SIDE

WHEN MY MAN COMES HOME
(MEMPHIS MINNIE)

RUBY AMANFU
Vocals

BRITTANY HOWARD
Vocals, Acoustic Guitar

DOMINIC DAVIS
Upright Bass

DARU JONES
Drums

CORY YOUNTS
Piano

IKEY OWENS
B3 Organ

FATS KAPLIN
Mandolin

Produced by Tall Poppy Red. Recorded by Joshua V. Smith, assisted by Mindy Watts. Mixed by Joshua V. Smith. Photography by Jo McCaughey, Design by Julian Baker.

TMR 201

"I had just purchased the DVD Searching for Sugarman and had watched it and cried. Hearing 'I Wonder' really moved me, so I asked Britt if she'd be down to do that for one of the tunes. I think it was a happy marriage."

BEN BLACKWELL: How were you asked to record a Blue Series single? Were you surprised?

RUBY AMANFU: We were out touring in 2012 and were playing a festival in Belgium. Alabama Shakes happened to be playing the same festival on the same evening as us, so we got to have some good times backstage. I remember it had been raining a lot and a lot of mud was everywhere (a pre-requisite for most festivals, right?) Anyways, after our set, Britt and I were hanging outside talking, standing in the driest patch of Belgian earth we could find and Jack walks up and says, "Hey, you gals wanna do a Blue Series together?!" There was only one answer to be given!

BLACKWELL: Were you previously aware of any Blue Series records before being asked to record? Any stick out to you as being favorites?

AMANFU: I had only been hip to the Blue Series collection for about a year and a half at the time I was asked to do one of my own with Britt, but I've had a few memorable experiences with them in general. I actually sang and also played percussion on a couple of them — the first of which was recorded on the very first day I ever met Jack. I had been invited to the studio to meet him; and when I arrived, he was in the middle of recording Chris Thile and Michael Daves' Blue Series single. I sat in the control room with Vance for about an hour (and with Jack when he wasn't tracking as well), just taking in the sights and

sounds. Suddenly, Jack asked if I would go into the tracking room and attempt to vocally mimic an electric guitar lick that he had recorded. I had never done that before outside of messing around when I'd listen to Journey or Zeppelin or Aerosmith! Well, I guess I nailed it because it ended up making it onto that Blue Series, along with some other parts I sang and some percussion I played that day as well. That's a nice way to get to know someone, I think!

My favorite Blue Series experience was working with Seasick Steve. Man oh man. "Write Me A Few of Your Lines" was one of my all-time favorite things to sing and get to record with Steve and the guys. I'll never forget that day that turned into a wonderfully raucous night.

The concept of a "single-driven" offering to fans makes a tremendous amount of sense to me. For an artist, to know that if you have a song on your heart you don't have to wait until you've got, like ten songs before you can put them out into the world. It also allows for easy collaborations between fellow musicians and that doesn't always happen so seamlessly in the business in this day and age.

BLACKWELL: What was the feeling while recording in the studio? How do you decide which songs to record? The Rodriguez cover is so spectacular ... how does that song speak to you, if at all? How about Memphis Minnie?

AMANFU: Jack had left it up to us to come up with the sides for the Blue Series and Britt and I decided we would each bring a song to the table. I had just purchased the DVD *Searching for Sugarman* and had watched it and cried. Hearing "I Wonder" really moved me, so I asked Britt if she'd be down to do that for one of the tunes. Britt offered up the Memphis Minnie tune which I truly couldn't have loved more. I think it was a happy marriage.

BLACKWELL: Did Jack impart any insightful knowledge or advice in the session? What was your impression of him as a producer?

AMANFU: One of the things I love most about working with Jack is the confidence he instills in the musicians around him. It's not always instant, of course, but that's largely dependent on the musician. Coming into a session calm and focused helps a lot, because mostly it's about the free flow in the room that is captured to tape. If you're not present in the midst of that, you're not going to be able to flow. Creatively, we generally make it up as we go, and there's no right or wrong until you try it once or twice. So I learned to find confidence in that approach because it's all about energy first and foremost, not perfection. I've redefined the word perfection since working with Jack, and I much rather prefer the new definition.

BLACKWELL: Did you notice any newfound attention after releasing a record on Third Man? Did it help you out at all in your career?

AMANFU: None of Jack's fans knew my name for a while (unless they read the credits or sought it out), whether on Chris & Michael's single, Seasick Steve's, or even *Blunderbuss* or *Lazaretto*. When Britt and my Blue Series came out it finally put a name to the face for me, and Jack's fans finally identified that I was in fact a career artist and that singing backup, though exciting and new, wasn't the only thing I did or even what I had ever done before working with Jack. As much as I and everyone inevitably in Jack's all-male and all-female touring bands for *Blunderbuss* are artists, it's still not a common thing for fans to view us as more than sidemen. So I appreciated that opportunity that Jack gave me to be known by his fans as an artist in my own right.

BLACKWELL: Any thoughts of the session players on your recording? It's pretty much Jack's all-male backing band "The Buzzards" ... were you aware of that? Any special connection to that group?

AMANFU: Hahahaha ...

TMR-202

Shovels and Rope's pairing of Bruce Springsteen's "Johnny 99" and Tom Waits' "Bad As Me" is, as of February 2017, still the only 7" single released by the Charleston, South Carolina husband and wife duo since they began performing together in 2008. The "No Vacancy" sign the band is sitting on in the back cover photo was gifted to Jack White and Third Man Records by none other than Mike Wolfe from the television show *American Pickers* and proudly hangs in the Third Man Records warehouse. It lights up every time the big blue garage door opens or closes.

A SIDE: JOHNNY 99
B SIDE: BAD AS ME

RELEASED: APRIL 2, 2013

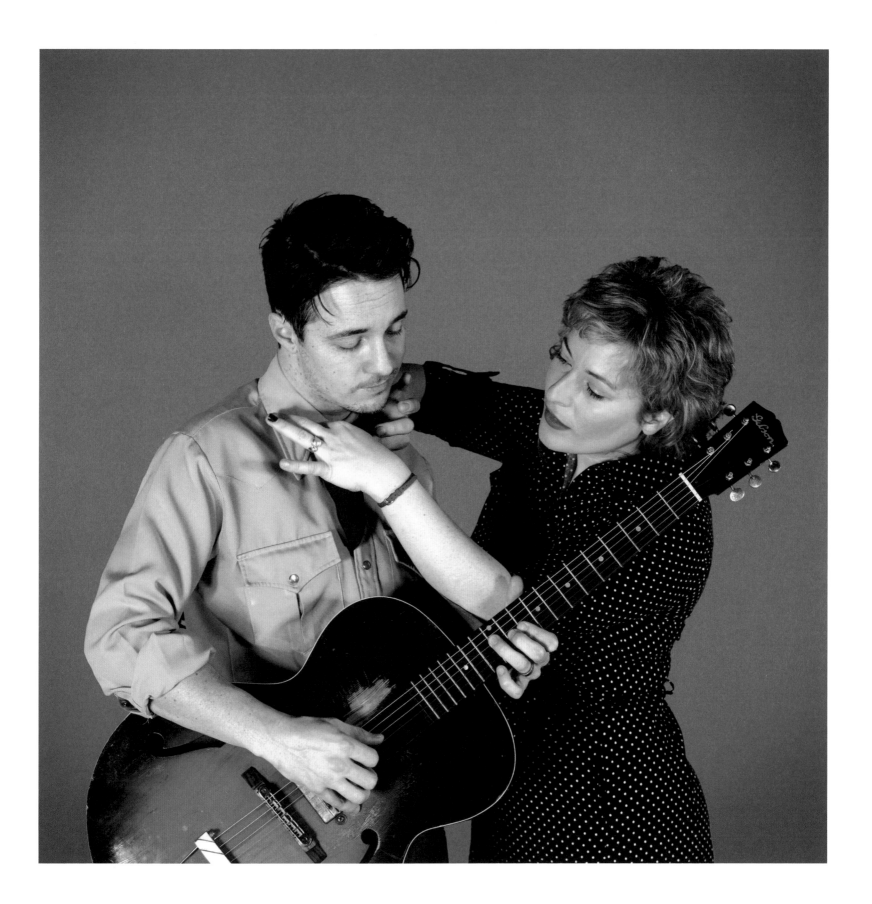

SHOVELS & ROPE

side A

JOHNNY 99
(Bruce Springsteen)

side B

BAD AS ME
(Tom Waits)

Cary Ann Hearst:
Vocals, Piano

Michael Trent:
Vocals, Drums

Cary Ann Hearst:
Vocals, Drums

Michael Trent:
Vocals, Guitar

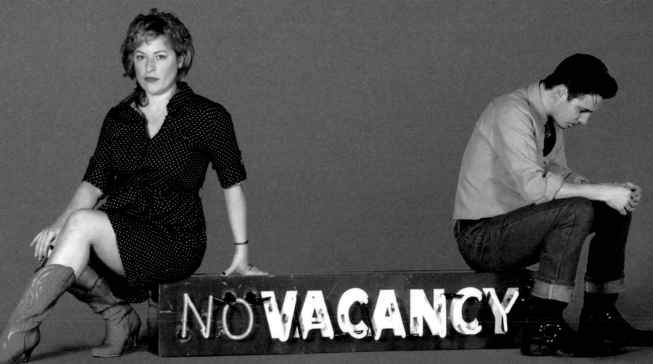

NO VACANCY

Produced by Tall Poppy Red. Recorded & Mixed by Vance Powell, assisted by Joshua V. Smith. Photography by Jo McCaughey. Design by Trent Thibodeaux.

TMR-202
www.thirdmanrecords.com

"That performance was live to tape, no messing about. The boo boos are real, the heart is real, there's no make-up on it. So it's a deep dark truthful mirror to where we were musically for better or worse."

BEN BLACKWELL: How were you asked to record a Blue Series single? Were you caught-off-guard by the offer?

SHOVELS & ROPE: We were very excited to get to have that opportunity for many reasons. First of all, we are fans of Jack's music and his aesthetic. We were excited to get to work with him, because we knew we would learn something or be inspired in some way. Also we were curious about his home studio. You can tell a lot about a person by their studio and we were excited to see into his mind in that way.

BLACKWELL: Were you previously aware of Third Man? Any thoughts about Third Man in general? Or even Jack?

SHOVELS & ROPE: We were definitely aware of Third Man. One of the cool things about Jack White is that he is a proletariat-hearted guy — works hard, stays busy. He is always building real business and never is his livelihood subject to the whims or risks of others. Third Man is an amazing company. They do what they want and they have fun doing it. It's a model for what can be done when you're up for it.

BLACKWELL: What was the the feeling while recording in the studio? Was there anything specific behind the decision to record the Waits and Springsteen songs?

SHOVELS & ROPE: The feeling was excitement and intrigue. Also, it was one of those times when you have to go into a super

professional place in your head and let go of preconceived notions about people who you feel like you know. You can't operate with them as the person who is famous who you see on TV, you have to recognize them as just a person. A working artist. Pants one leg at a time and all that ... so that you can work together in a genuine way. It was awesome. We chose to do the band version of "Johnny 99" from Springsteen's *Nebraska* (which is just a fantastic album) using just piano and drums. And the Waits' song was one that we just loved the herky-jerkyness of ... It seemed to reference the kind of sexy co-dependence that resonates with us [laughs].

BLACKWELL: Did Jack impart any insightful knowledge or advice in the session? What was your impression of him as a producer?

SHOVELS & ROPE: He is happy and having fun playing music in there. He works fast and that works for us because we work fast too. We got the room sounding good and then that goes to tape. Super real, no overdubs. He did warn us that the guy/girl band thing never works out.

BLACKWELL: What did you think about the studio space, the equipment used, the vibe in the room? Inviting? Cold? None of the above?

SHOVELS & ROPE: The studio space was a creative wonderland. We are afraid to be specific because it's like telling on Willy Wonka — he

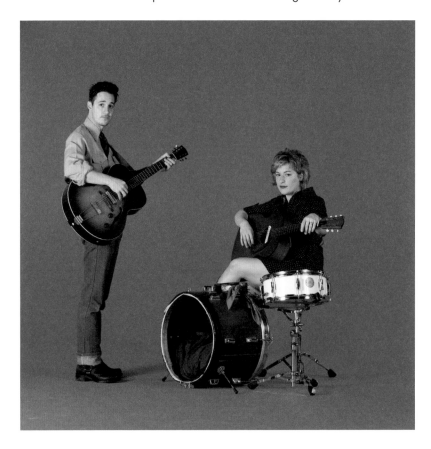

has a revolving speaker mounted where the ceiling fan goes, man. It sounds amazing. It was totally inviting. It was an honest-to-god garage studio, just badass gear — old analog everything, great amps. Every instrument sounded good and sounded interesting.

BLACKWELL: Did you notice any newfound attention after releasing a record on Third Man? Did it help you out at all in your career?

SHOVELS & ROPE: That year was an exciting year for us. Our collaboration with Third Man was certainly a professional highlight. It's often impossible to measure those kinda metrics as to the effect it had. We sold an awful lot of those 7"s on tour and it felt really awesome to see our dumb faces on that pretty record in that killer shop on 7th.

BLACKWELL: What was your main takeaway from the session and subsequent release?

SHOVELS & ROPE: The Blue Series was such a great way to capture an artist at a certain moment in time. For example, we were captured during a little growth spurt. We were introducing the idea of a real piano into our own live show. That performance was live to tape, no messing about. The boo boos are real, the heart is real, there's no make-up on it. So it's a deep dark truthful mirror to where we were musically for better or worse. You gotta be ok with that — showing your real self-warts and all. It's good and honest and that's a hallmark of Mr. White's brand and that's what the good folks at Third Man work so hard to curate.

TMR
202

MICHAEL KIWANUKA

TMR-215

Raised in Muswell Hill, London as the son of parents who escaped Idi Amin's regime in Uganda, Michael Kiwanuka is an acclaimed singer-songwriter whose albums *Home Again* and *Love & Hate* have garnered high praise and comparisons to the likes of Bill Withers, Van Morrisson and other greats. Having supported Adele on a portion of her 2011 tour dates, Kiwanuka has enjoyed a higher profile since those appearances. The B-side of his single is a cover of the classic Townes Van Zandt song.

A SIDE: YOU'VE GOT NOTHING TO LOSE
B SIDE: WAITIN' 'ROUND TO DIE

RELEASED: FEBRUARY 18, 2014

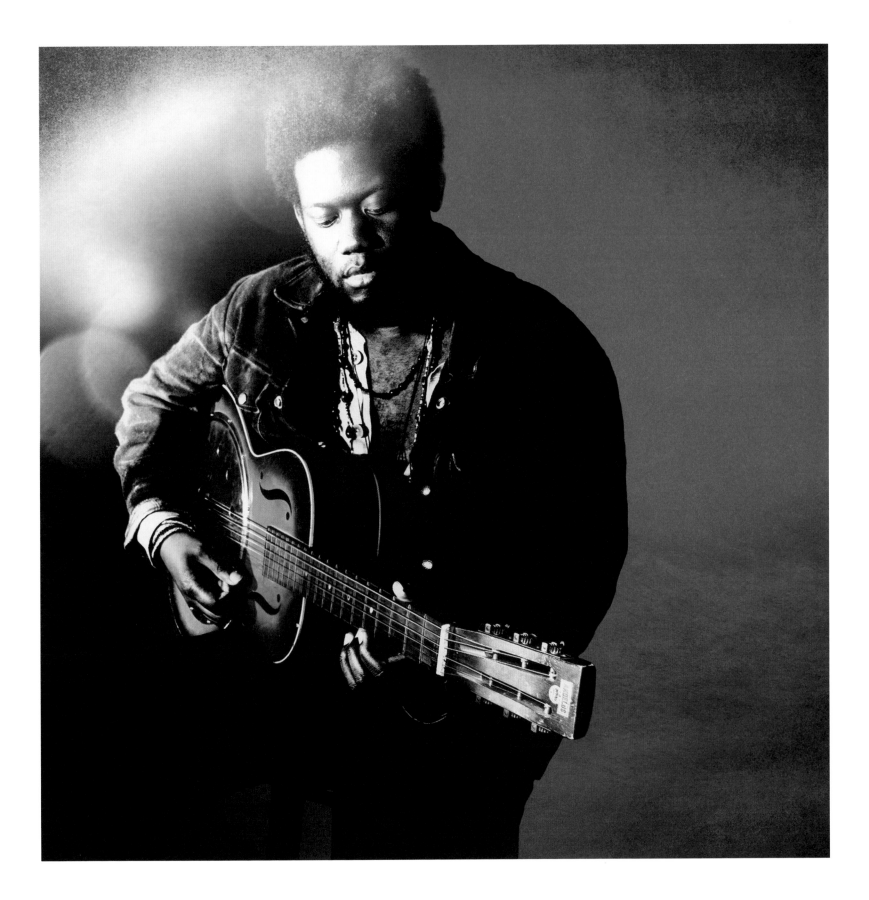

MICHAEL KIWANUKA

A. YOU'VE GOT NOTHING TO LOSE / B. WAITIN' 'ROUND TO DIE (TOWNES VAN ZANDT)

SIDE A

You've Got Nothing to Lose
Michael Kiwanuka
Communion

Michael Kiwanuka: Vocals, Acoustic Guitar
Lillie Mae Rische: Acoustic Guitar, Fiddle
Cory Younts: Piano
Dominic Davis: Upright Bass
Jeremy Lutito: Drums

SIDE B

Waitin' 'Round to Die
Originally by Townes Van Zandt
Silver Dollar Music, Inc. (ASCAP)

Michael Kiwanuka: Vocals, Acoustic Guitar
Lillie Mae Rische: Acoustic Guitar, Fiddle
Cory Younts: Wurlitzer, Piano
Dominic Davis: Upright Bass
Mickey Grimm: Drums

"This direction in particular was exciting and worked for me because I love singing, and I love performing, and the emotion of music the most."

BEN BLACKWELL: How exactly did you come about to recording this Blue Series single?

MICHAEL KIWANUKA: Well it was after my first album, and I wanted to work on some music, and I'm a huge fan of Jack White and The White Stripes. I discovered the Blue Series that he did and realized what he was doing. And mainly the Laura Marling one where she does "Needle and the Damage Done," she does a cover of that which I really liked. I think Brittany Howard had just done one as well. And I'm enjoying that, so I was like man, it would be like a dream to do one. So I actually reached out and asked would Jack be up for me coming down and trying to record some songs with him, I wanted to work with him on the Blue Series. It was kind of like a longshot, I thought maybe he would say no, but luckily for me he said yeah. And I went down to Nashville.

BLACKWELL: Nice. And did the fact that you were coming to Nashville, did that at all influence the idea of doing a Townes van Zandt song?

KIWANUKA: Yeah, definitely. Because I was just kind of getting into Townes and I had just seen *Heartworn Highways* and was just really into his music and especially that song that got famous, that performance when Uncle Seymore starts crying and stuff. I was thinking, well, it would be so cool to be in America — I love American music — for me to do someone that's like a modern day kind of American hero, and it would be amazing to try and see if I can record that song in Nashville, and I know it's in their blood to help me record it, and we could get people to know that music. So that was a huge influence and reason why I did that song.

BLACKWELL: And you just came by yourself, right? Or did you bring anyone with you to record?

KIWANUKA: I came on my own. I was excited because at that time Jack was touring his *Blunderbuss* album with his incredible band. I didn't say anything but, I was kind of hoping that maybe some of his band would be there, but I came ready on my own.

BLACKWELL: Right. Well then, what you were hoping for ended up happening — a bunch of guys from his band ended up playing on the record.

KIWANUKA: Yeah, which was amazing. We just played and cut to tape. And actually the coolest experience was doing the Townes song, 'cause the first tune I wrote and we just did it in a couple of takes, and we spent a bit more time on the Townes cover to just really get the emotion and the feeling right. Which is what I wanted, I wanted to see how far I could go with it, and Jack wasn't planning on using the reverb buzz and we just played that tune again and again and really got into it.

BLACKWELL: Had you ever done a session before where you just walked in not knowing who the band was gonna be?

KIWANUKA: No, I've never done that and so I was nervous. It was exciting and cool, because at that point, I believe it was my second time in Nashville, but I'd never spent more than an afternoon there, and never seen it, and then, on top of that, I had never kind of went into a studio on my own with people I've never worked with. So I was like terrified that I would start and then people would be like "Man, you're lame" [laughs]. So it was nerve-wracking but it was exciting as well, it was just a refreshing experience. Yeah I'd never done that before.

BLACKWELL: Was it a little like first day of school, am I gonna know anyone kind of thing?

KIWANUKA: Exactly. And also being a massive Jack White fan, it's always nerve-wracking working with people you've been listening to since you were like in school. You're excited but you're also terrified. So yeah.

BLACKWELL: So what was it like in the studio with him as a producer, what did he bring to it? What was your experience to being "produced"? How did that go over for you?

KIWANUKA: It was cool. Every producer is different. This direction in particular was exciting and worked for me because I love singing, and I love performing, and the emotion of music the most. That's the thing that really keeps me excited when I hear a record it's like. It's the feeling of amazement that keeps me wanting to play. And that's what we did to record that record. The way Jack works is very much performance and emotion-based. So the first few we did relatively quickly, and it was pretty

straightforward and the band learned and played it in three or four takes. But with "Waitin' Around to Die," it wasn't doing the most takes to try and get the right notes, it was to really get the emotion and the feeling across. So that was really cool just being able to focus on the performance and the feeling of the music.

BLACKWELL: Had you worked on tape before?

KIWANUKA: I had worked on tape before, but I didn't get to do it much. But it's not like a common thing, even since then I don't think I've recorded to tape. Recording and hearing music back on tape, and everything live with no overdubs, for a musician if you like playing music or being in a band, it's the best most exciting way to record.

BLACKWELL: Was there any reasoning or inspiration behind your song "You've Got Nothing to Lose"? You came in with that. Did you have any discussions prior with Jack about some ideas or something to come in with? How does that song become the song?

KIWANUKA: Well, we didn't really, I hadn't spoken to Jack before I got to Nashville. I always try to write songs or have ideas, and it was the most recent song I liked. There wasn't a particular reason other than that I thought it was cool and it might be a good way to start, to have one original, and then I know I could do some covers and that Townes song. So I always try and have at least one original written song with any kind of release I'm doing or any collaboration I'm doing.

BLACKWELL: More so than any other artists on the Blue Series, you've done a lot of 7-inches, you've done a lot of singles.

KIWANUKA: Yeah, yeah.

BLACKWELL: Is there a time and way to approach a single versus how you approach an album? For us here, I feel like singles are quick, they're of the moment, and you hurry up and get them out, and there's never really huge expectations, at least when you're just focusing on a vinyl 7" single, this isn't like a Rihanna or Jay-Z single or something like that. When you think of recording a single or releasing a single, what does that bring to your mind? What is your thought and approach? You said an original plus covers is part of it, but I'm curious if there's any more behind it.

KIWANUKA: For me, it's like an album (in my experience in my short career). In my head when I go in and I want to do an album, it's a big, it's like a big mountain to climb. I'm always like you know, you want it to be beautiful from beginning to end, and all that stuff thinking like classic albums. Sometimes the idea of doing a full album is overwhelming. And for me why I like singles or 10-inches, small pocket snapshots, you let the feeling and just the creativity go first, you're almost like precious with it, you know? Not like in a bad way, you can be way more vulnerable on a single and not

kind of so concerned with all these other parts of the process. I thought as much about the cover as I did my own song, because it's just A-side/B-side so I thought I'm definitely going to do the Townes tune and maybe, if it works out, I'll do one of my own songs because I always want to try to write my own, and that's as far as it went. It's more about the sound and to see what Jack would bring to the table and about the collaboration team/musicians. An album you can sort of get overwhelmed, so that's kind of why I like the small releases as well as the full-length album releases.

BLACKWELL: What would you say, how would you describe your profile in America at the time?

KIWANUKA: America is so big, I'd say I'm not really that known. And even now, it's like some people know me, but I definitely wouldn't put myself in a category of a huge success. I felt even more privileged that Jack and Third Man would have me come down and play and do some music, because it's not like I was doing things in Third Man terms regarding commerciality in my profile.

BLACKWELL: You said commerciality, is that what you said?

KIWANUKA: Yeah, with my profile and things like that. I know that's not Third Man's thing, but definitely, you never know, it's quite a big establishment so for someone like me, I didn't always think anyone would see my e-mail you know.

BLACKWELL: After you record the single and you release it, do you notice anything different for you in regards to what's the reaction amongst your fan base, how does everything look in the United States or England or anywhere after that comes out. What, if anything, changes?

KIWANUKA: In the UK, it was really cool. It's something that people weren't necessarily expecting so people found it interesting, like oh who thought Michael Kiwanuka would work with Jack White or Third Man? So that was nice. We have some stations over here that don't necessarily play me, 'cause I'm not like a pop act or anything, but they spun the single and spun the cover as well, which I wasn't expecting. And it brought me to a slightly new audience of people that were fans of Third Man and Jack's music who wouldn't have necessarily listened to mine. So yeah, definitely did some cool things, and it gave me confidence to kind of cover it more and just push myself to do music that maybe isn't so expected of what people would think of me.

BLACKWELL: What's unique, not unheard of, but, we don't do it often, we also did a video for the single. I don't think you were really very involved in the filming of it all, but what was your impression or thoughts on the video?

LILLIE MAE

KIWANUKA: I loved it. Basically what made me want to kind of go with Third Man and try and do a Blue Series is that they kind of have this bespoke, handmade, classy evidence to everything. It's so independent, the musicians, the artists, the photographs of the Blue Series, how the records look, the fact everything's on vinyl, no downloads — all those things have inspired me to want to, or interest me as an artist to come and be like "What should I do?" So when the video came, it reminded me of all those things, plus it had its own beautiful message and meaning that I wanted to be a part of. It kind of informed my music, when I went to start doing my second album, I wanted to have more of that into my music, be a little bit more vulnerable and get behind things I liked.

BLACKWELL: That's really awesome. I'm just looking at it right now the video has 117,000 views, which is quite a lot for something that's basically a 7" single.

KIWANUKA: So cool.

BLACKWELL: I love the fact that you took your experience here working with Third Man, and applied it moving forward, that's great. Because the whole idea of artists interacting is perpetuating further what they learn and what they like from a situation and carry it with you, and hope to influence your future self and your future situations. Isn't that why we do all of this? You know you're influenced by Townes van Zandt and all that stuff. It's really, really inspiring to hear that.

KIWANUKA: Amazing. Yeah I made it.

BLACKWELL: Is there anything else in terms of recollections or memories regarding the single?

KIWANUKA: The only thing was, it was interesting, what's really cool about doing the Townes cover was singing in English, the thing about being British, born and raised in London, you know, that song, it's so American with places like Muskogee and stuff. I didn't know what a lot of the lyrics were, so I'd ask Jack, "What's Muskogee?" You know it's a place and I was pronouncing it wrong. I liked the lyrics, but some of the things I didn't know the reference. So it was really cool, at the time I was really, really getting into that kind of American music. I've always been into American music but, I never really explored a lot of that. It was really fun, sitting with people that actually knew that history and how do you do this, what does that mean, you're saying that wrong ... that was pretty fun.

THE
DOUGH
ROLLERS

TMR-216

Guitarist Jack Byrne and vocalist Malcolm Ford are more than just the progeny of Hollywood stars Ellen Barkin & Gabriel Byrne and Harrison Ford. Along with bassist Josh Barocas and drummer Kyle Olson, The Dough Rollers have enjoyed three separate releases on Third Man with the Blue Series being their debut for the label. Said Jack White to *Rolling Stone* magazine about Byrne, "I like this kid's style. It's more in the simplistic realm of guitar playing. He's not trying to knock you over. I like watching him; he reminds me of a cool teenager or something who's just getting into playing guitar."

A SIDE: LITTLE LILY
B SIDE: THE SAILING SONG

RELEASED: JULY 9, 2013

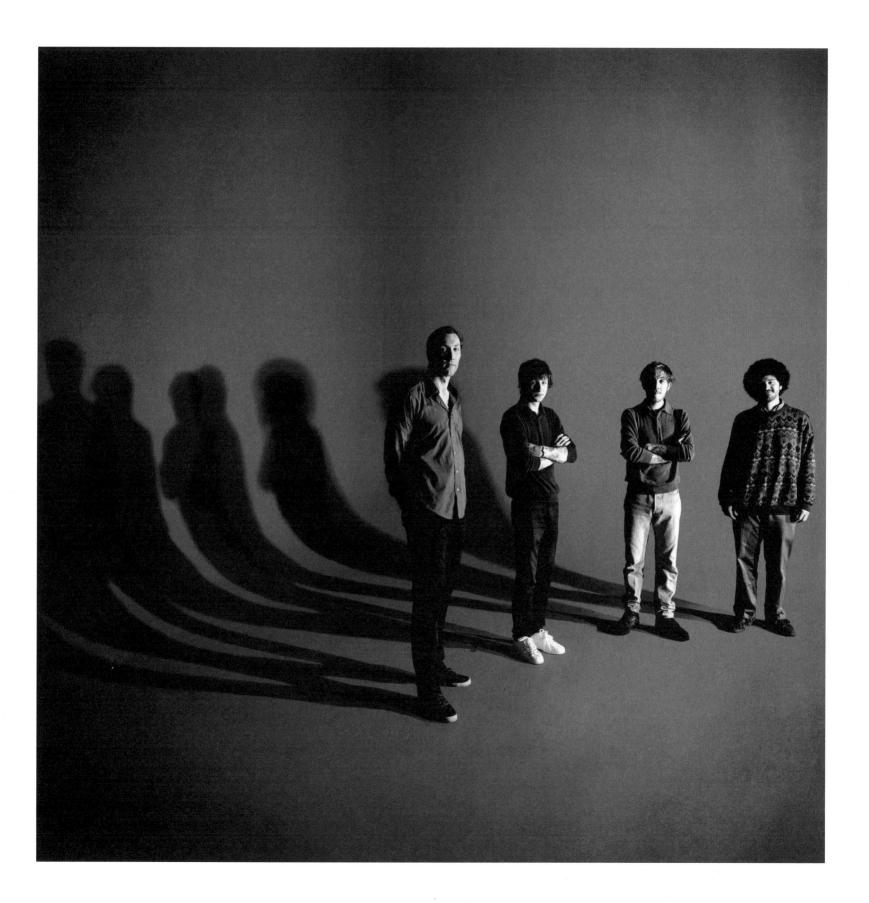

THE DOUGH ROLLERS

·A SIDE· **LITTLE LILY** · B SIDE · **THE SAILING SONG** ·

·MALCOLM FORD: VOCALS, ELECTRIC GUITAR · JACK BYRNE: ELECTRIC GUITAR, BARITONE GUITAR · KYLE OLSON: DRUMS · JOSH BAROCAS: ELECTRIC BASS·

TMR 216

Produced by Tall Poppy Red. Written by Jack Byrne, Malcolm Ford, Kyle Olson, and Josh Barocas (BMI).
Recorded by Vance Powell, assisted by Joshua V. Smith. Mixed by Joshua V. Smith. Photography by Jo McCaughey, design by Julian Baker.

"Once we got into the studio, Jack's suggestions ended up being crucial to the songs not being totally shitty."

A few words from **JACK BYRNE**

Definitely a big surprise for us when we got that call to record a Blue Series record We had been in Nashville a couple years before on tour with Queens of the Stone Age and we all ended up back at Jack's house after the show. It was an awesome night, but we weren't assuming it would turn into anything other than that. Anyway cut to a couple years later and we just got a phone call out of the blue (I think it was from Ben Swank) about coming down to record the single. Needless to say we were pretty juiced about it.

We'd heard of the Blue Series before. A good friend of ours who we'd done some recordings with also did stuff with The Secret Sisters, so he gave us the head's up on the single they put out. If asked about a favorite Blue Series single, other than ours, I think there's too many of the damn things released to pick out my favorite, but there's really been a lot of great stuff. Frank Fairfield did a very cool one.

It's funny because I can remember a few different conversations we had talking about how we thought it would be a great fit for us and Third Man after we heard our Blue Series single [TMR followed with a full length, Ed.]. I'd always really appreciated the music I heard from Jack because not only could I hear the influence of so much music that I love in it but then on top of that the creativity to take those influences and make them something his own. That doesn't come along every day. When I was a kid somebody invited me to a White Stripes show, and I just really got a kick out of seeing all of Madison Square Garden jumping up and down to all these old blues songs that I loved. I feel like I have a memory of looking around and thinking "Shit here's 20,000 some odd-people dancing to a song like 'Boll Weevil.'" That still kind blows my mind. As far as Third Man — well the fact that it can exist at all, let alone consistently put out so much different material is something that shouldn't be taken for granted nowadays.

About the session itself, it's kind of a blur to be honest just like any other recording session. But like I said we were all just really juiced to be down there so we were feeling pretty excited once we got into the studio. Plus once we got down to Nashville and everybody was so cool

and welcoming to us it just felt really comfortable. We hadn't had a lot of great positive experiences in the studio, so it was really refreshing to be in such a nice environment. I would say the only negative is that we wanted to keep doing more! We picked those two songs because we had been playing them a lot so they were pretty polished going in. Also the forms were pretty simple for both of them so they weren't too hard to crank out, which was good because obviously with the Blue Series thing you only have a certain amount of time on that one day.

Once we got into the studio, Jack's suggestions ended up being crucial to the songs not being totally shitty. Obviously for me as a guitar player, there were too many cool moments to list them all but the stuff he was doing with the echo on the solo in "Sailing Song" really opened my eyes to some new shit. Also, we went in kind of thinking, "okay these two songs are completely done, ready to be recorded," but then he really made us see we needed to reign in melody and vocal ideas for them more and Jack helped us do that. So yeah, as a producer, Jack is definitely one of our favorites that we've had the chance to work with. What else ... I also went home and bought a mini-moog as soon as we were done with the session after seeing Jack's at the studio. There's a couple amps he has over there too (like that Selmer ...) that we're still trying to hunt down.

In retrospect, after releasing that single on Third Man, things really started to pick up. We started getting real press which was something we hadn't really had up until that point. We were also being noticed for our own music as opposed to just being the opening act for bigger bands. Eventually this led to us being able to do Letterman and bigger, better paying shows etc. It's always hard to say what other people's impressions of your own music.

Aside from it just being a great time ... everybody at Third Man just made us feel like family, which again is pretty rare when you're going somewhere to record two songs and was hugely important for us as a young group trying to get started. As a band it really matured our approach to our music and recording. I don't know if I can really quantify how impactful of time that was for us, but everything was definitely different after we left Nashville.

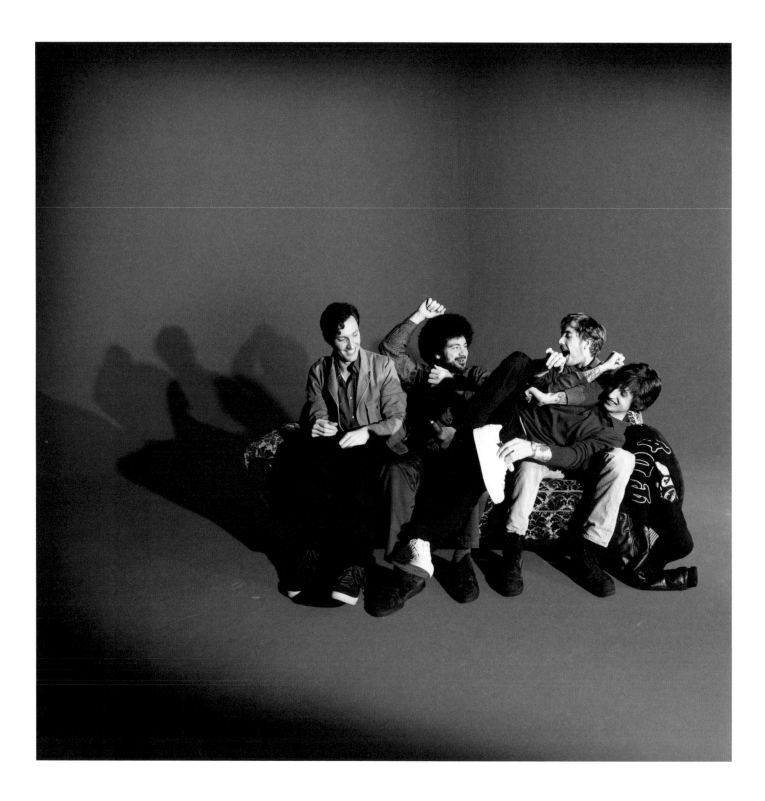

FRANK FAIRFIELD

TMR-244

Born in Fresno, California as Frank Gonzalez, the stage-named Frank Fairfield established quite the reputation for himself in the "old-time" music scene via memorable live pairings with Blind Boy Paxton and Fleet Foxes in addition to his stunning recordings of the two traditional songs on his Blue Series single as accompanied by Zac Sokolow on fiddle for the B-side. Despite his impressive vocal, banjo, guitar and fiddle work, Fairfield unexpectedly left the music business in 2015, with a scathing Facebook post that included comments such as "I don't feel I have a thing to offer. One also gets pretty sick of being as mediocre a musician as I [am] under the diligent scrutiny of all the banjo hangout bloggers in the blogosphere multiverse."

A SIDE: DUNCAN & BRADY
B SIDE: DEVIL'S DREAM MEDLEY

RELEASED: JANUARY 20, 2014

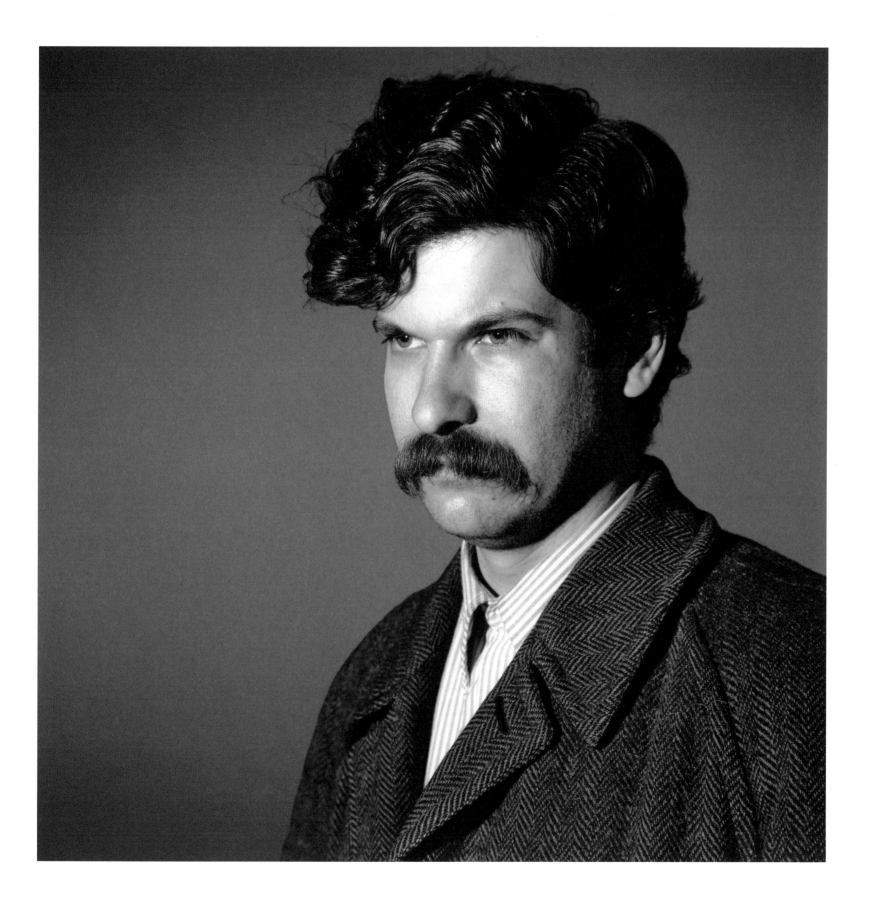

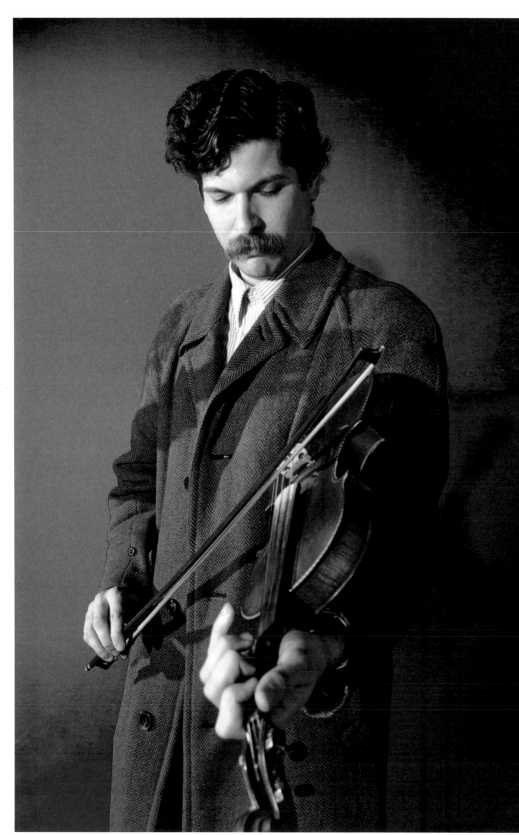

FRANK FAIRFIELD

~ Side A ~

DUNCAN & BRADY

Frank Fairfield : Vocal, Guitar

~ Side B ~

DEVIL'S DREAM
MEDLEY

Frank Fairfield : Vocals, Fiddle

Zac Sokolow: Fiddle

Recorded by Vance Powell.

Assisted by Joshua V Smith.

Mixed by Joshua V Smith.

Photography by Jo McCaughey.

Design by Julian Baker.

TMR 244

TMR
244

TMR-292

As a member of the band Jypsi along with three of her siblings, Lillie Mae was discovered by country music legend Cowboy Jack Clement in 2000. By 2012 she was touring as part of Jack White's all-female backing band the Peacocks and has played with him through 2016 ... including appearances on *A Prairie Home Companion*, *Saturday Night Live* and in front of hundreds of thousands of fans at live shows the world over. Her debut LP, *Forever and Then Some*, on Third Man was released in April 2017.

A SIDE: NOBODY'S
B SIDE: THE SAME EYES

RELEASED: DECEMBER 9, 2014

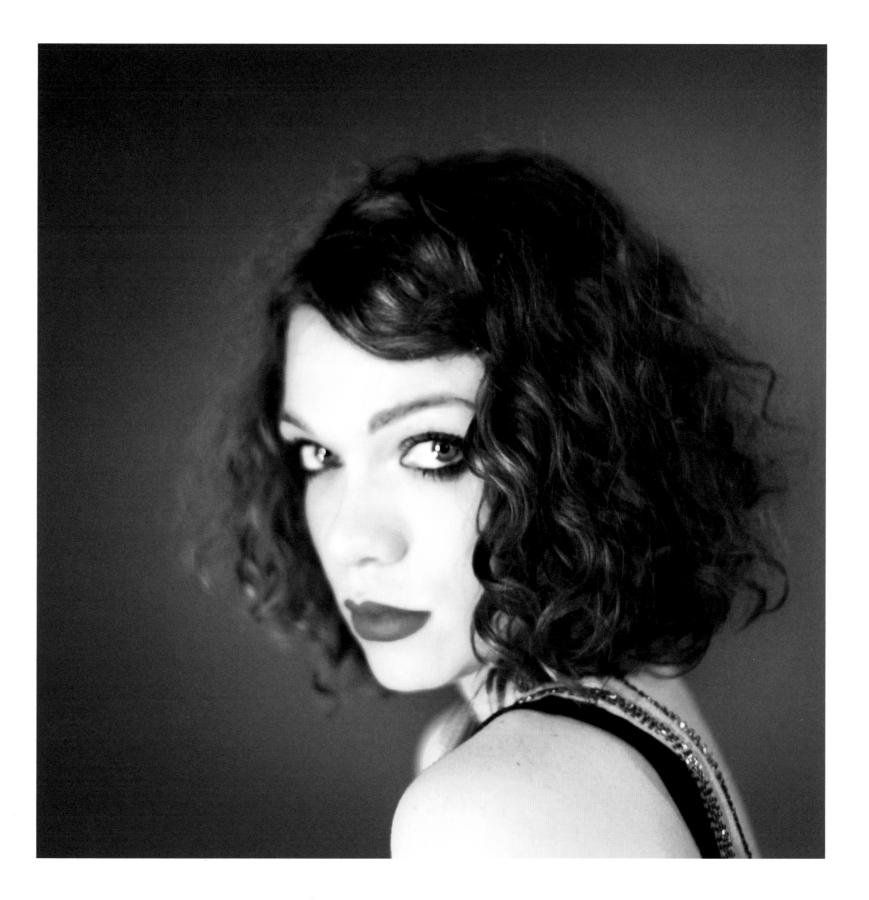

LILLIE MAE RISCHE →

Side A
NOBODY'S
Lillie Mae Rische: Vocals, Acoustic Guitar, Fiddle
Jack Lawrence: Electric Bass
Carl Broemel: Pedal Steel
Whip Triplet: Drums

Side B
THE SAME EYES
Lillie Mae Rische: Vocals, Acoustic Guitar
Dominic Davis: Upright Bass
Whip Triplet: Drums, Hammond Organ

PRODUCED BY JACK WHITE III. SIDE A: RECORDED BY VANCE POWELL, ASSISTED & MIXED BY JOSHUA V. SMITH. SIDE B: RECORDED & MIXED BY JOSHUA V. SMITH.
PHOTOGRAPHY BY JO MCCAUGHEY. DESIGN BY TRENT THIBODEAUX & JULIAN BAKER. UNAUTHORIZED DUPLICATION OF THIS RECORDING IS PROHIBITED.
ALL RIGHTS RESERVED. © & ℗ 2014 THIRD MAN RECORDS, LLC. 623 7TH AVE. S., NASHVILLE, TN 37203.
THIRDMANRECORDS.COM

TMR 292

"A very important person gives some street rat a chance, and then the street rat blows him off, and a year later he gives them a chance to come back and finish it. Who fucking does that?"

BEN BLACKWELL: You were in recording sessions with Jack before you did your Blue Series, is that correct?

LILLIE MAE: That is correct.

BLACKWELL: So how did you first start getting on Third Man sessions?

LILLIE MAE: Josh Smith called me and he had gotten my telephone number from a fellow in town, Joshua Hedley, another fellow fiddle player. And he had recommended me for some fiddle work. They called my sister and me. And so we both went in on a session. I think the first session was *The Lone Ranger.* And then he called me for a couple of things here and there —

BLACKWELL: Are these things that ended up being on his solo album at this point?

LILLIE MAE: The first session I did after The Lone Ranger session was *Blunderbuss.* When they first called me, I was living in Alabama and in the studio there, so I couldn't come in, but I did eventually make it on one track on *Blunderbuss.*

BLACKWELL: How old are you at this time?

LILLIE MAE: Ok, I was gonna say I was 19 or 20.

BLACKWELL: So at this point is this normal to you? Getting called to a session? Or is that still like this doesn't really happen to me?

LILLIE MAE: No, I've always — I mean I've never been a professional studio musician, I've never put myself in those peoples' leagues. But I've been called before, I used to just usually sing on stuff. Like I've done numerous sessions on fiddle and stuff but it's usually for a buddy or here/there. I never was a professional studio musician. But I sang a lot of demos.

BLACKWELL: You didn't start being a professional studio musician. You start just like you have friends, and —

LILLIE MAE: Right, right. I mean, as a fiddle player, like I don't think I'd ever be called for strictly fiddling. You know people are really particular about fiddle. A lot of the stuff that people require in the studio fiddle-wise, I don't do that stuff. And I never did, so it was perfect playing with Jack because he's out of that box.

BLACKWELL: Yeah, he's not giving you a chart or anything. So, you enter into the Third Man world and Jack's orbit that way, and you join his band. When does the conversation turn to "we should do a single?"

LILLIE MAE: When we were on tour, you know I am always with a guitar singing, playing, you can't shut me up. We were on the *Blunderbuss* tour, and I had written a song when we were in Washington, D.C., and I think I was playing it for Carla and Jack overheard and said, "I really like that song, we should really record something. You should come in and do a Blue Series." And so we did. We recorded two songs. The second song, it was kinda unfinished, and then it took me nearly a year, probably, or later to come back in and finish.

BLACKWELL: Why did it take so long?

LILLIE MAE: Because I made some bad personal decisions [laughs].

BLACKWELL: Fair enough.

LILLIE MAE: And I wasn't good for standing up for myself back in those days, so some things that were on the front burner in my heart, and what I wanted to do, I had put them on the back burner for somebody else.

BLACKWELL: When you're going into the situation, you're going in to record, let's just talk about the two songs that ended up on the single: "Nobody's" and "Same Eyes." Do you have a vision in your head of what you think the approach should be — we should have a full band, we should have drums — or is your thought I have a song and let's see where it goes?

LILLIE MAE: It depends on the situation. If I said, "Hey Jack, I wanna bring in these people on this." I would probably have a better idea of what it would sound like, but going into this session without having that, and playing with Jack

Lawrence on bass, who I had known but never played with him before, I wasn't sure what the outcome was going to be.

BLACKWELL: How did you take to Jack's production in the studio? What was your experience with that?

LILLIE MAE: His production is probably my favorite production. He just lets you be yourself. He allows good things to happen. He's not forceful or this or that. He really wants to hear what you have to say, musically.

BLACKWELL: Which isn't normal. It's not what you would usually encounter.

LILLIE MAE: It isn't. I mean, working with lots of different producers in the past on different projects, like very, very few give you that. I've heard that, well now I can't think of his name, I know there's that fellow who recorded the last Johnny Cash.

BLACKWELL: Rick Rubin.

LILLIE MAE: Rick Rubin. Like I've heard stories that he does that.

BLACKWELL: It's a legend in the music business that supposedly Rick Rubin lets you do what you want.

LILLIE MAE: But I don't think there's very many. You know, the experience I've usually had is "do this, do that, do this, do that" a hundred thousand times, until you're just discouraged, you have nothing left to give, and you're not gonna make anything magical.

BLACKWELL: Yeah, it makes you hate the process.

LILLIE MAE: It sure does.

BLACKWELL: You said Jack overheard you playing "Nobody's," so "Same Eyes" you brought in. Was that something you were kicking around for a while or something that you had written in the lead up to recording it?

LILLIE MAE: Both of them I wrote on tour, but I think probably I was leaning towards "Nobody's" because I liked it, or it felt good — I don't mean like [in a voice] "I like that song" — like it came out naturally and I always kind of leaned towards that song. And Jack liked it, so I said "Ok perfect. We can do that one and what other one are we gonna do?" We chose "Same Eyes" for the second because it was written on tour and it was kind of fresh.

BLACKWELL: You're saying you wrote it on tour with him?

LILLIE MAE: Yeah.

BLACKWELL: Does writing songs just come, it just happens?

LILLIE MAE: Absolutely. I'm not good at trying to make it happen. I've been down that road. Sit down and try to create something. I'm no good at that. When a song starts to come up, to me, it's ok I gotta go outside or something, or go somewhere they can come through, and it's my obligation to write them down.

BLACKWELL: That's a great way to envision it. Creative people are just conduits for whatever's out there. And I think that comes through in just knowing you and watching you perform. In recording the single, it takes a second to get it all finished, when it comes out do you notice anything different in your world, in your day-to-day performing, whether it's performing with Jack or performing with your family?

LILLIE MAE: I would say that it being maybe Jack's world and on Third Man, that was a different door musically — I had never reached people in that department of music before.

BLACKWELL: People who are collectors and buy whatever we put out, they are exposed to you whereas otherwise they wouldn't.

LILLIE MAE: Right. And through a lot of gigs, through the last couple years, people have brought the single to family band shows to either show me or sign it. That was different. I don't get out much in a way, and I'm not online a whole lot.

BLACKWELL: So your experience in terms of impact is only what you see in real life.

LILLIE MAE: Yes, exactly that was what I was trying to say, thank you [laughs]. Thanks!

BLACKWELL: It's unique for you also to be a member of Jack's touring ensemble. I remember around that time Jack saying, "Yeah man, Lillie Mae has fans! People come to Jack White shows, they hold up signs for Lillie Mae, and people go nuts for her!" That's pretty awesome, that's pretty unique. Whereas a lot of guys in his position would take that as an affront. "No! This is my show!"

LILLIE MAE: Absolutely. They would squash it immediately. Squash it and any chance of that happening. And Jack is and was the most encouraging person to me that I've known.

BLACKWELL: It's the opposite of squashing. He's just, "let's put out a record!" I remember that Jack and I kept having these conversations of him saying, "I think this could be on country radio. This song is so good, this is totally outside of our world. What do we do, how do we do this?" We've since found out that country radio is a very difficult nut to crack. But I still feel that sentiment that he said "this is great. This could and should be on

country radio." I think we still feel that in regards to those songs, but also all your songs coming out. So that's really exciting.

LILLIE MAE: That's really cool that you say that.

BLACKWELL: Do you have anything specific in terms of the experience in the studio for your Blue Series? I know you've done a bunch of other recordings in the same studio for your album, but anything that stuck out. Was this the first release that ever came out strictly under your name?

LILLIE MAE: I had never done it on that level. I mean once upon a time, in town here, I used to write with my brother-in-law a lot. We had written a bunch of songs and had made a demo CD. I sang on everything and he played on it. We all came together and just did it as soon as possible.

BLACKWELL: You shopped it traditional Nashville-style.

LILLIE MAE: Right.

BLACKWELL: You walked down Music Row in your cowboy boots and acoustic guitar.

LILLIE MAE: [laughs] Right. Got a lot of door slams. Not really. Never had that experience in Nashville. Like a lot of people have talked about.

BLACKWELL: That's good.

LILLIE MAE: I feel differently about a lot of things because I've had a lot of good experiences here. But that was a CD, and we ended up selling it downtown. It said my name on it.

BLACKWELL: But you don't necessarily view that as a release, that was kinda just like we were shopping it, trying to get it to the next level.

LILLIE MAE: No and it wasn't. But occasionally every once and a while someone comes up, or my dad's always trying to get copies.

BLACKWELL: But that CD was in line with you coming from a very different world from Third Man, where you've spent a lot of time playing honky tonks on Broadway. That's a world where the live performance is your goal, and the point of the CD was to try to get some gigs, from handing it to people, but the gig was more important than some little CD we have lying around. Is that correct?

LILLIE MAE: Very accurate. Yes.

BLACKWELL: Is there anything else you remember about your Blue Series experience? Maybe your photoshoot or anything along those lines?

LILLIE MAE: We did the photoshoot at Third Man, but it was pretty funny 'cause I just remember being extra exhausted, not together at all. I was really, really drab, and then I remember putting on this sparkly dress instantly. I had my dogs here and my sister was here and it was late at night when we did the shoot, that was fun. Coming in at whatever time at night with your dogs and stuff to take a photo — that's when I'm comfortable. And that side of it, being 100% comfortable in the studio and being able to open up about anything ... it creates a freedom that is just so appreciated. That's what's different about working with Third Man.

BLACKWELL: The Blue Series and also your album, I feel they depict — and tell me if I'm wrong — I feel like they depict you, who Lillie Mae is, as just about as truthfully as possible.

LILLIE MAE: You're not wrong. Yeah.

BLACKWELL: And I think as a label, that should be your goal. And as an artist that should be your goal.

LILLIE MAE: Yeah. It's pretty unbelievable, after some of my bad experiences in the past, it really is unbelievable.

BLACKWELL: Awesome. Well it's all downhill from here.

LILLIE MAE: Just like anything, you know if somebody tells a lie you feel like shit, you know? If you play a song that your heart's not in, it's not gonna sound good, or if you do it a way that's not meant to be, what's the point?

BLACKWELL: It reminds me of something that I've heard about when The White Stripes first signed a deal. Their lawyer advised that there wasn't any guaranteed money in the contract, that if they sold alot of records that maybe they might make money. The lawyer stressed that there was no advance and this might be their only shot to make any revenue. As the story goes, Jack said, "I'm fine with that. That's fine." And the lawyer, asked "Why? I don't really get it, I've never had people say this before." He's like, "I've been poor before, I know how to live poor. Where we're at now is great, I could live like this forever. I used to have to live on much less than this. I'm ok with that." I always get the impression when I see you on stage, when I see you here in the office, you're just so happy to be a part of it. This is what you want to be doing, this is what you're meant to be doing.

LILLIE MAE: You're absolutely right. I'm glad you told me that, I think that's awesome because I can identify with that. What have you got to lose? I mean, you know, things are a little different right now for me, but yesterday I had $2 to my name, you know, that was yesterday, today's a different day. But I'm like, I'm here, man, I get to play music that's true to my heart, and get to work with people who care about that stuff, I'm lucky.

BLACKWELL: People will fight for you here. I will punch someone's fucking teeth out if I have to.

LILLIE MAE: I will too [laughs]. It is amazing, just coming into Third Man. Where do you go when you show up to somebody's work? Where do you go? People are working, they're always working. Every time I walk past somebody they're working. And they're happy. I don't mean everybody's always happy, but people are happy to be doing what they're doing and that's so cool. It's like if you're playing in a band with people that don't wanna be there, what's the point? I appreciate it just tremendously.

BLACKWELL: Just in talking to you, you give off the impression of I don't care I'll fucking play for 20 people a night, this is what I love and I'll do that ... You don't ever come off as too cool for school. You're always prepared to do any heavy lifting. You've been doing it since you were three-years-old. So that to me, those are the artists you want to work with. Those are the people who know what the lowest of the low roads can be, and have also seen the highest of the high roads. Those people know I'm an artist, I'm not going to become a dentist. This is what I have to do. And so whatever road meets me, I'll take it. That's how I feel with you. And I feel like I've done a lot of talking here but —

LILLIE MAE: I'm glad you did [laughs]. No I mean I'm glad you said those things, that means a lot to me.

BLACKWELL: Definitely. And the Blue Series is a great way to kind of view it too, it really does feel like a family in terms of the people we've been able to work with, and that connection for most people. They come in and do a 7″ and they go off and do the rest of their world, their thing, and it's one little moment for us to connect, but to have you along and to have you doing an album, another 7″ and have Jack produce it and all that stuff, people are rooting for you here.

LILLIE MAE: It was so natural when he mentioned doing a record, because we sang together, or played together backstage, or whatever off the stage. It wasn't like some guy at this level, some famous guy, is listening to me sing. So when it did happen, it felt like it was just a natural course. And then, I let some bullshit in my life get involved, which pushed it back, and that broke my heart so bad because I wanted to finish. And it felt like it was unfinished, but my heart's still there in it because I wanted to do it so bad, and I had been so honored to be asked and been a part, and then like whatever asshole boyfriends can do to peoples careers happened, you know that shit does happen unfortunately.

BLACKWELL: Well it feels like everything is in its right place timewise and timeline.

LILLIE MAE: I know, and that's wild too, 'cause when you're deep into things, all of the sudden there goes a year. You don't realize it, but the way things do sometimes line up it is pretty amazing. I was just honored and glad that he even let me come back in and finish it. I was so happy. Because it was a year. Who does that? A very important person gives some street rat a chance, and then the street rat blows him off, and a year later he gives them a chance to come back and finish it. Who fucking does that? I have so much thank you and respect to that guy, it's crazy.

COURTNEY BARNETT

TMR-321

Melbourne, Australia's Barnett knocked out her Blue Series single in barely three hours on an off-day in June 2015, just prior to a featured appearance at the Bonnaroo music festival outside of Nashville. While the A-side is an updated take on the song featured on her 2015 album *Sometimes I Sit and Think and Sometimes I Just Sit,* the flip is a mellow take on the song written by Rowland S. Howard for the Boys Next Door, a band which would later change its name to The Birthday Party and was one of the earliest outlets for a young Nick Cave.

A SIDE: BOXING DAY BLUES (REVISITED)
B SIDE: SHIVERS

RELEASED: OCTOBER 15, 2015

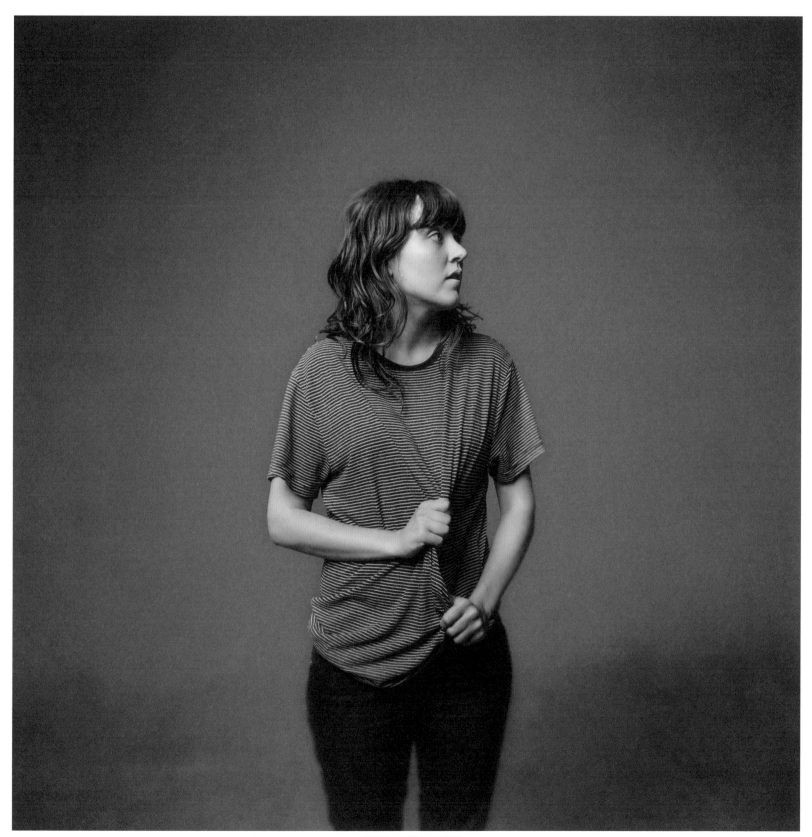

PHOTO: JAMIE GOODSELL

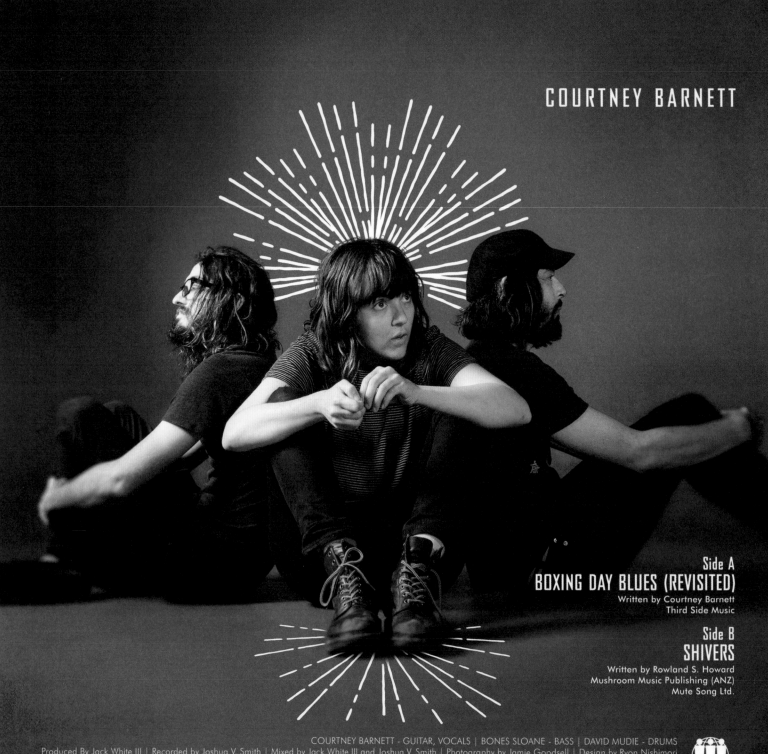

COURTNEY BARNETT

Side A
BOXING DAY BLUES (REVISITED)
Written by Courtney Barnett
Third Side Music

Side B
SHIVERS
Written by Rowland S. Howard
Mushroom Music Publishing (ANZ)
Mute Song Ltd.

COURTNEY BARNETT - GUITAR, VOCALS | BONES SLOANE - BASS | DAVID MUDIE - DRUMS

Produced By Jack White III | Recorded by Joshua V. Smith | Mixed by Jack White III and Joshua V. Smith | Photography by Jamie Goodsell | Design by Ryon Nishimori
www.thirdmanrecords.com

TMR - 321

"There's a real beauty and simplicity in that sparseness of a three-piece. Space exists where it would otherwise be filled."

BEN BLACKWELL: What was behind the decision of recording the Boys Next Door cover? Did you know that Third Man had released a live version of the Divine Fits covering this same song?

COURTNEY BARNETT: I wasn't aware of their version! But I had been singing the BND version on tour a lot in the shower, on the bus, during sound check. It had burrowed deep into my brain. We hadn't practiced the song as a band but I said, "ok boys, it goes like this." At first I felt a little self-conscious of our arrangement's simplicity, but I think the no-tricks approach matched my mood and shone through.

BLACKWELL: I seem to recall Jack saying your whole session was tracked and mixed in three hours. That may be the fastest Blue Series single ever. What was the feeling while recording in the studio?

BARNETT: I like to capture the whole band vibe live and see what happens. I'm indecisive, so if I dwell on anything for too long it's all over. There's a real beauty and simplicity in that sparseness of a three-piece. Space exists where it would otherwise be filled. Dave and Bones are such great and tasteful musicians, so it always comes together. I remember that the day of the recording was supposed to be a day off, a no-show/no-travel day, and we hadn't had one of those in a lonnnnnng time! But nobody wanted to pass on the opportunity of recording with Jack. So we were excited … but exhausted. Sleep when you're dead, etc.

BLACKWELL: Did Jack impart any insightful knowledge or advice in the session? What was your impression of him as a producer? How did he smell?

BARNETT: He's very tall. Taller than I suspected.

BLACKWELL: What did you think about the studio space, the equipment used, the vibe in the room? Inviting? Cold? None of the above?

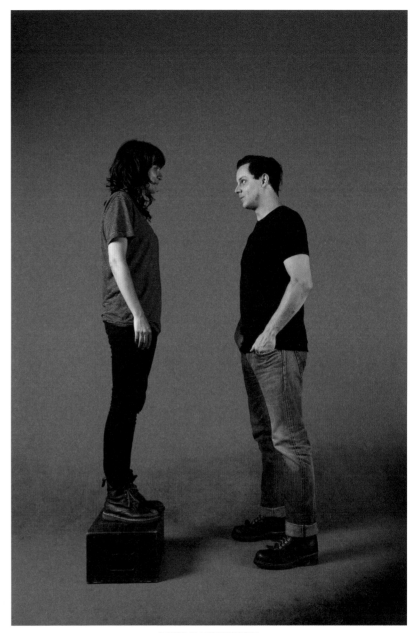

PHOTO: JAMIE GOODSELL

BARNETT: Very welcoming space & a perfect size for us as a band. I find studios a bit intimidating usually, but this was a good vibe. Nice tremolo on the amp haha! I think I used it on both songs, thanks.

BLACKWELL: You have some unique insight to this entire process as you run your own record label … what was your impression of Third Man as a whole? Thoughts on your photo shoot? Mail order department?

BARNETT: I'm a mega merch-nerd so the systematic organization of the mail order department really got me excited. I'm also a

230

big visual person and the overall aesthetic of Third Man really impressed me and sucked me in. The crew of people working there, each kinda doing their own thing in-house and being part of the creative process. Art over/but not lacking commerce. Definitely took some inspiration home to Milk! Records.

BLACKWELL: The idea of "Boxing Day Blues (Revisited)" is novel. Not too many artists "revisit" songs nowadays. Was there any specific inspiration for this?

BARNETT: Ha, yeah, it was a last minute decision (I was still finishing the song in the studio that day). I don't even know if "re-visited" is technically the correct term. Thru the madness and the melancholy it made sense to me ... "Boxing Day Blues" (the album version) was a pathetic tale about being too drunk to call my girlfriend after her mother died (on Christmas Day). "Boxing Day Blues (Revisited)" I actually started writing on the day of the funeral, I came up with the chorus "Like a Christmas tree / on Boxing Day / thrown away / nobody cares / for you anyway" but I never finished it until this studio session. It's on the same wave-length, but includes more time zones.

TMR
321

KATE PIERSON

TMR-343

Best known as one of the beehive-haired front-women of the B-52's, Kate Pierson visited Third Man and tore through a version of the Shocking Blue's "Venus," the instrumentation of which was originally recorded for possible use on a Wanda Jackson session. The B-side "Radio in Bed" was co-written by Pierson and her wife, Monica Coleman. The single was released as part of Record Store Day 2016.

A SIDE: VENUS
B SIDE: RADIO IN BED

RELEASED: APRIL 16, 2016

PHOTO: ANGELINA CASTILLO

KATE PIERSON

SIDE ONE
VENUS
(VAN LEEUWEN) NEW DAYGLO BV (BUMA)

KATE PIERSON - VOCALS
OLIVIA JEAN - ELECTRIC GUITAR
JACK WHITE - BASS
PATRICK KEELER - DRUMS
JOE GILLIS - WURLITZER ELECTRIC PIANO
CARL BROEMEL - PEDAL STEEL GUITAR
LEIF SHIRES - TRUMPET
CRAIG SWIFT - SAXOPHONE
JUSTIN CARPENTER - TROMBONE

SIDE TWO
RADIO IN BED
(PIERSON/COLEMAN) LAZY MEADOW MUSIC (ASCAP)

KATE PIERSON - VOCALS
OLIVIA JEAN - ELECTRIC GUITAR, AFRICAN DRUM
FATS KAPLIN - ACOUSTIC GUITAR, OUD
DOMINIC DAVIS - BASS, TAMBOURINE
DARU JONES - DRUMS, MARACAS

Produced By Jack White III | Mixed by Joshua V. Smith | Photography by Angelina Castillo | Design by Ryon Nishimori
© & ℗ 2016 Third Man Records, LLC. 623 7th Avenue South, Nashville, TN 37203. Unauthorized duplication of this recording is prohibited.
All Rights Reserved. www.thirdmanrecords.com

TMR - 343

"The track had such a great in your face raunchy quality — I guess that's what you miss about analog."

=== FATS KAPLIN ===

BEN BLACKWELL: How were you asked to record a Blue Series single? Were you surprised?

KATE PIERSON: The B-52s visited Third Man Records when we were playing at the Grand Ole Opry in Nashville — our band mate, keyboard player Paul Gordon introduced us to Jack White — Jack then gave the band a private tour of the whole shebang and we ended up in his office where he played us the Tom Jones record he had just recorded for the Blue Series — I was just blown away by the performance and the raw immediate gritty quality that was captured in that recording — I happen to be a big Tom Jones fan and I saw him in Vegas from the front row! We were so close we saw his uvula quivering and I was struck by how the recording captured the incredible sexuality of Tom Jones — then Jack White played his instrumental version of "Venus" written by Shocking Blue — he was looking for someone to sing it and oh how I wanted to do that — I think he said Loretta Lynn tried it but it was not her style — so when I did my solo show to support my record Guitars and Microphones at the City Winery in Nashville — my wife Monica and I invited Jack and Olivia Jean to the show — soon after he invited me to record Venus to the track he had made / and oh wow was I dreaming?

BLACKWELL: Were you previously aware of any Blue Series records before being asked to record? Any stick out to you as being favorites? Any you hate? Any thoughts about Third Man in general? Or even Jack?

PIERSON: I was aware of the Blue Series — I was totally captured by the amazing graphics — and when we visited I grab-bagged a bunch of singles at Jack's invitation and displayed them in my studio — as not only music to spin but beautiful artwork as well as the production — everyone in the band was just blown away by the space at Third Man, the store, the performance space, vibe, the design and records, records, records! Just fascinating and beautiful — Jack himself seemed very thoughtful, quiet, maybe a little shy but also very focused and intense.

BLACKWELL: What was the feeling while recording in the studio? How do you decide which songs to record?

PIERSON: The atmosphere in the studio was relaxed and like being at home because in fact we were in Jack's home — again we got a full tour and again I was very impressed with the detail and continuity of his design ideas and aesthetic, which carried over

from Third Man — eccentric individualistic down-home vibe — I have always loved the song "Venus" and it would definitely be on my list of songs I would like to record if I did a cover record — so it was crazy that this was the song I got to do — doing the vocals was a blast and Jack was very supportive in his suggestions, try this try that, more like mood explorations, nothing too strict or pre-determined, I definitely felt a trust that the artist needs from the producer, and the sensitivity he has as a musician, also the track had such a great in your face raunchy quality — I guess that's what you miss about analog — it made the vocals easy to place — the mood was already set for the vocals — I could really dig into it and give it all I had — in fact the track had all the dynamics built-in so it was easier for me to get it right from the start and a thrill to have a recording done so quickly.

BLACKWELL: Did Jack impart any insightful knowledge or advice in the session? What was your impression of him as a producer?

PIERSON: A week or two before the recording session Jack emailed and said oh what about the B-side? B-side? Oh I hadn't even thought of that! Monica and I were jamming and we came up with a song called "Radio in Bed" — we didn't have a demo I just had some sections of parts we recorded, like Monica's lead guitar hook, some verse chorus etc, we launched into recording with a band combo Jack put together — this was truly an exploration into outer space for me as I usually like to have a solid demo but the musicians and bands he put together had an intuitive reading of the song, and Olivia Jean ripped it up on guitar — what a woman! Jack had some really cool instrumentation as we felt our way along the structure of the song — I have to say I've never been in a recording session that felt so open minded free and open to the unexpected and yet came together so quickly and easily.

BLACKWELL: And you did a video plus photo shoot?

PIERSON: The next day was all make-up, hair, hair, hair, outfits, video shoot, photo shoot / again done with incredible ease and efficiency — we used the groovy new camera Jack had for the video and it was totally done on green screen — and suddenly glamorous quirky and cute dancers emerged ponying around — so a great and easy dance group choreography was established quickly — I lip-synched and we danced around for about an hour and then the video was shot and locked and loaded — then quick outfit change into Julia Gerard's fabulous gown and a quick photo shoot finished the glam team's work — The woman who did the photo shoot was pretty darn efficient — she had a pretty specific vision and it was easy no pain — same with the video shoot it was really fun — everyone was pro, make-up hair — no one but Olivia Jean could play guitar on my song and then do my hair! And what a great hairdo it was! Crazy!

BLACKWELL: What did you think about the studio space, the equipment used, the vibe in the room? Inviting? Cold? None of the above?

PIERSON: The vibe in the home studio was warm, comfortable, and intimate — all the band players seem to know how to play together instinctively, I guess they played together a lot before — and all seemed very organic — everything happened so quickly much like compressed time and I just remembered the equipment looked shiny and analog and — although I'm very used to analog equipment — some of it looked a little retro-futuristic to me — I was kind of geeking out on the equipment but I can't remember any specifics right now.

BLACKWELL: What was the public reaction once this was out there?

PIERSON: My fans loved it — they were so impressed by the collaboration, the look of the cover, the sound of the single made them tingle.

BLACKWELL: What was your main takeaway from the session and subsequent release?

PIERSON: My main take away is I'd like to do another!!!! The creativity and vision of what Jack White has created at Third Man Records is a true inspiration — it really is incredible the whole compound the concept the vision the sound blew me away — Monica as well, she was thrilled.

DWIGHT YOAKAM

TMR-363

With an A-side popularized by the Monkees and a flip that was successful for Johnny Rivers, Yoakam's entry in the Blue Series is the perfect snapshot of how the brain and inspiration works with the immensely successful Yoakam, a honky-tonk inspired country classic who has sold millions of records, won a handful of Grammys, and is still in high-demand for live performances over thirty years into his career.

A SIDE: TOMORROW'S GONNA BE ANOTHER DAY
B SIDE: HIGH ON A MOUNTAIN OF LOVE

RELEASED: JUNE 10, 2016

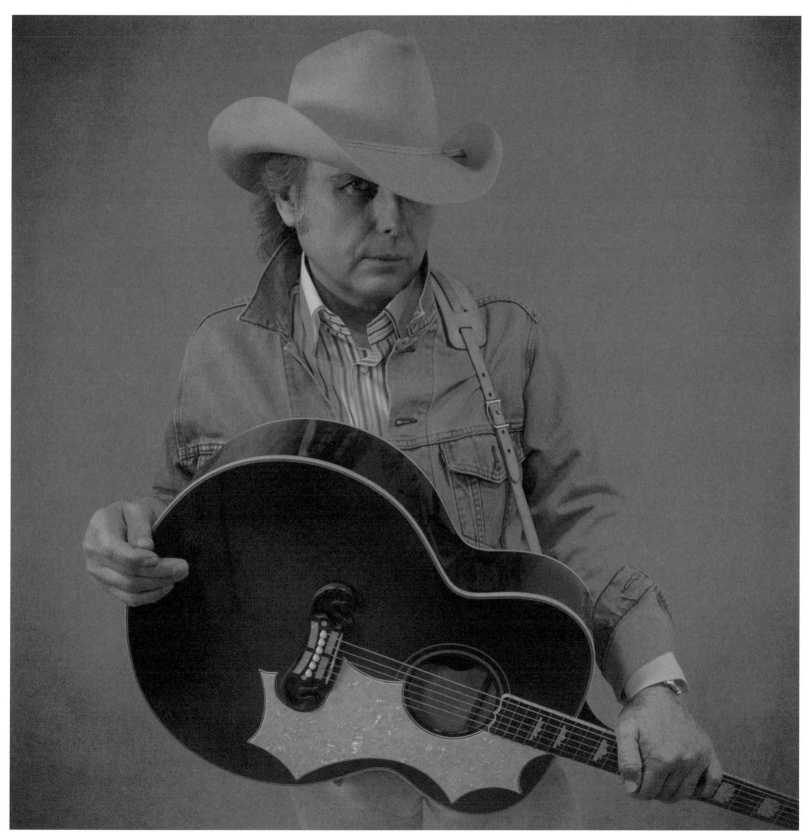

PHOTO: ANGELINA CASTILLO

DWIGHT YOAKAM

SIDE A
TOMORROW'S GONNA BE ANOTHER DAY
(BOYCE/VENET) SCREEN GEMS-EMI MUSIC (BMI)

DWIGHT YOAKAM - VOCALS, ELECTRIC GUITAR
DOMINIC DAVIS - BASS
DARU JONES - DRUMS
CORY YOUNTS - PIANO
LILLIE MAE - FIDDLE
FATS KAPLIN - PEDAL STEEL

SIDE B
HIGH ON A MOUNTAIN OF LOVE
(DORMAN) MORRIS MUSIC (BMI)

DWIGHT YOAKAM - VOCALS, ACOUSTIC GUITAR
DOMINIC DAVIS - BASS
DARU JONES- DRUMS
CORY YOUNTS - WURLITZER ELECTRIC PIANO, HAMMOND ORGAN
LILLIE MAE - FIDDLE
FATS KAPLIN - PEDAL STEEL

PRODUCED BY JACK WHITE III | RECORDED AND MIXED BY JOSHUA V. SMITH | ASSISTED BY DUSTY FAIRCHILD
PHOTOGRAPHY BY ANGELINA CASTILLO | DESIGN BY NATHANIO STRIMPOPULOS
DWIGHT YOAKAM APPEARS COURTESY OF WARNER BROS. RECORDS
© & ℗ 2016 THIRD MAN RECORDS, LLC. 623 7TH AVENUE SOUTH, NASHVILLE, TN 37203.
WWW.THIRDMANRECORDS.COM

TMR-363

"A highly evolved playhouse to make sonic mischief in."

BEN BLACKWELL: Do you remember how this record came to be? Did you ask, did someone else ask you?

DWIGHT YOAKAM: Jack had actually bumped into my drummer in Nashville a couple years earlier and mentioned something about the Blue Series and if I would be interested in doing it. And my drummer, Mitch, handed him the phone and we chatted for a second and, well, after a year or so, I didn't really hear anything immediate. Then bout two years later, I get a call, "Hey, Jack wants you to come do this if you want, if you're gonna be around, and it fits your schedule with work" — because I live on the west coast — and I said, "Absolutely. Count me in, let's go do this. Is it all, as the title suggests, blues music?" and they said, "Nope he's open to whatever. And kinda just wanted to hear what you wanted to do." I said there's this Monkees' track — "Tomorrow's Gonna be Another Day," right?

BLACKWELL: Yeah, yeah.

YOAKAM: I also said there's an old track that Johnny Rivers did a great cover of, "Mountain of Love," that would be a cool thing to do. And Jack, very graciously said, "Come on down, let's cut those." We did, but we didn't do a specifically literal lift of the arrangements, and then the band, of course, is uniquely something Jack would assemble in terms of the players. The kind of idiosyncratic nature of it was curious, and there's an intimacy to the studio and to the execution of the recording. We just kind of start to finish made that single that day, you know. soup to nuts kinda track overdubbing — the overdub is mostly live — I think I went back and just sang a little bit, and mixed it all in one fell swoop.

BLACKWELL: I want to test your memory. There was a song you suggested to record before you landed on those two songs — do you remember what that was?

YOAKAM: I don't because it was rejected, so I just wiped it from my memory. What was it?

BLACKWELL: Yeah, you suggested "What's New Pussycat?"

YOAKAM: Oh my god Tom Jones! Yeah. That's right. "What's New Pussycat?" [laughs] I thought that would've been cool.

BLACKWELL: Do you remember what Jack's response to that was?

YOAKAM: I'm trying to remember because it was all e-mail at that point back and forth. No, what was it?

BLACKWELL: He said something like, "Please, no, for the love of God, there's something — I have bad memories of that song — it goes back to my childhood. Anything but that please."

YOAKAM: [laughs] That's right. It referenced some sort of abusive moment, something awful connected to "What's New Pussycat?" Wow, I don't even wanna hear what that was. And hadn't Tom Jones cut there with him on the Blue Series?

BLACKWELL: Yeah, he did Howlin' Wolf's "Evil" and then he did a really, really cool arrangement of "Jezebel." He was great.

YOAKAM: Well, yeah, I mean, Tom Jones. I had the great fortune of singing with him at the House of Blues on Sunset Boulevard a few years ago. It's on YouTube now. We did The Rolling Stones, we did a duet of "The Last Time" [laughs].

BLACKWELL: Oh wow, that's great.

YOAKAM: It's pretty funny. If you get a chance look it up on YouTube. [sings] "I told you once, I told you twice / but you never listen to my advice ..."

BLACKWELL: So were you aware while you were recording that most of the players on your session were essentially Jack's live band?

YOAKAM: No, like I said, there was this idiosyncratic nature to the guys' playing, because I could tell they were doing things on instruments maybe that they didn't normally play, like there was a lap steel, a pedal steel part going ... But I didn't know that they were the live band — is the short answer to that. But I knew that they were all kind of eclectic in what they played at any given moment. It seemed like they were pretty "normal" musicians, you know, and picking up instruments playing additional colors. I remember him saying to me something about that. It felt like he didn't want to disturb anything with too much information.

I played an electric through my AC 30 at one point on — trying to think if I played it on the Monkees or — I don't know. It was literally in the moment, you're playing with people you met five minutes earlier, and have never picked up an instrument with or played with.

There's a certain magic innocence to it — if that makes sense — to further hyper-extend the metaphor, it's a teenage magic innocence. I mean, that's what it felt like: a magic teenage innocence that you're revisiting. It's what you think originally making records was like. You go in, you play all together with this band and cut this record. That's what Jack is essentially doing. I think we may have only fixed one or two things, I may have sang a part over. A sonic fix or something, it was very minor. And like I said, it was mainly about playing the song. Mainly about findings — that's what I meant about the kind of magical teenage innocence of jamming in a garage, you know? When you set up your amp in someone's garage and start playing towards one another in a circle, that's kinda what it felt like. It had a highly evolved garage magic to it.

BLACKWELL: I really like the phrase "magical teenage innocence." What about the space — Jack's studio, the room, the décor, the decoration, the fact that you're recording to tape — how is that informing your performance or your approach at all or is that you're just kinda going with the flow? How does that affect you?

YOAKAM: His aesthetic throughout, his nature is craftsman — he worked in upholstery — it's evident throughout, and the other building has a billiards room, the bowling alley over across the way. The experience with him is a highly evolved playhouse to make sonic mischief in. And there's absolutely an immediacy to the warmth of the situation there, I think sonically, and again, in the scale of the environment. It's not a totally large place, it's like he has converted a garage into the control room and added it into this space where you're gonna play in. I think that warms it, the intimacy of the space. And the immediacy of all of the experience is what you're feeling. That's what I felt. That day was almost surreal. I did leave him an appropriate parting gift — the creepy clown. Ask him about that. The bus driver was thrilled. I said we bequeathed this to Jack: the perfect guy to bequeath this Halloween clown to.

BLACKWELL: I want to touch on something you said about the whole experience being surreal — unexpectedly, while you were doing the photoshoot for the single, Mick Jagger showed up.

YOAKAM: Mick was in the shop, I guess. Very like Mick — Mr. Curious [laughs]. Mr. Curious shows up at Jack's Shop of Curiosity.

BLACKWELL: You two seemed like you were old friends, like you guys go way back — is that the case?

YOAKAM: Well, we go back a ways. Mick has been very gracious to me over the years. He came with Ron Wood to see me at in London at the Hammersmith Pavilion in 1992. He came out, watched my show, stayed the whole show, held a whole dinner party for me that week

while I was in London. Very, very gracious. A few years after we co-wrote a song for the soundtrack of my film, *South of Heaven, West of Hell*, a song we wrote together called "What's Left of Me" and it's on that soundtrack album. So, yes, we had known one another — we'd bumped into each other like that at random moments. Last time I was at a restaurant on Sunset Strip, I turned around and he was coming out of another dining room door as I was walking back through, we almost collided, and he looked up with that sly grin and said, "Well, they'll just let anyone in here won't they?" And I said, "Clearly evident of you I guess!" [laughs]. But no, it was fun to watch him peruse the record store and look at all the curiosities. Mick is a fascinating intellect and is curious about all things, especially things musical. Like I said, it was one of the most curious minds I've ever come across in Jack's Shop of Curiosities.

BLACKWELL: The session was in that old style — how you would imagine someone rolling into Chess or going to Sun, where you go in, you do a record, and that's it. And you keep on, you don't overthink it. You're not the first Blue Series artist who described the fact that since you're only in the studio for one day, recording everything so immediately, that you don't necessarily have a clear memory of everything.

YOAKAM: No, you don't, because you don't register over time everything repeatedly, it really is kind of a carnival, a midway at a carnival, you know that you went one afternoon/evening and then it's just gone. The parking lot where they set up. It's really kind of a cotton candy memory.

BLACKWELL: Man, I wish everyone had as many good quotes in their interview as you do. From "magical teenage innocence" to "cotton candy memories," these are all amazing, exactly what I want to hear.

YOAKAM: And like I said, you know the next day we have to go picture shooting and that's when ol' Mr. Cotton Candy himself shows up! [laughs]. He's always mischievously looking like he's getting away with something isn't he? Mick Jagger. Sly Mr. Jagger. The sly and sophisticated Mr. Jagger.

BLACKWELL: I want to explicitly ask in terms of Jack's production. You said that he kind of just let everyone play, was there anything deeper or more involved with that, or was his approach just kind of getting people in the room?

YOAKAM: Well, at first, he was sitting people around, seeing what we came up with. He was only injecting himself when he felt he wanted to, maybe something was a good idea, but maybe it could be flushed out more. He would say, "What if this or what if that" a few times, but basically he was allowing — sorry my dogs are, I don't know if something's — What's the deal? Sorry for the interruption.

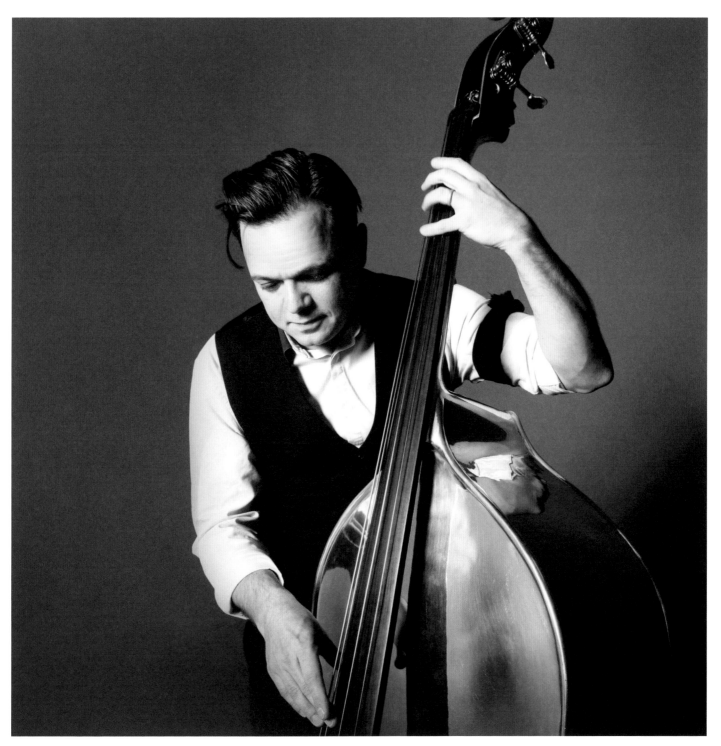

DOMINIC DAVIS

BLACKWELL: It's alright.

YOAKAM: So yeah, I mean he would direct, he would give direction of what was going on, but he didn't mettle with the intuitive moments, he allowed them to happen. Spontaneous moments. He allowed them to happen and was looking for them to happen. And thanks to him for allowing me to come in to make mischief, to make musical mischief with him.

TMR
363

Jo McCaughey is a British born photographer and film maker, based out of Nashville, Tennessee. Her work has been published in multiple publications such as *Rolling Stone, Vogue, The New Yorker, The Guardian* and *Vice*. She is predominantly best known for her music photography, of both portrait and journalist nature. She has worked for all major record labels and has documented and shot many varying artists such as Neil Young, Jack White, The Kings Of Leon, Willie Nelson, The Avett Brothers, The Kills, to name but a few. She has had several solo exhibits in London and is currently in production of a movie called *Horrors We Love*. She is interviewed by Third Man Records Queen of Hearts *Bonnie Bowden*.

JO MCCAUGHEY: BEHIND THE PHOTOGRAPHY

BONNIE BOWDEN: Who first approached you about photographing the Blue Series?

JO MCCAUGHEY: I suppose it's safe to say at first, it was by chance. I'd recently moved to Nashville from the UK and Third Man Records was just getting operational and I knew a lot of the folks who were starting the company and I had a camera.

BOWDEN: Fair enough. Do you remember how they asked? Or when you guys decided to do this, were you involved or do you remember where you were when you got asked to take pictures for this idea?

MCCAUGHEY: I was aware that Jack White was starting this project, and it sounded extremely interesting. I think even the first time I really grasped the concept was as they were painting the Blue Room. And then I was like ok I understand.

BOWDEN: Had you been working with Jack or Third Man photographing at that time? Or was this kind of the first time you got involved with this process? Do you remember?

MCCAUGHEY: The first Blue Series' shoots, Mildred and the Mice, was the first official shoot I did for Third Man Records.

BOWDEN: So what's it like to photograph in a Blue Room as many times as you have?

MCCAUGHEY: Every shoot in the Blue Room for the Blue Series was like starting with a blank canvas. Which was actually, well for me, more challenging than being on location with backdrops, props, with just a more structured setup. It was starting in a naked space every time. It was a new challenge every shoot to see what the artists' and I, I suppose, could bring to the blank canvas.

BOWDEN: Yeah — this isn't part of the question — but I always tell you I was always inspired to watch you come in when you had to shoot a Blue Series, and you'd be marching around Third Man looking for props! So did you get inspired by the music or were you just coming in thinking I wanna create — it seems to me, and I don't

want to answer the question for you — but it seemed to me that you were trying to make every one different and you had not much to work with because of the blue background. So what was your thought process when you were coming into the building to shoot?

MCCAUGHEY: Sometimes I would have heard the track, sometimes it would literally be they would go to the studio and record and head straight to the Blue Room, or sometimes they would come and have their photoshoot taken first, and then go and record. It wasn't ever relying purely on the music. It would be more about, the artists and collaborating with them and Jack to see — it was a collaboration with the artists and their personalities and what they wanted to show about themselves, and I would try to tap into that and work with their energy, their style, their message, and their music from what I would know already or from just meeting them and talking to them. And that would be the starting point and we would go from there.

BOWDEN: How long would it take, was it a pretty short period of time that you would kinda capture the moment?

MCCAUGHEY: With the whole Blue Series project I always felt like the aesthetic and the style and the emotion of the finished product would come from a lot of spontaneity and working with spontaneity. Due to that, the shoots would be sometimes very short and some others would be longer. Again, taking each artist as a separate project and obviously a separate energy and feeding into that. Say with the 5.6.7.8's, there was full make-up, there were dresses, there was a whole production, and then there'll be say, First Aid Kit who wandered in on set and we shot that within ten minutes. Beautiful Swedish girls! There was no structure of time, it really was spontaneous and whatever the shoot needed we would facilitate and work around that. Am I being way too vague?

BOWDEN: No, I can say that having started at Third Man and not knowing you as well as I do now, I saw you shoot and I've seen what you're talking about, and I saw moments where you would literally come in and shoot in five seconds and it would be done. I think the most elaborate one I remember is Shovels & Rope, I think you got some lighted signs and stuff?

MCCAUGHEY: That was the No Vacancy sign from the TMR warehouse.

BOWDEN: Yeah but it's so great! It happened so just naturally, but the way you would come in and kind of search around for things and a lot of those props were just things that were at Third Man.

MCCAUGHEY: I think again with the spontaneity of not really knowing the music or sometimes knowing the artist but still not really knowing what tracks they did ... yeah a lot of the props — ALL the props came from within Third Man. Once that started happening I actually found that quite brilliant because it became an extra extension of Third Man.

BOWDEN: You had mentioned to me that at the very beginning, there wasn't really equipment and stuff for the shoots. So starting with Mildred, did you just go in with your camera and no lights, and make do, how did you make it work?

MCCAUGHEY: Third Man was still a work-in-progress around the time of that shoot. It was very bare bones. And it was the first Blue Series project, and I think everyone was just seeing where the series would go, how it would form and how the project would shape. And Mildred, thankfully, had a very, very strong presence. Was very intimidating, and so were her mice! And it came together! I instantly realized these shoots are only going to be successful if the artist brings their personality with them and help this space because it needs to be filled. Personality was very important.

BOWDEN: If you can think back — how many years ago? Eight?

MCCAUGHEY: Yeah, something like that —

BOWDEN: And think of you shooting Mildred, and then maybe some more shoots, and then it's happening and — did you ever anticipate that we'd someday make a book about this whole process and how interesting it is, and how much it's a part of Third Man?

MCCAUGHEY: When I was shooting Mildred, way back when, I had no idea that several years later that there would be a beautiful book, published by a book company that's even part of Third Man. The scope of evolution from that first Blue Series single to where Third Man has grown and stretched its limbs outward — literally, making this book possible. It is a sign of the growth and continuation of this beautiful series. It's been an open door for every artist, from every genre of music, but at the end of the day, they all had to walk into that Blue Room and have their photograph taken.

BOWDEN: Alright, well I'll have to ask one final question. Do you have a most memorable shoot and why?

MCCAUGHEY: Each shoot was memorable and inspiring in its own way. But when you get to spend the afternoon alone with Tom Jones, I think we just need to stop the book right there. A Tom Jones hug leaves you with the — we'll stop the book right there.

BOWDEN: ALRIGHT, SIGNING OFF FROM ... NEW YORK, IT'S ... SATURDAY NIGHT!

A FEW WORDS FROM THE BLUE SERIES SESSION PLAYERS

know that everyone else I've worked with in Nashville would've gone back and fixed that section, just in case. To be able to capture the authenticity and spontaneity of live music in a studio setting is really rare, especially in the Nashville music culture these days.

Nothing great comes without risk. And that's why the music that comes out of these sessions is always so good. It wavers on the edge of completely coming apart, and you can feel that urgency and energy that only comes from everyone holding on for dear life and not knowing what's going to happen next. I always walk away from these sessions feeling like I was part of something special and historic, and never feeling like, "Man I wish the horns were more in tune on that bridge," or "The timing should've been better on that pre-chorus." Imperfection isn't condemned, it's celebrated. And that what makes every session I do for TMR such a unique and rewarding experience.

• • • • • •

TIMBRE CIERPKE

This was my first time working with Jack, (I later played harp on *Lazaretto*), and it was such a creative and collaborative experience. When I first got there, Jack helped me load in my harp, and then just played me a brief clip of the original song and said, "Any ideas?" He grabbed his guitar and we just played around for awhile until we came up with parts we liked. I felt immediately locked in creatively, and respected, which isn't always the case with bigger artists.

When rest of the band arrived, we played around with the arrangement until we were all happy. Then we tracked a demo for Jack to show Tom Jones. And when Tom arrived, it was with all the swagger and suave you could imagine. He commanded the room immediately — winking, laughing, flirting. We played the track for him one more time, then started tracking live. He poured all that swagger into the song and proved his voice is just as strong as ever. Jack ran the session with clear leadership, but with an obvious trust of his musicians. You can hear that collaborative energy in the track.

True to reputation, after the session, 70-something Tom unabashedly leaned in, kissed my cheek, and asked, "Did Jack tell you that for every session I play, I require a blonde harpist to come to my hotel room?" I laughed and fired back, "Sorry to disappoint you, but I'm technically a brunette. I dye my hair." He laughed, kissed my *other* cheek, and waved goodbye.

• • • • • •

DOMINIC DAVIS
THE SECRET SISTERS
"Wabash Cannonball"
The morning of the session Jackson Smith and I discovered that we shared an affinity for old-time fiddle tunes. After breakfast he was playing guitar in Jack's den and I joined in on the banjo for some tunes. This stripe date was tucked in the middle of tracking for Wanda Jackson's record. Both LJ

CARL BROEMEL
For almost every Blue Series session I was contacted the morning of the session, maybe once or twice I got an email the night before. In a way it's great to have no time to think about it or plan anything. That carries into the recording as well, the idea of let's get together and play something, not think about it, and go quickly.

I usually never knew who the artist would be until I got there, sometimes we'd begin working through a song before it was even discussed who would be appearing. Lo-and-behold, one day Tom Jones walks in the door — that was a surprise. We had already run through his songs a few times, so when he showed up, we immediately started recording. Since there is only one headphone mix at the studio, we all have to share. We are all hearing the same thing. And once Tom Jones went from "testing his mic" to "going for a take" his volume went up like 10 times. His voice was engulfing my brain, dwarfing all other sounds including my pedal steel, what am I gonna do? Stop everything and say, "For the love of god, turn Tom Jones down!!" No way, you gotta keep going, and no time for second guessing or perfection. Thankfully I managed to play in tune. Now that I hear it, I think maybe hearing yourself is overrated, Tom sounded incredible so we all played well because of him.

• • • • • •

JUSTIN CARPENTER
The thing I love about doing recording sessions for Third Man is how spontaneous and unrehearsed everything is. Walking in without printed music or charts and not knowing what the song sounds like (or often who the artist is) prior to the session is very different from the way sessions typically go in this town. I remember a particular moment when we were recording "The Party Ain't Over" with Wanda Jackson that this became very clear. I came in early on a unison horn line — something most people would refer to as a "mistake" — and it really stuck out in the mix, at least to my ears. Jack didn't seem to care, and when I brought it to his attention, and we all listened back he shrugged his shoulders and said, "Sounds great to me." And when I heard the final mix eventually, he was right. It didn't stick out like I thought it would. That was really eye-opening for me, because I

[Editor's note: Jack Lawrence] and I were there so Jack asked me to play banjo inspired by our den jam earlier that day.

Joe Gillis is always recording sounds everywhere he goes and happened to have a recording of a train on him that he captured earlier that week. He played autoharp on the track but stopped to play the train sounds on his little pocket recorder that you hear in the intro.

TOM JONES
"Evil"
I don't remember exactly what the case was but we knew our time with Mr. Jones was going to be limited, so we recorded the basic tracks for this side before he came in. Jack sang a killer scratch vocal live in the room. The fade out and back in that you hear was live to tape. Engineer Vance Powell didn't warn us that it was coming. He started fading and when we looked into the control room he motioned for us to keep going before fading it back in.

BRITTANY AND RUBY
"I Wonder" b/w "When My Man Comes Home"
We were rehearsing midway through the *Blunderbuss* tour when this session came up. That morning I went to pick Ikey up from his hotel to head to the studio. Things operate so spur of the moment that many times we wouldn't know what we were coming in to do, we just know there's a session. Alabama Shakes had just opened a few weeks of shows for us and I got to inform Ikey that we would be working with Brittany & Ruby. He blew his lid! Being from Long Beach and given his musical background, he was always pining for a reggae jam which he finally got in "I Wonder." What many think is a guitar solo is Mr. Owens losing his mind on the Hohner Clavinet.

"When My Man Comes Home" also features the debut of what I like to call the "Spin-O-Phone." Ian Schneller at Specimen Speakers made Jack a custom rotating speaker that hangs from the center of the studio ceiling. It's wired so that we can send anything through it and can control the speed it spins at. Brittany had learned all of Memphis Minnie's intricate guitar work in the original version of this tune so Jack decided to amplify her guitar through it. If you listen to the track it might sound like tremolo or some sort of chorus but it's actually the Doppler effect from the speaker spinning.

LILLIE MAE
"The Same Eyes"
Having spent so much time on the road with Lillie Mae, I got to hear a lot of her original songs. That girl is always singing and playing. I remember waking up in the middle of the night on the bus and she was up front singing this for our driver at 4AM.

MICHAEL KIWANUKA
"You've Got Nothing to Lose" b/w "Waitin' Round to Die"
As a bassist, one of my favorite things is when singers sing me bass lines. We were looking for a signature line for this song and Jack asked Michael to sing one for me. He hummed the line that would wind up on "You've Got Nothing to Lose" and it was just what the track needed.

This is also the studio debut of the Aluminum ALCOA bass that I was using on tour with Jack. This session was really the first time I understood that instrument. It has an interesting characteristic where it sounds like there was reverb added but it's just the acoustic resonance of the aluminum body.

DWIGHT YOAKAM
"Tomorrow's Gonna Be Another Day" b/w "High on a Mountain of Love"
This was a session to remember. Dwight can strum an acoustic guitar and sing a song by himself and you really hear all of the other instruments and an arrangement in just those two elements. When Jack asked him to take some solos he said that his guitar playing was limited to "this Pops Staples thing" which wound up on "Tomorrow's Gonna Be Another Day" and is pretty stellar.

I remember Dwight being thrilled with the session. When we cut "High on a Mountain of Love" we recorded it in a honky tonk style, but then he launched into more of a straight barroom rock & roll version, then immediately started a third that was more on the blues side of things. Each was great so Jack was fixed with the task of figuring out which one we were going to go with.

· · · · · ·

JOE GILLIS
The Wanda Jackson sessions were the most fun I've ever had in a studio! I admit I was a bit nervous at first, hoping to fit in well with all them aces! Thankfully, my years of being an oldies cover band piano hack would finally pay off! Playing a vintage Wulitzer electric piano for the first time ever was pure joy, and its unique sound lent itself well to "You Know I'm No Good" and especially to "Venus," which has that sound in its original version.

I think I played a little autoharp on "The Wabash Cannonball," but I managed to snooker a train air horn sound into a take of it from a cellphone recording I had. Jack jumped up and gave a what-the-hell look around the room when it went off, and I managed to look innocent for about two seconds!

"Shakin' All Over" and "Evil" were pretty straightforward bluesy rockers, so I just hit 'em with the 'high-notes-jangle riff-age, 'trying to fall in with a feel for that genre. Glad to hear the unused material went to a good home, and it was an awesome experience from one end to the other!

· · · · · ·

JOSHUA HEDLEY
So the thing that most sticks out in my mind about those sessions is Jack's command as a producer. So often as a fiddle player you come into these non-country situations where maybe the people involved aren't used to working with a fiddle and have a hard time articulating what they want. More often than not you end up with a producer who just tells you to "do what you feel" or whatever and after 6 or 7 takes they finally have some

idea of what they want which was absolutely nothing like what you'd been doing prior. But working with Jack was nothing like that. He knew exactly what he wanted and he knew exactly how to convey it. Do this, do that, and my part was done and in the can. It was so refreshing to work with someone who had that kind of control and vision. He made it easy.

KATE PIERSON
"Radio in Bed"
The first concert I attended was the B52's at Joe Louis Arena in Detroit. Jack and I went together. So this session meant a lot to me. Kate had already sung on the A-side and she wanted to record this original song of hers. She had an acoustic guitar and played it for us a few times singing many of our parts that she had in her head.

The most memorable part of this session was her overdubbing background vocals. The qualities of her voice mixed with Jack's production and the layering of it on top of herself made her vocal sound like a Farfisa or Mellotron. There aren't too many singers whose voices come across as an acoustic instrument in their own right.

• • • • • •

DARU JONES INTERVIEWED BY BEN BLACKWELL

BEN BLACKWELL: Specific to Black Milk ... what was it like that first time you stepped into Jack's studio?

DARU JONES: Great vibes. I was blown away by the analog gear, layout and color scheme.

BLACKWELL: Were you surprised when he called you to join his band?

JONES: Yes, I was surprised and honored. Didn't know what I was about to get myself into. I was also in a weird state as I had to make some tough career decisions to transition from hip-hop to rock-n-roll at the time.

BLACKWELL: What do you remember about the aborted RZA session?

JONES: I remember being very disappointed after getting the news that RZA was a no show. My heart was a bit crushed as he's one of my producer heroes, but God had a masterplan that was a better overall look for me and my career. What could have just been an uber cool and amazing one-off experience to work with RZA and Jack turned into something that exposed my talents to another audience and propelled my career to another level. I'm thankful!

BLACKWELL: How much advance notice did you get before any of these sessions?

JONES: It was a very short notice; I think a couple weeks or the following month after I got back to home (New York) from

Nashville after doing the Blue Series sessions collaboration with Jack, Black Milk and company and live performance at TMR.

BLACKWELL: Jack is notoriously last-minute in this process ... did that affect your mindset walking into the studio?

JONES: No it didn't! I'm used to working and being creative right on the spot as I'm a producer/composer.

BLACKWELL: Were you familiar with any of these artists before you recorded with them?

JONES: I'm a little sly to say this, but I remember when the opportunity came up to work with Jack for the Black Milk sessions, my ex-girlfriend had to school me on The White Stripes catalog and Jack's work which I recognized "Seven Nation Army" and a few others from hearing it on the radio but at this time, I was so engulfed in hip-hop as a musical religion lol. I think it worked out to my advantage so I wouldn't get nervous or be super fanned out. It was an honor and I knew he was top of line in the game. :)

BLACKWELL: What was the vibe in the room like?

JONES: It was one of my favorite recording experiences with all these worlds colliding. So much power and energy in one room. We simply jammed out like we do, then listened to the playback and it was magic.

BLACKWELL: Was there any sort of collaboration or exchange of ideas that was inspiring?

JONES: I'm used to being in these type of musical situations where you have to adjust to a new environment. I'm a team player so we all just vibed off each other and let the music tell us where to go. That's what happens when you work with skillful players that listen to each other.

BLACKWELL: How do you feel these recordings turned out?

JONES: They came out how they were supposed to. Classic, organic and amazing! True from the heart and soul from all the players.

• • • • • •

LAURA MATULA
Ok, so ICP. I honestly don't have a strong recollection of the experience because perhaps I have blocked it all out. I remember Jack asking me to look up this old Mozart tune and find some sheet music for it for the instrumentalists that would be recording the track in the studio that day – this was when I was still his personal assistant and working at the house every day. Being a German speaker and having lived in Germany for some time the title immediately gave me a good chuckle. I gathered the music I could

find and prepped it for the studio musicians to play and I'm foggy how it went from me collecting music to singing classically in the studio that day, but it did. Was pretty par for the course just going with the flow. One thing I most definitely remember thinking was 'this will be a fun story to tell/explain to my daughter one day when she's way grown up' and 'oh God, I hope my parents don't hear this any time soon.'

The ICP guys were completely chill and lovely to be around in the studio and a good time was had by all I think. It was a quick session as well. I really didn't know much about them or their music prior to the session and half expected them to show up in face paint. We had so many people in and out of the studio all the time it was really just another day. It was super easy and fun with a little terror mixed in that the first thing I was going to sing in the studio on a Blue Series record was about licking and ass but hey, it's Mozart right? Also, I was pretty certain it wouldn't be hitting radio any time soon.

It was also a chance to get to see Jack's method in the studio. I had booked tons of session players but hadn't really hopped in there myself much and it was exactly what I imagined. Open and experimental and just a bunch of people have fun making music that would for sure cause conversation and exploring the faaaaar reaches of art.

• • • • • •

LEIF SHIRES

It seems like every time I get a call from Jack it's the day before, or day of. Which is ok sometimes, but doesn't always work out so well. I remember one time in particular I got a call to do a couple days of recording with him for a soundtrack, but I couldn't make it as I was in Japan. One of my favorite sessions was the album we did with Wanda Jackson. Usually as a horn player with a section, I'll get the music and have time to write parts for all the players. However, Jack's style is more in line with create as you go. Which is always invigorating, especially when creating. But it is more like holding on to a telephone pole in a tornado.

Being a session player in Nashville, we are acclimated to perfecting everything. But, Jack was more interested in the spirit of the music and not in us being perfect. Which in many ways is very liberating, but also terrifyingly intimidating knowing that a mistake may forever be memorialized in one of these projects. I love how Jack genuinely loves the instruments and the sounds that they can bring to the table. He seemed to appreciate the type of horn lines that we came up with, and really allowed to be part of a collaborative process. Another thing to note, Jack really believed in showcasing the full group and the music as it was recorded. When the Letterman show tried to have Jack and Wanda on they requested them to not bring the horns. Jack wouldn't have anything to do with it. He fought vigorously to keep the whole group together.

• • • • • •

PONI SILVER INTERVIEWED BY BEN BLACKWELL

BEN BLACKWELL: What was your reaction upon being asked to do the session? Were you expecting this phone call?

PONI SILVER: I wasn't expecting this at all. I was called around 7 or 8 am to show up for a session that day. I remember feeling fortunate that I was actually in town and not on tour. I think I'd maybe gotten in the day before. They also don't tell you who you'll be recording with, but I love surprises so this added to the excitement. Once I met Lanie, I was like, this woman's cool and the studio has good vibes all around.

BLACKWELL: Lanie's style is a little different from what I know you to play ... were you at all put out of your comfort zone for the session?

SILVER: The first song we recorded was a banger so it felt very familiar. I remember that at first I was hitting the cymbals lighter than I normally would. Something I picked up from different recording sessions but Jack encouraged me to smash away "like you do live" and that made me VERY happy. The second song was this slow, groovier tune that I mostly played floor tom and some percussion, I think, but I was able to really listen to Lanie. She's got this incredibly rich voice that feels like she's luring you in but she's definitely going to break your heart at the same time.

BLACKWELL: Everyone has mentioned that the sessions go so quick that it's hard to recall much, in and out in one day it can be hard to remember five years later, so anything else you may remember (smells, feels, vibes, what you ate for lunch) would be insanely helpful in painting the picture of how these things go down.

SILVER: We had pizza ... I'm always going to remember pizza. And Vance and Mindy were there who I love! And Josh Hedley (old buddy) showed up sometime in the afternoon to play some fiddle!

BLACKWELL: Finally ... what were your thoughts on the final released product?

SILVER: I think it's a really great 45. Lanie's a really talented singer and songwriter and paired with Jack, needless to say, I was very happy to have been able to be a part of it.

• • • • • •

MARK WATROUS
THE THORNBILLS
This was the first Blue Series I remember playing on. I came in after they'd already gotten one song down and added fiddle to that and then I think we tracked one live and stacked violins to create a string section. We ran the fiddle through a POG and dirtied it up through an amp to get a kind of "cello" sound. Jim and Tamara were both really great to work with and we

forged a deep and lasting musical friendship that day as evidenced by the fact that we still like each other's Instagram posts from time to time.

INSANE CLOWN POSSE

I could be wrong, but my memory of this is that I was in the studio playing on another project for Jack and he said something like, "Hey, while we're here, can we try something on this other thing we did? Can you really quickly do a little baroque harpsichord bit on this?" And then I proceeded to fumble over it for the rest of the day.

TOM JONES

Jack called me early in the morning and asked if I could come do a session, but he wouldn't tell me who the artist was ... Now I just so happen to think that "What's New Pussycat" is one of the greatest vocal performances to ever be committed to tape, so the surprise that it was a Tom Jones session was like a thousand Christmases.

The band showed up and we messed around with the arrangement on "Jezebel" ... I think it ended up being pretty different from the original tune. We made a quick instrumental for Jack to play for Mr. Jones when he picked him up. The two of them arrived and Tom recorded his vocals live in the room with the rest of us and he nailed the arrangement on the first take. We tried a handful of other takes and I remember him always finding something to compliment each of the players on after each take.

DUANE

I think Jack, Duane and Vance had been working on this for a bit when I came in. We worked pretty quickly on keys but I remember being a little in awe of Duane and how creative he was. I really respected both how much he knew what he wanted to create and yet how open he was to all the ideas that were happening on his songs which I think is pretty rare for someone so young.

• • • • • •

CORY YOUNTS INTERVIEWED BY BEN BLACKWELL

BEN BLACKWELL: How much advance notice did you get before any of these sessions? Jack is notoriously last-minute in this process ... did that affect your mindset walking into the studio?

CORY YOUNTS: No notice whatsoever, almost always called in the day of with no idea what artist or even instrument for that matter. Jack is definitely known for a spur of the moment recording practice.

BLACKWELL: Were you familiar with any of these artists before you recorded with them?

YOUNTS: Chris Thile and Dwight Yoakam were the only two I had heard of before recording, but all the artists were a delight to work with.

BLACKWELL: What was the vibe in the room like? Was there any sort of collaboration or exchange of ideas that was inspiring?

YOUNTS: The first few sessions were a little nerve racking obviously because I was working with Jack White and didn't know what to expect, but later on I got a little more comfortable with the entire team, players and engineers. The creative process became more natural and fun.

BLACKWELL: (For any of your performances ...) I know you play a wide-range of instruments, were any of these recordings featuring you on something you felt less-than-confident on? How do you think it turned out?

YOUNTS: Jack had me play organ for Chris Thile on a bluegrass track, I didn't feel very confident playing it. However, I felt a little redemption on the B-side when Jack jumped on drums and I got to play piano which I'm most comfortable on.

BLACKWELL: And in general ... how do you feel these recordings turned out?

YOUNTS: Every project that I've been fortunate enough to be part of has been a pleasure and privilege but most of all damn good music! As for the first actual call I got to record, it was from Jack himself in 2009. I was on the road with another artist in Rock Island, Illinois. Jack asked if I was in Nashville. When I said "No," he said, "Don't worry about it." I thought that may be the only chance I would get, so I offered to fly home. He insisted it wasn't that big of a deal. Years later I found out "not a big deal" meant Keith Richards. I still don't even know how Jack got my number, but after working with Third Man for so many years, what they already know and can accomplish never ceases to amaze me.

SESSION PLAYER RECORDING CREDITS

RUBY AMANFU
Chris Thile & Michael Daves "Man in the Middle"
(background vocals, kettle drum)
Chris Thile & Michael Daves "Blue Night"
(background vocals, kettle drum)
Seasick Steve "Write Me a Few Lines" (backing vocals)

CARL BROEMEL
Wanda Jackson "You Know I'm No Good" (steel guitar)
Wanda Jackson "Shakin' All Over" (steel guitar)
The Secret Sisters "Big River" (pedal steel)
The Secret Sisters "Wabash Cannonball" (pedal steel)
Chris Thile & Michael Daves "Man in the Middle" (pedal steel, bass VI)
Chris Thile & Michael Daves "Blue Night" (pedal steel, bass VI)
Tom Jones "Evil" (pedal steel)
Tom Jones "Jezebel" (pedal steel, piano)
Lanie Lane "Ain't Hungry" (electric guitar)
Lanie Lane "My Man" (pedal steel)
Lillie Mae "Nobody's" (pedal steel)
Kate Pierson "Venus" (pedal steel guitar)

JUSTIN CARPENTER
Wanda Jackson "You Know I'm No Good" (trombone)
Wanda Jackson "Shakin' All Over" (trombone)
The Secret Sisters "Wabash Cannonball" (trombone)
Pokey LaFarge and the South City Three "Pack it Up" (piano)
Black Milk "Brain" (trombone)
Black Milk "Royal Mega" (trombone)
Tom Jones "Evil" (trombone)
Kate Pierson "Venus" (trombone)

TIMBRE CIERPKE
Tom Jones "Jezebel" (harp)

MITCH DANE
Lanie Lane "My Man" (saw)

DOMINIC DAVIS
The Secret Sisters "Wabash Cannonball" (banjo)

Tom Jones "Evil" (upright bass)
Brittany Howard & Ruby Amanfu "I Wonder" (electric bass)
Brittany Howard & Ruby Amanfu "When My Man Comes Home" (electric bass)
Michael Kiwanuka "You've Got Nothing to Lose" (upright bass)
Michael Kiwanuka "Waitin' Round to Die" (upright bass)
Lillie Mae "The Same Eyes" (upright bass)
Kate Pierson "Radio in Bed" (bass, tambourine)
Dwight Yoakam "Tomorrow's Gonna Be Another Day" (bass)
Dwight Yoakam "High on a Mountain of Love" (bass)

PAUL ECKBERG
Lanie Lane "My Man" (congas, bongos)

KAREN ELSON
Beck "I Just Started Hating Some People Today" (jazz vocal)

DEAN FERTITA
Becky & John "I'll Be There If You Ever Want" (piano)
Beck "I Just Started Hating Some People Today" (keys, acoustic guitar, bass, background vocals)
Beck "Blue Randy" (bass)

JOE GILLIS
Wanda Jackson "You Know I'm No Good" (organ)
Wanda Jackson "Shakin' All Over" (organ)
The Secret Sisters "Wabash Cannonball" (autoharp, cell phone train)
Tom Jones "Evil" (piano)
Kate Pierson "Venus" (Wurlitzer electric piano)

CHRIS GREGG
Pokey LaFarge and the South City Three "Pack It Up" (clarinet)
Black Milk "Brain" (saxophone)
Black Milk "Royal Mega" (clarinet)

MICKEY GRIMM
Michael Kiwanuka "Waitin' Round to Die" (drums)

JOSHUA HEDLEY
First Aid Kit "Universal Soldier" (fiddle)
First Aid Kit "It Hurts Me Too" (fiddle)
Lanie Lane "My Man" (fiddle)

OLIVIA JEAN
Wanda Jackson "You Know I'm No Good" (guitar)
Wanda Jackson "Shakin' All Over" (guitar)
The Secret Sisters "Wabash Cannonball" (electric bass)
Becky & John "I'll Be There if You Ever Want" (bass)
Kate Pierson "Venus" (electric guitar)
Kate Pierson "Radio in Bed" (electric guitar, African drum)

BEN JONES
Lanie Lane "My Man" (double bass)

DARU JONES
Black Milk "Brain" (drums)
Brittany Howard & Ruby Amanfu "I Wonder" (drums)
Brittany Howard & Ruby Amanfu "When My Man Comes Home" (drums)
Kate Pierson "Radio in Bed" (drums, maracas)
Dwight Yoakam "Tomorrow's Gonna Be Another Day" (drums)
Dwight Yoakam "High on a Mountain of Love" (drums)

FATS KAPLIN
First Aid Kit "It Hurts Me Too" (steel guitar)
Seasick Steve "Write Me a Few Lines" (fiddle)
Seasick Steve "Levee Camp Blues" (fiddle)
Black Milk "Brain" (fiddle)
Black Milk "Royal Mega" (fiddle)
Insane Clown Posse "Leck Mich Im Arsch" (fiddle)
Becky & John "I'll Be There If You Ever Want" (pedal steel)
Becky & John "I'm Making Plans" (pedal steel)
Beck "I Just Started Hating Some People Today" (fiddle, pedal steel)
Beck "Blue Randy" (pedal steel)
Gibby Haynes "Paul's Not Home" (bass, background vocals)
Gibby Haynes "You Don't Have to Be Smart" (bass)
Gibby Haynes "Horse Named George" (bass)
Brittany Howard & Ruby Amanfu "I Wonder" (steel, electric guitar)
Brittany Howard & Ruby Amanfu "When My Man Comes Home" (mandolin)
Kate Pierson "Radio in Bed" (acoustic guitar, oud)
Dwight Yoakam "Tomorrow's Gonna Be Another Day" (pedal steel)
Dwight Yoakam "High on a Mountain of Love" (pedal steel)

PATRICK KEELER
Wanda Jackson "You Know I'm No Good" (drums)
Wanda Jackson "Shakin' All Over" (drums)
The Secret Sisters "Big River" (drums)
The Secret Sisters "Wabash Cannonball" (drums)
Pokey LaFarge and the South City Three "Pack It Up" (drums)
Tom Jones "Evil" (drums)
Tom Jones "Jezebel" (drums)
Kate Pierson "Venus" (drums)

JACK LAWRENCE
Rachelle Garniez "My House of Peace" (bass)
Smoke Fairies "Gastown" (bass)
Wanda Jackson "You Know I'm No Good" (bass)
The Secret Sisters "Big River" (upright bass)
The Secret Sisters "Wabash Cannonball" (upright bass)
The Thornbills "Uncle Andrei" (bass)
First Aid Kit "It Hurts Me Too" (bass)
Seasick Steve "Write Me a Few Lines" (bass)

Seasick Steve "Levee Camp Blues" (bass)
Tom Jones "Jezebel" (bass)
Lillie Mae "Nobody's" (electric bass)

JEREMY LUTITO
Michael Kiwanuka "You've Got Nothing to Lose" (drums)

LILLIE MAE
Michael Kiwanuka "You've Got Nothing to Lose" (acoustic guitar, fiddle)
Michael Kiwanuka "Waitin' Round to Die" (acoustic guitar, fiddle)
Dwight Yoakam "Tomorrow's Gonna Be Another Day" (fiddle)
Dwight Yoakam "High on a Mountain of Love" (fiddle)

LAURA MATULA
Insane Clown Posse "Leck Mich Im Arsch" (vocals)

JO MCCAUGHEY
Gibby Haynes "Paul's Not Home" (mother's voice, vibrachime)

SHELBY O'NEAL [AKA SHELBY LYNNE OF THE BLACK BELLES]
Smoke Fairies "River Song" (drums)

JAKE ORRALL
Insane Clown Posse "Leck Mich Im Arsch" (electric guitar)
Insane Clown Posse "Mountain Girl" (electric & acoustic guitar)

JAMIN ORRALL
Insane Clown Posse "Leck Mich Im Arsch" (drums)
Insane Clown Posse "Mountain Girl" (drums)

IKEY OWENS
Brittany Howard & Ruby Amanfu "I Wonder" (keys, B3 organ)
Brittany Howard & Ruby Amanfu "When My Man Comes Home" (B3 organ)

LEIF SHIRES
Wanda Jackson "You Know I'm No Good" (trumpet)
Wanda Jackson "Shakin' All Over" (trumpet)
The Secret Sisters "Wabash Cannonball" (trumpet)
Tom Jones "Evil" (trumpet)
Kate Pierson "Venus" (trumpet)

PONI SILVER
Lanie Lane "Ain't Hungry" (drums)
Lanie Lane "My Man" (drums)

JACKSON SMITH
The Secret Sisters "Wabash Cannonball" (acoustic guitar)

KEITH SMITH
Pokey LaFarge and the South City Three "Pack It Up" (flugelhorn)

Black Milk "Brain" (trumpet)
Black Milk "Royal Mega" (flugelhorn)

LINDSEY SMITH-TROSTLE
Insane Clown Posse "Leck Mich Im Arsch" (cello)

BEN SWANK
Gibby Haynes "Paul's Not Home" (drums, background vocals)
Gibby Haynes "You Don't Have to Be Smart" (drums)
Gibby Haynes "Horse Named George" (drums)

CRAIG SWIFT
Wanda Jackson "You Know I'm No Good" (saxophone)
Wanda Jackson "Shakin' All Over" (saxophone)
The Secret Sisters "Wabash Cannonball" (saxophone)
Tom Jones "Evil" (saxophone)
Kate Pierson "Venus" (saxophone)

MARK WATROUS
The Thornbills "Uncle Andrei" (fiddle)
The Thornbills "Square Peg" (fiddle)
Tom Jones "Jezebel" (fiddle)
Insane Clown Posse "Leck Mich Im Arsch" (harpsichord)
Duane the Teenage Weirdo "Postcard from Hell" (synth)
Duane the Teenage Weirdo "Bubblegum Encore" (synth, bass)

JACK WHITE
Rachelle Garniez "My House of Peace" (drums)
Dex Romweber Duo "The Wind Did Move" + "Last Kind Word Blues" (guitar, bass, vocals, sawing wood)
Dan Sartain "Bohemian Grove" (piano)
Smoke Fairies "Gastown" (drums)
Smoke Fairies "River Song" (tympani, electric guitar, finale drums)
Wanda Jackson "Shakin' All Over" (bass, guitar)
The Secret Sisters "Big River" (lead guitar)
The Secret Sisters "Wabash Cannonball" (mandolin)
The Thornbills "Uncle Andrei" (drums)
The Thornbills "Square Peg" (kick drum)
Chris Thile & Michael Daves "Man in the Middle" (drums)
Chris Thile & Michael Daves "Blue Night" (drums)
Seasick Steve "Write Me a Few Lines" (bass)
Seasick Steve "Levee Camp Blues" (drums)
Black Milk "Brain" (guitar)
Black Milk "Royal Mega" (drums)
Tom Jones "Evil" (electric guitar)
Tom Jones "Jezebel" (electric guitar)
Lanie Lane "Ain't Hungry" (bass)
Jeff the Brotherhood "Whatever I Want" (organ)
John & Tom "Gonna Lay Down My Old Guitar" (drums, percussion, bass, organ)
Becky & John "I'll Be There if You Ever Want" (drums)

Duane the Teenage Weirdo "Postcard from Hell" (theremin, electronic drums)
Duane the Teenage Weirdo "Bubblegum Encore" (drums, C+G synth)
Beck "I Just Started Hating Some People Today" (drums, acoustic guitar, punk vocal, background vocals)
Beck "Blue Randy" (drums)
Gibby Haynes "Paul's Not Home" (guitar, background vocals)
Gibby Haynes "You Don't Have to Be Smart" (guitar)
Gibby Haynes "Horse Named George" (guitar)
Lillie Mae "Nobody's" (drums, as Whip Triplet)
Lillie Mae "The Same Eyes" (drums, Hammond organ, as Whip Triplet)
Kate Pierson "Venus" (bass)

CORY YOUNTS
Smoke Fairies "River Song" (piano, clavinet)
The Thornbills "Uncle Andrei" (piano)
The Thornbills "Square Peg" (piano)
Chris Thile & Michael Daves "Man in the Middle" (piano)
Chris Thile & Michael Daves "Blue Night" (piano)
Brittany Howard & Ruby Amanfu "I Wonder" (piano)
Brittany Howard & Ruby Amanfu "When My Man Comes Home" (piano)
Michael Kiwanuka "You've Got Nothing to Lose" (piano)
Michael Kiwanuka "Waitin' Round to Die" (Wurlitzer, piano)
Dwight Yoakam "Tomorrow's Gonna Be Another Day" (piano)
Dwight Yoakam "High on a Mountain of Love" (Wurlitzer electric piano, Hammond organ)

ACKNOWLEDGMENTS

There's no more boss boss than my boss, Jack White. Thank you for trusting me. From tearing down furniture at the upholstery shop, selling "Let's Shake Hands" at the merch table, driving the tour van through Montana, to starting and overseeing this beautiful menagerie — it's been a ride that I don't want to stop. Side note: your copy of "Down on the Street" does NOT have the organ overdub.

Ben Swank, there's no person I'd rather be with on this trip. Your laugh is the salve that gets me through the day. You are the best thing to ever come out of Toledo.

Bonnie Bowden, your ability to eat salads so consistently motivates me. Your mere presence keeps Third Man alive. Our world is brighter with you in it. I will gladly kill snakes for you.

Chet Weise, you calmly steer the ship with the sagacity of a seasoned sea captain and I'm jealous we don't play soccer together. Thanks for the one day notice that I needed to write these acknowledgements.

Jo McCaughey, your pictures make it perfect. Let us never forget that the longest conversation you had on your wedding day was between you and I, about Stephen Tobolowsky.

Ryon Nishimori, I can confidently say, you didn't fuck this up. Thank you for the eagle eye and sharp design on "our" book. I still think Slimer baby is hilarious.

Kim Baugh, this book would have died were it not for your tireless work transcribing every dumb run-on sentence to spill out of my mouth. Your path at Third Man continues to make me proud.

Violet and Mabel, Dada can't play right now, there's literally tornado sirens blaring in the distance and I'm on deadline, but hopefully someday you both learn to read and think this is funny. Or embarrassing. You two make me happier than I ever thought possible. I'll keep singing if you keep listening.

Malissa, my love, thank you for believing in me and not batting an eyelash when fatherly duties gave way to book writing. I am nothing without you. You are my everything. The next book is entirely your idea. Bill Murray.

Literally anyone else that feels like they're owed a mention, here's a line where you can write your name and if you find me in person I will happily inscribe a witty, poignant thought that you will cherish forever. At no cost to you.

Born and raised on the tony streets of Detroit, Michigan, Ben Blackwell has been a reluctant participant in the overhyped underground rock and roll community (both as a performer in the Dirtbombs and on the label-side in his work through Third Man and his own imprint Cass Records) since 1999, literally half his life. He miraculously won *Rolling Stone's* 2004 College Journalism Award and has contributed writing to countless rags and dog cage liners. He ate his first salad at the age of 21, has never gone to the bathroom on an airplane and on average buys two records a day. He falls asleep nightly on a couch in Nashville, Tennessee while his frustrated wife Malissa wonders why he won't just go to bed.